DETAIL

featuring

steel

resources
architecture
reflections

Authors

Andrea Bruno, Architect
Professor of Architectural Restoration at the Politecnico of
Turin and Milan

Klaus Bollinger, Prof. Dr.-Ing.
Professor of Structural Design, University of Applied Arts Vienna

J. Michael Davies, Prof. Dr. Dr. FREng.
Emeritus Professor of Structural Engineering, University of Manchester

Markus Feldmann, Prof. Dr.-Ing.
Head of the Institute of Steel Construction, RWTH Aachen University

Manfred Grohmann, Prof. Dipl.-Ing.
Professor of Structural Engineering, University of Kassel

Federico M. Mazzolani, Prof. Dr. Eng.
Full Professor of Structural Engineering, University of Naples "Federico II"

Gerard O'Sullivan, FRICS, FICS, FIArb
Director Mulcahy McDonagh & Partner Construction Economists
President of CEEC (Conseil Européan des Economistes de la Construction)

Francis Rambert, Journalist
Director of the l'Institut Français d'Architecture (IFA)

Alexander Reichel, Dipl.-Ing. Architect
Reichel Architekten BDA, Kassel

Llewellyn van Wyk, B. Arch., Architect
Senior Researcher, CSIR (Council for Scientific and Industrial Research)

Co-Authors:
Tóma Berlanda, Ph. D.; Francisco Cardoso, Prof. Eng.;
Pierre Engel, Prof. Dr. Eng.; Gerald Schnell Dipl.-Ing.;
Sébastien Turcaud

Editorial services

Project Manager:
Steffi Lenzen, Dipl.-Ing. Architect (DETAIL)
Christoph Radermacher, Dipl.-Ing/MBA (ArcelorMittal)

Editorial services:
Johanna Billhardt, Dipl.-Ing.

Editorial assistants:
Laura Hannappel; Eva Schönbrunner, Dipl.-Ing.; Cosima Strobl,
Dipl.-Ing. Architect; Melanie Weber, Dipl.-Ing. Architect;
Michaela Linder, State Certified Translator

Drawings:
Bettina Brecht, Dipl.-Ing.; Melanie Denys, Dipl.-Ing.; Ralph Donhauser,
Dipl.-Ing.; Michael Folkner, Dipl.-Ing.; Marion Griese, Dipl.-Ing.;
Daniel Hadjuk, Dipl.-Ing.; Martin Hämmel, Dipl.-Ing.; Caroline Hörger,
Dipl.-Ing.; Nicola Kollmann, Dipl.-Ing. Architect; Simon Kramer,
Dipl.-Ing.; Elisabeth Krammer, Dipl.-Ing.; Dejanira Ornelas, Dipl.-Ing.

Cover Design:
Cornelia Hellstern, Dipl.-Ing.

Translation into English:
Jutta Maerten, Dipl.-Übers., Wuppertal (D)

Copy editor:
Raymond D. Peat, Eur.-Ing. CEng MICE, Alford, Aberdeenshire (GB)

Proofreading:
James Roderick O'Donovan, B. Arch., Vienna (A)

DTP:
Simone Soesters

Reproduction:
Repro Ludwig Prepress & Multimedia GmbH, Zell am See (A)

Printing & binding:
Aumüller Druck, Regensburg (D)

Bibliographic information published by the German National Library.
The German National Library lists this publication in the Deutsche
Nationalbibliografie; detailed bibliographic data is available on the
Internet at http://dnb.d-nb.de.

Editor:
Institut für internationale Architektur-Dokumentation
GmbH & Co. KG, Munich
www.detail.de

© 2009, 1st edition

ISBN: 978-3-920034-32-4

This book was produced with the assistance of:

ArcelorMittal S.A., 19, avenue de la Liberté, 2930 Luxembourg
www. arcelormittal.com

Contents

Preface

Towards new behaviours

What would the history of the architecture of the 19th and 20th centuries be without the building materials iron and steel, without Joseph Paxton's Crystal Palace in London, without the great railway terminals and bold bridge constructions, without the iconic steel structures and high-rise buildings of the modern age? Even today, steel is often indispensable when it comes to particularly delicate, wide-spanning or geometrically complex constructions, while at the same time it is gaining increasing importance in everyday architecture.
It is stating the obvious to say that the 21st century will be different from the last one. The global population will continue to grow, while environmental pressure will increase and demand some drastic changes in behaviour. With regard to consumption demands in particular, whether in connection with food, infrastructure or living accommodation, the present culture of excess prevalent in the richer countries will have to give way to some essential rebalancing in favour of the emerging countries.

The pace of the global rhythm of construction of living accommodation will remain high, in the order of 40 to 50 billion units a day, in order to house new families, satisfy the demands of migration towards coastal areas where 50 % of the population is concentrated, provide for the victims of natural disasters, replace or refurbish old, no longer habitable buildings. The same is also true of the construction of other types of building to accompany population movements, such as schools, hospitals, sports, cultural and leisure facilities or business premises.
Unless materials are invented that radically change construction methods, the materials now considered traditional will still have a part to play, but the quantitative and qualitative roles and significance of each will be examined and adapted.

Steel – the material of choice

Steel will play an essential part in this redistribution, as a number of its intrinsic benefits were not given sufficient consideration, nor was sufficient advantage taken of them, during the 20th century. The contribution of steel to long-term construction is based on various common-sense concepts.

Its lightness, in the obvious sense of the ratio of its mechanical resistance to mass, has led to the design and construction of more lightweight buildings. This means smaller foundations and less material to transport, with the resulting ecological advantages. This lightness also allows for the flexible use of spaces and the fine adjustment of comfort parameters.
The complete recyclability of steel is a decisive benefit, and not only because used steel can be reclaimed and restored to its original strength. This also means that we can "clean up" the planet by means of the organised collection of ferrous waste, which at the same time will also make a significant contribution to reducing use of the earth's natural resources of iron ores and water.

Prefabrication in the workshop or the factory of large-scale structural, façade, roofing and partition elements reduces construction timescales and therefore leads to reductions in financial and borrowing costs and also to a quicker return on investment. In addition to this, factory prefabrication means construction workers can enjoy cleaner, less hazardous working conditions.

These arguments in favour of using steel should therefore encourage building owners, architects, designers, financers, users and others to consider a composite index that is not merely an economic reflection of the construction cost per m^2, but also takes into account the environmental impact of the structure and its contribution to the social well-being of its users. Buildings are no longer designed as they were 50 or even 20 years ago. Just as the practices of automotive or aeronautical design have evolved to a considerable extent, so those of building construction should move on from the traditional.

All over the world, new construction standards, including the Eurocodes in Europe, are really shaking up construction methods, providing solutions that are both more economical and more reliable. Paradoxically, with regard to steel as a construction material, these standards lead to the use of less but "better" steel. This is the objective of the steel industry – to provide its clients, and its clients' clients, with the very latest solutions and technologies that have been proven, tested and approved. Even today, construction is the world's largest economic sector in terms of steel consumption; almost 40 % of the tonnage produced goes to this market.

ArcelorMittal Group actively supported the production, publishing and distribution of this book, with the collaboration and expertise of DETAIL magazine. The responsibility of ArcelorMittal, global leader in steel, is to forecast accurately in order to respond better to future innovations and developments, in particular with the support of its Research and Development centres and its teams involved in the marketing, promotion and sales of products, solutions and systems for the construction industry. As a worldwide producer and distributor of a wide range of products specially made for the construction industry, ArcelorMittal is able to contribute to a wide variety of projects and activities undertaken by construction companies, whether medium-sized or large prestige organisations.

The aim of this publication

This publication about steel in construction
has been written by well-known interna-
tional authors and is intended to serve as a
standard work on construction in steel. It
addresses all relevant aspects – from the
architectural theory of the introduction it
goes on to examine the production of steel,
products and semi-finished products, build-
ing and designing with steel, as well as dis-
cussing the topics of sustainability, economy
and the role of steel in regeneration.

It is aimed at the promotion of steel as
favoured construction and building material
giving all necessary information to enable
planners and decision makers, above all
architects and engineers, to base their project
conceptions and pre-design on steel solu-
tions.
The examples section shows, with reference
to outstanding international projects, the
wide variety of steel applications in building,
in supporting structures, cladding and inte-
rior finishing, and also the wide variety of
projects in which steel is used: from small
residential properties to high-rise buildings
or football stadiums. As in all DETAIL publi-
cations, in addition to exemplary structural
solutions the focus is always on the aes-
thetic quality of the projects.

Pierre Bourrier, Patrick Le Pense,
Christian Schittich

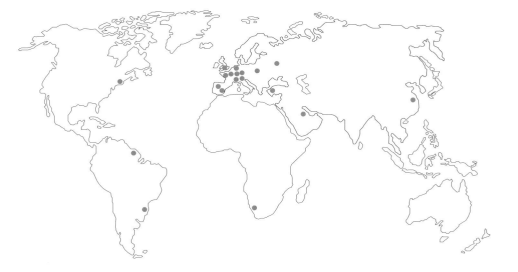

Pierre Bourrier
Former General Manager Building & Construction
Support – ArcelorMittal

Patrick Le Pense
General Manager Innovation & Construction
Development – ArcelorMittal Distribution Solutions

Christian Schittich
Editor-in-chief, Edition DETAIL

Case studies by location

Positions

Steel, Still –
Between Identity and Materiality

1

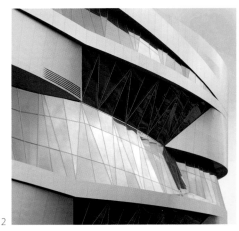

2

Francis Rambert

"L'image n'est pas tout" (The picture isn't everything), said the French philosopher Roland Barthes, yet without doubt the icon has found its way into our world. From Shanghai to Dubai, on our way through London or Barcelona, "signal architecture" and "sculpture architecture" are now widespread.

Let us think back to the intense moment in 1997 when the inauguration of the Guggenheim museum in Bilbao took place. On this very day, the whole world discovered iconic architecture in all its splendour. The work of Frank O. Gehry in the Basque country is still one of the cornerstones of architecture in the second half of the 20th century; as is the Pompidou Centre in Paris. Whilst Rogers and Piano dreamt up an "anti-monument", a cultural machine which since 1977 has done an excellent job in offering flexibility, Frank O. Gehry continued with the exploration of free forms. As a symbol of a city's mutation, the Guggenheim at Bilbao shows that the steel used for the construction of vessels in the past is today part of museum buildings. Underneath its titanium skin – the first anywhere in the world – the metallic skeleton of the museum is the result of a second experiment: the use of aeronautics software (Catia) to design a building is the second experiment. Since then the PC with its options of morphing and further lofting has considerably extended the field of possibilities. Everything or almost everything is now possible: folding, twisting, tensioning, realising torsion and distortion.

Towers today show a tendency towards "twisting". They – quite contrary to Burj Dubai, which is straight up to its height of 800 m – try to impress with another kind of moving. The Turning Torso residential tower, icon of Malmö by Calatrava, or the future towers by Libeskind and Hadid in Milan are examples of this.

Following iron, steel has taken over as regards experiments with vertical challenges. With the knowledge of its mechanical characteristics, steel is used for making skyscrapers and other "skyneedles". Always looking for "slenderness", these gigantic buildings strive to be streamlined. Remember the Mile High Illinois project by F. L. Wright.

From New York to Shanghai, from Malmö to Dubai, high-rise buildings are obliged – more than ever – to respond to the new sustainable agenda, and then get thicker. In New York, whilst the Hearst Tower by Norman Foster is a good example of dealing with heritage at a very big scale, the New York Times Tower by Renzo Piano (p. 146ff.) deals with both the American climate as well as the New York context.

Eager for new urbanisation practices, the first decade of the 21st century has turned out to be a large consumer of this kind of icon, in which the steel is visible here and hidden there. For this material provides many structural possibilities: long spans, height, cantilevers, suspended roofs, organic bodies, and other exoskeletons.

This high-tech age, which started in 1986 with the contemporaneous emergence of the HSBC Tower in Hong Kong by Norman Foster (an ode to metal) and the headquarters of Lloyd's in London by Richard Rogers (concrete with steel ornaments), may now be outdated, however, the expression of a business culture through expressive architecture is the gift of this early 21st century. Branding indeed! Let's have a quick look at Herzog & de Meuron (Prada Epicenter in Tokyo), Foster (30 St Mary Axe in London), Fuksas (Ferrari in Maranello), Van Berkel (Mercedes Museum in Stuttgart), Miralle/ Tagliabue – EMBT (Gas Natural office in Barcelona), Coop Himmelb(l)au (BMW Welt in Munich), Rem Koolhaas (CCTV in Peking), Frank O. Gehry (Ciudad del Vino in Elciego) and finally the flagship store of Freitag in Zurich, a tower of containers composed by SpillmannEchsle adhering to the complete logic of recycling. And in the public domain it becomes obvious that the brand image of

a town translated into symbolic architecture does not fall short of this. Great evidence of this 'city branding' is provided in particular in Beijing with the sporting venue Bird's Nest by Herzog & de Meuron (an intricate woven steel structure) or the National Grand Theatre by Paul Andreu (steel structure and titanium skin). In Europe a series of works with symbolic designs is confirming this tendency, for example the Philharmonic Hall in Paris (an ode to Claude Parent's theory of the oblique) designed by Jean Nouvel, the project "Cloud" by Massimiliano Fuksas in Rome, the "Musée des Confluences" in Lyon by Coop Himmelb(l)au (cantilevered prow over the end of the urban peninsula), or the monumental ring of the future Science Centre in Hamburg by Rem Koolhaas.

All these projects with iconic character – where steel plays a major role – have led to discarding Sullivan's well-known formula "form follows function", as the form tends more to follow the ambition of the project.

3

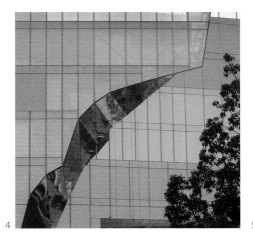

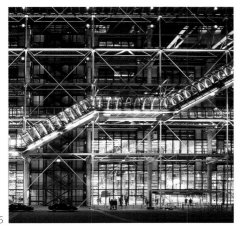

4

5

6

Above and beyond the technical performance offered by the material, it is a question of planning the city and of shaping a modern landscape.

Dealing with big scale, creating new "territories"

Overcoming difficult questions, mastering large dimensions. Today we hardly remember the Crystal Palace, the first of the grand buildings made of iron, 1851 feet long to match the year of the first World´s Fair exhibition in London.
Today you do not have to search in giant halls of this kind to find out how large dimensions are treated but in other meeting places of the modern world including stadia, intermodal transport junctions, and trading centres. As well as fulfilling complex programmes, which sounded the death knell of monofunctionality, railway stations and air-

ports have become shopping arcades, while cultural sites have absorbed this degree of change, too. And – what has never changed – architects fall back on steel to show the full vastness of large dimensions. Above and beyond the structural logic, the search for precision to meet geometric requirements arising from new kinds of quality inspections should be noted in this connection. Geometry - this is the common denominator in the work of Dominique Perrault. In Berlin, the reunited capital, the Olympic complex designed by the French architect creates its own geography by means of an immense concrete base embedded in the ground which houses the sports equipment. This work, both territorial and minimal, uses steel in a sense of a "global concept" where the skeleton and the skin engage in total coherence.
From the very beginning of his work (remember the buried Usinor-Sacilor conference centre in Saint Germain en Laye),

Dominique Perrault has notably used steel as a tool of urban composition. His very latest works (the extension to Luxembourg Law Courts, the Ewha womens University in Seoul and the "Caja Magica" in Madrid) confirm his ability to master the big scale in experimenting with the structural characteristics of steel. At ease with size, this French

1 Ciudad del Vino, Elciego (E) 2006, Frank O. Gehry
2 Mercedes-Benz Museum, Stuttgart (D) 2006, UNStudio
3 Turning Torso, Malmö (S) 2005, Santiago Calatrava
4 HSBC Tower, London (GB) 2002, Foster + Partners
5 Centre Pompidou, Paris (F) 1977, Studio Piano & Rogers Architects
6 2nd airport terminal of Beijing Capital International Airport, Beijing (RC) 2008, Foster + Partners
7 Hearst Tower, New York (USA) 2006, Foster + Partners
8 Lloyds headquarter, London (GB) 1986, Richard Rogers
9 Freitag Flagship Store, Zürich (CH) 2006, SpillmannEchsle

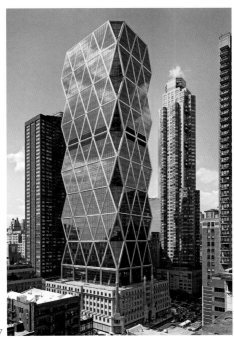

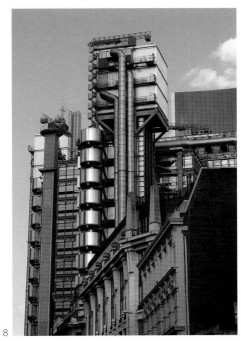

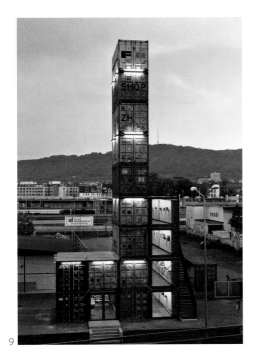

7

8

9

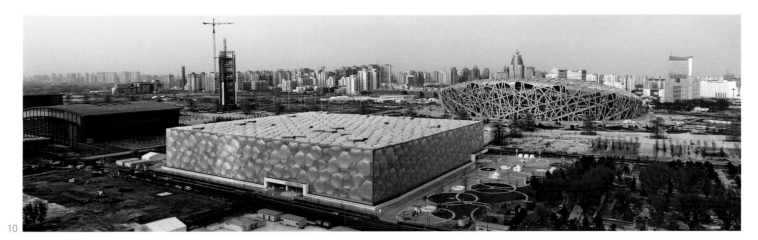

10

architect is also very comfortable with processing the material. In Luxembourg, he treated the existing Saarinen-type structure with great respect and transformed it into a large complex that asserts the sustainable approach of contemporary architecture. The new ring that embraces the old building is a composit structure that creates an opens square given rhythm by slender, highly flexible steel columns.

In Seoul, the issue was not the extension of a university building but the extension of a site, inside the city. This territorial project is designed as a "canyon- building" that offers a new topography in relation to the existing hill. Here again, Dominique Perrault plays with the repetition of very few elements and only two visible materials: steel and glass. This long "incision" in the landscape deals with urban quality as well as land art.

Large scale is synonymous with China. The icon of the new Beijing – the Olympic stadium – outstandingly glorifies steel, in an ornamental way. The "Bird's Nest" stadium is the result of collaboration between architects Herzog & de Meuron and a Chinese artist, Ai Weiwei. The sports arena is enveloped in a huge netting, which is structural in some parts and decorative in others. Thus, the skin of the building deals with coalescing the ambiguity between structure and ornament. Given this interlaced material, that is even chased like a piece of jewellery, this work is undeniably a work of fine art. Today, the audience makes its way to the stands beneath the interlaced steel. A different stadium, a different skin, a different game of structures: still in Beijing and close to the emblematic stadium stands the Watercube. The blue parallelepiped, the venue for the swimming competitions in the Olympic Games, was conceived by the Australian architects PTW and instead of a "nest effect" creates a "bubble effect" fitting for its purpose. The skin is made of poly-

mers, however the complex structure (22,000 tubes) that illustrates the translucent bubbles is actually of steel.

Mastering large dimensions means managing large flows in space-time. Airport platforms are places of large flows par excellence. Kansai International Airport Terminal, built by Renzo Piano in 1994 on an artificial island in Osaka Bay, is one of the first of this new generation. This terminal, 1.7 km long, which strives for the petiteness of a glider, owes a lot to steel; in addition to the expressive structure, 82,400 steel panels were needed to clad the terminal and, incidentally, provide the airport with silver reflections. With a far more noticeable structural expressionism, Terminal 4 of Barajas Airport in Madrid plays with colour and shape (p. 194ff.). Richard Rogers recognisable idiom is perfectly suited to this place of connection configured to welcome 35 million

passengers per year. From a formal point of view, the kilometre-long terminal impresses the rhythm of waves by means of prefabricated elements supported by their colours (as in the Centre Pompidou). Inside, the metaphor borrows from the world of trees to define the structure with natural lightwells required for to flood all airport levels with light. This way the "canyons" are open to the top and traversed by walkways which suggest a visual crossing of paths.
On a large scale, China is the land of development of new transport facilities; Beijing's second airport with its large 900-m-long hall designed by Norman Foster, and the future airport of Shenzhen in the south of China designed by Massimiliano Fuksas – a terminal of some 1.2 km in length built with a steel structure and a high-grade stainless steel skin underline this sense of dimension. In Shanghai, the South Railway Station – an intermodal junction point – has been com-

11

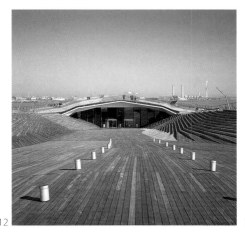
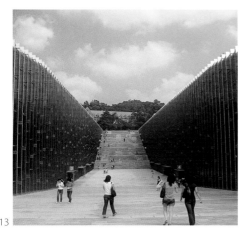

10 Watercube, Beijing (RC) 2003, PTW Architects
 and Bird's Nest, Beijing (RC) 2008, Herzog &
 de Meuron
11 Bird's Nest, Beijing (RC) 2008,
 Herzog & de Meuron
12 Yokohama International Port Terminal,
 Yokohama (J) 2002, Foreign Office Architects
13 Ewha Women's University, Seoul (ROK) 2008,
 Dominique Perrault

12

13

pletely integrated into the road network, whilst at the same time showing respect to Chinese traditions. A figure of tremendous symbolic significance to the Middle Kingdom – the circle – has been realised here in the form of a huge 260-m-diameter wheel appropriate to the scale of the metropolis. The building achieves its width through a steel structure defined by a ring inside of which the main flows are concentrated in a really geometric way. Here, the play of large spans with projections of 20 m starts. Experienced coppersmiths using shipyard techniques constructed the building.

In the maritime field, after the Yokohama International Port Terminal "scenery building" designed by FOA, Odile Decq followed with the new gateway to Africa in Tangier. An intermodal platform where the steel buildings are covered with a thin concrete skin to provide higher resistance to saltwater corrosion and allow limewash to be applied. Designed like hulls, the different buildings have an emphatically organic character. The largest of them, 360 m in length (with spans of 40 to 50 m), looks somewhat like a white whale.

Another place of large flows is the trade fair Fiera Milano in Italy (p. 198ff.).The large exposition buildings are located around a 1.7 km length of street connected to a metro network at the city end and close to the famous Galleria Vittorio Emmanuele. This is the link between the iron of the 19th century and the steel of the 21st century. On the new exposition sites, Massimiliano Fuksas has designed a real "scenery" with a relief that multiplies geographic and climatic metaphors. The "Vela", a thin and supple canvas, shelters the straight street whilst developing its highly supple steel and glass structure. No doubt one of the reasons steel was selected was the speed with which it can be erected, which allowed this vast construction site of one million square metres to be completed in just 26 months. From a technical point of view, most of the

projects realized by Massimiliano Fuksas deal with "transparency", an approach made possible by the engineering properties of steel. Linearity, articulation, large dimensions. The university project of Nicolas Michelin in Nancy shows the same kind of features as the Milano Fair. But the scale is not the same here the street is 400 m long. Not actually designed as a conventional campus, this future "knowledge base" underlines its urban character through a "street" – again a gallery of metal and glass – that forms a structuring axis for the arrangement of the buildings and is an interface between university and city.

As regards the world of commerce, our modern era has come up with new venues, the so-called "delivery centres" for cars or aircraft. In these centres possession of the new machines is a ritual which is given a really spectacular architectural translation. Munich has the BMW Welt, a work by Coop Himmelb(l)au, which is a monumental double cone and spreads out spaciously to cover a giant public area. This steel and glass unit, a hybrid of theatre and public area, is successor to the famous BMW headquarters, the "four-cylinder building", a technical icon of the seventies. It is noticeable that the reference made is no longer based on the power of engines but upon a much wider and immaterial horizon: the sky. The giant floating roof, a sculptural roof coupled to the cone containing a helicoid ramp inside, underlines the metaphor of a tornado used to provide the form for this building – demonstrating a corporate culture – with real energy (p. 202ff.).

Looking for cantilevers, the spirit of challenge

We recall Expo 58, the world exposition of 1958 in Brussels, because of the recently refurbished Atomium and the French Exhibition Hall by the architect Gillet and the

engineer Sarger – a demonstration of the heroic use of steel culminating at a height of 65 m and presenting an unprecedented articulation of three large metal girders of 80 m in length. Today, heroism is represented by other heroic deeds, by other spectacular projections which are always challenges to gravity, such as the Skywalk – a steel and glass walkway shaped like a horseshoe cantilevering 22 m out over the empty space of the Grand Canyon. In urban surroundings, these matchless objects try to redefine the city skyline. Let's take a look at three examples in the United States. The Seattle library by OMA replies to the concept of three flying boxes in the style of the concrete flying box above the house in Floirac, France by Koolhaas. The library encases its volumes in a hairnet in order to transform them into "floating boxes". Here, the metal of structural potential (anti-seismic boxes and hairnet) is given a very dynamic formalisation, increasing the force of attraction represented by this cultural site in communication with the surrounding towers.

Displacement of boxes – this is also the systemised idea in the Cubist manner as presented by Sanaa in the Museum of Contemporary Art in the Lower East Side (p. 152ff.). In actual fact this is an urban sculpture 54 m high, all steel, completely enveloped in a grey aluminium skin.

In Downtown Los Angeles, only a stone's throw away from where the very sculptural Disney Hall by Frank O. Gehry glorifies metal, a steel monument rises like a monolith. Designed by Morphosis, the Caltrans District 7 Headquarters (California Department of Transportation) makes a lasting impression with its strong presence and can be identified by its house number 100, a giant sculpture, as well as by its projection.

In Germany, the cult of the motor-car results in signs of a comparable magnitude. Here the trend is emphasising the corporate identity by means of strong architectural

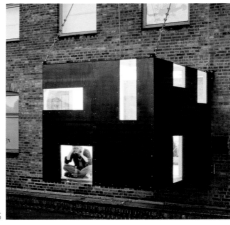

14 15 16

images. The Mercedes Museum in Stuttgart by UNStudio was designed as DNA double helix – with two spiral ramps as the main routes. Altogether a spectacular demonstration of space, where steel and concrete are mixed in the dynamics of the trajectories.
In the same city, but celebrating a different myth, is the Porsche Museum, which the Austrian architects Delugan Meissl have realised as a steel monolith searching for levitation.
In Rotterdam where Van Berkel has already built a contemporary icon in the form of the Erasmus Bridge, the Shipping and Transport College adopts the same measure of a signal building. With this strong act, Neutelings Riedijk Architects plays with shape and graphic design. Whereas the head of the building tries to establish communication with the city, its envelope stands out thanks to its chequer-board pattern. Such decentration of the audacious projection creates strong dynamics. This giant eye, a large window opening in the auditorium, focuses the fluvial topography.
In the field of wine, a symbol for regional rootedness, architecture is also expressd through objects of unique metal. In Rioja in Spain, Frank O. Gehry does not try to blend into the surrounding area like the celebrated winery made of gabions in Napa Valley, California. With his hotel and bodega Marqués de Riscal, the Californian architect has designed a building that is an outstanding sculpture. Wine – red and gold are the colours of this "Ciudad del Vino en Elciego", a complex of volumes which toys with the effects of an envelope above a stone foundation.
Wine tourism in Italy where the Nardini centre in Bassano del Grapa is still committed to branding by architecture: Massimiliano Fuksas has shaped two large crystal balls which – floating in the air – suggest an alembic. These two elliptical volumes form a counterpoint to the buried architecture. After it becomes clear that no two panes are

of the same shape, the transparency reveals the structure of the steel arches so decisive to this dynamic shape, which rejuvenates the venerable distillery.
Did you say skyline? Ever since the "cloud-irons" by El Lissitzky, cantilevers are no longer incompatible with the typology of a tower. The corporate head office of Gas Natural in Barcelona designed by EMBT proudly presents a cantilever of 30 m. Actually, the complex consists of three asymmetric elements defining the public space.
In Beijing, the dominating icon of the Central Business District is the China Central Television CCTV Headquarters. But is this really a tower? For Rem Koolhaas and Ole Scheren have reinvented the typology of skyscrapers in as a clasp, size XXXL. With its stunning cantilever, the CCTV, peaking at 234 m, seems to defy gravity. Huge cross-bracings, visible through the glass, reveal the load-bearing steel system, 14 times the weight of the Eiffel Tower, required to realise this building! And not forgetting the tower of the congress centre – the "missing leg" which completes the complex.
Another clasp – inspired more by a buoy than by a Möbius ring – the Science Center in Hamburg, was also designed by OMA. In Hafencity, an extensive territory for architectural experiments, a monumental building will arise to compete with the scale of the new generation of cruisers. Steel makes this unmatched typology of ring buildings possible where 23,000 m² of land will be developed through the aggregation of 10 blocks.

Thanks to its characteristics (in particular its mechanical properties), steel allows architects to reduce thickness and to control the distortion of structures.
Jean Nouvel's architecture provides us with interesting examples of astonishing cantilevers. Since the Lucerne Cultural Centre in Switzerland with its very thin "blade-roof" framing the lake scenery, Jean Nouvel has experimented with steel in various situa-

tions. Let's take, for example, three museums. In Madrid, the Reina Sofia's extension creates a new public space, thanks to its monumental red roof. In Paris, the cantilever effect is to be seen in the series of coloured boxes projecting out of this "bridge-building" spanning over a new park on the right bank of the Seine. In this case, the cantilevered steel boxes nestle against to cantilevered steel floors in search of global lightness. In Abu Dhabi, the opportunity of creating a prestigious "branch" for the Louvre Museum, gave birth to a new aquatic village. A cluster of volumes is sheltered by a big steel cupola of 180 m in diameter. The light is filtered by this magnificent steel cap. And Nouvel's Gulf experience can be compared with other architectural gestures. For, in this brand-new cultural pole of Abu Dhabi, Frank O. Gehry, Zaha Hadid and Tadao Ando are also each building a monumental museum.

But isn't this the age of composite materials? In France, Massimiliano Fuksas operates with dialectics for the Archives Nationales to be built on the site of Pierrefitte sur Seine in a Paris suburb. His building couples a long concrete column covered with aluminium with a more complex geometry emerging from a steel structure.
Another anti-block concept is the centre of academic research into the field of environmental protection and the economics of energy built by Mario Cucinella on the campus of Tsinghua University in Beijing. Reduction of CO_2 emissions without reduction of architectural ambitions – that is the challenge of this 40-m-high steel-glass building, which develops a horseshoe-shaped series of terraces as a cantilever. The concept of an Eco Boulevard developed in Madrid by the young Spanish team Ecosistema Urbano Arquitectos also aims at creating a different landscape in peripheral areas. Thus three round and light metal installations with vegetation accentuate the public area. These "air trees" – one of them

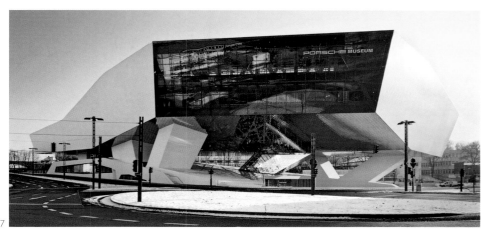

14 Musée des Arts Premiers, Paris (F) 2006, Jean
 Nouvel
15 "Rucksack", Leipzig (D) 2004, Stefan Eberstadt
16 Housing for the Elderly, Amsterdam (NL) 1997,
 MVRDV
17 Porsche Museum, Stuttgart (D) 2008, Delugan
 Meissl
18 CCTV Headquaters, Beijing (RC) 2002, OMA 17

consisting of a series of suspended tubes – contribute to the creation of a new climate, at times achieving a temperature reduction of 8 °C. However, this is far removed from Calatrava's monumental steel structures for the Olympic Games in Athens in 2004 – a triumphal alley made solely to provide shade between the stadia.

Cantilevers and other projections are not reserved for public buildings, they can also be found on residential buildings. After the celebrated operation WOzoCo, an assisted living project signed by MVRDV, other projects are developing living space above empty space. For example at the end of the Borneo quarter in Amsterdam where the inhabitants may "ensconce" themselves in suspended glass boxes, just like the cars which – in the facades - are also placed in the limelight. Even earlier, in Carabanchel one of the new residential quarters on the periphery of Madrid, the work of Dosmasuno Arquitectos multiplied the excrescences in facades. In this building complex of 102 flats, "the extra-room" resulting from the architectural grafting of a steel structure on to a concrete core justifies the game played with cantilevers.

Furthermore, it can be seen that Lacaton & Vassal, in search of an answer to the difficult question of how to transform the heritage of the sixties in Paris, has responded by enveloping the obsolete concrete tower in a new type of steel structure in order to enlarge the flats.

The "Rucksack" is also suspended: this work by artist Stefan Eberstadt is hooked onto the facade of a building in Leipzig. Held by cable ties fixed to the facade, the little steel box tries out an unexpected "outside-inside" effect.

Bridging the city, back to superstructure

Is it perhaps a consequence of increasing density? Traversing the city, overhanging 18

urban space – these are tightrope walks for which architects volunteer.

Let's have a look at one of the mystic buildings of modern times, the Lingotto in Turin, this concrete colossus tailored to the assembly line. Renzo Piano has installed in it the Pinacoteca Agnelli. The final step in the transformation of the former Fiat factory, this metal building, a precious box suspended above large patios, can be seen from a considerable distance and shelters the collection of the former Fiat boss.

In Rotterdam, the De Brug building is located above a factory, too. The logics of this commercial building is based on the context of the city port. Chris de Jonge has designed a bridge-building of 132 m in length which develops its parallelepiped silhouette above existing industrial premises. Still in the Netherlands, where the issue is also inclusion of the existing into radically

changed infrastructures, the complex construction called Kraanspoor in Amsterdam by OTH architects is a bridge-building where business is added to industry by reusing a loading bridge over its length of 270 m (p. 174ff.).

Beyond works of art, in the moment when architecture appears to cross frontiers, it is often steel that provides relationships. Consider the latest example in Paris, where the Musée des Arts Premiers, a hybrid building designed by Jean Nouvel, spans like a bridge over a garden, converting this cultural object into a true "landscape building" at the foot of the Eiffel Tower.

In Jeongok in South Korea, the Prehistory Museum is like a real bridge between two hills. The team from X-Tu Architects created this physical line embedded in the topography. Actually, the organically shaped building inspired by the amoebe and provided

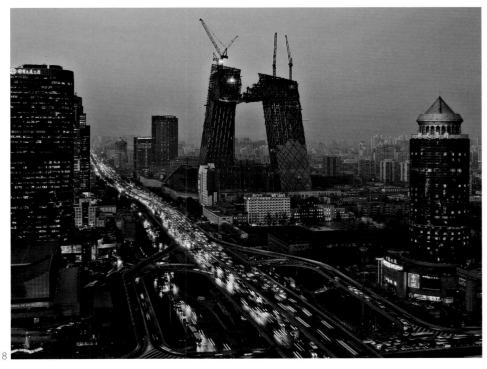

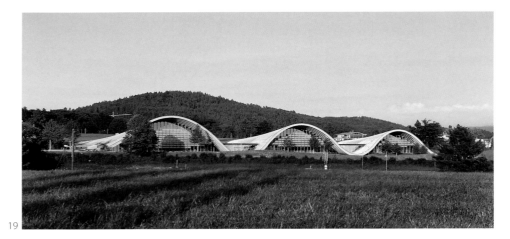

19

with a brilliant stainless steel skin extends over a distance of 100 m and spans the empty space over 30 m. A grid-shaped structure of girders concealed inside allows the "bridge" passage to become reality. For the Paul Klee Museum in Bern Renzo Piano has integrated three metal waves into the landscape. However, it should be noted that concrete is here the mediator to ensure better anchoring in the hill.

Further waves in the sector of sports. Here, we notice a return to steel for the creation of new aquatics sceneries in urban surroundings. These represent the palpable translation of the idea of fluidity with a metaphoric reference to the function. The wave effect is the common feature in two projects, one realised on the outskirts of Madrid, the other on the banks of the Seine in Mantes-la-Jolie. The municipal swimming pool of Valdesanchuela built by Alberto Nicaolau creates a complete landscape of metal inside. The nautical pole designed by the French architects Search, an hour away from Paris, tries to create an interface between the "sensitivity" of city and the environment of the hills of Vexin. In order to ensure a dialogue, the architects have combined a metal structure with grassed roofs.

A building as a landscape. This is certainly the main theme of the National Opera in Oslo, masterwork of Snøhetta. This "iceberg type" building is a an excellent example of a civic building. It is more than a single cultural place, above all it is a public place. The volume of the opera is wrapped by public space (20,000 m²). Inside the foyer that makes the missing link between the city and the sea, slanted columns hold the space. Outside, the emerging volume (the fly tower) is clad in aluminium, which was worked by Norwegian artists.

Structural skins, new skeletons for buildings

If the skin is one of the favourite research topics of architects, the structured skin is still being explored. The loadbearing envelope – or reticulate system – often made of steel – is entering the architects' vocabulary. Since the John Hancock tower in Chicago, which makes no secret of its transverse bracings, emblematic buildings have not been afraid of clearly showing their structure.

The Sendai Mediatheque by Toyo Ito offers us a fine example. There, technology satisfies poetics in an arborescent structure combined with transparency. In this trilogy of Plate-Tube-Skin, the 13 tubes that pierce the plates, from the floor to the roof, present a flexible structure that embodies flows and energies.

Still in Japan, at the end of the "fashion street" in Tokyo where the names are strung together in a catalogue of luxury labels, the Prada Epicenter in Tokyo designed by Herzog & de Meuron reveals a hybrid typology, somewhere between a small tower and a large house. The finish of the glass with its sets of rhombi between concavity and convexity is inseparably bound up with the structural result, whilst the reticulate steel system provides the geometry as well as ensuring aseismatic characteristics.

In London, in dialogue with the emblematic headquarters of Lloyd's, 30 St Mary Axe, an icon of the City , expresses a pivoting motion through its ogival shape, which has given it the nickname "Gherkin" (p. 138ff.).

In Barcelona, in the Diagonal del Mar near the Pixel Tower by Jean Nouvel, the bronze-coloured Torre Mediapro designed by Carlos Ferrater now rises. It displays perfectly controlled geometry with all the glass panes identical. A metallic structure around the outside allows a column-free interior.

In Champs Elysées, Paris, the building "C 42" – the Citroën showroom – occupies the entire depth of a small plot. As an answer to such narrowness and to the brand identity, Manuelle Gautrand has designed a reticu-

20

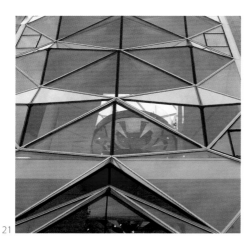

21

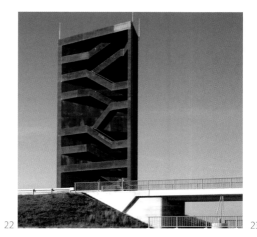

22 23 24

late herringbone system as a loadbearing structure that envelops the building from one facade through the roof to the other facade in the spirit of perfect continuity. "Better life, better city" – this is the theme of the world exposition in Shanghai in 2010. The French Exhibition Hall designed according to the theme of "7 senses" by Jacques Ferrier will be based on the idea of a particular constructional ambiguity. Whilst the building structure is 100 % steel, the reticulate envelope is made from a light-coloured "mineral mixture". As was announced, the idea behind this is to reflect the colour of Paris as well as that of the Châteaux on the banks of the Loire. It should be noted that, conversely, the Japanese architect Shigeru Ban, author of the antenna of the Centre Pompidou in Metz, covers the steel structures of the building with wood. This emphasizes the tendency to mix.

Mix is the point. New typologies of building will emerge with the new requirements of sustainable cities. The offices for the Federal Environment Agency in Dessau, a large complex built by Sauerbruch Hutton is perhaps a kind of prefiguration of the forthcoming attitudes (compactness, energy). This crescent-shaped "case study for sustainable building", has created a covered atrium which is a generous public space accessible to everyone. And, even though the external panel facades are in wood, steel also plays a major role in this project (atrium structure, footbridges).

At a minor scale, steel brings a lot of manufacturable solutions to cope with the demands of "small" projects, such as ease of assembly and low cost solutions. The architecture of Glenn Murcutt is, perhaps, the best evidence that here ecology meets economy.

Skins in relation to landscape, opening the dialogue

The skin is a medium of interchange, a surface on the interface. It allows contact with the environment. We often recall Jakob & Mac Farlane who – fighting the challenge to touch the mystic building of the Centre Pompidou – have provided a new creation whilst still keeping to a metal vocabulary. Consequently, deforming the floor surface into the volume was the strategy for the Restaurant Georges. Thanks to the fluidity resulting from such deformation (and thanks also to the employment of technologies used for boats) the architects could blend into the work by Piano & Rogers. Certainly under a less heavy burden, wide topographies are quite different in relation to architecture, but not less sensitive. The sculptural often comes with contact with the vegetal and the mineral. At the gates of Senftenberg in Germany, the look-out tower of Lausitz performs as sculpture in the scenery. A monolith made of weathering steel, the work of the architects Stefan Giers and Susanne Gabriel, peaks at 30 m. The really striking flights of stairs play a graphic game while presenting the materiality to its full extent.

Catalan architects RCR, who adore weathering steel as a material, embedded plates into the soil to create exceptional scenery for the interior of a bodega (Bell-Lloc) situated in the hills above Palámos. At the gates of their native city Olot, they have designed a great house – Casa Rural – a homage to Donald Judd. A battery of canons of light, huge metal cuboids, blend into the flank of the hill.

Steel as the only material – in the country side, too. A single skin without pores. Without any windows, obligatory in the battle against industrial espionage. On the basis of this exclusive principle, Dominique Perrault has designed the Aplix factory embedded in the scenery near Nantes. A stainless steel envelope like a mirror develops over one kilometre in length where patios have to pro-

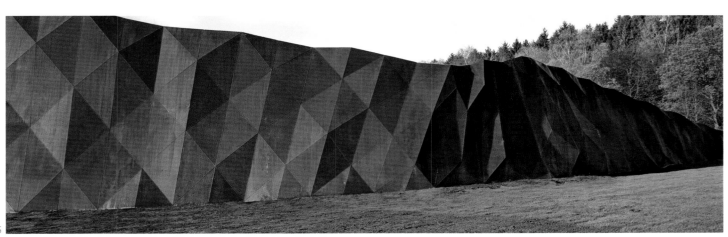

25

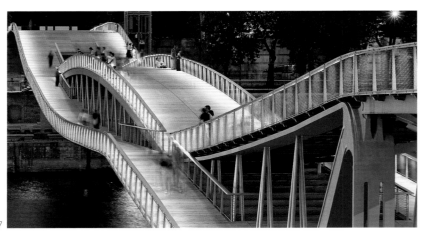

26 27

vide light inside the premises. All in all, a work that is as economic as it is aesthetic and is nourished by the surrounding plants and allows the industrial presence in the scenery to fade into oblivion.

Based on the same logic of the introverted buildings, the Hinzert Information Centre in Germany stands out due to its unifying metal skin. The architects Wandel Hoefer Lorch + Hirsch opted here for weathering steel to produce a monolith of (3000) facets. In the middle of one of the largest urban parks of the world – the Golden Gate Park in San Francisco – the De Young Museum has made a comeback. This new cultural object designed by Herzog & de Meuron is built (with a metal structure) upon the idea of total interaction; between the different periods presented in the collections as well as between the museum and its surroundings. Representing integration, the museum also works on the subject of materials. While the twisted tower and the projection try to dematerialise through their fine mesh, the complex plays with the transformation of a work made of 7200 copper plates.

A unique skin that develops its own diversity is the intention of the Glenburn House in Australia. The dwelling designed by Sean Godsell is based on recycling materials. Thus, a steel structure supports numerous preoxidised steel elements over a length of 30 m.

Reacting to a suburban context, this is also the role of the Zénith, a venue that turned up on the French scene in the eighties. Since then, the concept has been realised in many architectural varieties. Obviously, so many envelope exercises led the architects to differentiate between the entrance hall and the performance level. In Rouen, for example, Bernard Tschumi has built circulation and gradins of concrete and has selected steel for the structure and skin. The same dichotomy can be found in Strasbourg, where Massimiliano Fuksas has revisited the archetype of a monumental circus

tent. Here, let's talk about the translucid attractiveness. Indeed, this concert hall built in the periphery of this eastern metropolis acts as a magnet at night. You have to slip into the orange textile skin to discover the metal structure added to the concrete core. Behind the skin the powerful steel structure is then not hidden at all; it participates in the show.

New links

The complexity of our modern metropolises makes links indispensable. Virtual links via the Internet and other communication channels, physical links via a variety of walkways connecting contemporary space over motorways and other traffic flows. One example of this is the office complex in Beijing by Steven Holl, where several buildings along an express highway have been connected by metal foot-bridges.

In order to celebrate its status as European Capital of Culture in 2003, the city of Graz in Austria presented several architectural events, the most polemic of which was the "friendly alien" designed by Peter Cook & Colin Fournier. A short distance from this organic architecture (metal skeleton with plastic skin) a no less informal work was placed in the river bed of the Mur. This object invented by the artist Vito Acconci is much more than a walkway, it is an urban location with a café and an open-air theatre. And, unusually, it connects both banks of the river by means of a walkway that is anything but straight.

But after all, what is the beeline between two points? The zigzag bridge by Miguel Arruda in Alverca, Portugal, also makes certainty begin to waver. The proof has been furnished that the work of art is nothing but a matter of technique – the objective is to create a course. Here, 150 m result from two unequal metal beams of 60 and 90 m that describe an acute angle. And in an ancient

setting on the border between Austria and Hungary, the open-air theatre realised by the team Alleswirdgut encourages this trend of indirect courses by playing with the topography as well as with the materials. Here, we find in particular a set of walkways as well as a weathering steel block embedded in the rock.

At Kew Gardens in London famous for its marvellous 19th century greenhouses, Marks Barfield has designed a "treetop walkway". A complete network of walkways in the trees is designed to welcome 3000 visitors daily. Here again, weathering steel was selected to advance fusion with nature. The walkway describes an irregular loop suspended at a height of 18 m and spaced by platforms every 12 m.

The Simone de Beauvoir walkway designed by Dietmar Feichtinger does without detours; this is a work of art spanning 190 m over the Seine without any piers. It connects the esplanade of the Bibliothèque de France and the Parc de Bercy and provides a nice lens effect just in the middle of the walkway. This prefabricated bridge made in Germany was transported by ship to its final location. The Möbius effect can be found in the middle of Tianjin where Marc Mimram twisted the sheet metal in order to design large straps. The architect devised the structures not as isolated elements but as surfaces. Further into the city, he designed another work of art, a bridge of petals, a large-scale experiment with a fibre-glass and metallic structure. In both cases the decision to use steel was made to take advantage of factory prefabrication.

The Bridge Pavilion by Zaha Hadid, a highlight of the Expo 2008 in Saragossa, is a steel monument. Bridging 270 m over the Ebro, the hybrid building profits from its concept of four elements: Its "pods" of variable length develop the dynamic flow, which the London-based architect likes to give her buildings (starting with the BMW factory in Leipzig up to the future TGV station in Naples).

26 Citè de la Mode, Paris (F) 2009, Jakob &
 McFarlane
27 Walkway Simone de Beauvoir, Paris (F) 2006,
 Dietmar Feichtinger
28 Blur Building, Expo 2002, Yverdon-les-Bains (CH)
 2002, Diller + Scofidio

Dealing with heritage

Transformation of the heritage often is a
requirement for its survival. Here, we enter
the field of contemporary refinement of a
monument or of a quarter. Some 30 years
ago, Coop Himmelb(l)au burst through
the roof of a building in Vienna to open up
space. In Falkestraße, steel now allows new
perspectives to be gained or even better, a
whole field of possibilities.
The same type of project that goes beyond
the scope of readily anticipated solutions
can be found in Barcelona – the Mercat San
Caterina, a really conspicuous work by EMBT.
Within a stone's throw of the cathedral, the
expression of structure lets us forget the
borders of the old market, only the facades
of which still exist. A poetic structure with a
sculpture to support this coloured roof
which reminds us of pixelised fruits and veg-
etables.
For Herzog & de Meuron, the creators of
the CaixaForum, a cultural centre in Madrid,
the challenge of reutilisation is even more
urban (p. 154ff.). Transformation of old stor-
age buildings instead of contemporary art
appropriate to the quarter, this is a nice
exercise in shape and material (facilitated
by the use of steel). Here, brick walls exist
alongsideraised parts made of ornamented
cast-iron, and overgrown gable walls.
Whereas Zaha Hadid is building the "Museum
of Art for the XXI Century – MaXXi" in Rome
with dynamic concrete walls, Odile Decq is
using steel for the extension to another
location of contemporary art – the Macro. A
"flying roof" made of steel and covered by
concrete to serve as a terrace. Here a glass
canyon opens up!
The "Cité de la Mode" in Paris, a work by
Jakob + McFarlane is derived from the con-
cept of a "plug-over". This building is a trans-
formation of a reinforced-concrete ware-
house dating back to 1907. The strategy
here is to reutilise the repetitive structure
while assigning it a new function and a new

structure. This results in a volume produced
by an arborescent system. The logic of the
building's skin (made of glass) meets struc-
tural logic (made of steel), refining the
"phantom" of concrete. Having been given a
hybrid nature, the building reconquers
space through projections over the Seine
(constructed on the model of the Centre
Pompidou stairs shaped like a large worm)
and over the roof. The fifth facade therefore
becomes an urban space, which can be
accessed as an independent area.

Cloud effect, more than aesthetics

Is the "cloud effect" a trend? In "Foam City",
the philosopher Peter Sloterdijk evokes
practicable clouds. This search for immateri-
ality can be found in the works of certain
architects who feel attracted by vague and
moving forms. The entire works of Coop
Himme(l)blau since 1968 has related to such
imaginary nebula . And then came the "Blur
Building" in the Lake Neuchâtel on the occa-
sion of the Expo Swiss 2002. This ephemeral
work by Diler + Scofidio was based on the
effect of vapourisation and represented an
environmental architecture in permanent
motion. The cloud produced by the trans-
formation of water pumped out of the lake

was also due to a steel structure which be-
came blurred in this cloud. This installation
by the New York architects emerged at ex-
actly the same time as Jean Nouvel let swim
his giant metal cube swim in the nearby
Lake Murtensee. An interesting contrast!
At the moment two works treating the
cloud subject, two performances impa-
tiently awaited are on the horizon. Accord-
ing to a scenario imagined by Massimiliano
Fuksas, the congress building in Rome will
stage a cloud floating in a glass cage.
In Paris, a glass cloud is heralded to appear
in the Bois de Boulogne. The future location
of the Fondation Louis Vuitton was de-
signed by Frank O. Gehry like an apparition
above the trees. A cloud that gets ready to
shoot holes in the maximum height of 37 m
permitted for buildings in Paris. How to sup-
port the glass without steel, here?
Although highly conventional in terms of its
external appearance, a building's interior
may take you by surprise. Using the incorpo-
rated metal alien by Frank O. Gehry behind
the glass surface of the DG Bank in Berlin as
an example, Ron Arad creates a "mushroom
effect" in the middle of the headquarters of
Natify in Milan, Massimiliano Fuksas and
Doriana Mandrellis produce a "smoky effect"
for Armani in New York. Joining materiality
to identity, that's the idea – more than ever!

An example of the synergy
between architects and industry
is the prototype for a new floor-
ing concept, developed by
Mario Bellini Architects and pro-
duced by merging a layer of
black rubber with a thin bright
stainless steel sheet. The sheet
is perforated in a special pattern
and is similar in aspect to a 3D
mesh, but still remains a stand-
ard machined product. A cost
optimized contribution of the
industry to an innovative and
aesthetic flooring solution.

Steel and Sustainability

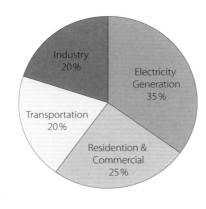

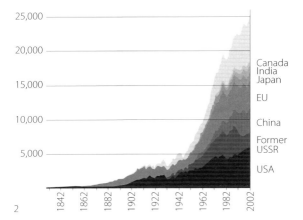

Llewellyn van Wyk, Francisco Cardoso

1

2

The potential impact of climate change and global warming is without doubt one of the most life-threatening challenges facing humanity. Central to this challenge is our dependence on fossil fuels as the primary source of energy – the major contributors of greenhouse gases (GHGs) including carbon dioxide (CO_2) – and the extensive use of non-renewable resources.

It is now widely recognised that our climate systems are warming: there is also fairly good evidence that other effects of regional climate change on natural and human environments are emerging, although many are difficult to identify due to adaptation and non-climatic drivers. Global GHG emissions due to human activities have grown since pre-industrial times, with an increase of 70 % between 1970 and 2004. [1] Anthropogenic warming have some impacts that are abrupt or irreversible, including severe species loss, depending upon the rate and magnitude of climate change (fig. 1).

Nevertheless, a wide range of adaptation options is available, although a more progressive rate of adaptation than is currently evident is required. With an increase in adaptation rates, many impacts can be reduced, delayed or avoided. [2] There is thus a causal relationship between climate change mitigation and sustainable development: Sustainable development can reduce vulnerability to climate change by enhancing adaptive capacity and increasing resilience.

The construction and maintenance of the built environment has a fundamental role to play in this challenge, as energy efficiency options for new and existing buildings could considerably reduce CO_2 emissions: By 2030, about 30 % of the projected GHG emissions in the building sector could be avoided while simultaneously improving indoor and outdoor air quality, social wellbeing and energy security (fig. 2).

At the same time, the built environment is where the majority of the world's popula-

tion now reside: one in every two people lives in a city. [3] Global population has expanded more than six fold since 1800 and gross world product more than 58-fold since 1820. As a result, the ecological footprint (EF) of humanity exceeds the earth's capacity by about 30 %. If we continue on the same development trajectory, by the early 2030s, two planets would be required to keep up with humanity's demand for goods and services.

Sustainable development imperatives

However, while the contemporary focus on energy efficiency, conservation and alternative energy sources is entirely appropriate, it is important not to forget the implementation of other sustainable development imperatives, which calls for the use of complementary approaches.

The notion of sustainable development arose out of the seminal study commissioned by the United Nations. This report, Our Common Future, also known as the Brundtland Report, coined the phrase "sustainable development" and its definition "those paths of social, economic and political progress that meet the needs of the present without compromising the ability of future generations to meet their own needs". [4]

The 1992 Earth Summit in Rio challenged humanity to reduce its impact on the earth. At this summit the assembled leaders signed a:
• Statement of Principles on Forests (to guide the management, conservation and sustainable development of all types of forest);
• The Framework Convention on Climate Change (an agreement between countries for action to reduce the risks of global warming by limiting the emission of greenhouse gases);
• A Framework Convention on Biological Diversity (an agreement on how to protect

the diversity of species and habitats in the world);
• Endorsed the Rio Declaration on Environment and Development (27 principles guiding action on environment and development);
• Adopted Agenda 21 [5] (a comprehensive action programme to help achieve a more sustainable pattern of development).

The United Nations Commission on Sustainable Development (CSD) was created in December 1992 to ensure follow-up and to monitor and report on implementation of the Earth Summit agreements at the local, national, regional and international level.

To mark the dawn of the new millennium, the United Nations adopted the Millennium Declaration in September 2000. The Declaration included resolutions on:
• Peace, security and disarmament
• Development and poverty eradication
• Protecting our common environment
• Human rights, democracy and good governance; protecting the vulnerable
• Meeting the special needs of Africa
• Strengthening the United Nations.

The year 2002 marked the 10-year anniversary of the Earth Summit held in Rio de Janeiro, and to commemorate the milestone, a follow-up summit was held in Johannesburg, South Africa. This summit, known as "Earth Summit II" or the World Summit on Sustainable Development (WSSD), produced two key outputs: The Johannesburg Declaration on Sustainable Development (re-affirming the commitment of the world's nations to sustainability); and a Plan of Implementation (building on the achievements made since Earth Summit I and expediting the realisation of the remaining goals). The summit adopted a number of commitments and targets in areas including poverty eradication, water and sanitation, sustainable production and consump-

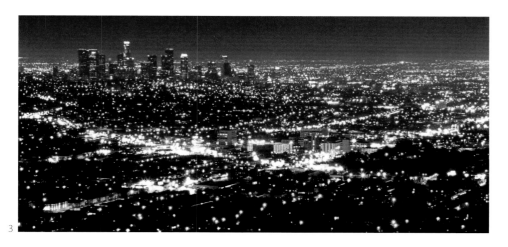

1 Carbon emissions from fossil fuel burning, by
 sector, 2002. Source: John Browne: "Beyond
 Kyoto". In Foreign Affairs July 2004.
2 Data on the major global sources of carbon diox-
 ide (CO_2) emissions by country, from the begin-
 ning of the Industrial Revolution to the present.
 Source: http://www.epa.gov/climatechange/
 emissions/globalghg.html. 2009
3 Los Angeles (USA) at night – an area of high
 population density
4 Major events causing global awareness and their
 relation to the construction industry.

tion, energy, chemicals, management of the
natural resource base, corporate responsibil-
ity, health, sustainable development of
small-island states, sustainable development
for Africa, and institutional framework for
sustainable development; many topics relat-
ing to construction.

Sustainable development and the construction industry

Construction forms a fundamental part of
a society: its contribution reaches across
a number of economic sectors and digs
deeply into the very psyche of society. The
nature of society in most civilisations is illus-
trated by the contributions made by their
construction works. Construction surrounds
us and determines the quality of our daily
lives, transforming the world into a totally
new society – the urbanised society.
Construction is a major contributor to eco-
nomic growth and employment: output
worldwide in 1998 was estimated at just over
US$ 3 trillion with in excess of 111 million
employed in the industry [6]; by 2007 con-
struction spending reached US$ 5.7 trillion. [7]
However, as issues such as globalisation and
environmental concerns are rapidly chang-
ing the operating environment, construc-
tion is expected to develop and implement
the prerequisite adaptation and mitigation
strategies.
Construction is a massive user of capital:
Edwards [23] notes that global construction
is responsible for:
• 50 % of all resources used globally
• 45 % of energy generated to heat, light
 and ventilate buildings and 5 % to con-
 struct them
• 40 % of water used globally for sanitation
 and other uses in buildings
• 60 % of prime agricultural land lost to farm-
 ing being used for construction purposes
• 70 % of global timber products ending up
 in building construction

Events related to construction	General events
	1967 Silent Spring (book)
1970	
	1972 Oil Schock
1980	
	1984 Bhopal gas leak in India
	1986 Chernobil nuclear accident
Our Common Future Bruntland Report 1987	
BREEAM certification UK 1988	
1990	
PassivHaus Germany 1991	
Minergie Lable in Switzerland 1991	
Earth Summit Rio de Janeiro Agenda 21 1992	
UN Comission for Sustainable Development 1992	
United States Green Building Council creation 1993	
LEED™ initial development in the USA 1994	
Habitat II in Istanbul 1996	
HQE Association creation in France 1996	
	1997 Kyoto Proto adopted
	1997 El Niño-Southern Oscillation
2000	2000 Millenium Declaration
Démarche HQE initial development in France 2001	
CASBEE creation in Japan 2001	
Green Building Council in Australia 2002	2002 Earth Summit Johannesburg
	2005 Hurricane Katrina
DGNB in Germany 2007	2007 Generelle Énvironnement in France
Code for sustainable homes in UK 2007	2007 Nobel Prize for Al Gore

4

5

Agenda 21, adopted at Rio de Janeiro in 1992, establishes an agenda for sustainable development, and, as a consequence, a conceptual framework for sustainable construction that defines the links between the global concept of sustainable development and the construction sector enabling other agendas on a local level to be compared and coordinated.

The main challenges of sustainable construction which emerge are as follows:
• Promoting energy efficiency
• Reducing consumption of high-quality drinking water
• Selecting materials based on environmental performance
• Contributing to sustainable urban development
• Contributing to poverty alleviation
• Promoting healthy and safe working environments

In 1996, the United Nations Conference on Human Settlements (Habitat II) in Istanbul defined goals in which the construction industry could play a direct and substantial role:
• Changing unsustainable patterns of production and consumption
• Avoiding environmental degradation
• Promoting social and economic equality
• Managing inadequate resources
• Overcoming a lack of basic infrastructure and services
• Overcoming inadequate planning
• Mitigating against increased vulnerability to disasters

More recently, and in response to the imperatives of climate change adaptation and mitigation, the United Nations Environment Programme (UNEP) published its report Buildings and Climate Change: Status, Challenges and Opportunities. [8] The report made a number of recommendations, including the need for:

• Policies to encourage the wide support for more energy-efficient buildings
• Benchmarking to quantify what may constitute an energy-efficient building under different conditions and for different typologies
• Economic tools to impact on the economics of construction-related activities
• Education and training to build knowledge and increase general awareness
• Understanding human behaviour to influence how building occupants behave
• Public sector to set an example for others to follow
• Support technology transfer and improved access to technology

In 2007, the World Business Council for Sustainable Development (WBCSD) released its report "Energy Efficiency in Buildings: Business Realities and Opportunities" [9], which collated the current state of energy demand in the building sector. Critically it concludes that it is possible to immediately drive down energy demand and reduce carbon emissions using technologies and knowledge already available today.
All these challenges require responses at different scales and by different players: of a component, by a producer; during the conception of a new product (based on the Life Cycle Assessment concept and on the ISO 14042:2000 standard); of a project, by a developer during the construction of a new building; of the construction industry or of part of it, by the agents involved; or by the government, as part of a public strategy, at local, regional, national or even trans-national level; etc. With each scale comes a particular agenda, which must respect global issues and consider local particularities.
In response to these challenges, green building councils have been established in many developed and developing countries and have devised a set of practical and realistic requirements, indicators and criteria for

evaluating the level of sustainability of a project. Most of them are related to an assessment method, and many to a certification process. Among these are BREEAM – Building Research Establishment Environmental Assessment Method (UK), LEED™ – Leadership in Energy & Environmental Design (USA), NF Bâtiments Tertiaires – Démarche HQE® (France), DGNB – German Sustainable Building Council, Minergie® – Swiss sustainability label, CASBEE – Comprehensive Assessment System for Building Environmental Efficiency (Japan), Green StarTM – Green Building Council of Australia and Green Building Challenge Assessment Method (international network).
The International Standards Organisation (ISO) has also produced the Technical Specification ISO/TS 21931-1 (framework for methods of assessment for environmental performance of construction works) [10], which proposes a structured list of issues for environmental assessment methods, corresponding to a common basic agenda for the building sector. These issues deal with environmental impact categories such as climate change, destruction of the ozone layer, depletion of non-renewable resources, formation of pollutants, formation of photochemical oxidants, acidification of land and water sources, and eutrophication. It calls for the inclusion of:

Issues related to energy and mass flow during the project´s life cycle:
• Material use, differentiated into depletion of non-renewable material resources, use of renewable material resources, and use of substances classified as hazardous or toxic according to national or international regulations
• Primary energy use, differentiated into depletion of non-renewable primary energy and use of renewable primary energy
• Water use
• Land use

6

5 "Green architecture for the future", Louisiana Museum, Humlebæk (DK) Denmark 2009, Ecosistema urbano
6, 7 Ecological and energy-efficient, designed as a showcase for potential CO_2 reduction in China, SIEEB in Beijing, Beijing (RC) 2006, Mario Cucinella

• Waste management, differentiated into reuse/recycling or energy recovery and waste disposal

Issues related to local impacts:
• On soil
• On ground water
• Of noise
• Of odours

In addition, it notes that the following issues of concern related to building management should be taken into account, where relevant: limitation of waste production, recovery of waste, reduction of nuisances, reduction of pollution, pollution control, water savings, wastewater treatment, maintenance, rehabilitation of the environment to promote biodiversity, and environmental emergency management.

With regard to the assessment of the indoor environment, the following issues of concern are noted:
• Indoor air quality
• Quality of ventilation
• Hygrothermal conditions (air temperature and humidity)
• Noise and acoustics
• Glare
• Access to daylight and exterior views
• Quality of light
• Odour conditions
• Quality of water
• Intensity of electromagnetic fields
• Radon concentration
• Hazardous substances
• The existence of unwanted micro-organisms, e.g. black mould

High-performance green buildings: The 21st century paradigm

Buildings are often used for centuries, but the rapid pace of development increasingly means that it is impossible to imagine the demands that future uses will place on

buildings. Consequently, the designer should select products and systems that make adaptation easier. While aesthetic appeal will always be a component of building design, the real challenge is to create built environments that are durable and flexible, appropriate in their surroundings and provide high performance with less detrimental impacts.

In response to this challenge, a global initiative launched by the World Business Council for Sustainable Development (WBCSD) and supported by over 40 global companies, with the participation of major players of world's steel industry, aims to "transform the way buildings are conceived, constructed, operated and dismantled" to achieve zero energy consumption from external sources and zero net carbon dioxide emissions, while being economically viable to construct and operate. Included in the initiative is the identification of the full range of present and future opportunities with regard to "ultra-efficient building materials and equipment". Additionally, this aim is enhanced by using the "cradle to cradle" concept of producing, using and later re-using building materials, a design evolution needed to achieve sustainability for buildings.

7

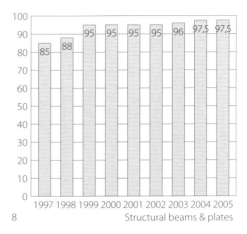

8 Structural beams & plates

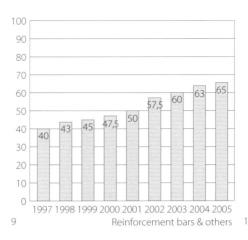

9 Reinforcement bars & others

10

The current generation of "green" buildings already offers significant improvements over conventional buildings, in as much as they consume less energy, materials and water; provide demonstrably healthier living and working environments; and greatly enhance the quality of the built environment, including the neighbourhood. However, these improvements are offered through the use of existing materials and products, design approaches, and construction methods. Because of this conventional approach to design and construction, it remains difficult to incorporate truly innovative technologies into current construction practice.
Two schools of thought are emerging that address this challenge.

The first relates to high-performance green buildings. The characteristics of high-performance green buildings, as suggested by Fujita Research [11] include:
• Optimal environmental and economic performance
• Integrated processes, innovative design and increased efficiencies to save energy and resources
• Satisfying, healthy, productive, quality indoor spaces
• Employing lean construction methodologies and tools to improve waste management and reduce the environmental impact of construction waste
• Increasing the emphasis, at R&D stage, of whole-building design, construction and operation over the entire life cycle
• Fully integrated approach, including teams, processes and systems
• Renewal engineering methods
• Management and business practices
• New standards, open buildings, advance jointing and assembly techniques, process engineering
• Materials and systems: new function integrated building components, durability, ability to repair and retrofit components

The second relates to "radical sustainable construction". Radical sustainable construction has five major features:
• Integration with local eco-systems,
• Closed-loop material systems,
• Maximum use of passive design and renewable energy,
• Optimised building hydrologic cycles, and
• Full implementation of indoor environmental quality measures. [12]

The role of steel in "radical high performance green buildings"

Good design is fundamental to sustainable construction. Decisions made at the initial design stage have the greatest effect on the overall sustainability of projects. The issues to be faced by radical high-performance green buildings favour construction products and methods that are flexible, light and durable: It is here that steel emerges as a material-driven construction system capable of achieving the prerequisite performance standards. The advantages encouraging the use of steel include its cost, non-combustibility, resistance to mould, gases, mildew and termites and its environmental friendliness.

Construction is a major consumer of materials and resources and thus it is imperative to reduce its resource consumption and to maximise material reuse. Prudent use of natural resources results in a more efficient industry and a restricted usage of natural materials. Practices such as material recycling, waste minimisation, local product resourcing, land decontamination, and minimising construction- and demolition-waste disposal make sound business sense and encourage good construction housekeeping. Application of the principles of lean construction and life-cycle analysis, including life cycle costs (p. 32ff.) are equally important. The steel industry itself is making

huge strides in its efforts to achieve sustainable development imperatives (fig 8).

For example, the Canadian steel industry has achieved [13]:
• A reduction in carbon dioxide (CO_2) emissions of more than 20 % since 1990
• Emissions of sulphur dioxide (SO_2) reduced by 77 % since 1990
• Emissions of nitrogen oxides (NOX) reduced by 24 % since 1990
• Polycyclic aromatic hydrocarbons (PAH) emissions reduced by 74 % since 1993
• Energy efficiency improved by 25.4 % between 1990 and 2001
• Waste going to landfill reduced by 52 % between 1994 and 2002

Under the drivers of mass production, quality control and cost reduction, technical progress has led to large energy savings and to the systematic use of lean and clean processes in steel plants. As a result, energy consumption and CO_2 generation in the steel industry have decreased. Western nations have reduced their relative CO_2 emissions by 50 % over the past 30 years, so that today, depending on the age of the plant and other factors, CO_2 emissions in Europe and the Americas average 1.5 to 2 t for each tonne of steel produced from iron ore. Furthermore, in respect of those figures, the effect of forty years of recycling has to be taken into consideration, when comparing with other materials. Water use in steel manufacture has been greatly reduced, and in most instances water is recycled and reused.

All steel production has a high recycled scrap steel content and all steel is recyclable. Steel is the most widely recycled material in the world: many steel components can be unbolted and even reused for future applications. The possibility of reusing building elements makes steel construction even more sustainable than the already signifi-

8, 9 Steel recycling rates
10 Old cars are a major source of scrap steel
11, 12 Court of Justice of the European Communi-
 ties, Luxembourg (L) 2009, Dominique Perrault.
 In connection with the extension the old steel
 structure of the building was taken down,
 cleaned and assembled again.

11 12

cant contribution of today's simple material recycling. Steel can be repeatedly recycled because it does not lose any of its inherent physical properties as a result of the recycling process. It also has vastly reduced energy and material requirements compared with steel made by refining iron ore: the energy saved through recycling reduces the annual energy consumption of the industry by about 75 %, which is enough to power 18 million homes for one year. The steel industry has been actively recycling steel for more than 150 years: recycled steel provides 40 % of the world's steel industry ferrous resources. Steel recycling rates vary by product and geographical region: about 97.5 % of structural steel beams and plates were recycled in 2004 and 2005, while the for reinforcement bars the rate is about 65 %. Structural steel sections generally contain about 95 % recycled steel, whereas flat rolled steel contains about 30 % reused material due to the different processes involved. However, until now, global steel demand has always exceeded maximum recycling capacity, so that there is still a need to produce new steel from iron ore.

The use of steel construction components, elements and systems enhances the sustainability of buildings in terms of these issues, and the economic and social performance of the project in its phases – fabrication of products, design, erection, use and end of life. The following section is intended as a guide to assist project managers and designers who wish to adopt some of the above pro-recycling measures into their projects. It is structured around the five major structural components of building, namely, substructure, superstructure, roof assembly, services and finishes.

Substructure

Construction challenges in substructures fall into both the environmental protection and economic growth sectors as the industry

has significant impacts, both positive and negative, on the natural environment. Effective protection of the environment is possible through controlling and minimising the impacts of construction acoustics, airborne and other pollutants, including potential damage to biodiversity. Construction site control and minimisation of energy consumption, awareness of embodied energy, improved economy of materials transport and a reduction in water usage also improve environmental management and conservation. To meet these objectives requires the adoption of construction technologies that minimise the requirements for on-site working space, supporting materials, and machinery and equipment, especially those which burn fossil fuels and generate noise.

The ultimate environmental objective is to avoid leaving an unwanted legacy for future generations. At the end of a structure's useful life, when a site is cleared, foundations are generally abandoned and left to be someone else's large immovable problem. Steel foundations like sheet piles, steel pillars or tubes can be extracted, allowing a site to be returned to its original condition. The recovered steel can be reused or recycled. During installation, driven steel piles do not produce spoil and require far fewer

vehicle movements to take material off site (figs 11 and 12).

Beside the fact that steel structures, being lighter, generally require smaller foundations, steel may also reduce project impacts in other ways. Steel construction, because it can be prefabricated to meet the specific requirements of every component of the project, reduces the amount of working space required on-site. Joints, penetrations, and holes are pre-drilled, reducing the extent of work on-site and the amount of machinery required. Where the construction method relies mainly on bolted joints, nuisance noise from the site is reduced. Prefabrication also facilitates just-in-time delivery, removing the need to store or stack vast quantities of construction materials and further reducing the extent of the site required for preparatory work. A typical light steel-framed house with lightweight cladding weighs approximately 30 t (excluding foundations), in comparison to 100 t for a brick and blockwork house. This difference has also a great impact on site transport and logistics.

Superstructure

The demands placed on buildings can change for a host of reasons, perhaps

Thanks to steel's high strength (HSS) to weight ratio, steel construction requires less material than traditional technologies and contributes to reducing a building's environmental impact.
By replacing traditional beams, 50 KT of HSS like the S460 M steel grade represents a saving of 14 KT of CO_2 (roughly the annual emissions of 4000 vehicles).

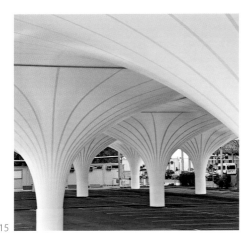

13 14 15

because of new technology or just a growing business needing more space. Whatever the reason, if a building cannot be easily adapted, then owners face the costs of demolition and redevelopment. Steel offers a more sustainable solution and steel-framed buildings are among the most adaptable and flexible assets in which a business can invest.

A building with a structural steel frame can be easily and economically adapted to changing requirements, which is a major sustainability advantage. Instead of demolition, a steel-framed building can be extended vertically or horizontally with minimum disruption to existing building users and neighbours (p. 96ff.). Perforations are commonly provided in supporting steelwork to carry services, and extra ducting can be installed in beam webs to allow for future changes to services.

Large spans can be achieved with graceful designs using the minimum quantity of structurally efficient steel. Steel buildings can be kept modern-looking throughout their lifetimes by updating with new facades and other architectural features. Column-free spaces in factories and warehouses provide more flexibility in locating fixed equipment, and moveable plant can operate more safely when there are fewer obstructions. Depending of the individual weighting of different topics in the sustainability assessment, green building rating tools generally encourage and recognise designs that produce a net reduction in the total amount of material used. Credits are awarded, for example, where it is demonstrated that the building's structural requirements and integrity have been achieved using less structural and reinforcing/prestressing steel by mass than in a structure with conventional steel, without changing the load path to other structural components. Green building rating tools generally encourage and recog-

nise pioneering initiatives in sustainable design or processes, or those that have a substantial or significant environmental benefit.

Steel contributes to innovative solutions including demountable and reusable components, reduction of material volume by the use of composite members or innovative structural solutions, and the integration of structure and services. Furthermore, the rating tools award credits for a reduction in embodied energy and resource depletion associated with reduced use of virgin steel. Credits are typically awarded where a certain proportion of a building predominantly framed in structural steel has a post-consumer recycled content. Additional credits may be obtained if all the steel used in the building – structural, reinforcing/prestressing, and steel products – has a post-consumer content.

Because steel components are manufactured to standardised dimensions, there is often very little waste produced during construction, and that which is produced is in any event recycled, and does not present an environmental risk (contamination). The application of steel technology in radical high-performance green buildings results in the use of industrialised components produced by modern manufacturing processes. These components are often highly prefabricated, which minimises the work on-site and reduces construction waste. Prefabrication takes place in a factory where safe, warm, and high-quality working environments can be provided (figs. 13–15). Components are delivered to the construction site on a just-in-time basis, where they are then assembled under much safer work conditions than would otherwise prevail. The benefits include lower site management costs and reduced storage and worker facilities, as well as less material damage and waste and a reduction of noise and particu-

late matter emissions into the atmosphere (mainly dust).
The cost of a construction product is the sum of materials, labour, specialist components, equipment, machinery and design costs. Steel construction achieves higher levels of productivity, thereby reducing labour costs both in the factory and on site when compared to conventional construction methods. The higher levels of prefabrication applied in steel-intensive construction systems also improves construction speed and safety.

Quality is a factor of ease of installation, good workmanship, material and component performance, reliability and design integrity – aspects which are far more difficult to quantify than cost. However, poor quality has a negative effect on construction costs and reputation. The elimination of wet trades, thanks to the use of steel components, reduces typical quality defects such as cracking, shrinkage, and poor finish, resulting in potential cost savings of 1 to 2 %.

The time taken to complete a project on site depends on the speed of construction. The quicker the construction process, the greater the potential cost savings due to lower on-site costs and interest payments, earlier income generation from sales or letting, and less disruption to users, especially in building alteration and extension contracts. Steel construction methods, because they rely on extensive prefabrication, are quicker to install on-site, thereby reducing on-site construction time (p. 32ff.).
Comparative studies on the benefits of different forms of construction with various levels of prefabrication found that fully modular construction reduced the total construction period by 60 %; the time to achieve a weather-tight envelope by 80 %; and the proportion of total cost of on-site

materials by 50 % compared to conventional construction. [14] In a separate study, lightweight steel frame buildings were found to be erected faster and more efficiently than buildings constructed with bricks or blocks, concrete formwork or panelised timber frame methods. [15]

Building reuse encourages and recognises developments that adapt existing buildings to minimise material consumption. Steel-frame buildings are generally the easiest to reuse due to their inherent flexibility and adaptability. Changes in the structural frame often require very little demolition work, and, with only a small amount of adjustment, a building can be put to a completely new use with basically the same structural system. Where the structural dimensions are not compatible with the proposed new use, steel frames can be disassembled and reassembled with very little loss of material content and value. Even in cases where the structural system is not suitable for reuse on a project, it can be sold or moved to another site and reused on a different project. Thus, high proportions of the existing steelwork or steel facades of a building can be reused. Material reuse encourages and recognises designs that prolong the useful life of existing products and materials. Because steel comes in standard sizes and sections, the designer can design a building in steel to reuse existing steel sections he knows are available. Thus, it is relatively easy to ensure that reused steel products and materials make up at least 1 % of a project's total contract value.

In spite of those favourable general characteristics of components and elements in steel, the option to use a certain product in a building should be taken into account tangible information on environmental performance. The correct method for manufacturers of building products to communicate the environmental characteristics of their

products to developers, designers and specifiers is to use ISO 21930:2007. [16] This standard describes the principles and framework for environmental declarations of building products (EPD), taking into consideration the complete life cycle of a building. Nevertheless, as it is still a relatively new approach, the number of EPDs covering construction products made with steel or other materials is limited, but is going to be drastically increased by the global steel industry.

Green building rating tools generally encourage and recognise the environmental advantage gained, in the form of reduced transportation emissions, by using materials and products that are sourced within close proximity to the site. Transport of materials and personnel in construction is responsible for 10 % of all vehicle movements across the EU, and 40 % of the energy used during construction relates to the transport of materials and products. [17] Steel construction can reduce these

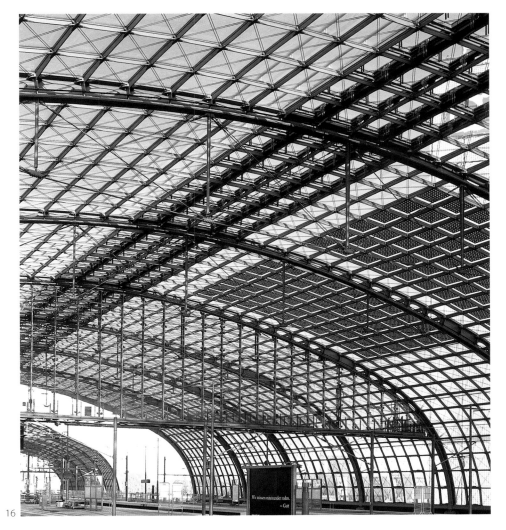

16

17

17 California Academy of Sciences in San Francisco (USA) 2008, Renzo Piano Building Workshop. The building is covered by a green roof. A third of the round windows are photovoltaic modules covering 5 % of the building´s energy demand.
18 Villa Arjala, Villeneuve-Lès-Avignon (F) 2004, Patriarche & Co

impacts through: transporting prefabricated frames and modules; transporting more components per vehicle movement due to the lighter weight of the components; timing deliveries to suit traffic conditions; reducing the number of on-site workers and therefore worker flows to the site; and, as a consequence of less waste generation, reducing vehicle movements to landfill sites.

Gervásio et al. (2007) presented a comparative case study performed in order to evaluate two alternative structural systems of a dwelling from a sustainable point of view (environmental impacts and embodied energy) [18]:
• A light-weight steel frame
• A concrete frame

Even though the authors state that their results are subject to a certain degree of variability, they concluded that "in both cases the structural system using the lightweight steel structure, irrespective of the end-of-life scenario, showed a better lifecycle performance compared to the concrete structure". At all stages of the life cycle, the steel solution has a better performance with regard to embodied energy, which becomes higher due to the recycling and reuse of steel (allowing savings of approximately 50 % of the embodied energy). Concerning environmental lifecycle analysis – human health, ecosystem quality and resources – the environmental impact of the lightweight steel house, irrespective of the end-of-life stage assumed for steel, is better than that of the concrete house, "although the difference depends on the scenario assumed".

The adaptability of steel structures, cladding and partitioning can offer the designer the flexibility and scope to provide good daylighting, and to maintain unobstructed views.

Roof assembly

Technical progress is leading steel into a new era. Precision fabrication allows steel components to be made up in unprecedented ways using special steel sections, unusual angles and advanced CAD programmes. Structural steel will carry the required loads using a minimum amount of steel, while allowing the re-design of facades as the building's need changes. Computer software helps determine how large openings can be, where they can be located and whether or not they require strengthening. Steel's strength-to-weight ratio enables it to span large distances – more than any other building frame material. [19] The long-spancapability of steel enables the creation of large areas of unobstructed space in multi-storey buildings. Steel is inherently ductile and flexible: It flexes naturally under extreme loads rather than crushing or crumbling. Steel structures also have reserves of strength. Steel is the only material that allows the strength of a structure to be increased economically after it has been built.

Steel's high strength-to-weight ratio is exploited in lightweight structures that have low overall environmental impacts and often require fewer and lighter foundations than alternative methods of construction. Its long-span capabilities create flexible spaces that facilitate changes in use during the life of the building, maximising letting potential and reducing refit costs. Choosing the right material for roofing applications also contributes to limiting solar impact or to the exploitation of solar energy. A large range of colours and finishes of organic, metallic and even radiative coatings are available for steel solutions making them ideally suited to all kinds of climatic conditions.

In addition, a number of steel roofing systems exist which are compatible with renewable energy generation. These sys-

tems allow for the easy installation of photovoltaic panels, energy generation and solar absorbers for water heating.

The structural properties of steel make it possible to install green roofs without adding undue structural loads. A green roof provides various benefits to a building, such as longer roof membrane life, acoustic insulation; and increased energy efficiency. In summer, a green roof shades the building from solar radiation and reduces heat gain. In winter, a green roof provides additional insulation, thus decreasing the amount of energy required to heat the building. On a larger scale, green roofs mitigate the heat island effect, thereby helping to bring down temperatures in the built environment.

Services

It must be noted that sustainability involves more than the choice of products and components, and that other sustainability benefits arise from improvements in the performance of buildings in service, including operations and maintenance, refurbishment, and demolition.
Life-cycle cost analyses also reveal that the operational costs of buildings are 100 times more than the construction costs over a 50 year period; therefore material choices and construction methods that reduce operational costs have a far greater influence on sustainability than first costs.
The energy associated with the occupation of buildings (operational energy) exceeds that used in their manufacture and construction (embodied energy) typically by a factor of between four and ten over a 60-year design life. Reducing operational energy consumption reduces environmental impact as well as saving money.
Due to internal heat loads from computers etc. and solar radiation in commercial office buildings, cooling is often the most significant energy use. Steel frames and associated composite members achieve high levels of

18

fabric energy storage. Steel-based cladding systems for industrial buildings and light steel-framed residential construction provide well-insulated and airtight solutions. Designing buildings for long life and minimising operational burdens are key aspects of sustainable construction. Extending the life of buildings maximises value from the financial and material resource investment. These characteristics provide maximum flexibility in the subsequent modifying of an existing space. Steel framing and floor systems allow easy access to the fast-changing world of wiring, computer networking cables and communication systems without disrupting the operation of the facility or people working in the area. All of the above increase flexibility of use in the medium and longer term, ease of extension and adaptation, recycling and reuse, and ultimately demolition and removal.

In a comparative study between the sustainability of a modular system of construction and an equivalent precast concrete structure, it was found that material use, waste and embodied energy were greatly reduced and the recycled content and recyclability were greatly increased by using a light steel modular form of construction. [20] The embodied energy in materials was reduced by 27 %, equivalent to two years operational energy consumption. Operational energy was improved by 38 % due to higher levels of insulation and airtightness in the manufactured units.

Designs that minimise greenhouse gas emissions generally consume less operational energy and maximise the potential operational energy efficiency of the base building. Steel buildings can be easily designed to achieve and exceed the required base levels of energy efficiency, with the level of success depending on the detailed design of the building, its location and type of fuel used. Steel frame structures, facades and roofing systems readily accom-

modate high levels of insulation and flexible servicing strategies to maximise efficiency. Steel is dimensionally stable and can provide an exceptionally well-sealed building envelope for less air loss and better HVAC performance over time.

The efficient and effective use of steel sunscreens provides protection from the sun and helps to reduce solar heat entering the building. This is an effective strategy for reducing heat gain and lowering HVAC design loads and costs.

Historic buildings took advantage of fabric energy storage (FES) through the massive structures of walls and floors necessary in those days of low-strength materials. However, research undertaken by Oxford Brookes University and the European Union (EEBIS – Energy efficient buildings in steel) has proven that optimum levels of FES can be achieved in relatively light, structurally efficient buildings that are constructed from fewer resources. Using dynamic thermal modelling, the FES performance of common structural framing options were compared over a period of a year. The difference in the passive cooling provided by steel and by concrete-framed buildings were insignificant. In addition, a number of FES systems can be used in conjunction with steel-

framed buildings, including passive systems in which the slab soffit is exposed or thermally permeable suspended ceilings are used, and active systems that include air core systems and water-cooled slabs. In a similar research project, two experimental houses – one conventional and the other steel framed – were compared for energy efficiency. The results of the study showed that these means of energy savings are sufficient to reduce the heating energy demand by 50 % compared to a typical Finnish row house. [21]

Green building rating tools generally encourage and recognise designs that reduce the consumption of potable water. Steel construction is essentially a "dry" construction technology and therefore greatly reduces the amount of water used during construction. In addition, the prefabrication of steel components and modules takes place in a factory-controlled environment, where proper supervision and management of water use can be exercised.

Green building rating tools generally encourage and recognise designs that provide occupants with a visual connection to the external environment, achieve a high level of thermal comfort, maintain internal

Innovative steel solutions for solar buildings utilising the intrinsic durability and quality of steel construction; integrated solar photovoltaic cells on newly designed steel roofs combine two functions: the water-tightness and insulation and eco-friendly production of electricity. Research is also taking place into photovoltaic active steel coatings which are much less efficient, but nevertheless very interesting due to the huge potential surface of steel envelopes.

19

noise levels at an appropriate level, and use interior finishes that minimise the contribution and levels of volatile organic compounds (paints, adhesives and sealants). Dry composite floors made with a steel deck achieve good airborne sound insulation levels with a comparatively simple structure. Experience with dry composite floors shows that, with adequate impact sound insulation, a sufficiently high airborne sound insulation level is reached automatically. Tests on real buildings demonstrated excellent acoustic performance.

The Stromberg Report [22] further examined vibration through the floors and found it to be satisfactory for single family houses.

The report recommends certain interventions for multi-storey buildings where tenant expectations are higher. Vibration tests carried out on the demonstration building where the design interventions had been applied yielded excellent vibration behaviour. The report noted the difficulties arising from thermal bridging and prepared design recommendations on thermal bridging, hygrothermal functionality and acoustic performance. The results from the experimental building showed that it is possible to achieve U-values as low as 0.1 W/m² °C. The report noted that air-change rates of less than two per hour at an over-pressure of 50 Pa could be achieved.

Finishes

Maintenance of buildings is vital to achieve longevity. Steel construction products require little maintenance, generally only where the steel is exposed to the elements or for aesthetic reasons.

Steel components can often be used in their manufactured state, thus obviating the need for subsequent painting or polishing, and therefore also reducing the generation of indoor air contaminants. A wide range of advanced coatings is available for steel, and when used in accordance with the recommended maintenance programmes, these coatings offer excellent long-term protection with much reduced environmental impacts. Steel components that require painting are most often pre-painted in the factory under controlled conditions, with a consequent reduction of worker risk and off-gassing in the building. Low-emitting paints and coatings can also be used on steel to further this objective.

In construction, durability and recyclability make stainless steel a clearly sustainable choice. As a direct result of the material's inherent properties, stainless steel does not require any coatings, while the upkeep and maintenance of a stainless steel product is simpler and its service life longer. Stainless steel is a durable material that does not age: Its improved corrosion resistance is due to the formation of a self-healing passive protective layer on the material's surface. Subject to compliance with simple instructions that ensure the conservation of this protective layer, the material offers exceptional natural longevity (p. 110ff.). Stainless steel is also one of the most recycled construction materials. More than 90 % of end of life stainless steel is collected and recycled into new stainless steel, without loss of quality. The high value of stainless steel scraps helps to ensure this recycling loop.

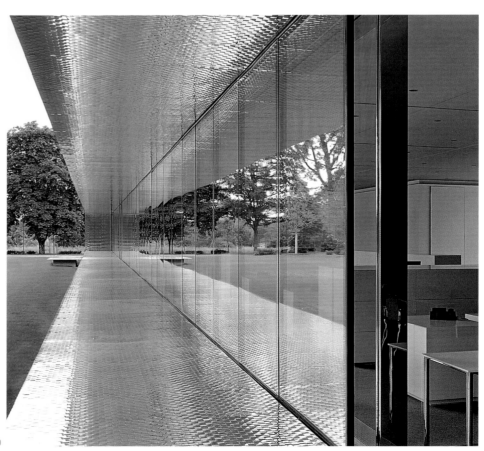

20

21

Steel – stepping into the 21st century

In high-performance construction, the key issue is how the choice of construction products and methods can create scope for reducing burdens. It is perhaps in this regard that the real role of steel in the 21st century construction will emerge, namely, an integrated and systemic approach to construction.

At a glance, the major environmental benefits of steel framing include:
• Recycled content and 100 % recyclability
• Minimum on-site waste due to high quality, shop prefabrication and standardised processes (2 % for steel versus 20 % for wood)
• Life-cycle energy savings due to the insulation and air tightness of the envelope
• Long-lived structure that reduces the need for future building resources (zero depletion of iron resources)

A similar review of progress made in steel buildings demonstrated that:
• Steel construction is efficient, competitive and makes a significant contribution to society.
• Buildings can be rapidly constructed using high-quality, largely defect-free steel components that are efficiently manufactured off-site.
• Steel framing and envelope systems provide the scope, in association with other materials, to design buildings with low overall environmental impacts.
• Steel-based construction systems provide flexible spaces that have the potential to be easily modified and adapted so that the life of the building can be extended by accommodating changes in use, layout and size.
• At the end of the useful life of buildings, steel components can be dismantled easily.

• Reclaimed steel products can be reused or recycled without degradation of properties.
• Off-site manufacturing facilities entail fewer itinerant workers, which, in addition to being safer, promotes stability in the workplace, encourages skills development and fosters good local community relations.

There is, however, an onus on manufacturers and suppliers to develop systems and methods for using their products that will facilitate designing for reduced impacts. There is a further onus on developers, designers and specifiers to use these properly. Key drivers of 21st century change that demand an appropriate construction sector response include the infrastructure needs of the growing global population, resource consuption, energy supply and global warming.

Steel's inherent qualities – including durability, non-combustibility, green attributes, safety social performance – coupled to a "pre-engineered" approach using design software programmed for flexibility and emphasising preparation and precision have all the attributes required by a 21st century construction sector.

The benefits of steel construction when measured against the triple bottom line approach are the following:

• Economic
Long lasting flexible buildings retain their economic value at the end of first use.
• Social
The demountable stadium was a key element of London's successful bid to stage the most sustainable Olympics ever and generated a six-year feel-good factor for the country.
• Environmental
Buildings that can easily be adapted and re-used avoid demolition and the associated disruption and waste.

The efficiency of steel construction can, therefore, encourage new building to achieve higher standards and improve the economic, social and environmental performance of the activities within them, while steel's inherent adaptability provides flexibility for an unpredictable and rapidly changing future.

Thermal inertia is not related to the mass of a building. Phase change materials store thermal energy based on aggregation state changes form "solid" to "liquid". They are micro or macro encapsulated and either based either on salts or paraffins. The melting process at 24–28 °C absorbs energy keeping temperature at a comfortable level. Solidification at lower temperature gives back this energy to the ambience, permitting a sustainable energy management of light steel buildings.

Steel and Economics – The Benefits of Steel in Construction

Gerard O'Sullivan

In the design of any construction product the choice of material will always play a significant part in meeting the designer's purpose. Historically, in addition to the local geography, a material's availability, physical properties, costs of production and installation usually dictated the choice. Hence materials sourced or produced locally tended to be reflected in the character of buildings in that locality. That in turn traditionally influenced the available skill to work the material. Costs tended to increase the further one had to go to source the material and the available labour skills available to work it. With the onset of industrialisation other factors, such as improved processes and assembly techniques, led to a more complex choice and range of construction materials being available. Mass production meant increased end-user demand for the raw material resulting in lower production costs all round. The resulting profits were further invested to produce an even greater range of products with varied performance to meet the customer's needs and budget. With improved technical processes came the development of a range of materials with greater strength and durability than traditional building materials. They were often more compact or plastic in form, offering a greater variety of structural forms, such as framed systems. Timber had long provided the latter but with industrialisation it was to be replaced in both practical and economic terms by steel and reinforced concrete. None of this could have occurred without the introduction of steel.
Steel as a building material is a relatively recent entrant in the history of building. In its raw state as iron ore it is the second most common metal on the planet, but its use in buildings had been confined"... to make nails, hinges, bars, gates, bolts for fastenings, and such like works." [1] That is, until the late eighteenth century, when the industrialisation of iron production in England began dramatically increasing its quality and

reducing its production costs. New markets opened up in the building and engineering industry, and the industrial revolution fuelled that demand with bridges and factories being constructed in the new material. The first complete metal frame building was a flax mill in Shrewsbury, England. It was built in 1797 and still stands today.
The nineteenth century saw some spectacular leaps in the development of iron and steel. Paxton's Crystal Palace, amply demonstrated the speed and efficiency of properly organised prefabricated cast iron framed construction. It was built to house the Great Exhibition of 1851 over an area of 6.4 ha in London's Hyde Park. By applying the glass and metal framing design techniques used for the great conservatory at Chatsworth House in Derbyshire, the huge hall was constructed in five months, something which could not be achieved with any other material at the time. Steel-glass construction is still important for today's architecture, and prefabricated structural systems based on steel are known for their high speed of construction.
However, engineering research also demonstrated the limitations of cast iron for structural work and, after some bridge failures, engineers increasingly looked to steel as the alternative. Initially, the high cost of manufacture restricted its use until the introduction in the mid-nineteenth century of the Bessemer system followed by the Siemens-Martin open hearth process, which forms the basic process for steel manufacture today. As technical processes developed, the durability and strength of the new material improved while increased production volume to satisfy growing demand reduced unit costs.
At the same time the introduction of steel H- and I-sections for metal frame members, which form the standard in modern structural steelwork, rationalised the production on a more economic scale (p. 110ff.). The oldest metal frame multistorey building, the

four-storey Sheerness Boat House dating from 1860, is the first example of what is now commonplace in modern office building.
In North America, which has the largest deposits of iron ore in the world, steel became the principal material shaping the skyscrapers and factories of this new world. Albert Kahn in the 1920s and 30s introduced the single-storey, steel-framed, shop-welded and site-bolted factory that is the typical concept, even today, for most industrial units, with economic 12 × 18 m bay sizes, with additional height to accommodate administration units at high level, leaving clear floor space for industrial activities.
Steel has largely written the story of the framed building, with engineers and architects exploiting its power as a strong and easily worked material to develop challenging architecture. Improvements in steel construction technology have addressed steel's perceived disadvantages of corroding if exposed to the atmosphere and, although non-combustible, losing its strength in fire and have produced better and more economic solutions. Today, there are multiple alternative solutions available to protect steel against corrosion and elevated temperatures, if really necessary. The attitude to its use in building suffers from the common perception that these alternative solutions cause only additional costs without viewing the further benefits that can accrue or fully examining the available options that are possible with steel.
The ongoing improvements in steel and its products have taken it out of the heavy engineering construction sector and transformed it into a material that can both clad and roof the frame, though in most cases a protective coating, usually zinc-based, is involved in giving these materials their longer life cycle. And it is the economic evaluation of the life cycle of the product and its incorporation into the building that will now be the focus of our attention.

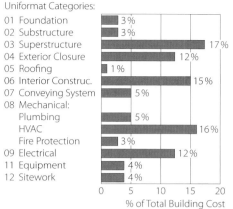

Uniformat Categories:
01 Foundation — 3%
02 Substructure — 3%
03 Superstructure — 17%
04 Exterior Closure — 12%
05 Roofing — 1%
06 Interior Construc. — 15%
07 Conveying System — 5%
08 Mechanical:
 Plumbing — 5%
 HVAC — 16%
 Fire Protection — 3%
09 Electrical — 12%
11 Equipment — 4%
12 Sitework — 4%

% of Total Building Cost

2

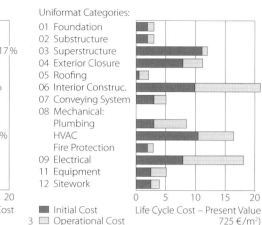

Uniformat Categories:
01 Foundation
02 Substructure
03 Superstructure
04 Exterior Closure
05 Roofing
06 Interior Construc.
07 Conveying System
08 Mechanical:
 Plumbing
 HVAC
 Fire Protection
09 Electrical
11 Equipment
12 Sitework

■ Initial Cost Life Cycle Cost – Present Value
□ Operational Cost 725 €/m²)

3

1 Assembly of a large scale steel structure
2 Simple cost analysis of an office building
3 Simple life cycle cost analysis of an office building

The global view – life cycle costing

When it comes to choice of materials in buildings, cost is only one factor, although to the building client it will be a very important one.

Life cycle costing – the approach

Among other factors which influence choice are the client's perception of what he needs, the architect's interpretation of those needs in relation to the building's functions, structural requirements, aesthetics, the local environment, servicing the building, flexibility in use, energy efficiency, site limitations including ground conditions, planning, health and safety and other restrictions, and the experience of the available construction market and the added value that the material can give to property values.

Timing will be another factor, as the building may be an intimate part of the client's business plan for a new product or expansion to accommodate new business or public services. In this case, the choice of material may be the factor which allows the client to complete in time in order to achieve that particular business opportunity or close that particular deal. Any additional capital cost arising is balanced by the benefits achieved when meeting the target. In the process engineering industry clients are prepared to pay a premium to achieve target dates rather than delay the start of production of a new product.

When the building client is building purely for rent or sale on the property market, then timing is critical in order both to reduce the outlay and borrowings, and to reach the market when the rental or sale price can be maximised to recoup the investment. Again, increased capital expenditure on materials that can meet a time-critical project's targets may net greater rewards for that client. The concept of valuing the benefits accruing from the project is consistent with these aims, that is the total value of the

outputs and outcomes achieved by the business unit that occupies the building. [2] A similar exercise can be useful for public buildings.

Time is also a factor for the construction contractor in reducing his overheads and administration costs on a project and improving his profits. Time is again valued as a cost where it is critical to the process, and usually that is with reference to the time and cost taken compared with suitable available alternatives, including the gain or loss arising from making or not making the target date.

However, cost itself is an even more complicated matter. The general tendency in construction has been to focus on the initial expenditure, known as the capital cost, without due reference to the whole-life cost of the building. With the rise of procurement arrangements such as the Public-Private Partnership (PPP) and the Private Finance Initiative (PFI) and their variants in both public and private sectors, the life cycle cost of buildings has come more into focus. Furthermore, in real estate the more discerning property investors are going to seek to invest in or rent buildings that can demonstrate lower operational and maintenance costs, and display a pleasing aesthetic image over time. Not to mention the additional benefits accruing to the occupants by reducing staff turnover costs.

In the late 1990s a survey was carried out into the long-term costs of owning and using office buildings [2]. This survey, based on a London city office, established a ratio of the costs over a period of 20 years which is frequently quoted in many articles on life cycle costing and facilities management. The ratio C 1 : F 5 : S 200 compared:

C = Capital cost (excluding land purchase)
F = Facilities management or operational costs
S = Cost of providing final services by occupying and using the facility (staffing)

The results of the survey have been seriously challenged by a more recent analysis [3]. where the ratio was reduced to C 1 : F 3 : S 5, but however much one might quibble with the exact ratios, the operating cost over the life of a building for the operator or owner is certainly significant. It is considerably influenced by the choices made at the design and construction stages.

An equivalent exercise for a typical office building in America (figs. 2 and 3) demonstrates an even lower ratio for operational cost, nearer 1:1. It further demonstrates the distribution of capital and operational costs over the elemental functions of the building with superstructure and exterior construction representing 29 % of construction costs but only about 20 % of the operational costs (figs. 2 and 3).

Higher specification and quality products can minimise maintenance costs and improve operating costs throughout the building's lifespan, particularly in relation to energy consumption.

The added value of the "better building" can be demonstrated by lower employment costs or higher gross output (lower recruitment/retention staff costs, reduced absence or higher productivity) [2].

It is generally accepted that some form of life cycle costing methodology has to form the basis for evaluating the sustainability of building projects. Various methodologies for measuring sustainable indicators such as BREEAM (UK), BEES (USA) LEED (USA), DGNB (D), HQE (F) have been developed and many others are under development, even though the different valuation systems are not always very coherent when compared with one another. These labels are gaining importance for the marketing and commercialisation of buildings, office space and houses. Also the reputation that accompanies certification plays an increasingly important role in this context. Since Kyoto, sustainability has become a pressing issue for all governments to address, with the

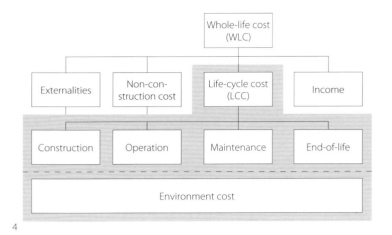

4

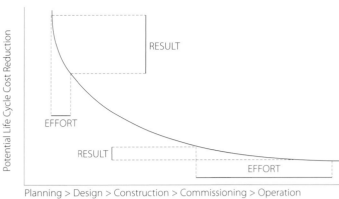

5

added economic penalty for those govern-ments who fail to meet their targets. Con-struction activities, including the manufac-ture and transport of construction products, have a major contribution to make in reduc-ing a nation's carbon footprint. Life cycle analyses and economy as major integral part of sustainability, are therefore very important for assessing this topic (p. 20ff.). The European Commission has identified the use of life cycle cost tools and criteria in all key phases of the construction process as one of the main ways of improving the competiveness of the construction sector [3] and it was a core recommendation of the Sustainable Construction Working Group [4]. By taking into account not only the initial capital cost but all subsequent costs, clients could undertake proper assessment of alter-native ways of achieving their requirements whilst integrating environmental considera-tions.

Life cycle costing (LCC) has been defined as "an economic evaluation method that takes account of all relevant costs over the defined time horizon (period of study), including adjusting for the time value of money". [3] The definition equally applies to whole life costing (WLC), in which, accord-ing to the cost breakdown structure in ISO 15686 Part 5 Building & Constructed Assets – Service Life Planning – Part 5: Life Cycle Costing, the costs of a building asset can be subdivided as follows:

Life cycle cost (LCC)
• Construction (capital costs) – construction cost, design fees, site costs, statutory charges, taxes associated with foregoing costs, finance charges and development grants
• Maintenance – planned maintenance, replacement and emergency repairs so that the building continues to meet the original levels of quality and functionality
• Operation – cleaning, energy consump-tion (heating, cooling, electricity, water

and drainage) waste management, prop-erty management (administration, insur-ance etc) and occupancy costs (security, switchboard, ICT, laundry, car parking etc.)
• End of life (disposal, demolition, refurbish-ment) to meet change of use require-ments or upgrade of construction stand-ards.

Whole life cost (WLC)
• Non-construction costs (leases, rents, taxes etc)
• Income (rent and service charge payments etc.)
• Externalities (costs associated with the asset but not included in foregoing)

The environmental costs would also be a consideration under LCC or WLC and would be dependent on the national statutory and legal requirements, including planning, and the environmental policies of the client (fig. 4).

Underlying all LCC are environmental and social costs including sustainable develop-ment. An optimal sustainable development is one which balances the total economic costs, social change and the inevitable environmental consequences, but current design approaches do not address this balance. The position on carbon costing remains confused, ranging from renewable obligation certificates between electricity generating companies to international green certificate trading. Accounting for embodied energy in construction products is an ongoing process being very depend-ent on the local energy sources used in pro-duction but better assessments continue to be devised. Several database have been developed, mainly on national basis, and processes like the European environmental product declaration (EPD) have been intro-duced to assess this aspect.
Statements that sustainable design will add 10 to 15 % to the total whole life cost is a

gross oversimplification and it is, from the pure financial point of view, advised that only verifiable facts from reliable sources should be included in the calculation. How-ever, the challenge is to balance the initial construction expenditure for more sustaina-ble buildings with the benefits that accrue from the investment in the whole life cycle cost of the building. Sustainable design will increase construction costs but will be more economical in the long run in terms of either whole life costs or life cycle costs. The steel industry is already proposing com-ponents and construction systems which answer, for example, the demand for higher energy savings at a competitive price.

Life cycle costing – cost application including cost planning

Not all these costs will be relevant to every life cycle cost calculation. Some will have negligible value whilst others will not affect the decision, having been "sunk" in that they are already committed or will leave the cost unchanged. It depends mainly on the weighting and importance of the different aspects in a construction project pro-gramme or the requirements and priorities of the investor.

The two primary purposes for undertaking a life cycle study are:
• To predict a cash flow over a fixed period of time for budget, cost planning, cost rec-onciliation or audit purposes
• To compare cost assessments of design options (value engineering) or appraise tenders.

In all cases, the earlier the exercise is carried out in the project, preferably at an early planning or design stage, the greater the benefits (fig. 5).

In the context of a life cycle study, there are

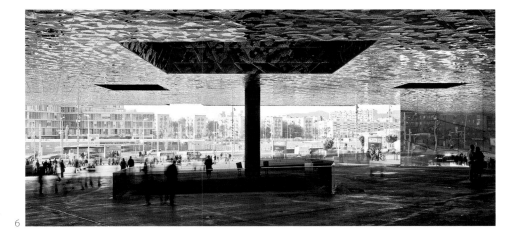

4 Whole life cycle and life cycle costing in accordance with ISO 15686: Part 5
5 Integrating LCC into the design process
6 Auditorium, Forum Barcelona, Barcelona (E) 2004, Herzog & de Meuron

6

five important criteria to define:
• Lifespan or service life
• Discount rate and future inflation value
• Value of future costs and incomes (nominal costs)
• Current costs (real costs)
• Residual and terminal values

Real costs are those costs current at the base date, which is the date when all capital expenditure is complete and revenue expenditure commences. Nominal costs are the future costs discounted to bring them to their value at the base date.

The important issue is that they should be established as accurately as possible and preferably in the early planning and design stage. Cost planning as a skill and art is an essential part of the operation. Without early accurate cost advice arising from effective cost planning, there is no raw data to complete even a basic cost study exercise. Reasonably accurate estimates of the anticipated construction costs must be available to validate any life cycle cost.

The period of appraisal depends on the purpose of the exercise. An example of a simple exercise would be a project where a short-term target is involved, such as achieving an opportunity cost. It may involve a comparison of alternative materials to see which can best achieve the target date. If there are maintenance and operational cost differences, they need to be included in the calculations, as the opportunity gain must also be compared with the long term costs to the client. Considering structural frame options is another situation in which such exercises can be fruitful. Where the size and scope of a project requires meeting a retail tenant's market deadline, then the best choice will normally be the option that involves as much off-site prefabrication and reduced on-site installation as possible. Such was the case in respect of Europe's largest shopping development in Dundrum, Dublin. With PPP or PFI procurement methods, the

client will need a longer review period to cover not only the time over which the building or service is procured and constructed, which for a typical state school programme of say six schools could be anything between 9 to 18 months, with a construction period of 18 months, but also the overall economic life (say 60 years for a school), even though the franchise period may be much shorter (say 25 years). The client will need to ensure the provider is catering for both options, otherwise he might find the building is not fit for purpose on completion of the PPP-providers contract.

It is therefore important to define the expected service life of the various building features:
• Substructure/superstructure (say 50 – 90 years)
• Components (30 – 35 years)
• Finishes (5 – 20 years, depending on the finish)
• Services (1 – 20 years, depending on the fitting)
• External ground works and the expected service life of the components
• Products that meet those requirements.

The following time periods can be defined: [5]
• Economic life – period of occupation, which is considered to be the least cost option to satisfy a required functional objective
• Functional life – period until the building ceases to function for the same purpose as that for which it was built
• Legal life – period until it no longer satisfies legal or statutory requirements
• Physical life – time when physical collapse is possible
• Social life – time reached when human wishes dictates replacement for reasons which are not economic
• Technological life – time when it no longer is superior to alternatives

The actual periods of study are often less than this and for many commercial developments the payback/break-even period for the investment will dictate the period of study. For public buildings, the period is set by the state; for example, the UK Government's discount rates are based on 30-year periods. It is probable that predictions over longer periods would be fraught with unforeseen consequences that would have greater effect on the outcome over longer periods of time.

Two methods of discounting can be used, annual equivalent and net present value (NPV). The latter is preferred for construction assets. This method compares the value of money now with the value of money in the future. The theory being that the pound in your pocket now is worth more than the same pound in the future assuming that inflation erodes the buying power of future money whilst money available today can be invested and will grow. This can be expressed as the formula below:

$$NPV = \Sigma^T_{t=0} \, C/(1 + r)^t$$

t = period of study
r = discount rate
C = capital sum to be discounted

The discount rate chosen is the percentage used to calculate the NPV and reflects the time value of money, taking account the prevailing inflation rate and the time period. Instead of using the formula, tables are available setting out the answers for different discount rates and periods (fig. 7).

For example, the current discount rate set by the UK government for public sector projects is 3.5 % (January 2009) and is suitable for cost study periods of up to 30 years. With private clients, the rate is particular to each client, the question being one of "if you were to invest 1 pound in your organisational activity rather than the building what would that 1 pound earn?". Private

UPV – Modified Uniform Present Value Factors (Discount Rate r = 8 %)

Year						Escalation Rates							
	0 %	1 %	2 %	3 %	4 %	5 %	6 %	7 %	8 %	9 %	10 %	11 %	12 %
1	0,926	0,935	0,944	0,954	0,963	0,972	0,981	0,991	1,000	1,009	1,019	1,028	1,037
2	1,783	1,810	1,836	1,863	1,890	1,917	1,945	1,972	2,000	2,028	2,056	2,084	2,112
3	2,577	2,628	2,679	2,731	2,783	2,836	2,890	2,945	3,000	3,056	3,112	3,170	3,228
4	3,312	3,393	3,474	3,558	3,643	3,730	3,818	3,908	4,000	4,093	4,189	4,286	4,384
5	3,993	4,108	4,226	4,347	4,471	4,598	4,729	4,863	5,000	5,141	5,285	5,432	5,584
6	4,623	4,777	4,936	5,099	5,268	5,443	5,623	5,809	6,000	6,197	6,401	6,611	6,828
7	5,206	5,402	5,606	5,817	6,036	6,264	6,500	6,745	7,000	7,264	7,538	7,823	8,118
8	5,747	5,987	6,239	6,501	6,776	7,062	7,361	7,674	8,000	8,341	8,696	9,068	9,455
9	6,247	6,534	6,837	7,154	7,488	7,838	8,207	8,593	9,000	9,427	9,876	10,350	10,840
10	6,710	7,046	7,401	7,777	8,173	8,593	9,036	9,505	10,000	10,520	11,080	11,660	12,280
11	7,139	7,525	7,935	8,370	8,834	9,326	9,850	10,410	11,000	11,630	12,300	13,010	13,770
12	7,536	7,972	8,438	8,937	9,469	10,040	10,650	11,300	12,000	12,750	13,550	14,400	15,320
13	7,904	8,391	8,914	9,476	10,080	10,730	11,430	12,190	13,000	13,870	14,820	15,830	16,920
14	8,244	8,782	9,363	9,991	10,670	11,410	12,200	13,070	14,000	15,010	16,110	17,300	18,590
15	8,559	9,148	9,787	10,480	11,240	12,060	12,960	13,940	15,000	16,160	17,430	18,810	20,310

7

sector options should be tested for the sensitivity of the result to varying discount rates. At the end of the appraisal period there may be elements and components which are replaced during the period and have recycling or scrap value – the terminal value which is included as a credit in the LCC calculation. Those that have a remaining life or utility at the end of the period should be credited at that value in the residual value. Finally, the accuracy of the calculation is dependent on reliable data for predicting the future performance of the building and the component or material. This data comes from three sources – historical, contemporary and predictive:

• Historical data might be sourced from the records of building and facilities management consultants. Experienced trade construction companies and design consultants may have useful recorded data. However, reliable independent and published data is limited and better developed in some countries than others. The important factor is that the data should be relevant to the environment and the use to which the intended subject of the LCC exercise will be put. For example, imagine two identical building; one located on the Irish Atlantic coast, subject to constant rain and winds from the sea, and one located in central Spain , subject to a dry arid heat in Summer and cooler winters. The potential for corrosion at either location is quite different and if you do not adapt the corrosion protection system to the local environment you cannot and should not compare the data from those projects, as the conditions are not comparable. The data used must be local. Corrosion protection may also be an economic issue in some locations as the chosen system will have a defined lifespan.

• Contemporary data can also be sourced from building or facilities managers, contractors, manufacturers and suppliers. For

8

example, manufacturers of some colour-coated steel cladding products claim a lifespan of 30 years and even more. The warranty offered with the product should be its minimum expected life but most products or components will be expected to function well beyond such warranty periods.

• Data from predictive calculations such as energy consumption can be carried out by energy consultants using simulation software. Much of the history of the introduction of structural steel into construction has been based on predictive exercises carried out by the engineering profession into its behaviour under stress. Such data, of course, needs the further application of predictive calculations by a professional engineer to determine the most suitable solution for a project.

However caution is advised here as the client will need to have any LCC exercise

justified to him. Who will have responsibility for the cost of maintenance and operation of the building? If it does not rest with the client procuring the building and there is no perceived benefit in higher rent for the reduced LCC for the building, then lower capital cost may well be the dominant factor. Using LCC early in the design phase to optimise the project layout requires a different approach in which each party involved is not trying to optimise only his own part of the project. The global approach, real team work and a clear allocation of the potential benefits are essential for success. However, the definition of the client's benefits is part of the LCC exercise and the rent obtainable often has to take account of the operational and maintenance costs, even if the client is not directly responsible for them. Therefore a lower LCC may increase the profit available to the commercial developer and the benefits of a better building

Options	Steel Cladding A	Steel Cladding B
Capital cost	€ 40,000	€ 55,000
Recoat frequency	10 years	20 years
Cost of recoating	€ 10,000	€ 20,000
Life span of building	40 years	40 years
Discount rate for PC	3 %	3 %
Service life of material	20 years	40 years

Assumed annual maintanance and cleaning costs and residual value the same

Life cycle costing			Steel Cladding A	Steel Cladding B
Capital cost			€ 40,000	€ 55,000
Recoat A	yr. 10	€ 10,000 × 0,744 PV	€ 7,440	–
Recoat A	yr. 20	€ 40,000 × 0,554 PV	€ 22,160	–
Recoat B	yr. 20	€ 20,000 × 0,554 PV		€ 11,080
Recoat A	yr. 30	€ 10,000 × 0,412 PV	€ 4,120	–
Totals			**€ 73,720**	**€ 66,080**

Cladding B is 11.56 % less expensive though the capital outlay was 37.5 % more expensive

9

can be translated into value. It is a fact of commercial life that the key factors influencing the value of property are not necessarily the quality or sustainability of the building as measured by the LCC model; other issues such as location and planning laws will have important influence on value. However, an LCC exercise should still be part of in preparing the overall development budget, as it will assist in defining the benefits available from investment in the project in the first place. And there is no point in carrying out an LCC exercise unless it defines the benefit for the participants in the project. A greater understanding of LCC and sustainability issues in relation to property valuation will increase its influence on rent and value of property in the medium to long term.

Having considered the necessity of life cycle cost (LCC) and whole life cycle cost (WLC) options, how does this apply to considering steel as construction material?

Life cycle costing – steel frames and steel products: key building elements

In respect of the structural frame the prime aspect to be considered is usually the potential physical lifespan of the building.

Steel Structures

Though two options are traditionally available, steel or reinforced concrete (either pre-cast or in-situ), it can be said of steel that, no matter what life span is required for the property, it has the potential for greater residual value.

Steel framed structures for buildings are normally considered as an economic option when the designers wish to create long spans for large open spaces, for example in industrial buildings, large retail areas or open plan offices. Usually it results in the external wall options being non-structural and this can give the freedom to include large expanses of glazing or uninterrupted space. With a greater number of storeys,

framed structures become the only economic option, transferring the weight of floors and internal walls and live loads through the framed structure to the foundations. For instance, the slim steel columns of high-rise buildings do not take up much space and allow economic floor plan concepts, even on the lower floors where they may have to carry high loads. Steel also provides speed if time is a factor in costs and in achieving a client's goals for the project. Even with non-industrial buildings of one to four storeys, where the common view is that traditional loadbearing walls are more economic than a framed structure, the latter justifies any additional capital costs by giving greater flexibility over the lifespan of the building and ultimately reducing the maintenance and operational costs. For example, loadbearing internal walls do not have much to offer public buildings such as secondary schools and universities, which can be expected to undergo many future

10

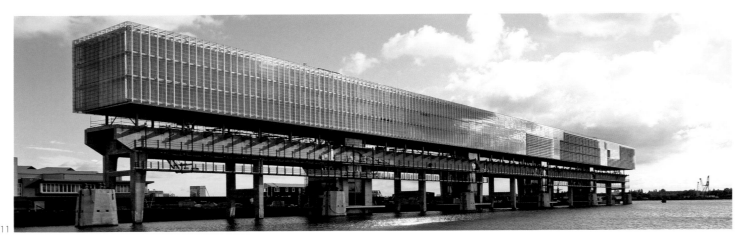

11

changes to their internal layouts. The framed structure can allow for greater flexibility in relation to room layouts by allowing for future removal of partition walls at a minimum cost. The LCC analysis here shows that the additional initial capital expenditure buys the client future functional flexibility options.

These options have to be considered particularly with public buildings, such as educational or health institutions, which are expected to have fairly long lifespans of 50 years or more but which need to allow for future changes in needs. Buildings intended to last a human lifetime will inevitably change their functions a number of times over that period.

The longer the initial lifespan of a building, the more important it is to get these issues right.

The design of hospitals, for instance, is notorious for major changes between the feasibility stage and final construction and throughout the life of the building as medical science and procedures advance. For example, a hospital might consider the option of a framed structure to provide a large open space to accommodate operating theatres constructed from specialist clean room standard partitioning with efficient connecting clean and dirty corridors, and allow for the large expanse of plant required to service the theatres from above. The industrial process has arrived in the medical world, too. Steel framed structures are seen as providing the greatest flexibility by allowing internal changes of layout with minimal effect on future costs. Many common problems with the current building stock, especially in the public sector, stem from its inflexibility, which results in a series of unrelated extensions and an inability to meet functional or environmental changes without radical and expensive refurbishment.

It is arguable that Kahn's philosophy of design applied to the American factory

ought to be considered where processes are involved which will radically change over time, such as medical facilities, leisure centres or where a building's entire function could be changed, say from offices into apartments or a hotel.

Given the considerable initial investment that is involved in land purchase and steel construction, and taking account of the necessary requirements of sustainable construction, the frame option needs to be considered as part of the early LCC exercise.

Where the steel structure option is considered, it will usually have to be evaluated against the available alternatives, which are often reinforced concrete (cast in-situ or precast) and, less frequently, timber. Commonly the choice is based on capital cost rather than LCC and the steel solution has to be considered in relation to the fire safety and weathering options together with the appropriate aesthetic requirements of the building. If a comparative LCC analysis is required, the lifespan of the additional treatments must be considered together with the residual values of the steel frame compared with the concrete frame. Generally, the disposal and demolition costs of a steel structure are considered as nil because it is completely recyclable, whereas concrete is only partially recyclable and will have a disposal cost. One must also consider that steel structures are often just refurbished for a new use, such as the now common conversion of city centre industrial warehouses into apartments, offices or hotels. .

However, if future options for alternative uses are to be considered as part of the client's needs, then the comparative flexibilities of the respective frame materials should also be considered and a steel frame may prove more adaptable if the design anticipates this need for flexibility.

The comparison of cost alternatives can be extended to cover the full range of the different structural systems steel has to offer.

Steel to the US-Amercan standard ASTM A36 (equivalent to EN 10025 grade S235) was once the standard carbon steel used in building construction. It is been largely replaced by the higher strength A992 (equivalent to EN 10025 grade S355) steel, which is used for rolled wide-flanged sections and where seismic design issues arise. This higher strength steel can reduce the overall tonnage by 10–15 % giving material and on-site welding cost savings and improved weldability.

For high-rise multistorey structural frames where weight reduction is of paramount importance, high yield strength steels with low alloy content complying with ASTM A 913-07 (equivalent to EN 10225 grade S460) have been developed that can reduce the construction weight by 25 to 50 %, depending on the structural layout.

For a moderate increase in cost, alternatives to the standard I-and H-sections can be found in the form of frames using hollow section steel of various profiles which can offer more aesthetically acceptable solutions, though available sizes and load capacities will limit these options.

The LCC must relate to the client's initial brief, which must include what form of statement they wish to make with their building-this includes any added aesthetic/style value required to reflect its corporate image or which is essential to sell the client's business. What are initially considered more costly solutions may give greater value for money in the end.

For example, in a refurbishment of the oldest foundling hospital in Europe, the Rotunda in Dublin, a new canopy in stainless steel was erected recently in front of the facade of a 1980s extension. The choice of product, though four times more expensive than the equivalent standard steel structure, was based on the aesthetic gain and the avoidance of any highly disruptive future maintenance at the main public entrance to the hospital.

11 Sustainable office building, Kraanspoor,
 Amsterdam (NL) 2007, Ontwerpgroep Trude
 Hooykaas bv
12 Reflective stainless steel facade, Aplix, Nantes (F)
 2000, Dominique Perrault

Structural tubing to ASTM A501 (equivalent to EN 10210 S275), made using hot-formed carbon steel with properties similar to grade A36, is being used more frequently where resistance to torsion is required and when a smooth closed section is aesthetically desirable. This material may be the economic choice for compression members subject to light to moderate loads.

Steel structures are no longer confined to heavy framed structures. Light steel frames of galvanized and cold-rolled profiles are manufactured and designed for residential units and two/three storey hotels have been found to be economically competitive against both timber framing and conventional constructions.

Steel structures can be designed to be lightweight in order to accommodate problems with foundations or when adding additional storeys to existing structures.

A similar option was taken on the Kraanspoor project in Amsterdam harbour. A three storey office building had to be constructed on top of an existing concrete frame structure, on which two rail-mounted harbour cranes used to run. Due to the limited load-bearing capacity of the existing structure, the third floor was possible only with a steel structure and a specially designed floor system. The 30 % increase in lettable floor space provided by the additional floor has also made the project profitable for the investor. The steel solution made the whole project feasible (p. 174ff.).

Where soil conditions are poor, lightweight steel structures may prove to be the only option to reduce the loads on foundations. Floors were traditionally formed either with cast in-situ concrete or precast concrete. Developments in steel manufacturing have introduced decking systems which replace temporary formwork and allow a thinner concrete floor. However, the use of a steel structure can in itself result in slimmer floor slabs with consequential reduction in facade heights and reduced external cladding area.

The introduction of asymmetric beams in new flooring concepts has provided cost-effective flat slab solutions for steel construction. The integrated floor beams, often called slim floor beams, simplify service integration and avoid the problem of having an additional service zone below the beam level which otherwise would increase floor to floor height, facade area and column heights. Another solution with minimal floor depth for multistorey framed buildings is cellular beams with large web openings. The openings accommodate the service zone within the beam space, thus reducing the floor height, and, likewise, the facade area and column heights.

These options can offer suitable exposed soffit finishes, integrated services and speed of installation.

In industrial buildings, steel floor plate offers cost-effective solutions with slip-resistant, durable surfaces for walkways, stairs and platforms.

Returning to our basic structural steel frame option, attention should be paid to the following points in order to optimise the LCC of a steel structure, although they are equally relevant to minimising the capital costs of a steel frame – (see life cycle cost optimisation of steel structures) [6]:
• Select discrete commercially available sections with the lowest cos
• Select commercially available sections with the lightest weight
• Select the minimum number of different types of commercially available sections
• Select commercially available sections with the minimum total perimeter length.

The sustainable characteristics of structural steel offer economic benefits:
• 100 % recyclable – good end of life value
• Uses minimum volume of material
• Clean, dust-free construction process with minimal site wastage
• Off-site fabrication in a controlled environment

• Adaptable and flexible to suit changing lifetime requirements

Steel prefabricated buildings of a more permanent nature are commonly manufactured for such purposes as medical units to house operating theatres, clean rooms etc. All of these off-site prefabricated options are dependent on the ongoing demand sustaining the costs of maintaining industrial-type manufacturing facilities.

Cladding/roofs

Steel cladding was once just the preferred material for agricultural buildings, industrial warehouses and stores. However, with the introduction of the insulated sandwich panel, composite or separate, with a high quality external finish, the possibilities of using it for non-structural external walls and roof cladding increased, both as a material which can compete in terms of performance with the other traditional solutions and as an aesthetic choice for designers seeking a more modern, technological look for their buildings.

The long life of galvanised steel roof sheeting on public buildings has been frequently demonstrated. When the 140-year-old pump rooms at Tenbury Wells, Worcestershire, England were renovated in 2000, it was found that 90 % of the original galvanised steel roof sheets had survived and were in sufficiently good condition to be re-galvanised, powder coated and refitted. [7] "The fact that they could be re-used after all that time testifies to galvanising and steel as the ultimate in re-usability and eventual recyclability – no other construction product comes close."

The lesson to be learned here is that the protective coatings on steel may last far longer than predicted, though it is important to check the local conditions against the data offered by the manufacturer. The corrosive atmosphere, the way conditions may change over the planned life time, and

13 14

the accuracy of these predictions are the main influences on durability. The more accurate your predictions, the better you can optimise the cost-value ratio of the coating system.

Looking at the thermal performance of existing buildings and their envelopes, and rising energy costs in recent years, thermal refitting by means of over-cladding or replacing old cladding might also be reasonable from an economic point of view, once you take into account energy losses, which can be calculated from temperature differences. Numerous options for protective coatings with various lifespans are available from the major steel manufacturers. There are also combinations incorporating other energy efficiency options, such as photo-voltaic cells or using weathering steel or stainless steel for the cladding. How well do these products compare with the established competitors? Recent LCC models published in the UK [8] compared steel cladding products with common alternative materials and, even though it was a general exercise rather than relating specifically to a particular building, it gave some indication of how steel cladding products compare. The exercises were carried out in 2003. And the aim was to produce a working LCC model that could be used to compare metal-based cladding products with other conventional building materials and to demonstrate the whole life cost difference between coatings available for the steel outer sheets.

A number of assumptions were included as a basis for these life cycle models:
- The capital cost of the cladding system includes its substructure – the supporting steel rails or purlins
- Routine maintenance – includes annual inspection and repairs
- Exceptional maintenance costs include recoating the cladding after 20 years
- The end of life value of a steel-based

system is zero as the scrap value will equal the demolition costs
- Masonry (one of the alternative materials) has demolition and disposal costs
- Maintenance costs include wash-downs every five years, roof weather sealing and repainting at industry standard levels
- The Period to Repaint Decision (PRD) frequency is based on data from the manufacturer
- The costs exclude energy consumption during the building's lifetime

One model compared options for a school roof of 1000 m² in area with an assessment period of 60 years. The steel metal profile roof with a PRD of 30 years was compared with a concrete tile roof and a single-ply pitch polymer system on galvanised decking (flat roof). The LCC for the polymer was higher due to the need to replace it every 25 years, even though it had the lowest capital cost. The concrete tile proved to have the lowest LCC mainly because its end of life value was taken as zero on the basis that it could be recycled and its substantially lower capital cost. However, factors such as aesthetics and speed of construction, the effect of loads on the roof and because of its degree of adaptability on large, relatively flat-roofed industrial buildings were not considered. The cost model demonstrated that the coated steel sheeting compared favourably against the other materials where the lifespan was 25 years or less.

Use of steel – construction process
From a cost perspective, one of the most important factors influencing steel as an economic choice is the cost advantages it may or may not give the contractor, who is ultimately responsible for the delivery of the project.

Cost, time and risk
Recently, general contractors have started to look beyond the pure construction cost and

are expanding their range of services by using LCC analyses to advise their clients on how best to satisfy their future needs in a building.

However, it should be noted that in some national construction industries, the design and construct-culture can lead to one particular form of structure dominating the market. This is the case with concrete frames in continental Europe, and steel frames in America, Australia and UK.

The advantages are factory-controlled off-site production, which means computerised production with minimal waste of material; high accuracy and precise detailing; the contractor can have the foundations ready to receive the structure early in the construction programme; no heavy plant or labour-intensive operations such as formwork or reinforcement fixing are required. Finally, the contractor has to commit less plant, equipment and staff to a particular site, which increases his overall flexibility and speed of reaction.

Accelerated ordering and design approval procedures. Ordering in good time allows the shop drawing to be produced and approved early in the programme. Fabrication and delivery follows with minimal down-time between foundation completion and steel erection. Erection time on site is reduced with an overall benefit to the contractor's site costs and off-site overheads. The need for detailed planning and design minimises risks and brings forward the final completion date.

Erecting a simple steel framed structure, being a dry operation, is generally done cleanly and quickly with the help of a crane, thus shortening the contractor's programme. The basic building shell can be rapidly weatherised, which simplifies the remaining internal and more often costly work.

Due to reduced on-site time and higher quality in fabrication, steel construction also

13 Enamelled steel facade, Deixa Bill, Esch Belval (L)
 2007, Claude Vasconi
14 Folded, stamped and rolled facade system, Civic
 Hospital, Strasbourg (F) 2009, Claude Vasconi
15 Composite flooring system

15

mitigates external risks, including delays by and for other trades and operations. This allows more precise budgeting of the project.

An integrated design approach can avoid further on-site operations by incorporating services, supports etc. in the off- site production stage. For instance, intumescent paints can be applied in the shop which might prove more economical in some cases. Furthermore, good fire engineering design optimises the degree of fire-proofing required and may even demonstrate that the necessary level of fire safety can be achieved without any additional protection. Depending on the fire protection requirements for the steel, a further fire enclosure can be dealt with as a decorative element or can form part of the dry wall trade. It is not in this context do synergies and mutual dependencies between different operations should be taken into account in both their technical and economic aspects.

Steel has advantages over more traditional materials when it comes to the choice of an envelope option. Sheets are easily and quickly attached to a secondary steelwork system, which can be adapted for combinations of other materials, such as stone and timber panels.

The choice of cladding ranges from profiled sheets used in industrial buildings to more modern options, with coloured flat steel often selected for its aesthetic effect.

The advantages of off-site fabrication can extend to having combined elements of frame and envelope manufactured under factory conditions. Where the overall market demand for a particular building type, such as high rise apartments or hotel blocks, justifies investment in long-term off-site fabrication facilites, the entire building can be prefabricated with only the substructure and site infrastructure requiring on-site works. Steel manufacturers are continuously developing new construction systems that will further shorten erection times, reduce costs

and improve energy efficiency.

However, contractors with adequate knowledge of steel construction may not get involved early enough in the process to influence the choice of material, and this decision may have already been made based on other factors before the procurement stage. Furthermore, as structural steelwork is often subcontracted, a project can only benefit from the experience and expertise of the steelwork manufacturer when the decision about the material choice has more or less been made and there is very little scope for any contribution that might develop an alternative proposal. Among the factors influencing the decision are the preferences of the architect and his client, methods of procurement, influences of local and national statutory regulations and controls, building and fire regulations and the local planning authority's requirements, including planning policy restrictions for the locality.

Steel – factors influencing construction costs
Among the key issues which will affect the cost of the building are its design, space requirements, shape, height , positioning and orientation on site, its required environment internally and the nature of the external environment, functionality, quality of finish, the expected life and the construc-

tion methods available on the local market. In addition, the cost may not reflect the price to the building procurer or the main contractor employing a subcontractor, as a major influence will be the supply and demand on the local or national market, which influences the labour rate, management costs, on-costs and profit.

As with any project, establishing realistic budgets at an early stage is essential and early cost studies are advisable. At the feasibility and early design stage, only elements that constitute a significant proportion of the cost of the building need to be considered. These would include foundations, environmental services, wall and roof cladding envelopes, combinations of either structural or non-structural envelopes with structural floors. The latter option influences the decision whether to have a framed structure or not, which in itself can make up a significant proportion of the cost. Obviously structural steel frames become a necessity for larger open spans or buildings over 3 or 4 storeys high.

With reference to framed options, it has been said "if either steel or reinforced concrete held all the cost advantages the other would long since have disappeared." [9] However, in the UK studies comparing steel and concrete buildings have indicated that

Stainless Steel Swimming Pools:
In construction, durability and recyclability make stainless steel a clear sustainable choice.
As a direct result of its material's inherent properties, stainless steel doesn't require any coatings and the upkeep and maintenance of a stainless product is simpler, its service life longer. Stainless steel is a durable material that does not age. Natural longevity of the material for pool's longer life, lower operational expenses, reduced upkeep and maintenance costs, end of life economic value of stainless steel.

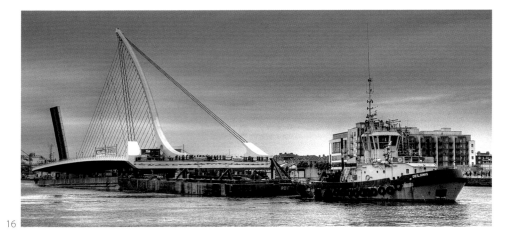

16

16 Transport of the James Joyce Bridge to Dublin,
 (IRL) 2009, Santiago Calatrava
17 Relativ costs per square metre for different floor
 systems assuming facade costs of 500 €/m² as
 an assumption

there is a widening gap in competitive cost since 1995, with steel being shown to be the fastest and most cost-effective choice for commercial multistorey buildings. Construction systems have optimum conditions of loading and spans in which they are the most cost-effective. Manufacturers have developed higher strength steels capable of supporting longer spans with lighter, smaller cross sections, which has improved the material's competitiveness.

However, account must be taken of building physics, sound and thermal insulation, and fire safety.

When analysing steel frame costs, an important influence is the design of the connections between steel frame members; the greater the forces required to be transmitted, the more complex and costly the fabrication. Engineering design is essential to assist in producing working drawings and to order materials. In any modern fabrication works, computerised design is normal and assists in ensuring accurate and economic cutting and fabrication. Fabricating steel offsite is generally cheaper, even after taking into account the costs of delivery, offloading, on-site touch-up treatment and erection.

The designer must consider at an early stage whether simple rolled sections or fabricated complex components are required, and must decide on the type of steel. The decision to use welded or bolted connections will also have an influence on cost. With welding, an adequate, well-supervised pool of skilled labour is essential. The cost breakdown for a typical medium-sized steel structure of 500–1000 t in one of the developed countries would be:

• Raw materials 30–35 %
• Engineering design 5 %
• Fabrication 25–35 %
• Protective priming 8 %
• Transport and delivery 2 %
• Erection 20–25 %

The above figures exclude costs for cranes, which could be provided by permanent on-site cranage or hired cranes could be used. The early involvement of structural engineers and fabricators can be the most effective way to value-engineer the structural design. For example, more substantial steel columns might reduce the need for stiffeners, with a consequent reduction in labour costs, but this would depend on the cost of the materials relative to the cost of local labour, the latter ranging from high in western Europe to low in China. In all such exercises, the local labour costs will heavily influence the outcome of the cost analyses.

Designers must take into account dead and imposed loads. Clients may request higher live loads but designers should note that the difference in terms of weights of steel for imposed loads of 3.5 to 5 kN/m² is negligible. For structures with long spans like bridges or even halls, the ratio between dead load and imposed load can be used as an indicator of the performance or effectiveness of a structure.

Wind loads will also be a critical design factor, both lateral and, sometimes, vertical. Lateral resistance can be provided by a stiff core or the frame connections themselves (moment frames), however diagonal bracing is usually less expensive than using stiff structural members or rigid connections, although where the appearance is important bracing may not be desirable. When assessing the optimum economic design of steel frames, there are a number of rules of thumb which can be applied:

• Doubling the span of beams from 7.5 to 15 m would generally increase the average weight of a supporting column by 50 %, a ratio that might decrease if higher strength steel was used for the columns.
• Primary beams made of H (wide-flange) or UC (universal column) sections are around twice as heavy as I or UB (universal beam) sections but can achieve reductions in structural depths of 150 mm, which can

be critical over a certain number of storey heights.
• The higher materials cost of larger bay sizes from the extra weight of steel required to support longer spans may be totally offset by a reduced price per tonne, savings in the number of columns and on site labour. The resultant column-free space can add value to the project by allowing more flexible internal design options.
• Using heavier secondary beams can increase the maximum allowable span. Again the additional weight of steel incurred for spans between 6 and 9 m may be up to 100 %, and as much as 200 % for spans up to 12 m. But overall depths could be reduced by 150–300 mm, which again with multiple storeys can offer overall savings with regard to the building cost.
• Where really necessary, fire protection has to be assessed when comparing different alternatives. There are a number of options ranging from filling flanges between I beams with fire resistant blocks for a 30 minute rating, filling hollow steel sections with concrete or coating the steel with intumescent paints can give a 2 hour fire rating, while encasing with fireboard gives up to 4 hours. We have previously referred to the role played by fire engineering design in reducing or optimising fire safety requirements. Price is influenced by the number of pieces per tonne, the fewer the pieces, the less the cost.
• Complex designs will generally involve more complex components, with added costs. For example, steel roof trusses are usually more complex than the average box frame structure and the cost per tonne will be up to 25 % more expensive, depending upon the complexity. It is therefore always advisable to rationalise the range and tonnage of section sizes to be used when designing complex steel components .

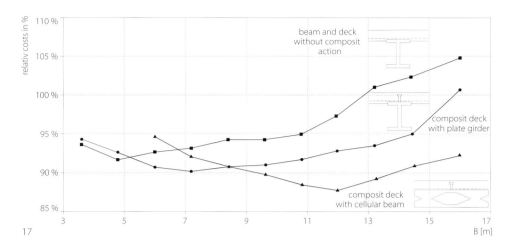

Construction factors which affect costs in steel frame construction include:

- Access to the site must be safe and allow delivery of the steel components close to the building. Handling of components for a steel structure is relatively easy compared with other types of construction. Lightweight, modular steel elements offer the advantage that they can be scaled up or down to suit the allowable limits on weights or dimensions. The key issue being a suitably accessible crane.
- The erection area needs to have a solid, level surface, clear of obstructions and with adequate space for temporary storage. The soil must be capable of safely supporting loads during erection. However, the light weight of steel structures will tend to lower the cost of foundations, even in poor ground. For the same reason, steel also makes it possible to develop new areas for construction on poor ground in delta regions or near rivers and coasts, where many main centres of population are located.
- Sufficient area to erect steel in one continuous visit with no interruption from other trades. Additional site visits mean additional costs
- The capacity and reach of the crane

Procurement – various models
In a survey in 2004 in the UK [10], it was found that the following were the preferred procurement methods for procuring structural steel frames :

- Construction management 45 %
- Subcontract by general contractor 33 %
- other 22 %.

As mentioned above, early involvement of the steel fabricator in the design can result in optimum cost savings. In design and build options there is the potential for early involvement, but that is also very much dependent on the extent of the design development actually transferred to the

contracting organisation. Much "design & build" occurs after feasibility design and often planning consents have already been completed, losing much of the advantage which would arise from early involvement of the steel fabricator.

Of course, the architects, engineers and quantity surveyors in the design teams can involve the fabricators in the early design, particularly where complex design problems are involved. Fabricators are often willing to offer early budgetary advice in return for early notice of a potential project. Also, on major projects where the frame is a significant factor, early involvement may be essential to ensure there is adequate time to order and fabricate the steel required, particular when tight programming is involved. As a rule, British and French construction contracts work through main contractors, who engage the subcontractors. In countries influenced by the German construction culture, projects are managed by design and build contractors or by project managers, architects or engineers, who deal directly with the trade contractors. It could be argued that the intervention of the subcontractor system under the UK introduces additional on costs, but similar costs will arise to cover management risk under the alternative systems.

Contract conditions such as payment clauses can influence costs. The subcontracting system can involve considerable risk of delay in payment or non-payment, given the relative financial weakness of subcontractor compared to the main contractor (though that is not always the case with the steel fabricator, some of whom can be relatively large, depending on their local market share). However, it cannot be said that the steel fabrication industry is any more vulnerable than any other industry as a result of contract conditions.

Lead-in times from the placing of the order to delivery and erection depend on the size and complexity of the project. Typical lead-in times for a 500 to 1000 t frame would be 14 to 16 weeks, allowing 4 weeks for working drawings, 4 weeks for approval and 3 weeks for fabrication, but these periods can be reduced with good forward planning.

Steel as a construction material on the market – the economic benefits

To understand the influence of the pure steel price on the price the end client pays, it is necessary to first quickly review the main ingredients of cost.

Being able to build within tight timeframe, under exploitation and to offer users comfort and safety, are some of the decisive pitches in favour of the steel solution for multi-storey open car parks.
This solution has also demonstrated its high competiveness and has became the solution chosen by private or public developers, every time a new car parking facility is required.It is also possible to design completely demountable construction systems for future reuse.

18

19

20

The economical context for steel as construction material

The cost of the steel frame as with most building components can be simply broken down into the costs of materials, fabrication, transport, labour, plant, management, design, on-costs and profit.

Steel, when it is incorporated into buildings, usually has an on-site cost and an off-site cost. The latter usually is dependent on the complexity of the building and weight of the steel components to be erected. The more complex and heavy they are, the greater the labour and plant cost, as the weight of the heaviest component will determine the size and jib length of the crane and the space required to store and lift the components. On-site labour and plant hire costs will generally reflect labour and plant charges n the local building industry, unless there is a shortage of skill or plant in that field.

Transport costs are usually small in relation to the total cost unless there are oversized components to deliver. In extreme cases, like bridges, the superstructure may be transported by water from a steel fabricator in one country to the site in another.

This demonstrates that, although in many countries local fabricators may have limited capacity, by forming consortiums they can provide solutions for major projects. Larger fabricators may also compete, as nowadays large buildings tenders have to be organised at the international level.

The fabrication cost is generally dependent on the complexity of the design and the use of special steel grades or components. Again, labour costs reflect those of the local construction market and there is the cost of providing either enclosed or open fabrication yards.

Generally speaking, the cost of the steel frame does not represent the major part of the total construction cost. But its choice and design have strong impact on the future use of the building.

In multistorey buildings, it is generally considered that the total cost of the steel frame will represent between 8 and 12 % of the construction cost, not including the decks. For an individual house, the same ratio is about 10 %. If the cost of the material represents on average one third of this amount, it means the cost of the steel product is less than 3 % of the total construction cost.

Steel price

As a material in worldwide use by all the industry including construction, steel is a key material for the economic and sustainable development of a society. Steel price has therefore always been subject to fluctuations in line with events in the global economy, its evolution and growth rate.

Construction use worldwide represents more or less 45 % of the total consumption of steel. This figure is higher in emerging countries, due to the need for new buildings and infrastructure, and slightly lower in developed countries.

The steel market is a globalised market. In the recent past until 2008, the global demand for steel grew continuously. Steel prices depend on the final demand, but also on supplies of raw materials and energy.

In 2008, the price of steel rose rapidly following the affect of unprecedented rises in the price of oil and gas and raw materials like iron ore, coke coal and scrap. This was followed by a rapid fall in price due to the global financial crisis.

These raw material price fluctuations were mirrored in construction prices, with a 12 % rise and fall in structural steel framework prices in UK and an even more pronounced increase in steel reinforcement of up to 68 % over the same period. Given that reinforcement could amount to about 20–25 % of the cost of a reinforced concrete frame, this would translate into a 10–15 % increase in the cost of a concrete frame compared with a 12 % increase for a steel frame structure. And these figures do not take in account the

increase in cement prices during the same period.

Taking the average of the various construction alternatives based on different construction materials, there was no real difference as all materials are dependent on raw material prices.

A recent study analysed the competitiveness of steel solutions for public multistorey car parks during the period 2004–2008, generally considered as "high price period". Taking into account the usable area of car park provided, the results show the consistent competitive advantage of the steel solution to be least 13 % per parking space offered [11].

Therefore the influence of fluctuations in the pure steel price could never be considered a major aspect of the design choice. Comparing the various structural options , steel or reinforced concrete, it would be reasonable to assume that the overall cost increase for the steel raw material content of the structure was about the same ignoring other material associated material costs and labour.

A study done on residential multistorey buildings in continental Europe has shown that the cost of the steel frame was generally lower that the cost of the partition work, in which the impact of plasterboard price rises is even higher than the effect of higher steel prices [12].

An examination of the rise in the use of steel in construction demonstrates that there is no elasticity in the demand for steel in response its price. Other factors contribute far more to the competitiveness of the solution.

Steel competitiveness

The competitiveness of a material is not solely dependant on its price, performance plays a major role too. It ultimately is the price-performance ratio that counts.

By definition, a construction solution providing poor value to the end customer will not

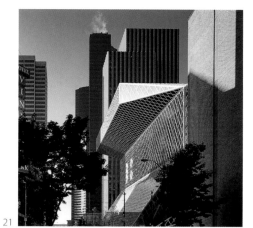

18 Steel strips in a continous coil coating process
19 Packed steel coils ready to be shipped
20 Steel wire
21 Seattle Library, Seattle (USA) 2004, Rem Koolhaas

survive in a competitive market.
For example: steel corrugated galvanized sheets were used for decades in developed countries as a roofing material for roofing basic buildings, like hangars or garages. It was an extremely cheap roofing material. It has almost completely disappeared to be superseded by coloured profiled sheets, which, although more expensive, have far better durability, appearance and technical performance.
Therefore, the question of price has to be considered in the context of the "value proposition" for the customer, not just the contractor who buys steel products or steel solutions, but the final user or future owner of the building.
With reference to the interest in steel for construction, the fact cannot be overlooked that steel has gained a market share in the construction industry, irrespective of the prevailing economic climate.
Take for example the multi-storey market in UK. In 1980, the market share of steel frames in multi-storey buildings was less than 20 %. In 2005, steel dominance in the high rise market was as high as 70 % and was touching 43 % in residential high rise buildings. Similar trends were evident in other European countries, especially in the area of high rise office buildings, and this tendency was apparent in emerging countries including Romania, China and Russia.
The competitiveness of the steel solution is even higher in countries in earthquake zones.
Insights can be gained from the consideration of similar trends in other countries and building segments:
• The growth of steel frame use in multistorey car parks can be seen in Germany and now in France, Italy, Japan and Australia.
• Steel frames are popular in residential buildings in Scandinavia and the Netherlands, as well as in Australia, South Africa and Japan.
Steel is also one of the most popular materi-

als for roofing all over the world, not only for industrial buildings, but also for residential property in Central and Eastern Europe, South East Asia and India.
Such developments have not much do with the price of the steel material itself.
It is the result of a complete analysis of the value chain from the steel manufacturers to the end user or owner which has identified steel as the most interesting value proposition for the end customer, generally supported by strong marketing plans and innovation support involving designers, contractors and manufacturers.
The price of the material is only one parameter and generally accounts for only a small part in the total cost.
There are clearly other important factors.
First is the availability of the solution on the potential market. With the exception of really major building projects, construction is a local activity.
Guaranteeing a product delivery time that is acceptable for a building project, not only depends on availability of products, but also the existence of an operational network of designers and contractors able to design, fabricate and install the solution on site.
Secondly, standards, regulations and specific local requirements play a key role in the competitiveness of solutions.
On European markets, the introduction of the Eurocodes in recent years and the tools they offer to designers of steel and composite structures have played a major role in the competitiveness of steel solutions in multi-storey buildings.
Depending on the local regulations, the use of very high strength steel for the design of a steel structure could produce cost savings of more than 20 % for the structure. In this case, the support given by steel manufacturers to introducing the steel solution to the market and customer support will be crucial to the success of steel-based projects.
The same issue applies to fire safety solutions for cladding or partitioning, for which

the designer generally needs specific approval from the appropriate national authorities. Here the impact of the possible solution on the final cost of the building is far more significant than the price of the steel itself.
Educational programme for architects and engineers and professional training sessions organised for contractors to improve their skills also play a part in increasing the competitiveness of the material.
And, finally, the reputation of steel manufacturers and their marketing plans to develop their range of products and services also exert a real influence on the final choice. In this context, specialised web sites dedicated to construction are now contributing to the dissemination of best practice in the use of steel, and are particular effective where they are available for practitioners in their own language.
All these factors are linked and they all contribute to the global competitiveness of steel solutions. The price of steel itself is therefore only one factor, even if it is a particularly sensitive one because of its visibility.

Design of Steel Structures and Building Physics

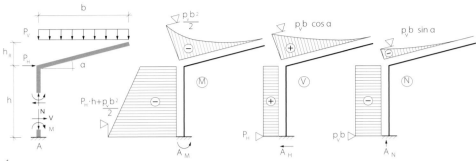

1

Markus Feldmann

Basics

The design and dimensioning of modern buildings require the consideration of a wide range of technical aspects extending, to varying degrees, into other fields of architecture, engineering and science.

Starting with the basics, such as theory of structures, stability, materials, and manufacture, through questions of usability, building physics, convenience and human comfort, and ending with specialisms, such as seismic and explosion-proof design.
The particular characteristics of constructional steel, namely its strength and toughness, as well as the design possibilities it provides mean that steel structures can often be the ideal solution for the optimum and simultaneous satisfaction of the architectural, engineering and economic requirements in a building, while still remaining a separate entity.

Basics of design

Loads such as self-weight, wind and snow, or live load generate actions (E) in the individual building elements as internal forces and moments, referred to as sectional forces (fig. 1).

All forces and moments acting on a body (loads and support reactions) have to be in equilibrium (external balance); however, the internal section forces also have to be in equilibrium (internal balance). Equilibrium is reached if all forces and moments to be applied add up to zero, e.g. for coplanar systems (equations of equilibrium):

$$\sum H = 0 \; \sum V = 0 \; \text{ and } \; \sum M = 0$$

where
H = horizontal forces
V = vertical forces
M = moments

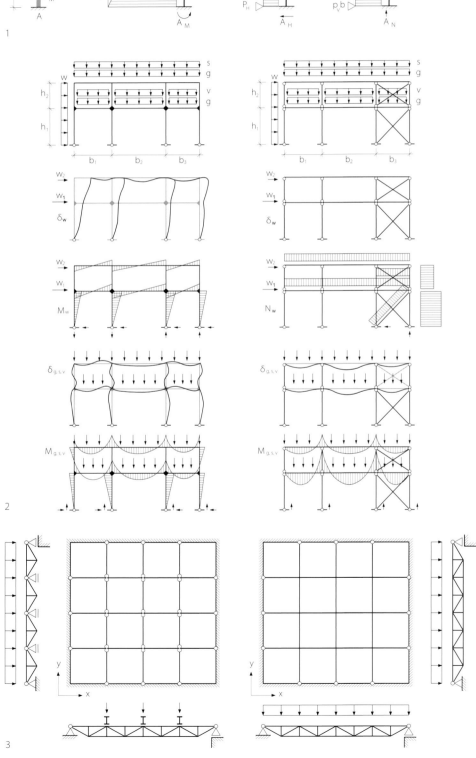

2

3

	Type	γ_E	γ_M	Ψ
Actions E	perma- nent	self- weight	1.35	
	changing	traffic	1.50	
		snow	1.50	< 1.0
		wind	1.50	
Resist- ance R	members and cross sections		1.00 (1.10)	
	joints		1.25	

4

1 Diagrams showing the bending moment M, shear force V, and normal force N in an angled canti-lever under a uniformly distributed vertical load p_v and a horizontal point load P_H. Internal forces and moments (sectional forces) and the support reactions A_M, A_H, and A_N are shown, too.
2 Multistorey frame with continuous beams and unbraced (left) and braced columns (right) with diagrams showing the contrasting structural behaviours.
3 Plane grillage with short secondary beams simply supported between continuous primary beams (left) and the alternative with equal continuous members in both directions, X and Y (right).
4 Partial safety factors γ and combination factors Ψ
5 Details of beam and column joints, column feet and frame connections – with varying ability to transfer bending moments.

Should the actions E exceed the resistance R of the member, an internal equilibrium cannot be reached, with the result that the member will fail.

The basic requirement is that the action must be less than the resistance regarding each of the following: bending moment, normal force, and shear force thus:

E/R ≤ 1.0

The fundamental principle of dimensioning is the assessment of the actions E resulting from the different loads, the resistances R of the selected member, cross-section, and material, and the comparison of E to R. Here, in order to allow for uncertainties, the characteristic values of the action E_K and of the resistance R_K are determined first and then either increased (γ_E for the actions) or decreased (γ_M for the resistances). This defines the dimensioning level for action and resistance:

$$\frac{E_d}{R_d} = \frac{\gamma_E \, E_K}{\dfrac{R_K}{\gamma_M}} \leq 1.0$$

There are many load scenarios for a building which usually include an ever-present dead load and single or combinations of chang-ing live loads.

Consideration of several coexistent chang-ing loads allows the partial safety factors to be decreased from $\gamma_E \cdot$ E to $\Psi \cdot \gamma_E$ with – because of less probability of occurrence – combination factors Ψ < 1.0. Extraordinary loads, such as earthquakes, impacts, etc. are generally calculated without partial safety factors. The calculation of the deformation δ does not consider safety factors either.

Design of structures

Structural frameworks are designed, dimen-sioned, and constructed taking into con-sideration the function, architecture, con-struction method, assembly, and cost-effec-tiveness. The approach should take into account the fact that buildings are large bodies. Entire building sections or single members can be designed this way, either by treating them as plane structures after sectioning into primary and secondary structures, or as 3D spatial structures, and continuing the process down to the small-est detail (figs. 2 and 3).

Furthermore, the concept of load transfer has to be defined for the individual assem-blies (floor, beam, column and frame sys-tems). This will affect the structural design of the beams (bending cross section, com-posite cross section, framework, etc.), bear-ings, column and base connections (pinned or fixed), direction of span, bracing systems, etc. (fig. 2). Such boundary conditions are important when sectioning the structure into single members and for subsequent dimensioning and design.

Material properties

Unlike pure iron (Fe), steel contains addi-tional alloying elements, sometimes up to 2 % carbon (C). Constructional steels have a carbon content of approximately 0.2 % as well as further alloying elements, such as

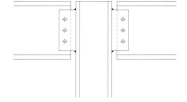

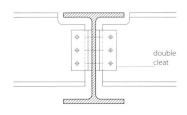

double cleat

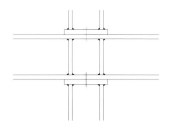

5

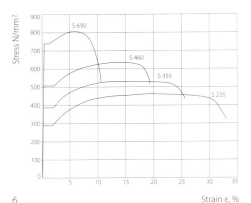

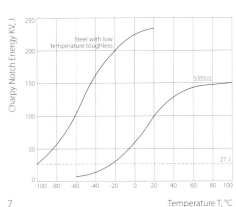

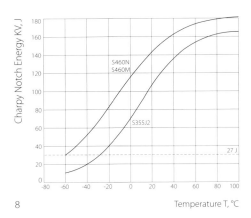

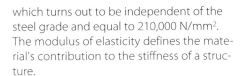

6 Strain ε, % 7 Temperature T, °C 8 Temperature T, °C

manganese (Mn). Constructional steels are mainly characterised by their strength. However, there are further material properties that give an indication of their suitability for use in structural engineering applications. The first of these is strength, but elasticity, ductility, toughness and workability are often essential to satisfy the wide range of safety, stiffness and manufacturing requirements.

In this respect, constructional steel compares exceptionally well with other building materials. This combination of desirable properties is the reason for its enormous significance in structural engineering, as evidenced today when almost every building incorporates steel products or components to a greater or lesser extent.

These properties are determined from various standard tests on small specimens of the material. Strength, elasticity, and ductility are measured using a uniaxial tension test, whereas toughness is measured using the Charpy impact test, and workability estimated from chemical analyses.

Elasticity

If a steel specimen is subjected to a tensile load, it extends elastically until the elastic limit is reached and during this time stress increases directly in proportion to strain, in accordance with Hooke's Law.

This can be seen in the stress-strain diagram (fig. 6). The applied force is divided by the original cross-sectional area A_0 to give the stress σ, and elongation $\Delta\ell$ of the specimen is divided by the original length ℓ_0 to give the strain ε as in the equations below:

$$\sigma = F/A_0 \text{ and } \varepsilon = \Delta\ell/\ell_0$$

The ratio of stress and strain is called the modulus of elasticity (or Young's Modulus):

$$E = \Delta\sigma/\Delta\varepsilon$$

which turns out to be independent of the steel grade and equal to 210,000 N/mm². The modulus of elasticity defines the material's contribution to the stiffness of a structure.

Strength

Beyond the elastic limit there is initially no further increase in load, the steel starts yielding – it has reached the so-called yield point f_y and the plastic domain starts.

At the yield point stress f_y constructional steel extends by a further 1 to 2 %. Then the material hardens and the load increases until the ultimate tensile strength f_u is reached. Finally, the specimen necks and the load and therefore the calculated stress F/A_0 decreases until rupture occurs. The most important feature on the stress-strain diagram is the yield point f_y. In Europe this is used to identify the steel grade in accordance with EN 10025, e.g.

S235: f_y = 235 N/mm²
S355: f_y = 355 N/mm²
S460: f_y = 460 N/mm²

The above values are the minimum for a plate thickness ≤ 16 mm. The yield point is also the limiting value for strength in static structural design calculations, i.e. static analyses for members do not consider hardening and tensile strength but are based on the stress at the yield point f_y (which is nevertheless assumed to be unlimited) (fig. 6.).
The position of the yield point on the diagram affects the contribution of the material to the loadbearing capacity of the member and its slenderness.

Ductility

Ductility is the capacity of a material to deform permanently in response to stress on the level of the yield stress. In principle it gives an indication of:

- The capacity to support or absorb mechanical energy (this is important for earthquake or impact loads)
- Whether and to what extent plastic dimensioning methods are allowed
- Whether the material is able to minimise peak stresses without embrittlement.

Constructional steel meets these requirements by ductility values of often about 20 %.

Toughness

Toughness extends the term ductility to consider the material's response to sudden loads, under low temperatures, and with notches in the member.

The Charpy V-notch test is used to measure toughness; a pendulum test hammer swings down from a standard height to strike a notched test specimen at a specified (low) test temperature (figs. 8 and 9). The test specimen ruptures and the maximum height the hammer reaches after impact is compared to the original height to calculate the energy A_V the test specimen has absorbed, i.e. dissipated.

The dissipated energy A_V (in joules) depends on the test temperature T_{AV}. Recording the energies A_V at different test temperatures produces an A_V-T curve. This has a lower zone (brittle reaction) at lower temperatures and an upper zone (tough reaction) at higher temperatures. Depending on the toughness grade, the A_V-T curve exhibits a shift along the temperature axis. As a general rule, the test temperature at which the steel specimen achieves A_V = 27 J is used to specify its toughness.

The different strength grades of constructional steels are sub-classified into the toughness grades J2, J0, and JR) resulting e.g. for a steel of quality S355 in accordance with EN 10025 in the following classification

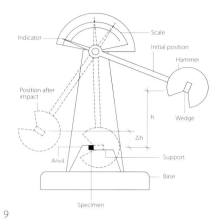

9

6 Stress-strain curves of different grade steels in a
uniaxial tension test
7–8 Charpy V-notch curves, examples of
A$_V$-T curves
9 Charpy impact test machine
10 Plastic moment resistance compared to elastic
design bending resistance for different cross sec-
tion geometries

of its toughness properties:
S355 J2 (bridge construction),
S355 J0 (building construction), or
S355 JR (general metal construction

In steel construction, toughness is an impor-
tant factor in the choice of steel grade, since
toughness is used to control susceptibility
to brittle fracture, in particular in structures
that are subject to fatigue loads, low ambi-
ent temperatures or have very thick plates,
flanges etc.

Workability

The term workability is normally used to de-
fine how well disposed a steel is to cutting,
machining, forming and welding.

Cutting, machining, and cold forming are
generally not a problem for the entire range
of constructional steels. Therefore in steel
construction workability first and foremost
means weldability. This is controlled by the
proportions of individual alloying elements
and expressed by the carbon equivalent
value, CEV where

CEV = C + Mn/6 + (Cr + Mo +V)/5 +
(Ni + Cu)/15 [%]

Steels with carbon equivalent values of
a CEV of between 0.4 and 0.5 are consid-
ered to be conditionally weldable or non-
weldable, therefore modern constructional
steels have to achieve high strengths with
only small amounts of alloying elements,
as higher proportions of carbon and man-
ganese (Mn) (used to increase strength)
severely reduce weldability (risk of hot
cracking). In fact the characteristics of
strength and ductility of modern con-
structional steels are achieved by metal-
lurgical and rolling processes, such as
grain refining, normalising, thermome-
chanical rolling, micro-alloying, and the
purity degree which also lead to improved
toughness.

Elastic and plastic behaviour of steel structures

The external loads applied to a structure
are transferred through moments M, shear
forces V and normal forces (axial forces) N
to the foundations (p. 46). Bending mo-
ments and axial forces lead to bending and
direct stresses σ, i.e. stresses acting at right
angles ("normally") to the cross section,
while shear forces and torsional moments
create shear stresses τ acting parallel to the
cross section.

Moments, shear, and normal forces can be
regarded as internal or sectional forces. They
are determined by theoretically cutting the
structure at a suitable point, applying the
internal moments, shear and normal forces
here as unknowns and calculating them
from the external loads on the basis of the
conditions of equilibrium, i.e. the sum of all
forces and sum of all moments equal zero.
In principle you will only succeed this way if
the structure is statically determinate, i.e. it
is made in such a way that it is possible to

determine the internal and external forces
using only the conditions of equilibrium of
the undeformed structure.

In contrast, a structure is statically indetermi-
nate if the internal forces or external support
reactions cannot be calculated using barely
the conditions of equilibrium. Such struc-
tures have more blocked degrees of free-
dom than statical equations of equilibrium.
In such cases, the extra internal forces or
external forces can be determined only by
theoretically cutting the structure, applying
the surplus internal forces or member forces
as unknowns, and deriving them from equa-
tions of deformation compatibility at the cut
lines (based on the fact that in reality the cut
edges are joined).
The technique assumes that the structure
behaves elastically. It not only determines
the distribution of working loads over the
system and the stresses on the cross-section
but also defines the elastic load capacity
of the structure. This is reached when the
stress upon a cross-sectional fibre at one
point in the system achieves the value of

Cross section	Description	Increase of plastic α_{pl} bending resistance compared to elastic bending resistance
	Two-point cross section (latticed girder, sandwich)	1.0
	I-section, rectangular hollow section	1.15 + 1.20
	Round hollow section pipe	1.30
	Rectangular section	1.50
	Round section	1.70
	Triangular section	2.40

10

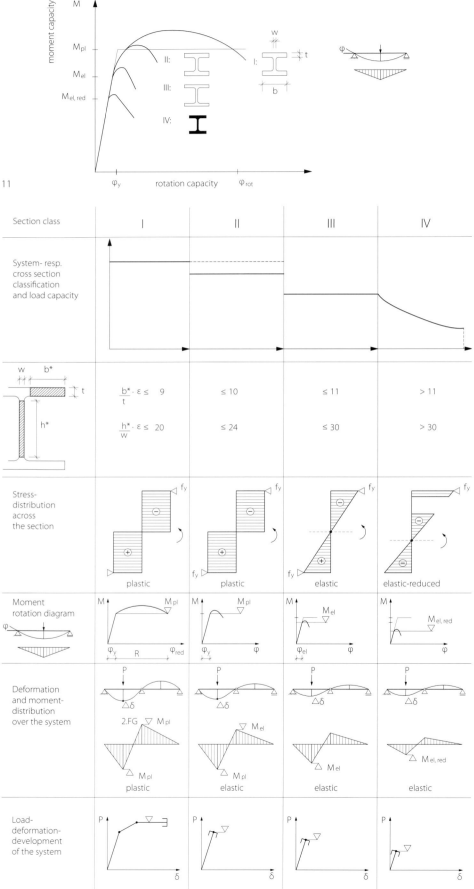

11

Section class	I	II	III	IV
System- resp. cross section classification and load capacity				
Stress-distribution across the section	plastic	plastic	elastic	elastic-reduced
Moment rotation diagram	M_{pl}, φ_y, R, φ_{red}	M_{pl}, φ_y	M_{el}, φ_{el}	$M_{el, red}$
Deformation and moment-distribution over the system	2.FG M_{pl}, M_{pl}, plastic	M_{el}, M_{pl}, elastic	M_{el}, M_{el}, elastic	$M_{el, red}$, $M_{el, red}$, elastic
Load-deformation-development of the system				

$$\frac{b^* \cdot \varepsilon}{t} \leq 9 \qquad \leq 10 \qquad \leq 11 \qquad > 11$$

$$\frac{h^* \cdot \varepsilon}{w} \leq 20 \qquad \leq 24 \qquad \leq 30 \qquad > 30$$

12

11 Classification of cross sections based on the moment and rotation capacities reached in the bending test, and slenderness
12 Cross section classifications and associated aspects illustrated graphically.
13 Bifurcation path for a perfect and an imperfect structure using the example of a column
14 Sketch of European Buckling Curves of imperfect structures for a column subject to buckling due to axial forces
15 Euler buckling cases

the stress at the yield point f_y for the material.

This traditional approach greatly underestimates the actual loadbearing capacities of steel beam and frame systems and often leads to larger cross sections than are really necessary. There are two main reasons for this:

- Plastic cross-section reserves. The pronounced plastic behaviour of the material causes – upon exceeding of the elastic limit or the yield point, on the external fibres of the cross section – the stresses on successively deeper fibres to build up to this yield point as well, thus resulting in a considerable increase in bending resistance. The actual bending resistance of a cross section is only reached upon developing full plasticity over the entire cross section by bending. This is called the "plastic moment" M_{pl}. The plastic moment e.g. of rectangular cross sections is 50 % greater than conventionally calculated elastic moment of resistance. Afterwards resistance cannot be increased further; however, the location might further deform under M_{pl}, i.e. the adjacent cut edges might be subject to further straining. The spot where the plastic moment develops is called a "plastic hinge" which is able to "rotate".
- System reserves in the case of statically indeterminate systems due to rotation in the plastic hinges. A plastic hinge of a statically indeterminate structure redistributes internal moments arising from an increase in external loads by rotation at the hinge into areas of the structure not yet utilised to the maximum. If the structure is appropriately designed, this transfer results in a considerable increase of the usable system resistance.

The effects, however, may only be used with profiles with sufficient plastic deformation capacity whilst maintaining the required plastic moment resistance. This plastic

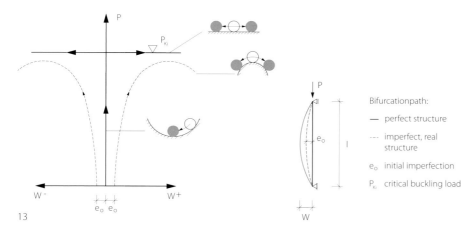

13

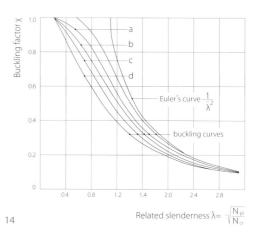

Bifurcationpath:

— perfect structure

--- imperfect, real structure

e_o initial imperfection

P_{Ki} critical buckling load

14

Related slenderness $\bar{\lambda}= \sqrt{\dfrac{N_{pl}}{N_{cr}}}$

deformation capacity is called "rotation capacity". Rotation capacity is limited if buckling occurs during rotation.

Normally, only "compact" cross sections reach sufficient rotation capacity, i.e. cross sections with flanges or webs that are not too slender. Slender sections are not able to rotate when providing resistance at the M_{pl} level because they tend to buckle. Furthermore, extremely slender sections do not even reach M_{pl} because they buckle first. Figure 11 shows the corresponding load-deflection curves determined from static load bending tests. These curves characterise the moment-rotation behaviour of steel sections of different cross-sectional slenderness expressed as b/t or h/w. Depending on their slenderness, sections are classified according to their moment utilisation factor and rotations into the classes I to IV in accordance with EN 1993-1-1, which is one of the series of standards generally known to structural engineers as "The Eurocodes". The plastic behaviour of the cross section classes is summarised in figure 12 and can be described as follows:

I: reach the plastic moment M_{pl} and develop sufficient large rotations on at least this level. These compact sections allow the application of the plastic-hinge method with plastic moment distribution over the system and plastic stress distribution over the cross section.

II: reach the M_{pl} level, too, but do not exhibit enough rotation capacity with the result that plastic stress distribution occurs but not moment redistribution from plastic rotation.

III: owing to their slenderness do not reach the M_{pl} level; their loadbearing capacity is limited to M_{el}, and attempts to obtain further moment capacity will result in buckling of the cross section.

IV: are limited by elastic buckling, which occurs before they reach the M_{el} level.

Stability

In addition to the static proofs of strength, safety against complete failure or excessive deformation of members and joints, it is also necessary to check stability, bearing in mind that loss of stability may occur on several levels.

Global stability

The loss of global stability is the consequence of poor stiffening or stabilisation of buildings or building parts, which may become obvious by for example collapse, development of a chain of hinges, etc. An effective stiffening concept should be defined at an early stage in the design. Stiffening of buildings is designed around the degrees of freedom of a body in space.

System and member stability

Steel is a material capable of carrying high stresses and therefore design can result in some very slender members. If sections are subject to axial compression stresses, they must be checked for stability. Three types of loss of stability have to be considered:
- Flexural buckling (buckling) during which components, such as columns, members in compression, etc. or systems, such as frames, truss rods, etc. suddenly deflect laterally due to compression forces, sometimes combined with bending moments.
- Lateral torsional buckling (LTB) of beams subject to bending with parts of the cross section that are subject to compression tending to deflect laterally and twist.
- Buckling which may lead to lateral bulging of slender sheet panels subject to membrane stress resulting from axial loads or moments of bending.

Stability is verified in accordance with EN 1993-1. Input parameters to these calculations include the loads resulting from the building itself, the bearing conditions (fixed, pinned or free) of the member ends, which

are used to determine the buckling length (fig. 15). If such boundary conditions are not realised in the built structure as assumed in the design (e.g. a sliding bearing installed instead of a fixed support), then this may lead to a considerable overestimation of the actual safety factor against loss of stability.

Local stability

This is primarily local buckling at points where the loads are concentrated or at points where peak stress leads to local buckling of non-compact cross sections (refer to figs. 11 and 12). In most cases this can be avoided by incorporating loadbearing stiffeners or thicker or reinforced plates.

All stability phenomena have one common feature: members which are subject to axial loads or axial stresses lose their resistance before reaching the full material strength. Key to this is the fact that members are never perfectly shaped (i.e. perfectly straight, perfectly symmetrical, etc.), nor is the material perfect (i.e. without internal strains, perfect elastic-plastic behaviour, etc.), but actually imperfect. This leads to a member being "straight" and remaining "straight" only as long as these imperfections do not destabilise the member (fig. 13). All stability failures involve a sudden loss of loadbearing capacity.

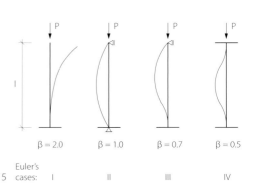

$\beta = 2.0$　$\beta = 1.0$　$\beta = 0.7$　$\beta = 0.5$

Euler's cases:　I　　II　　III　　IV

15

17 Designation of components in a bolt assembly
18 Bearing type joint, slip-resistant pretensioned joint, load-deformation behaviour of the different joint types and failure types of bolt and plate
19 Left: hexagon-head bolt; right: stainless steel bolt.
20 Mechanical properties of bolt steel
21 Characteristics of bolts with allowance (not fitted bolts)

In practice, stability is demonstrated either by:
- Analysis of the entire system where imperfections are explicitly considered in the structural analysis (non-linear calculation according to the second order theory) or by
- Splitting the entire system into notional members and identifying those that are under axial compression forces, and employing subsequent standard calculations related to their slenderness which implicitly consider the effects of possible imperfections (p. 51, fig. 15).

Via the material related slenderness of the column with $\bar{\lambda} = \sqrt{N_{pl}/N_{Ki}}$ where N_{pl} is the squash load and N_{Ki} is Euler's bifurcation load. The allowable load the n can be obtained by applying a factor χ to the squash load N_{pl}. Thus the allowable design load resistance is:

$$N_{Rd} = \chi \cdot N_{pl} \cdot 1/\gamma_M$$

The choice of buckling curve $\chi(\bar{\lambda})$ is dependent on the kind of section.

Joints and connections

Transmission of forces and moments from one member to another requires joints. In steel structures joints are normally composed of several parts. Joints can be classed as disconnectable, fastened by screws, bolts or push-fit connections, or as permanent, such as welded joints, rivets, powder-actuated fasteners, clinched joints and glued joints. Disconnectable joints are normally punctiform connections whereas the internal forces at permanent joints are transmitted linearly (welding) or surface to surface (bonding). Riveted joints are an exception.

Connection technologies are developing continuously. Until the mid-1950s riveting

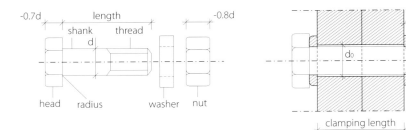

17

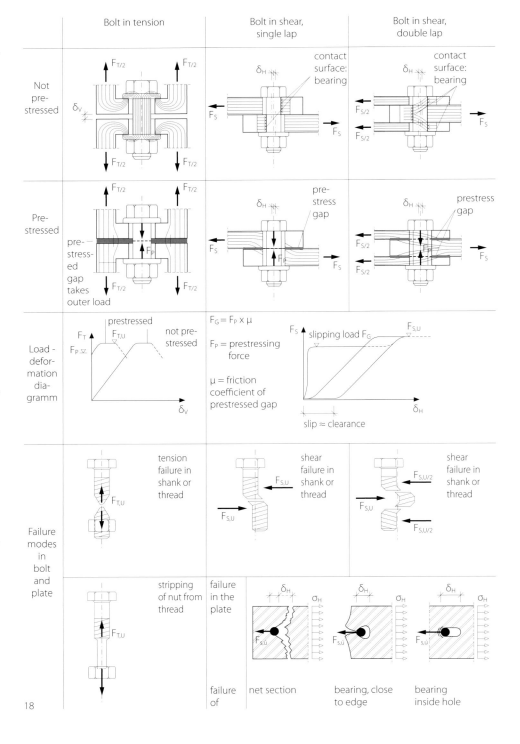

18

19

was virtually the only way of making connections in steel construction, since then welding technology has advanced with the development of suitable construction steels and welding methods as has bolting technology. Today, the most important disconnectable method is bolting and most important permanent connecting method is welding.

In recent years, great progress has been made in the field of bonding technology. This is expected to play a major role in future steel construction.

Bolts and bolted joints

A bolted joint relies on combinations of bolts, washers and nuts (fig. 17). Bolts for constructional steelwork are of different strengths, depending on their intended purpose and factor of utilisation (fig. 20).

Bolts for constructional steelwork are available in different shank diameters (fig. 21) which each require a particular bolt hole size.

Bolts available on the European market may carry loads by shearing action, by axial tension, or simultaneously by shearing action and tension. Bearing bolted connections transfer the forces by the contact of the bolt shank and the bearing area of the plate and by the shear resistance of the bolt shank. In order to accommodate tolerances, the drill holes in building construction are oversized (fig. 17). Fitted bolts may be used in cases where such allowance is undesirable. The bolt heads may have a special markings to show they are fitted bolts.

Bolts of grade 8.8 and 10.9 are called "high-strength". High-strength bolts can be preloaded. This pretensioning of the bolts clamps the plies of the joint together, compressing the contact surfaces. Now, if external loads apply shear or tension forces, the joint will not slip or open. The joint reacts

monolithically. This type of joint is called slip-resistant pretensioned joint. Owing to the type of direct load transmission generated by the pre-tension the joint is considerably stiffer (fig. 18). If the slip load (= load when the joint starts slipping) is exceeded, the joint will behave like a bearing or fitted bolted connection (fig. 18).
Failure may occur in the bolt (shearing or tension failure of the shank or the thread) or in the plate (bearing failure or rupture of the net section) (fig. 18).

The design equations for the plates consider the edge distances e_1, p_1 as well as the hole distances e_2, p_2 for which minimum and maximum values in accordance with EN 1993-1 are to be taken into account (p. 54, fig. 24).
The preloading of high-strength bolts makes sense not only for shear connections (see above) but also for tension connections, as the pre-tension creates compression in the joint that absorbs external tension loading to the point of decompression and, consequently minimises the load in the bolt from the external tension force (fig. 18). This

makes the connections stiffer and more durable, particularly under fatigue loadings.

Bolted joints

The characteristic plastic load deformation behaviour of bearing bolts allows bolts to be designed as groups using simple elastic or plastic load distribution models in lapped joints (i.e. where bolts are loaded in shear and bearing), such as those commonly found in beam splices.

Lapped joints with bolts in bearing
Figure 23 shows a lapped joint where the load can be divided into moment, normal force, and shear force to be further distributed to the individual bolts. Here, the moment component can be distributed elastically or plastically.
An analysis of the distribution of forces in normal force joints with multiple bolts in a row assuming fully elastic behaviour initially produces a non-uniform load distribution (fig. 22). As the outer bolts reach their limit and start to deform plastically (e.g. expanding the hole) the load is redistributed to the internal bolts. Only by the activation of the

20

21

Bolt type	Bolt grade	Yield point $f_{y,b}$ [N/mm²]	Tensile strength $f_{u,b}$ [N/mm²]
Low strength bolts	4.6	240	400
	5.6	300	500
High strength bolts	8.8	640	800
	10.9	900	1000

	M12	M16	M20	M24	M27
Shank diameter d [mm]	12	16	20	24	27
Drill-hole diameter d_0 [mm]	14	18	22	26	30
Shank cross section A [mm²]	113	201	314	452	573
Stressed cross section [mm²]	84	157	245	353	459

22 Reduction of loadbearing capacity in case of
 long bolted joints in shear and bearing due to
 limited ductility of the external bolts
23 Example of the distribution of forces for a lapped
 joint under moment, shear force, and normal
 force
24 Sketch of bolted lap with edge and hole dis-
 tances in parallel and vertical direction to the
 direction of force

25 Classification of joints according to moment
 capacity: non moment resistant, partial moment
 resistant and moment resistant capacity and
 stiffness classes: rigid, semi rigid and hinged.
26 Welding
27 Schematic diagram of gas metal arc welding
28 Schematic detail of gas-shielded metal arc
 welding

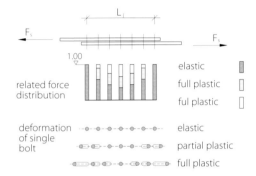

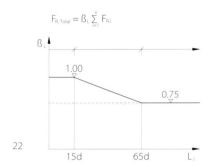

22

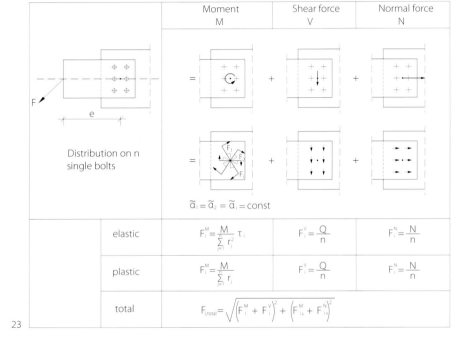

23

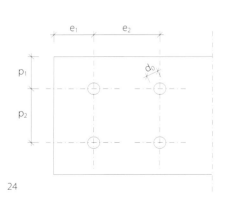

24

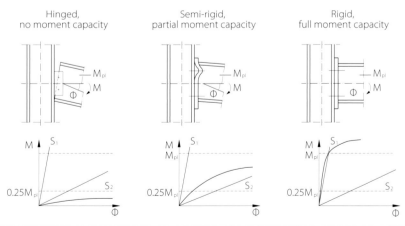

25

26

inner bolts by the deformation of the external bolts can the total plastic resistance of a lapped joint be equal the sum of the plastic resistances of its individual bolts.

However, if the total length of the joint exceeds the value of 15 d, the ductility of the outer bolts may not be adequate for full load redistribution to take place, and the total plastic resistance has to be reduced by factor β in accordance with EN 1993-1 (fig. 22).

Joints with end plates
Joints with end plates are frequently used for transfer of moments between beams and columns or between butt-jointed beams (fig. 25) . Here, the forces can also be distributed either elastically or plastically. Depending on the thickness of the bolts, end plates or stiffeners (joint components), the plastic resistance moment of the joint may be greater than, equal to, or less than that of the connected sections. Here, the joints may be considered as full moment, partial moment or non-moment (nominally pinned) beam-to-column connections. The structural design of the connected members also affects the stiffness of the joints. Joints may be rigid, semi-rigid, or articulated. Figure 25 shows the levels of load-bearing

capacity as well as the options of stiffness in the moment-rotation diagrams of the three joint types.
The realistic approach of the moment-rotation reaction of beam-to-column connections allows the use of deformable partly load-bearing connection types which results not only in substantially cheaper joints without stiffeners, but also in a far more balanced distribution of moments over the entire structure, i.e. makes optimum use of the connected beams and columns.

Welded joints

In steel construction, apart from bolting the most important permanent connecting method is welding. Welding melts and fuses together the members at the points being joined. In steel construction, this is usually done by striking an electric arc between the points being joined and a welding electrode. The weldability of steel depends on its workability (p. 49) and on its content of various alloying elements. Weldability is most often assessed by its carbon equivalent value (CEV) .
Due to the low carbon equivalent of thermomechanical steels, welding of these steels with greater thicknesses up to

125 mm is even possible without any preheating in ambient temperatures > 0 °C. Where the weld is large, it is composed of several weld beads starting with the root run.

In order to protect the molten weld pool from detrimental agents in the air, modern welding processes use shielding gases or shields.

The most important arc welding processes in steel construction are:
- Manual arc welding with a coated welding electrode for minor welding jobs
- Gas metal arc welding (GMAW/MAG/MIG) where the electrode is an automatically fed filler wire. The wire is fed through a welding gun together with a shielding gas that is composed of either a mixture of CO_2 and inert noble gases (active gas for MAG – Metal Active Gas) or exclusively of inert gases (inert gas for MIG – Metal Inert Gas). The gas metal arc welding processes are all-purpose welding techniques used most frequently in steel construction.
- Submerged arc welding (SAW) – a semi-automated process that is important for bridge construction. SAW uses a welding machine that runs along the weld seam to fuse it whilst feeding a shielding powder.
- Tungsten inert-gas welding (TIG) is often

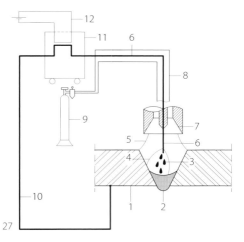

27

1 Base material
2 Weld material
3 Drop transfer into weld pool
4 Arc
5 Shielding gas atmosphere
6 Electrode (metal wire)
7 Nozzle
8 Gas tube
9 Gas bottle
10 Electrical circuit
11 Welding machine with transformer
12 Power supply

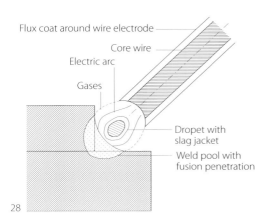

28

29

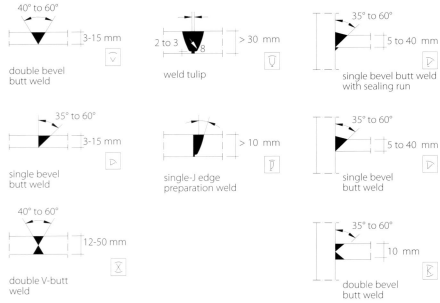

Joint	Full penetration weld	Partial penetration weld	fillet weld
Butt joint			
T-joint			
Overlap			

30

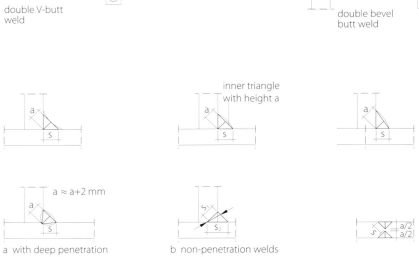

40° to 60°

3-15 mm

double bevel
butt weld

2 to 3 · 8 > 30 mm

weld tulip

35° to 60°

5 to 40 mm

single bevel butt weld
with sealing run

35° to 60°

3-15 mm

single bevel
butt weld

> 10 mm

single-J edge
preparation weld

35° to 60°

5 to 40 mm

single bevel
butt weld

40° to 60°

12-50 mm

double V-butt
weld

35° to 60°

10 mm

double bevel
butt weld

31

a x s

inner triangle
with height a

a s

a s

a ≈ a+2 mm

a s

s_1 s_2

s a/2
a/2

32 a with deep penetration b non-penetration welds

29 Transfer of forces of a double fillet weld and
 weld cross section a · ℓ
30 Various weld seam types
31 Examples of full penetration welds and their
 symbols
32 Definition of the throat thickness a (weld seam
 dimension) for fillet welds and welds with partial
 penetration weldss
33 Schematic diagram of the temperature profile
 during welding: the structure may be impaired
 in the heat affected zone
34 Typical composite flooring system
35 Action of shear studs: A: no bond, B: partial bond
 (seldom), C: continuous bond: optimum combi-
 nation – concrete in compression and steel in
 tension
36 Steel-reinforced concrete combinations

used for the crucial first weld run (root run)
in a multibead weld. TIG-welding uses a
specific Tungsten electrode which does
not melt itself. The weld seam additive
here is fed manually. The shielding gas is
the same as for MIG-welding – a mixture
of inert gases.

The important factor when manufacturing
weld seams is controlling the altered struc-
tures at the transition point between weld
seam and base material so as to ensure the
strength and toughness at such points are
not degraded.
For full penetration welds (fig. 30) that are
checked by nondestructive testing (NDT)
and for welded joints in steel grades S235
to S460, it is important that the strength of
the welded joint is at least that of the con-
nected plates. If this is the case, then no spe-
cial design checks need to be made on the
weld, apart from fatigue.

The design of fillet welds and other weld
seams that are not full penetration welds
is based on an effective throat thickness or
a weld seam dimension a which is the
height of the triangle formed from the
weld seam shape (fig. 32). The calculated
weld seam strength (i.e. the load transfer

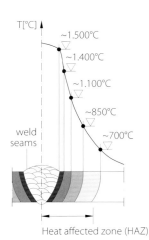

T[°C]

~1.500°C
~1.400°C
~1.100°C
~850°C
~700°C

weld
seams

33 Heat affected zone (HAZ)

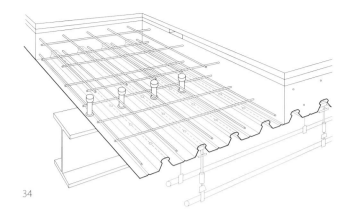

34

capacity of a weld seam) refers to the cross section resulting from the weld seam dimension a and the length of weld seam ℓ (fig. 29).

Composite structures

Composite construction combines the advantages of concrete and steel. The areas of a cross section that are subject to compressive stresses are designed in concrete, and the areas subject to tensile stresses are designed in steel. So, the concrete works with the steel to carry the bending moment of the beams and the normal forces of the columns (fig. 35).

Activation of the composite action requires sufficient transfer of shear force between the steel members (welded section or rolled section) and the concrete. Without composite action, the structural resistance would be purely additive i.e. the loadbearing capacity of the system is only determined by a simple addition of the loadbearing capacities of the individual section parts. In contrast, composite action results in a new, larger member cross section with highly increased loadbearing capacity and stiffness.

This composite shear transfer between the steel member and the concrete for composite beams is most often provided by headed stud shear connectors welded onto the steel member, but it can also be achieved by other means (e.g. cutouts in welded steel strips).

For composite floor slabs, the bond between the concrete topping and the steel sheets is the product of appropriate profiling of the sheets, web embedment or simple friction. Anchoring at the end of the sheets by means of studs further increases the composite action and hence the load capacity.

In the event of fire, composite cross sections are advantageous, since the attached concrete cools down even exposed steel sections, reducing the increase in temperature and delaying or preventing loss of strength in the steel (p. 62ff.).
The designer calculates the horizontal shear force between the concrete and the steel to arrive at a suitable number and arrangement of shear studs to be welded onto the top of the top flange. The distribution of this force, e.g. along a single-span beam, usually results in a greater requirement for shear

studs at the ends of a beam. However, for ease of manufacturing, designers strive to achieve an even spacing of studs along the whole length. "blurring" is allowed if the shear connectors are sufficiently ductile (i.e. the stud shear connectors have a height-diameter ratio greater than or equal to 4), which gives an even distribution of shear force over the entire length of the beam. Furthermore, partial composite action with a reduced number of studs is also allowed, but requires an appropriate level of ductility. In contrast to full composite action, where the shear connectors transmit all shearing forces, partial composite results into a relative slip displacement between steel and concrete and a reduced moment capacity (fig. 35).

Composite concrete-steel slabs are extremely common and result in integrated, wide-span floor structures of low construction depth, light weight, and excellent durability.

Composite concrete-steel sections allow a span lengths of 10 to 15m or even more. Hence, composite beams are economically advantageous, provide extremely stiff floors and allow open, column-free layouts.

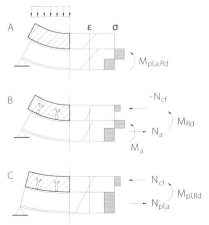

35

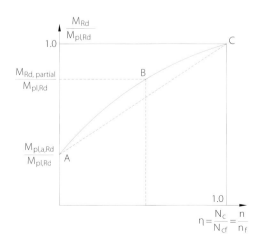

$$\eta = \frac{N_c}{N_{cf}} = \frac{n}{n_f}$$

36

37 Single-span beam under static deflection as a
 result of F (top); after sudden removal of F vibrat-
 ing (middle); single-mass vibrator as equivalent
 system with the same vibration behaviour in the
 1st eigenmode (bottom)
38 Single-mass vibrator with damper: fading of
 vibration amplitudes
39 Single-span beam under forced vibrations (here:
 rotating unbalance), fig.ure in equivalent system
 of single-mass vibrator (left bottom), time course
 of unbalance and eigenfrequency behaviour of
 beam (top right), result of forced vibrations at
 beam: resonance (bottom right)
40 Example of footfall force for two step frequencies
 shown relative to time

Vibrations

If dynamic loads such as vibrating or
impulse loads act upon buildings, they may
cause time-dependent deformations which
are perceived as vibrations or shocks. The
vibrational behaviour of a building or com-
ponent depends on the size and distribu-
tion of inertial masses, the inherent ability of
the basic material to damp the vibrations
and its elastic stiffness. In the case of vibra-
tions, additional forces generated by the
acceleration and deceleration of masses
occur. If vibrations are induced in a building
or component, these vibrations may take up
a variety of forms (modes), which can be
characterised in terms of deformation type
and frequency (fig. 37). These deformation
forms with the associated frequencies are
characteristic properties of the individual
structure. This is why they are also desig-
nated "eigenmodes" or "eigenfrequencies".
In general, the examination of the eigen-
mode with the simplest deformation type
and the lowest eigenfrequency is sufficient.
It is then possible to transfer the multimodal
vibration behaviour of complex compo-
nents and buildings to a simple mass-spring
model in which the spring has the same
elastic stiffness as the component (i.e. the
compression strain of the spring is equal
to the bending deflection of the modelled
beam at midspan) and the lumped mass
acting upon the spring features a mass
which is not the same but comparable to
that of the beam. Thus, the most important
factor for the assessment of vibration behav-
iour, i.e. the eigenfrequency, can be easily
determined (fig. 37).
In reality, vibrations are damped by the char-
acteristics of the building material e.g. fric-
tion, which is why the amplitude of the
vibration fades away fairly quickly (fig. 38).

Structures vibrate "freely" if they are loaded
or relieved (stimulated) abruptly only at the
start; afterwards they fade away "freely"

37

38

39

40

$f_1 = EI$ stiffness
$\mu = \dfrac{M_l}{l}$ (distributed mass)

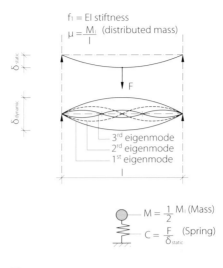

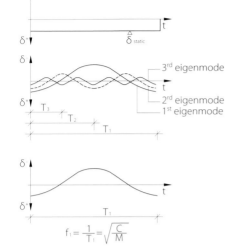

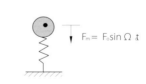

$M = \dfrac{1}{2} M_l$ (Mass)

$C = \dfrac{F}{\delta_{static}}$ (Spring)

$f_1 = \dfrac{1}{T_1} = \sqrt{\dfrac{C}{M}}$

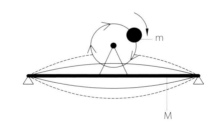

Mass
Spring
Damper

$\Delta = \ln\left(1 - \dfrac{A_{i+1}}{A_i}\right) \cdot 100 =$ Damping value

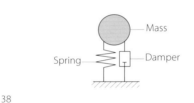

m
M

$F_m = F_0 \sin \Omega \cdot t$

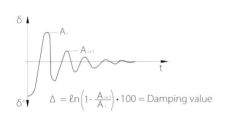

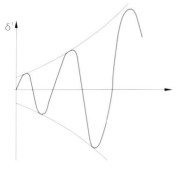

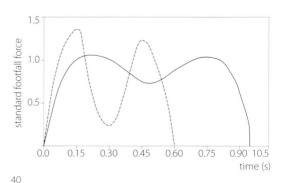

Pace frequency: f_s

——— $f_s = 1.5$ Hz
- - - - - $f_s = 2.2$ Hz

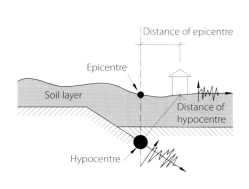

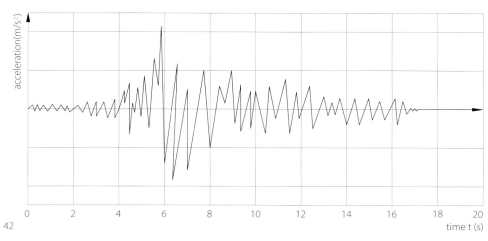

41

42

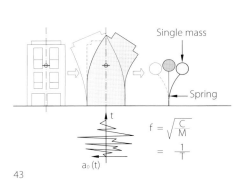

43

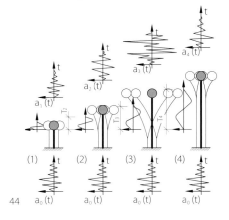

44

(fig. 38). If, however, they are further loaded dynamically during the vibration phase, what are termed "forced" vibrations occur. If the eigenfrequency of the structure corresponds to the frequency of the forced vibrations, then the latter may build up easily. In this case, the system accumulates more and more dynamic energy, the vibration amplitudes increase continuously, and a "resonance catastrophe" occurs (fig. 39).

This excitation (resonance) is encountered in real buildings, e.g. gusts acting upon towers or skyscrapers or rhythmic stimulation of vibrations of bridges and floors by dancing, jumping, marching or even walking.

Prevention of vibrations of floors induced by persons

In addition to the limitation of deflections, insensitivity to vibrations is the main feature of the fitness for use of floors. Both phenomena are related to one another, as they are interconnected mechanically by stiffness. Dynamic stimulation is mainly caused by human walking or jumping, individually or in groups (fig. 40).

The resonance effect may occur in floors or beam structures and be felt as an uncomfortable vibration of the floor. This vibration of the floor should be reduced either by:

• Ensuring that the eigenfrequency of the floor is not less than the minimum recommended for its intended function
or by
• More precise analyses which take into account other factors such as cross section layout, acceleration of vibrations, human perception and assessment of vibrations, etc.

Steel buildings under seismic load

Earthquakes occur if the plates of the Earth's mantle move in such a way that stress relief and displacements take place at their interfaces. The displacements occur suddenly so that the energy released during this process causes heavy shocks (= earthquakes), which may even trigger catastrophes. The strength of the earthquake is measured by recording the amplitudes of horizontal motions in the earth's crust around the epicentre (fig. 41). The magnitude of an earthquake is often expressed using the Richter scale, in which the energy of an earthquake at its hypocentre is expressed as a logarithmic value. An increase of one unit on the scale means a ten-fold higher amplitude in the seismogram and a 32-fold greater release of energy. An earthquake is perceptible from a value of 3.0 on the Richter scale. The first serious damages occurs from 5.0, which is

regarded as a moderate earthquake. A magnitude 6.0 earthquake is described as strong and could have dangerous effects on buildings. Seismic measurements during an earthquake provide information on its length, maximum accelerations and the inherent frequencies at which the impulses occur (fig. 42). In order to determine the effects of such acceleration patterns on buildings, they are first considered as elastic systems with masses that are stimulated to vibrate (fig. 44). The horizontal accelerations initially affect the base of a building. This inevitably initiates motions which may vary considerably, depending on the mass and stiffness distribution. In order to illustrate this, a building can be reduced to a very simple mechanic structure consisting of only one single mass, which reflects the total mass of the building, and a (compound) spring, which represents the horizontal stiffness of the building (fig. 43). This reduced structure is called "single-mass vibrator" and shows a vibration behaviour which is approximately comparable to that of the building which is mainly marked by the 1st eigenfrequency f_e of the building.

If the single-mass vibrator has a high stiffness and low mass, its eigenfrequency is high and it behaves like a rigid body during earthquakes, i.e. it is not stimulated and the

41 Position and distance of the epicentre and hypocentre relative to the building
42 Time graph of acceleration of an earthquake in
43 Reduction of vibration behaviour of actual buildings to the "single-mass vibrator" with natural mass and single spring
44 Single-mass vibrator with varying natural vibration times T_i and the system response (schematic) with equal bottom stimulation $a_0(t)$

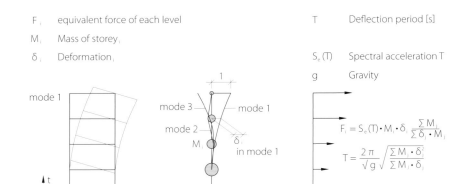

F$_i$ equivalent force of each level

M$_i$ Mass of storey$_i$

δ$_i$ Deformation$_i$

T Deflection period [s]

S$_e$(T) Spectral acceleration T

g Gravity

$$F_i = S_e(T) \cdot M_i \cdot \delta_i \frac{\sum M_i}{\sum \delta_i \cdot M_i}$$

$$T = \frac{2\pi}{\sqrt{g}} \sqrt{\frac{\sum M_i \cdot \delta_i^2}{\sum M_i \cdot \delta_i}}$$

45

46

accelerations of the top mass are equal to the base stimulation, case (1) in figure 44.

But if the single-mass vibrator has a lower stiffness and higher mass which result in eigenfrequencies that correspond to those of earthquakes, the structure may be subject to a build-up of vibrations (resonance effect) which may induce great accelerations and forces at the top mass, case (2) and in particular case (3) in figure 44.

If the eigenfrequency is clearly below the frequencies of the earthquake stimulating the base, the structure is "vibration isolated", i.e. the inert top mass remains relatively still and the motions are absorbed by the resilient substructure, case (4) in figure 44. The resulting top acceleration (or its variation over time) is designated "system response". These system responses can be allocated to response spectrums depending on their natural vibration frequencies and different soil conditions (fig. 48).

The response spectrum reveals the frequency ranges in which such a resonance-type increase of the floor acceleration may occur. Other buildings, however, may remain almost unaffected. The reaction of buildings to the exciting frequencies of an

earthquake is largely dependent upon the subsoil (fig. 48) between the hypocentre (fig. 41), at deep in the rock and the surface at the site of the building. Depending on the characteristics of the different layers, some frequencies are reinforced, others are suppressed.

Using more refined analyses, it is possible to determine the forces that act upon each mass of a building (mainly floors) during earthquakes (fig. 46).

If the forces acting on a building during an earthquake can be determined, the building can be designed to accommodate them. In doing so, the following principles must be observed:

· Connect structural elements one to another; i.e. form statically indeterminate structural systems, so that the entire building vibrates and no individual parts can fall down (floor slabs) or overturn (walls) in an earthquake.

· Select stronger column cross sections for multistorey buildings under seismic load (compared to purely static loads) in order to prevent the building from undergoing horizontal deformations generated by the seismic excitation, which could cause stability failure of the columns.

· Design components in a way that they dissipate as much energy as possible

during cyclical moment load (generated by earthquakes), i.e. activate plastic features of the construction (p. 50).

The special characteristics of steel are useful here, in particular for dissipating energy in the last measure listed above. Forming plastic hinges with large rotation angles mobilises the plastic resistance of the component (especially for bending moments) and dissipates the energy from the earthquake. The forces acting upon the building are thus

45 Earthquake resistant beam connection – with dogbone – cut-out
46 Equivalent static load for assessing the dynamic effects resulting from earthquakes (fully elastic)
47 Structural design of connections under cyclic moment load
 a Plastic hinges form where the section is reduced
 b "Dog-bone" sections in the flanges to define nominal zones of energy dissipation
48 Response spectrums of a single-mass vibrator for different soil conditions as in EN 1998 (Eurocode 8)
49 Time graph showing formation of pressure/ suction close to an explosion/detonation
50 Favourable and unfavourable design of ground plan and elevation
51 Force generated when the explosion blast wave strikes a rigid wall (a) and a resilient surface (b)
52 Design of robust, statically indeterminate structural systems which retain their loadbearing capacity even if a column fails
53 Design of plastic zones which absorb explosion energy (belt effect).

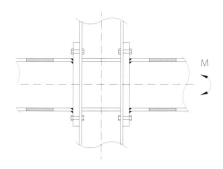

47a

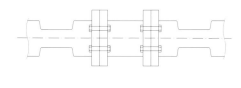

47b

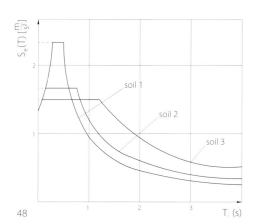

48

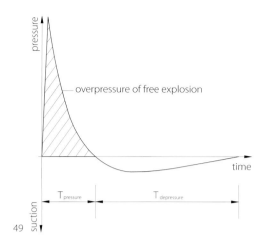

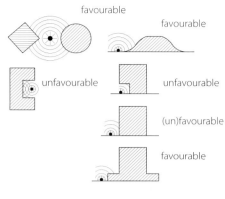

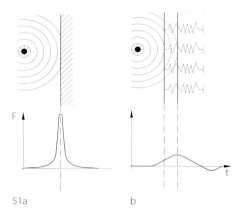

49

50

51a b

reduced and it is protected against collapse. This energy dissipation can be compared to the crumple zone in car manufacture: but here the occupants are protected against excessive forces in an earthquake-crash by the energy-dissipating components.
It is clear that energy dissipation is extremely important during earthquakes. The high ductility of steel makes it the ideal material for creating earthquake-proof buildings (p. 48).

Figures 45 and 47 shows typical details which can be used to promote energy-dissipating behaviour in buildings.

Blast effects on buildings

In addition to earthquake and fire loadings, a further exceptional load case, "explosion", has received much more attention in the design of public buildings in recent years. Thanks to the characteristics of the material and the presence of alternative load paths, buildings made of steel resist explosions very well.

In the event of an explosion, the building has to resist both detonation and explosion loads. Detonation is the immediate effect of firing an explosive; a sudden, extremely rapid chemical reaction of high explosive

with the powerful evolution of gas or explosive mixtures of gas or fumes. An explosion is accompanied by a loud bang and the bursting or shattering of nearby objects.

Detonation and explosion result in the subsequent formation of a shock wave with compression and suction components travelling at supersonic speeds. In particular, the compression phase of the wave can apply very high short-term pressures to a component which are many times the design wind load pressure, for example (fig. 49).

The processes acting upon a component and the forces developed from them are relatively complex. The type of wave and the compressibility of the air are important in this respect. Due to the wave-type character, reflection, refraction or superposition of blast waves may occur, which reduces or increases the effective pressure load depending on the geometry of the affected object (fig. 50).

Due to the compressibility of air, the compressed volume of the blast wave can be considered a "compressed spring", which applies its full force when it encounters strong resistance, but looses a large amount of its force when it hits a flexible, elastic object (figs. 50 and 51).

Furthermore, the size of the affected object and its distance from the source of explosion play an important role.
Buildings can be designed and dimensioned to offer protection against explosions by taking and combining measures on a number of different levels:

* By organisational and structural measures to prevent delivery and/or storage of explosives
* By designing "relief valves" so that blast waves do not have any impact. For example: a double-skin facade, the outer skin of which fails at pre-defined points when struck by a blast wave, can protect the building by allowing the compression wave to dissipate its energy in the facade cavity.
* By designing robust buildings that are prevented from extensive collapse when a component fails by the activation of background systems or alternative load paths. In this context, beam systems should designed to be able, with the acceptance of reduced safety factors and large deformations, to compensate for the failure of a column caused by an explosion and prevent progressive collapse of the building (fig. 52). Often, horizontal members are designed as ring beams around the building which

52

53

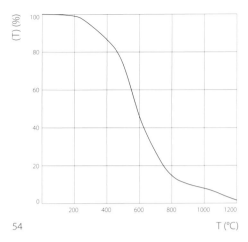

54

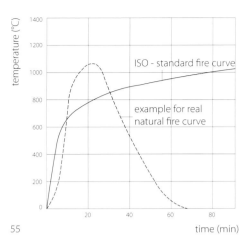

55

absorb the internal pressure of the explosion.
- By reinforcing components, e.g. complementing steel columns with concrete to create composite steel columns
- By modifying the elasticity of components so that blast wave peaks are absorbed effectively, e.g. by designing elastically supported curtain wall facades
- By arranging energy-dissipating components, connections and joints with sufficient ductility to reduce the explosion energy and avoid stress peaks; steel is particularly good at this (similar to earthquakes) (fig. 53).

The design and construction of explosion-proof buildings should ensure the stability of the building not only during an explosion but also afterwards, albeit with reduced safety factors, when it may be considerably changed or deformed.
The design of buildings to resist explosions is still a relatively "young" field in structural engineering.
Various bodies and organisations have already defined standards for civil and military buildings but they vary considerably with respect to definitions, methods, measures, objectives, etc. Useful information can be found in EN 1991-1-7, which offers a consistent set of recommendations for the size and type of different explosion loads.

Fire protection in steel construction

In a fire, steel does not burn, nor does it give off toxic gases. Therefore, it does not contribute to the development of a fire or represent a fire load. However, the yield point and strength of steel diminishes with rising temperature. At 500 °C the strength of steel is about two thirds of the strength it has at room temperature; at about 800 °C it is barely 15 % (fig. 54). This temperature-dependent loss of strength varies for differ-

ent steel types and grades. Austenitic stainless steels exhibit better strength retention than carbon steels above about 550 °C and better stiffness retention at all temperatures. Nonetheless, the main objective is not to prevent high temperatures in steel components but to ensure the building as a whole remains stable in a fire. By designing a suitably redundant structural framework and taking protective measures, this objective can be achieved quite successfully.

Fire protection measures adopted in Europe include:
- Structural and constructional fire protection, which aims at providing safe escape routes and preventing the spread of fire by incorporating fire compartments (fireproof bulkheads, fire-resistant walls, minimum dimensions to avoid flashovers) and by selecting non-combustible or hardly inflammable materials (fig. 56). The stability of a building in a fire must be preserved for a specific period of time, which is defined according to the type of building and component to be protected (fig. 57).
- Plant-engineering fire protection, the objective of which is to draw attention to the fire early by means of technical equipment (fire alarm boxes). Other technical devices (e.g. sprinkler systems) intervene in the fire early and prevent the spread of the fire (also included in fire-fig.hting).
- Fire-fig.hting, which covers direct measures for extinguishing or preventing the spread of a fire.
- Organisational and corporate fire protection, which aims at reducing the risk of a fire by preventative measures (e.g. organisation and supervision of a fire safety plan) as well as information and training of the users in order to ensure rapid escape and early fire-fig.hting.

A successful fire protection concept always includes a complete package of all types of fire precautions.

One of the most important aims of structural fire protection measures is to prevent or retard the critical temperature rise of the component. Materials are assigned fire resistance classes (fig. 57) based on how long they maintain substantial mechanical load capacity while undergoing a standard ISO temperature rise (fig. 55). The requirements vary with the type, height, floor space of the building, etc., as well as the function and position of the component. Due to their high thermal conductivity and reduction in strength at high temperatures, exposed loadbearing steel components are protected by oversizing or "hot dimensioning", cladding with fire boards or simple plasterboards, spray-on cement or vermiculite-based coatings, intumescent paints, concrete filling or composite construction (fig. 58). These insulating, shielding, or heat-dissipating precautions work passively.

Passive fire precautions can be avoided or reduced by:
- Justifying a reduction of the fire resistance class, e.g. for buildings with fewer storeys, selected areas where damage does not have any consequences, rapid reaction fire-fighting, etc.
- Installing active fire precautions such as fire extinguishing equipment (e.g. sprinklers).
- Arriving at a realistic calculation of the time-related effects on and resistance of the structure during a fire. This can be derived from structural design calculations in which the temperature rise of the (protected or unprotected) steel components is determined numerically based on a natural fire curve (fig. 55). Afterwards, the point of time is calculated at which the structure becomes unstable due to the increasing reduction in strength of the steel sections. The same resistance periods as in the traditional classification of passive fire precautions are required. Often, the evidence by calculation according to, for example, EN 1991-1-2 and EN 1993-1-2

54 Reduction in yield stress of constructional steel with rising temperature (schematic).
55 ISO standard temperature curve and example of natural fire curve
56 Classification of materials by combustibility and inflammability
57 Fire resistance classes and designation, where:
 R = Loadbearing capacity
 E = Integrity
 I = Insulation
 M = Mechanical action
58 Passive fire precautions in steel construction; effects of fire protection as a function of type and component as well as Hp/A value (circumference/cross-section area)

Official designation	Material class acc. to DIN 4102-1		Class acc. to EN 13501-1	
Non-combustible	A1	(without combustible components, e.g. steel, concrete)	A1	
	A2	(non-combustible components, e.g. gypsum plaster boards)	A2	-s1d0
Hardly inflammable	B1	(e.g. oak parquet on cement floor)	B, C	-s1d0
			B, C	-s3d0
			B, C	-s1d2
			B, C	-s3d2
Normally inflammable	B2	(e.g. wood and wood materials)	D	-s3d0
			D	-s3d2
			E	-d2
Highly inflammable	B3	(e.g. coconut fibre plate)	F	

56

provides considerable advantages, e.g. by waiving passive fire precautions, as in this method, the actual delays in temperature rise and the actual cross-sections and system reserves are taken into account.

Corrosion protection

Corrosion is an electrochemical process which occurs under the action of a corrosive medium and leads finally to erosion of material (fig. 60).
In the case of steel, the visible corrosion product is known as rust, which may cause deterioration of the external appearance and finally loss of loadbearing capacity of a steel member as well as damage to other (adjoining) components. Constructional steel tends to undergo corrosion in a neutral atmosphere from a humidity of about 50 to 60 %. Anticorrosion measures impede these processes or slow them down considerably.

Factors influencing the likelihood corrosion
The decisive factors influencing corrosion in steel buildings are:
- Type of surrounding medium e.g. air or water
- Aggressiveness of medium (humidity, salt and nitrogen oxide content of air and/or salt and chloride content of water),
- Temperature,
- Ventilation conditions,
- Duration of effect,
- Quality of surface, and
- Detailing

Special conditions, such as sediments, condensation water, gaps, etc, increase the exposure to corrosion and reduce the service life of the anticorrosion system. Standard EN ISO 12944-2 describes the various typical atmospheric environmental conditions and categorises them according to the average loss of effective thickness of a coating in relation to time (fig. 62).

Fire resistance class acc. to DIN 4102	Official designation	Fire resistance period under ISO standard fire	Fire resistance class acc. to EN 13501-2 for components		
			with shutter		without shutter
			supporting	not supporting	supporting
F 30 – B	fire-retardant	≥ 30 min.	REI 30	EI 30	R 30
F 30 – A	fire-retardant, made of combustible materials	≥ 30 min.			
F 60 – AB	highly fire-retardant	≥ 60 min.	REI 60	EI 60	R 60
F 60 – A	highly fire-retardant, made of non-combustible materials	≥ 60 min.			
F 90 – AB	fire-proof	≥ 90 min.	REI 90	EI 90	R 90
F 90 – A	fire-proof, made of non-combustible materials	≥ 90 min.			
(F120)	(highly fire-proof)	(≥ 120 min.)			
(F180)	(highly fire-proof)	(≥ 180 min.)			
	fire-resistant walls	–	REI – M 90	EI – M 90	

57

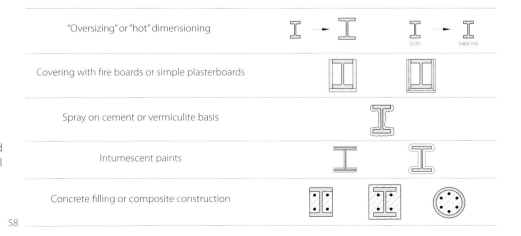

| "Oversizing" or "hot" dimensioning |
| Covering with fire boards or simple plasterboards |
| Spray on cement or vermiculite basis |
| Intumescent paints |
| Concrete filling or composite construction |

58

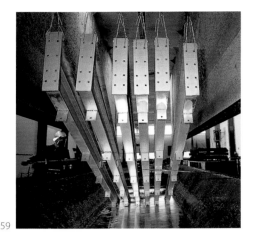

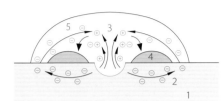

1 Substrate = steel
2 Electrons
3 Positive ions
4 Corrision product
 Fₑ O (rust)
5 Medium

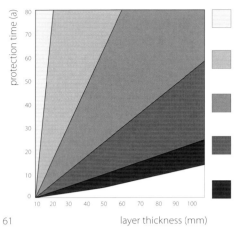

59

60

61

Anticorrosion measures

Optimum corrosion prevention is achieved by a combination of "active" and "passive" measures.
Active measures:
- Details designed to promote corrosion protection: allowing water to drain away, and avoiding condensation water, sediment build-up, gaps, and eliminating contact of constructional steel with more noble metals
- Intelligent choice of materials, e.g. stainless steel, weathering steel
- Reduction of exposure to corrosion

Passive measures
- Application of coatings and protective layers which achieve their anti-corrosive effect mainly by keeping corrosive media away from the constructional steel (depending on the system)
- Application of metallic coatings, such as hot-dip galvanising, which intervene directly or indirectly in the corrosion reactions
- Combination of both methods

All procedures require appropriate surface preparation. In steel construction, the following anticorrosion measures are taken, often in the factory:
- Organic coating systems of liquid or powder materials such as coil coating, powder coating, spray-applied paints, and brush-applied paints,
- Metal coating by hot-dip galvanising, melt drawing, or gun spraying,
- Combinations of metallic and organic coatings, so-called duplex systems.

Galvanising
Hot-dip galvanising (batch galvanisation) is a highly effective and economic factory-applied corrosion protection system. When the component is dipped in molten zinc (approx. 450 °C) a rigid and non-detachable layer is formed at the steel surface as a con-

sequence of the iron-zinc reaction (iron-alloyed zinc coating). The zinc coating protects not only by keeping the medium away from the steel surface but also by its "cathodic effect". In the event of a corrosive attack, a galvanic cell is set up which causes the less noble zinc to corrode instead of the iron (zinc = "sacrificial cathode"); you might say it sacrifices itself upon corrosive attack. This is why the anticorrosion effect of the zinc coating continues even if it suffers minor damage, as this "cathodic protection" still works across small gaps in the zinc coating.

Hot-dip galvanisation can be applied to individual components in batch galvanisation, where the layer thickness is between 70 μm and 180 μm, or to linear steel products, such as thin sheets or wires, in continuous galvanisation, where between 5 μm and 40 μm of zinc is applied.

The coating thickness and appearance depend upon the chemical composition of

the steel (silicon and phosphorous content), the dipping period and the surface quality.

Coatings
Coating systems for steel structures comprise of several individual layers (primary coat, intermediate coat, and final coat).

The coating material is generally a mixture of medium, pigment, filler, special additives and solvent. The manufacturer's data sheet for the coating will give details of how to apply it. In reality, the layer thickness may vary, but the dry thickness, once the solvent has evaporated, must not be less than 80 % of the nominal thickness.
Due to surface tension in a layer which is still liquid and not yet hardened, smaller layer thicknesses may occur in the area of the edges. This effect can be compensated by the application of an additional edge protection coating.

Criteria for selection
In addition to cost-effectiveness and the

Corrosivity category EN ISO 12944-2	Examples of typical environments	
	Outside	Inside
C1 – Safe	–	Insulated buildings
C2 – Mild	Slightly polluted air, dry atmosphere, rural areas	Non-insulated buildings with temporary production of condensation water, e.g. warehouses or sports halls
C3 – Moderate	Town areas and industrial zones with moderate air pollution (SO_2) or moderate coastal climat	Rooms with relatively high humidity of air and moderate pollution of air, business enterprises, breweries, dairies, laundries
C4 – High	Industrial zones and coastal areas with moderate salt contents	Rooms with high humidity of air and chloride load; e.g. swimming pools, chemical plants
C5 I– Very high	Industrial zones with high relative humidity of air and aggressive pollution of air	Buildings or areas with almost permanent condensation and heavy pollution of air
C5 II – Very high	Coastal areas and offshore with high salt contents	

Please note: special loads and local microclimate conditions, such as chimneys, bridges, penetration points, etc. are to be considered seperately; they possibly require more specific measures and are often subject to
62 further technical regulations.

59 Several steel components being lifted out of the
 hot-dip galvanising tank
60 Corrosion process
61 Protection period as a function of layer thickness
 and corrosivity category in hot-dip galvanising
62 Corrosivity categories according to EN ISO
 12944-2
63 Building envelop made from sandwich panels
 a External corner with inner steel sheet facing
 penetrating construction
 b Temperature distribution
64 Analysis of an annual simulation: office with
 composite floor slab, passive cooling, compari-
 son with requirements of DIN 4108-2

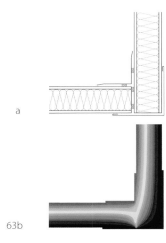

a

63b

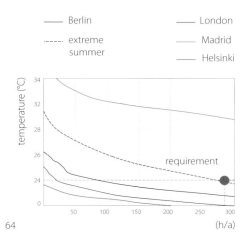

64

aggressiveness of the environment, the desired protection period plays an important role in the selection of a corrosion protection system. The protection period is normally defined as the expected useful life of the coating system until the first maintenance/repair measures are required (EN ISO 12944). It is used to schedule future maintenance and repair work and is considered in the selection of the protection system. The protection period depends, among other things, on the characteristics of the corrosion protection system, such as the thickness of the zinc coat (fig. 61).

The resistance to mechanical damage and aesthetics are also important criteria for the selection of corrosion protection systems. Furthermore, when choosing the shade of colour, resistance to weathering and, above all, ultraviolet light have to be taken into account. Preservation of surface gloss, chalking resistance, and thermal resistance are further criteria which can be significant, especially when painting large surface areas. All in all, the selected corrosion protection system should be harmonised with the site conditions, function, and useful life.

Thermal performance

Being an essential requirement of the European Construction Products Directive, energy saving (and with it the reduction of CO_2 emissions) is of utmost importance for building design and construction. The effects of this legislation can be seen in heat insulation requirements and permissible energy consumption levels. Thus, for instance, the energy conservation regulations governing heat insulation in some European countries have fundamentally changed, for it is no longer only the heat-transmission coefficient of individual structural elements which has to be proven but, beyond the thermal loss certificate for the

building, an overall energy balance including all energy losses (e.g. due to electrical appliances etc.) as well as all gains in energy (e.g. due to insolation, heat emitted by users, etc.) has to be assessed for the building as a whole. This is the only way to meet the future requirements drawn up with emphasis on the total energy efficiency of buildings. Similar changes are being introduced in countries outside Europe.

For these reasons, the energy saving effects arising from both physical (passive) actions relating to construction as well as plant engineering (active) actions are considered in their entirety and set off against each other. The issue of particular gains in energy resulting from insolation in winter, which depends on the building's orientation, user behaviour, etc. is also highly significant. Against this background the distinction is drawn between winter and summer thermal insulation, both with a view to energy saving resulting from heating or cooling a building.

Winter thermal insulation
A modern winter thermal insulation system aims to minimise the heat loss from the heated interior outwards at low outdoor temperatures (limitation of the heat transmission H_T of the building envelope). This applies to all adjacent structural elements from heated to unheated, i.e. floor, wall, and roof including their details:

$$H_T = \sum_i U_i \cdot A_i + H_{WB} \ [W/K]$$

where
U_i = heat transmission coefficient of the structural element i $[W/(m^2K)]$
A_i = heat transmitting surface of the structural element i $[m^2]$
H_{WB} = allowance for thermal bridges $[W/K]$

The U-values are normally determined in accordance with EN ISO 6946 except for

transparent materials and those penetrated by a metallic layer. The airtightness of the structural elements and their joints also has an effect on heat transfer.

Furthermore, a hygienic indoor climate has to be ensured for each point of the interior surface to prevent the formation of condensation and mould, provided that heating and ventilation are sufficient and the room is used normally.

Regular cross sections are interrupted or broken up by junctions, supporting structures, etc. so that analytic determination of the heat transition coefficient in these areas is no longer possible and the average values change. A determination of the values in such areas can be made either by experiments or using numerical analyses in accordance with EN ISO 8990. It is particularly important to avoid the formation of condensate in these areas. This is done by analysing the dew point temperatures on the steel surfaces.
Further important areas where heat losses occur are corner regions or regions pierced by steel elements which may cause an increase in heat transmission. Thermal breaks that meet structural and thermodynamic requirements can be of help here. Often, these regions are points of air permeability. Therefore, special attention is must be paid to the design of details, bearing in mind the need for airtightness, especially at gaps between prefabricated panels, cladding joints with the structure, junctions of doors and windows to walls etc. A more realistic approach to air tightness would take the explicit levels of air tightness achieved with the building components and compare the overall results with what is required for the building as a whole.

Summer thermal insulation
A modern summer thermal insulation system aims at maintaining a comfortable

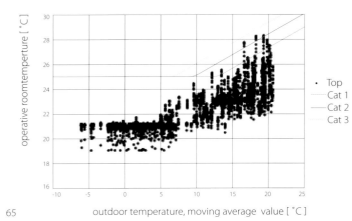

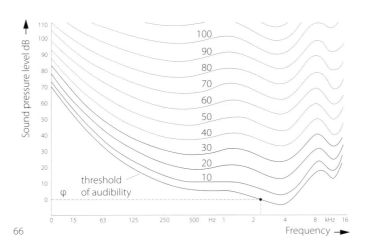

65 outdoor temperature, moving average value [˚C]

66 Frequency →

climate inside the building even at high out-door temperatures, as far as possible with-out energy consumption. The definition of a comfortable climate may vary from coun-try to country. For instance, according to German standards, the indoor climate may be called "comfortable" if the (indoor) tem-perature does not rise above 26 °C for more than 10 % of the period during which the building is used (requirement for temperate climate in Germany) (fig. 64). In addition to this standard, the more recently published EN 15251 sets a top limit depending on the outdoor temperature (fig. 65). The require-ment can be met by means of structural measures, cooling concepts, and the use of modern building materials like phase change materials (PCM).

In addition to a structural sunscreen or solar shading devices, it is possible to equip win-dows and glass facade surfaces with solar glass which uses very fine vaporised metal coatings and screen prints to reduce trans-mission of radiation and, consequently, unwanted warming up of the interior. Com-bined with natural draught ventilation, this can often be sufficient to achieve very effec-tive summer thermal insulation or at least reduce required the cooling energy demand.
In combination with free night cooling, ther-mal inertia (or fabric energy storage (FES), which is not just the pure mass of a struc-ture, can have a positive influence on ther-mal behaviour. Concrete slabs, as the only remaining massive construction element in modern buildings, should therefore be in contact with the compartment air, with no intervening false ceilings. However, thermal storage is limited due to the low tempera-ture differences between the air and the slab surface, which is the main driver of the energy flow. No more than 10 cm of slab thickness is likely to be activated as an effi-cient thermal mass within one day-and-night cycle.

Phase change materials, which absorb ther-mal energy when they change state from solid to liquid, can be used to improve the thermal storage capacity of lightweight buildings and keep temperature within a comfortable range.
A further increase in cooling effect can be reached by active cooling measures using water or air.

Architectural acoustics – sound insulation
Ambient sound levels considerably affect human well-being and health. Here, the degree of noise nuisance subjectively depends on the situation (sleeping/living/working), type, intensity, and number of noise events. Therefore, the design has to take into account the sound sources inside and outside the building, the sound transmission paths, and the user's require-ments.

The physical reference value for the sound level in the air is the sound pressure level L_p after A. G. Bell:

$$L_p = 10 \log p^2/p^2_0 = 20 \log p/p_0 \ [dB]$$

with the reference sound pressure [p_0] being the minimum perceptible sound pressure at a pure tone of a frequency of 2000 Hz where

$p_0 = 20 \ \mu Pa \approx 0 \ dB$. The introduction of the sound pressure level allows the sound pres-sure to be described over a range of six orders of magnitude using values between 0 dB (threshold of audibility) and 130 dB (threshold of pain), in which 1 dB is the mini-mum perceivable alteration in sound pres-sure level. Several sound sources of number n and varying individual sound pressure levels L_i generate an overall sound level L_{total} amounting to

$$L_{total} = 10 \log \sum_{i=1}^{n} 10^{Li/10}$$

The sound level of two vehicles with an acoustic emission amounting to 70 dB each thus is not 140 dB but.

$$L_{total} = 10 \log (10^{70/10} + 10^{70/10}) = 73 \ [dB]$$

The sensitivity of the human sense of hear-ing depends on the frequency (fig. 66). In the case of equal sound pressure levels, low and high tones seem to be fainter than tones of medium-range frequencies of about 1000 Hz. Measuring takes into account this characteristic of the human sense of hearing by weighting the frequencies. The standard recognises several weighting graphs called A, B, C, (and D), the A-weighting has become the preferred setting all over the world for sound rating. This is a simplified simulation of the sensitivity of the human sense of hearing at low and medium levels.

Sound power and sound power lovels of several sound sources

Sound source	Sound power W [W]	Sound power level L_w [dB]
Refrigerator	10^{-7}	50
Talking, typewriter	10^{-5}	70
Loud talking, lively class of pupils	10^{-3}	90
Concert grand, piano	10^{1}	110
Jack hammer	1	120
Large diesel	10^{2}	140
Jet engine	10^{4}	160

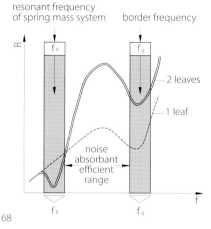

resonant frequency
of spring mass system border frequency

noise
absorbant
efficient
range

2 leaves

1 leaf

68

$L_W = 10 \log W/W_0$ [dB]; $W_0 = 1$[pW]

The sound pressure level is only of use in an acoustic description of a sound sources if the distance to the sound source at the time of recording is known, e.g. 3.0 m distance. That is why the classification of sound sources also makes use of the emitted sound power W or the sound power level L_W (fig. 67).

Architectural acoustics
Architectural acoustics differentiates between
- Air conduction of sound, i.e. initial acoustic oscillation of air particles and subsequent transmission through the air and the building (airborne sound) and the associated airborne sound insulation.
- Impact sound transmission, i.e. initial stimulation of sound waves in the building and subsequent transmission through the air (structural sound) and the associated impact sound insulation.

Both phenomena require reduction by design measures and cross sectional shapes so that we do not feel uncomfortable due to the emitted sound. To this end, each sound insulation measure or sound insulation effect is expressed by a sound reduction index R [dB].

Airborne sound insulation
- One-leaf elements
 In case of one-leaf elements, only their mass per unit area M/A and the thickness d of the element has an effect on the sound reduction index R at the frequency f in question. Here, we detect a decrease of the sound reduction index R in a particular frequency range where the frequency-dependent bending wave speed corresponds to the sound velocity of air. The effect is called "wave coincidence frequency" the corresponding frequency is called "limit frequency f_g". If the limit fre-

quency is less than approx. 200 Hz, the structural element has sufficient bending stiffness, whereas it provides sufficient flexibility if the limit frequency exceeds a value of approx. 2000 Hz. Thus, there result two options for the acoustic design of one-leaf elements – either as "flexible" as possible or as "stiff" as possible. Furthermore, it becomes evident that one-leaf elements derive their sound insulation properties only from their mass and thickness.
- Two-leaf or multiple-leaf elements
 In general, the acoustic performance of clad elements can be considerably improved by providing a double skin – or a two-leaf structure. A continuous air gap between the materials of a double shell significantly reduces sound transmission. Therefore, sandwich panels, two-leaf or three-leaf gypsum plasterboard walls, false floors under composite slabs, etc. are well-suited to meet the requirements and can considerably improve acoustic comfort in steel buildings. However, the elements of sound barriers should have sufficient mass, as this is an important factor in the field of sound barriers. This effect is described below for airborne sound as well as for impact and structural sound.

An idealised two-masses-spring-model provides an approximate model of the general sound transmission behaviour of two-leaf elements (fig. 68) where the sound reduction index R between the resonant frequency f_R of the spring-mass system and the limit frequency f_g (wave coincidence frequency , see above) of the leaves is considerably improved. The following conclusions for the structural design of efficient acoustically insulating multiple-leaf lightweight walls (light steel walls) can be drawn:
- Least possible stiffness s of the elastic interlayer, e.g. s < 11/d [MN/m³] (d [cm])
- Prevention of sound bridges d

- As flexible leaves as possible
- As large a mass per unit area as possible

The two latter objectives can be achieved together by sufficiently increasing the mass per unit area of the inner leaf sides without increasing the bending stiffness.

Impact sound insulation
As with solid floors, the impact sound insulation of steel composite floors is mainly improved by adding an appropriate floor finish, e.g. a soft walking surface or a floating screed. The insulation efficiency (which is frequency sensitive) is calculated as the difference in the standard impact sound level with and without floor coverings as $\Delta L = L_{n, without\ measure} - L_{n, with\ measure}$. High-quality floor coverings lead to an improvement of up to $\Delta L = 25$ dB , floating screeds up to $\Delta L = 35$ dB.
Generally, evidence of improvement of the impact sound insulation compared to the standard impact sound level L'_{nw} can be obtained from the impact sound insulation index ΔL.

$L'_{nw} = 63 - \Delta L$

As with air conduction of sound or impact sound insulation through floating floors, it is important to provide continuous separation of structural elements in the case of building components with particular impact sound requirements.

Conception of Steel Structures

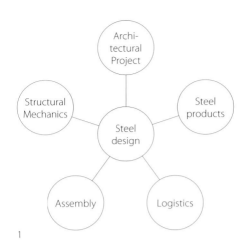

1

Klaus Bollinger, J. Michael Davies,
Manfred Grohmann, Sébastien Turcaud

Designing steel structures

A design process, from the idea's birth to its
realisation, can be compared to zooming in
on the final project through a camera with
a telescopic lens. From afar, only the out-
lines corresponding to the primary con-
cepts are visible. The more mature the
design process becomes, the more detailed
the structure appears, until it becomes real
and is eventually built. If the individual paths
explored by designers are far too numerous
and diverse, their intentions and overall
philosophy in the field of steel design may
become impractical and lacking in overall
coherence.

Steel as a material distinguishes itself in the
field of construction by its outstanding
mechanical properties which permit long
spans, great heights and light structures.
The possibilities offered by prefabrication
simplify the realisation of the planned
project through industrial manufacturing
and efficient erection phases. Although the
prevailing specificity of steel lies in its deep
relation to the architectural expression, the
steel structure often remains visible and cre-
ates its own aesthetics.

The design of a steel structure takes place
in an abstract environment where different
thematic issues represented by several
stakeholders interact through the design
process. This design environment does not
necessarily lead to a unique solution for the
design task, but rather to a set of alterna-
tives. The choice between the spectrums
of possibilities relies on multiple causes in
which the understanding of structures
plays a major role. This knowledge helps
to define structural typologies based on
mechanical and constructive considerations
which are chosen at the beginning of the
design. Further on, the structure is refined
into its elements and connections and pre-
cisely studied. The emergent notion of

computer-aided design offers great pros-
pects for the future by integrating more and
more steps of this process into one digital
model.

Initial design concept stage

Steel design encompasses several thematic
issues which define an abstract environ-
ment. Each issue plays a specific role
embodied through different trades or
specialists. Their definition arose histori-
cally and is changing. The roles induce a
specific point of view in the creative proc-
ess and set limits to the range of the possi-
ble. The definition of those issues and their
interactions within the environment can
be schematised with the help of a polar
diagram (fig.1). The quality of the design
process depends on the type of influence
each issue has on the final project.

Structural mechanics
Structural mechanics represents the sci-
ence of understanding and making struc-
tures. It is often misleadingly reduced to
the theory of structures, with disregard
to the construction knowledge gathered
throughout history. Analytical knowledge
would be unfounded without constructive
knowledge. All this constitutes technical
knowledge and is embodied by the engi-
neer and defines its know-how (p. 46ff.).

Architectural project
The architect makes choices during the
design process of the whole building in rela-
tion to the programme. The resulting archi-
tectural project often offers several levels of
significance according, for example, to the
site, to global and local scales, or to func-
tional, aesthetic and symbolic meanings.
The structure must be integrated in the
architectural design process, as the design
possibilities of the form greatly depend on
the type of structure adopted. As a rule,

projects in which the architectural and the
structural design are interconnected yield
much better results.

Steel products
Steel products are defined by their steel
grade, their shape and the way they were
produced (p. 110ff.). There exists a huge
variety of steel types for construction. A
useful classification of the steel products is
given by their geometrical shapes, which is
linked to the way they were produced,
either hot or cold rolled, and the distinction
between two categories, long products
(beams, cables, wires, sheet piles) and flat
products (sheets, panels, thin-walled pro-
files, hollow profiles).

The standardisation of steel products
induces a modular logic into the steel solu-
tion design process. Even though specific
solutions can be produced, they always
imply higher costs and longer manufactur-
ing times. The fact that standardised steel
products exist influences the design of the
elements. The structural analysis links the
geometry of the matter, that is to say the
shape of the elements constituting the
structure, to the forces applied. Since
particular shapes are serially produced, it
reduces the possibilities of shapes. The
form-finding process of the structure must
fit in with the available steel products. This
reduction of the range of possibilities is out-
weighed by the particular shapes of stand-
ard products. They are not arbitrarily chosen,
but directly derived from mechanical con-
siderations.

Logistics
In the construction process, the term logis-
tics summarises the questions linked to the
transport of construction elements from the
factory to the site. The consequences for
the design of steel elements include restric-
tions on dimensions, which depend on the
capacities of the factory (internal transport,

2a 2b

1 Design enviroment
2 Kunsthaus Graz, Graz (A) 2003, Peter Cook
 a + b Assembly of the steel structure
 c Finalized project

loading onto the means of transport), the
mode of transport (different types of lorry,
train, boat or plane), and the lifting equip-
ment on site. A typical transport container
is 2.38 m high, 2.33 m wide and 6 or 12 m
long. Those constraints often limit choices
in the assembly thematic. They push the
designer towards adopting standard solu-
tions and are always limiting in terms of the
development of new ones.

Assembly

The designer's challenge is to divide a large
structure into smaller elements that can be
easily fabricated, delivered and assembled
on site without loss of structural capacity.
Particular attention must be given to the
splices in order to transfer the force flow cor-
rectly and ensure adequate resistance. The
connection possibilities on site often deter-
mine the design of the connections. Welding
on site requires a highly skilled labour force.
Therefore, it is often prohibited and bolting
is preferred. Assembly in the factory is
cheaper than on site. That is why the ele-
ments are designed to be as large as logisti-
cally possible.

It is almost impossible and particularly
expensive to adapt elements on site. Typi-
cally tight steelwork tolerances require high
precision. This sets steel elements apart
from those of other materials such as con-
crete or wood, which are manufactured to
wider tolerances. Connections between dif-
ferent materials must take tolerances into
account.

The tolerance is defined by the difference
between the planned dimension and the
real dimension of an element. Usually a
tolerance sets the permitted limits on
undersize and oversize. The specific toler-
ances for a given project can be fixed by
the design participants. Otherwise, the
default tolerances are fixed by reference
to standards.

Structural design concept

The history of structural design is shown by
the evolution of the models developed by
builders to represent the physical world, as
described in Oliver Tessmann's Thesis "Col-
laborative Design Procedures".

Evolution of structural design

Models reflect the development of abstract
thinking at a given time and summarise the
amount of knowledge available. While
Greek and Gothic models focused on quali-
tative aspects like the geometry of the
design, the beginning of modern science
yielded precise mathematical rules describ-
ing the inner states of matter inside the
models. Models also allow the designer to
make predictions about an idea. They help

to explain how something works, to some
extent at least.
The first to dare to reach the gap of abstrac-
tion, read the particular structural principles
of what they had built and understood the
hidden mechanism laying beneath the real-
ity of the structures. Thus they opened the
way to the possibilities offered by abstract
planning and scientific knowledge. This
way of thinking, also called the rationalist
tradition, emerged in the 16th century and
is embodied by renowned personalities.
Galileo was one of the founders of this
new approach who merged empirical
observations with theoretical knowledge
by directed experiments like the observation
of falling bodies.
The shift from a traditional master builder's
approach to a scientifically based engineer-

2c

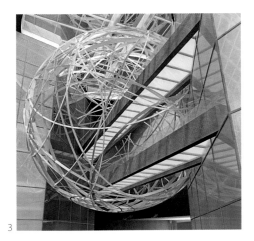

3

4

3 Rendering of "Sphere" in the Deutsche Bank for a
 competition, Frankfurt (D) 2007, Mario Bellini
4 Peripheral iron tie beam in the cupola St Peter's,
 Rome (I) 1593, Michelangelo
5 Competition pedestrian bridge Bergwerk Reden,
 Reden (D) 2007, FlosundK
 a The framework was designed freely through an
 optimisation algorithm. The criterion was to
 keep the bending moments low and to focus
 on tension and compression load transfers.
 b Optimised structure
 c Rendering of the bridge

ing approach is commonly identified with
the expertise displayed in controlling the
cracks in the dome of the Basilica of Saint
Peter in Rome (fig. 4). Those principles,
which generated the basic knowledge of
structural mechanics, gave birth to a new
dimension of building, always striving to
become wider, bigger and structurally more
efficient than their predecessors. The evolu-
tion of Gothic churches through the Middle
Ages is a good example that illustrates the
growing power of abstraction and the
impact of the understanding of the princi-
ples of vaults.

The use of steel as a construction material is
directly derived from this rational scientific
approach. The World's Fair of 1851, one of
the main events that can be considered as
decisive for the beginning of the era of the
industrialisation, was held in the Crystal
Palace in Hyde Park, London. Built by Joseph
Paxton, it probably is the first large-scale
famous iron structure. As there were no
predecessors for this kind of construction,
the design could only rely on abstract con-
siderations. It is remarkable that the increas-
ing use of cast iron structures gave birth to
new graphic methods for calculating struc-
tural behaviour. The technique of graphic
statics was based on projective geometry
and the vector analysis of forces, and shaped
the familiar standard typologies.

The next step towards abstraction, which is
now enabled by the ever-expanding capa-
bilities of computers, consisted of designing
whole new forms based only on the theo-
retical laws of structural mechanics. This
continuation of the general theories and
analytical methods was implemented into
computer numeric procedures in the second
half of the 20th century. It led to a generation
of new structures detached from the labori-
ous development of traditional construc-
tions, which probably wouldn't have been
discovered without the skills of abstraction.

The following statement of Nikola Tesla
depicts the hazards of where this abstrac-
tion can lead:

"Today's scientists have substituted mathe-
matics for experiments, and they wander off
through equation after equation, and even-
tually build a structure which has no relation
to reality." (1934)

Even if Nikola Tesla probably meant scien-
tists in general, the particular field of con-
struction offers the possibility to reconcile
abstract science with reality.

The gap between traditional building meth-
ods, deeply linked to the reality of construc-
tion, and abstracted planning could not
have been bridged without the various,
intense and assiduous tests and experi-
ments which have been carried out during
recent decades. The results of these labora-
tory tests on different material characteris-
tics calibrate the theoretical models and
extend the knowledge about how a specific
material works. Eventually, they improved
structural mechanics as a science.

Choosing the static system
Choosing the appropriate static system can
lead to drastic savings in material. For exam-
ple, shortening the distance between bear-
ing points reduces the maximum bending
moment. This has an impact on the dimen-
sioning of the elements. The problem of the
right choice of the static system is a difficult
one, because the static system has an influ-
ence on the loads, which finally help deter-
mine if the static system is right or not. So
when you change the static system, the loads
are change again, and so on. That is why
experience and construction knowledge is
required in order to break that causal loop.
For the same loads and same element
length, the required depth of the element
can be reduced by comparing different
static systems.

Dimensioning

The overall philosophy of all the design
codes is to predict the reliability of the struc-
ture over time with reference to certain limit
states. The discipline of structural mechanics
procures the numerical values needed to
make this verification.

Limit states
The ultimate limit state (ULS) and the serv-
iceability limit state (SLS) concentrate on the
stress state and on the deformation of the
structure respectively.

• ULS
This state represents the critical loads
acceptable for a structure before it breaks or
deflects widely. In first order analysis, the
stresses are deduced from the loads applied
on the static model of the structure, and the
resistance depends on the material models
used. Those inputs are then compared and
deliver the statement of whether the
desired level of safety of the system is
reached or not.

• SLS
In the case of steel structures, which are usu-
ally very light and slender, the serviceability
limit state is often predominant. In order to
function properly, a structure must behave
in an acceptable way. This means that the
deflections over time must stay reasonably
low.

Typologies

One of the most characteristic traits of steel
construction is the readability of the struc-
ture.

Force flow
Once accustomed to the laws of structural
mechanics, it is easy to guess the static
system in a built steel structure, which then
permits the internal forces to be deduced
from the loads. In comparison with other
materials, steel is isotropic. This means that

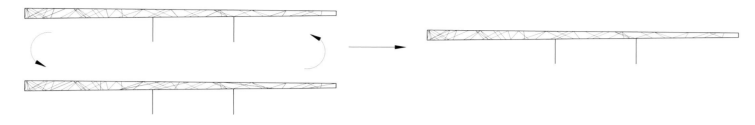

5a 5b

the properties of steel are the same in all three spatial dimensions. That is why it is legible.

Steel is the perfect material for a structural engineer, as the form reflects the vector behaviour of forces. The models behind concrete construction are often related to a truss analogy based on an equivalent steel solution.

The concept of force flow consists of following the load forces from their points of application to the foundations through the different parts of the structure. Its path and intensity through the elements and connections furnish the main design criteria for the structure's form and shape. The force flow can be broken down into three operations: load reception, load transfer and load discharge.

Structural systems are often composed of one-dimensional elements combined into a spatial framework, which simplifies reading the force flow. Those elements are generally loaded in pure compression or tension.

A bridge in the mining district of Reden was subject to structural transformation and is a

good example of force-flow in relation with a structural design. The architectural idea was to link the old to the new. The framework was designed freely with help of an optimisation algorithm. The criterion was to keep the bending moments low and to focus on tension and compression load transfers (fig. 5).

Standard typologies
Standard engineering typologies are deduced from the comprehension of mechanical laws and filtered through the question of functionality and feasibility. The form is derived from the understanding of the force flow. As with all real building evolution, the historical achievements of one generation constitute the initial state of the art for the next generation. This offers the perspective of standardisation and true modularity and feeds the dream of an exhaustive knowledge of what is possible in steel construction.

The distribution of forces within a massive beam is hidden from the observer's eye. However, if one visualises the statically determinate force paths, a number of system inherent types can be recognised, like the arch, truss, and beam.

Before the time of computers, static systems had to be analysed by hand. This is the reason why clearly defined stress states were preferred and the attempt was often made to reduce the structure to a few simple principles. This is one of the main reasons why standard solutions were developed.

The organisation of standard typological structures is always hierarchical, regular and subordinate. In those structures, a primary and a secondary structure can be clearly defined and the readability is increased. For example, structures can be classified according to their mode of resistance on the basis of their shape and main statical dimension as various forms, vector structures, sections, surfaces, vertical structures, etc. This idealisation may change as the design progresses.

Beyond typologies
In contrast to standard typologies, other global principles that do not follow the strict rules of functionality expand the possibilities of structural engineering design.
Free form design (FFD) is an example of such new approaches. Here, designs evolve freely, and instead of sticking to simplicity, they play within the range of possible stress

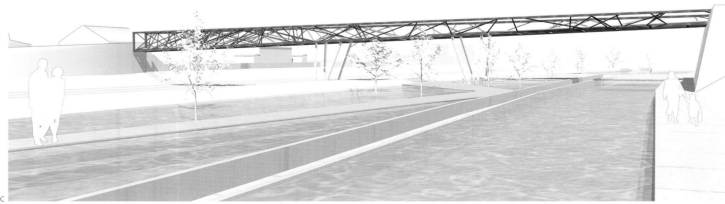

5c

6

6, 7 Structure above roof, an example of a
 suspended structure. A lattice of beams is sus-
 pended from six 20 m high masts. ZDF-Fernseh-
 garten, Mainz (D) 1997, Albert Speer und Partner
8 Different cable connections
 a Cable skylight connection
 b Cable-truss node
 c Cable-truss node underside

states using computational models. Despite its considerable age, the concept of form-finding is still an example of a design concept. There, the form is based on analogies with physical models, which makes standard typologies inadequate. This approach tends to define the structure as a direct expression of the construction with the help of perfect shape calculation.

The use of software allows the designer to explore new kinds of typological logics and create very sophisticated structures. Several load-bearing behaviours can be mixed together to create combined systems.

Whatever the final draft of the form may be, it is essential to maintain the adaptability and the flexibility of the structural design concept as well as its optimisation to the chosen form. With the growing number of specialist computer design programs and the tendency to integrate the steps of the design process into one coherent function, the structural design concept is becoming increasingly intertwined with the other issues of the design process.

Designing elements and connections – structural elements

The following steel elements are separated into three categories, according to their functionality: structural elements, semi-structural elements and the remainder. In terms of constraints, the design of structural elements exclusively depends upon structural constraints, whereas the design of the two other categories of elements must take a growing number of non-tructural constraints into account, like heating, ventilation and air-conditioning (HVAC).

This overview of the fundamental element and connection types is intended to give an impression of the archetypes present in steel construction. The result of a structural design is a combination of these archetypes in combination with the structural design concept highlighted previously. The list is not exhaustive, but should cover most of the variety of archetypes found in steel construction.

The structural elements are the main parts of the structure and their design is mainly mechanical. A design based upon the notion of structural safety produces different types of solutions, which represent alternatives for the complete design of the steel solution. The choice between these alternatives is made with reference to the two other assessment concepts of the design process, economic efficiency and architectural quality.

The following structural elements are classified according to their geometries in space into linear, planar, spatial and eventually node elements. Inside each part, the elements are classified according to mechanical considerations.

Structural elements possess three dimensions in space. However, the elements can also be modelled according to the number of parameters necessary to describe them. Though, elements can be divided according to their principal dimensions or idealised dimensions from a global consideration of the structure.

Linear elements

One-dimensional elements are elements in which one dimension is predominant like a straight line. Due to fabrication processes (linear work flow), most steel elements are one-dimensional as they come out of the factory. One-dimensional approximation can be useful to model complex structures in the preliminary stages of the design. For example, a skyscraper is similar to a vertical cantilever. In the same way, a bridge can be compared to a horizontal beam from bank to bank.

A classification based on the curvature and the stress state is an efficient method. Straight tension members and cables are similar, and the same applies to straight compression members and arches, because they show the same stress state.

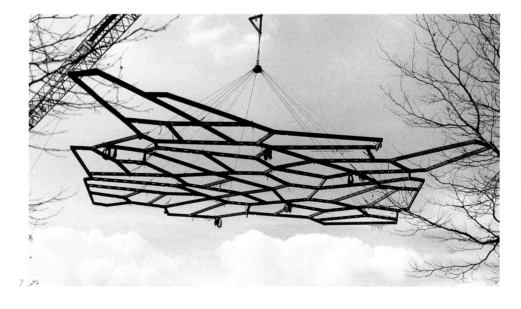

7

8a

8b

8c

Straight tension members

The main design criterion for tension members is the required cross sectional area. It is derived from the applied tension and the material properties.

$$\frac{N_{max}}{A} \leq \sigma_{material} \Longleftrightarrow A \geq \frac{N_{max}}{\sigma_{material}}$$

However, the design of the connections often determines the geometry of the section. The presence of holes (e.g. for bolts or service ducts) diminishes the resistance of the section and leads to a reduced allowable stress near the hole. This notch stress can sometimes be as little as one third of the maximum admissible stress in the rest of the element. The use of standard elements leads to the choice of a constant cross sectional area as defined at the location of the notch stress.

The presence of load eccentricities creates additional out-of-plane bending moments, which can be transmitted only to a small extent. Symmetrical connections reduce those effects. Particular attention should also be paid to the design of assembly splices. It is often revealing to focus on the design of the connection devices, which depends in a large part on the architectural expression.

Tension members can be made of flat steel profiles. This increases their stiffness in the direction in which they are wider. In the other direction they behave like very thin bars. As already mentioned, the design of the connection is particularly decisive for the connected elements, if not the whole structure. The shape of the connection follows from the forces acting on it. The forces model the connection device by pulling it in different directions.

Cables

Cables are more flexible than tension members, but their transverse rigidity is decisive.

They deform under loads, which enables them to take up loads transverse to their principle direction. They are made of high grade steel with a tensile strength up to 1770 N/mm². They are not weldable. It should be noted that such steel grades do not follow linear force-deformation diagrams. Their Young's modulus (E) is expressed as an equivalent modulus and depends on the stress in the cable. However, a secant E-modulus for given increases in load can be determined from tests. As their deformation under transverse load is huge, they have to be modelled using non-linear analyses.

Cable Types

Cables are made of wires or strands with a diameter between 0.7 and 7.0 mm. They are wound in different ways depending on their intended use and may often be referred to as ropes.

Cable deformed shapes

Depending on the particular load cases and support conditions, cables take up different shapes. The most notable forms are circular, parabolic and catenary curves. These shapes are obtained when a uniform perpendicular force, a uniform vertical force or a constant or dead load respectively is applied to a cable clamped between two articulated joints (refer to the section about arches for a similar behaviour). The stress state is only constant for the specific case of a circular geometry under a uniform perpendicular load. Under point loads the deformation is affine in parts. It is striking how many load cases on cable structures can be modelled with specific mathematical functions (figs. 6 and 7).

Although the cables are relatively thin, they carry huge tensile forces, for which the anchors must be designed. It is often quite enlightening to take a look at the anchorage points of suspended structures. Despite the

very lightweight appearance, the anchor blocks are generally massive to prevent uplift. Thus, the judgment of the lightness of the structure should be based on the whole structure and not only on its visible part. A lot of "light structures" actually hide considerable anchoring points.

The assembly phase is another crucial phase in the design. An entire assembly may be lifted and installed in one piece by means of a large crane. Here, the designer must consider the resulting stresses applied to the structure during the lifting phases as specific design stages where different load cases and support conditions apply. Temporary construction phases also have a huge impact on the global design of the structure.

Cable tensioning

In most cases, cables must be tensioned to work efficiently and to admit small variation of loads without deflecting too much. This stage must be designed carefully, as the tensioning possibilities on site are often limited. The tensioning device can modulate the value of the tension in the cable within a given range, which depends on the dimensions and the calibration of the device. In this phase, imperfections due to fabrication have an overwhelming impact.

Cable connections

Cable connections have to be carefully designed and detailed to prevent premature failure. Attrition or physical wear can appear under dynamic loads and can potentially lead to rupture.

Straight compression members

As steel expands and contracts the by same amount under compressive load as it does under the same tensile load, it could be assumed that the main design criterion for compression members would be the same as for tension members. However, the phenomenon of instability steps in to become

9 10 11

the crucial design criterion for elements under compression. It defines the form of the section as well as the support conditions.

The shape of the cross section is particularly determinant for the buckling behaviour. Profiles where the material is located far from the centre of gravity will resist buckling better. The most efficient sections are hollow sections, as the mass is spread around the longitudinal axis. However, their use often involves complex connection designs.

As for elements working under tension, the connection must ensure that only axial forces are transmitted to the compression element, as it cannot generally accept bending moments. Potential eccentricities of the applied loads must also be taken into account.

Arches
In terms of static analysis, arches work like inverted cables, where tension becomes compression. As for compression members, compression forces determine the design of the element. The prevailing stability criterion of the arch is buckling. Thus, like for straight compression members, arches must undergo a buckling analysis.

Funicular arches
A funicular arch has a profile which ensures it is always in pure compression for a particular load case or range of load cases. This shape is typically designed for the permanent load on the arch. There is a remarkable correlation between particular load cases and particular geometrical forms with funicular arches and, for that matter funicular cables, where the same loads in the opposite direction lead to mirror geometries: compression is replaced by tension. A uniform perpendicular load equilibrates a portion of circle, a constant linear distributed

load equilibrates a portion of parabola and the geometry of a funicular arch under dead load is described by a mathematical function called cosine hyperbolic. This last shape is also referred to as a catenary, as catena is a synonym for chain.

The line defined by the centre of force on an arch is called the thrust line. It is obvious that its path depends on the particular load case. A structure whose geometry follows the shape of the thrust line defined by the estimated loads is optimal in terms of material savings, as every section experiences pure compression. However, this can only be designed to work perfectly for a particular load case or prevalent load combination. In particular, the ratio of variable loads to permanent loads is decisive. When the determining load case is described by an envelope and not a line, the structure is bound to be exposed to bending moments, as no single geometric arch can accommodate all the different thrust lines. The bending moments result from the difference between the actual geometry and the thrust line defined by the particular load case. As a matter of fact, each prevailing load case leads to a specific thrust line. Hence no geometry completes the funicular definition for all the load cases. The design according to bending considerations leads to greater depth and area of section.

Static analysis of arches
The challenge in arch structures is to control the horizontal bearing forces. The smaller the rise, that is to say the flatter the arch, the greater the horizontal component of force. As the arch becomes a straight line, it will "fall down" according to this model. At the same time, the compressive force continues to increase and the buckling phenomenon becomes more critical. The horizontal bearing forces must be contained by accurate bearing supports. As it is the case for cables, the anchoring points are relevant to any

judgement of the efficiency of the total structure.

For a symmetric arch under symmetric loading, there is a fundamental relation between the horizontal bearing force (H), the maximal moment (M) and the height of the arch (f), which can be derived from simple static considerations. For a constant linear distributed load (q) the formula is very simple. The horizontal bearing force determines the design of the lateral bearing supports of the arches.

$$H = {}_{max}M/f = ql^2/8f$$

The vertical bearing force only depends on the span of the arch. It influences the settlement of the arch foundations and the size of the vertical bearing supports.

$$V = \frac{ql}{2}$$

The determining normal force results from the hypotenuse of the triangle of the horizontal and vertical bearing forces.

$$N = (H^2 + V^2)^{1/2}$$

This normal force is responsible for the potential instability of the arch and must be smaller than the critical buckling normal force.

Types of arch
Arches can be classified according to their connection types as either pinned or fixed. The buckling mode of thrust arches under their corresponding loads with zero, two or three pins is the same except for the flat three hinged arches. The buckling mode shows how the arch is going to fail. The critical buckling load depends on the quotient f/l. When f/l is smaller than 0.3 the buckling mode is symmetric. Otherwise it is asymmetric. For the critical value of 0.3, the two buckling modes appear at the same frequency.

9–12 Individually prefabricated arches, Paul Klee Museum, Bern (CH) 2005, Renzo Piano Building Workshop

The above discussion is intended to emphasise the necessity to study carefully the static systems and to challenge every preconception. Variable loads can also play a huge role in the design of the section as they lead to destabilising bending moments. In practice arches are usually made of discontinuous straight elements. Just as curves can be approximated through polygons, these can also be used to construct arches. This brings the model "back to reality", but also implies non-negligible bending moments at the edges of two segments.

A polygon approximation of an arch leads to parasitic moments and shear forces in the sections. The structure can still be considered as an arch if those parasitic values are negligible compared to the normal forces, then the prevailing design consideration is still based on the normal force.

Example of an arch-based structure
Arches are often used in bridge designs, as they offer the possibility of wide span and are aesthetically convincing. The bridge in Sheremetyevo Terminal 3 in Moskow for example is mainly composed of a trussed deck spanning between two inclined arches over approximately 60 m. The complete bridge is connected to the rest of the structure through a web of cables. However, it is not a suspension bridge, as the forces are transmitted through the arches. The role of the cables, which are, connected to dampers at their top, is to control the dynamic behaviour of the bridge.

Columns
Columns are discrete vertical members under compression. They can also carry bending moments so their thickness must be modelled. They are part of the primary structure. Their role is to concentrate loads and to transmit them vertically. They have to be designed structurally for compression due to vertical loads. They also have

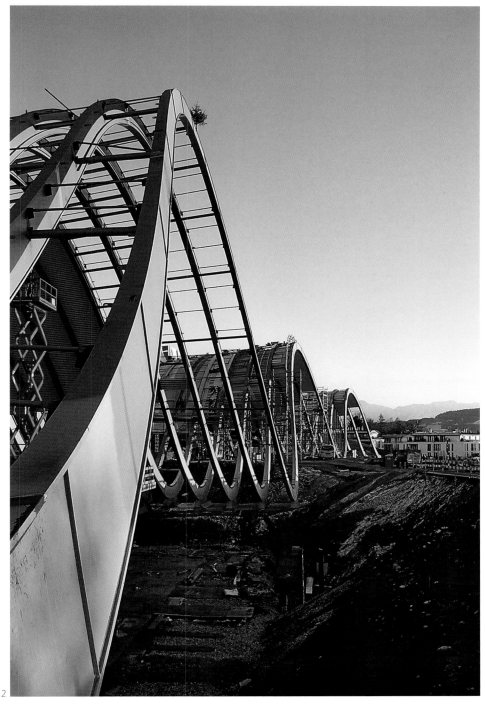

12

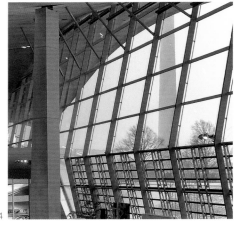

13 Steel I-Beam, Office Block, Fellbach (D) 1998,
 Dollmann + Partner
14 Composite column BMW Welt, Munich (D) 2007,
 Coop Himmelblau
15 Frame structure with rigid corners, Rade-
 vormwald (D) 2003, Christoph Ingenhoven

to be designed for bending when they are subjected to horizontal loads (like wind loads), eccentric vertical loads or of induced bending moments from other elements of the structure. In some cases, they must be designed against buckling. Buckling, like for compression members, is determined by the section characteristics especially by its inertia and by the end restraint conditions.

End restraint conditions
Columns can be separated into two types, depending on the end restraint conditions. They are either pinned or rigidly fixed to the rest of the structure. The analysis of the end restraint conditions can be separated into two parts: the column's head and base. The head transmits the loads into the body and the base distributes them to the foundations.

For columns bases, articulated bearings are realised through plain or reinforced base plates or support grids. Rigid connections must transmit the moments to the foundations. This occurs classically through anchors and dowels or through special concrete footings. For columns heads, the connection is either rigid or articulated and may provide this restraint in one or two dimensions. Their effectiveness depends on the number of srews or the types of weld seams.

The optimisation of the number and positions of the points of support is also a central question when designing the global structure. It is a matter of unobstructed space, building use, efficiency and costs. Structures with few bearing supports tend to imply high material use, which leads to high costs. Light structures often require a large number of supports.

Buckling considerations
Variation of the cross section can counteract buckling by increasing the critical buckling

load. Columns in the form of in a double cigar shape illustrates this idea. Another method consists of diminishing the buckling length by adding intermediate lateral restraints.

Composite columns
Composite columns, where the steel structure is covered with concrete, benefit from using smaller sections for the same fire resistance. The concrete can be designed to participate in the load transfer of the column, but most of the time its role is to increase fire resistance. In practice, the structure can be designed to resist fire exposure from 30 to 120 minutes. The concrete inside the column also stabilises against local buckling.

Beams
Beams primarily carry loads at right angles to their longitudinal axis and transmit them by shear forces and bending moments to the rest of the structure. They either support or shelter used spaces. They can be part of the primary as well as the secondary structure in terms of standard typology. The simplicity of beams can be put forward for architectural expression.

Optimisation
The optimisation of the section must be considered as a worthwhile design option to reduce material costs and to design a structure in agreement with the force flow. The utilisation of the section in terms of stresses is optimised and the geometry of the section is directly derived from the loads. The aim is to use the material to the greatest degree possible throughout the whole section. There are two ways to approach this concept. Either the depth of the element is kept constant and the distribution of mass inside the section is adapted to the internal forces, or the depth is directly adapted to the bending moment diagram.

However, as the loads often change with time (live loads, wind loads), this logic is limited. Every load case leads to a different level of optimisation of the section and, like thrust lines in arches, no geometry is a perfect match for each and every load case taken separately. The final draft should verify all the design load cases, that is to say the envelope of the load combinations. Sometimes, the optimisation costs are higher than the benefits in terms of material use.

Different types of profile
Several different types of profile are directly derived from the optimisation process. In order to simplify the market and to standardise fabrication, standard profiles have been defined. They are classified into different families, depending on their shape: I, H, T, U, circular and rectangular hollow sections or profiles. Each of these families offers special benefits and corresponds to a particular range of standard applications. All the main characteristics of those profiles are summarised in tables, which are a useful tool for a quick preliminary design of a steel structure.

Welded plate girders
The use of welded plate girders offers the greatest flexibility in choosing the most economical section for a given load envelope. They are made up of plates and sheets welded together. Thus their geometry and their inertia can be varied to suit structural needs. They are normally produced in fabrication shops and assembled on site. Typical welded plate members are box girders, often used in bridges. This technique is also used to produce very deep sections (h > 1000 mm).

Cellular beams
Like their forerunner, the castellated beam, cellular beams are produced from rolled sections, which are split to a complex shape

15

longitudinally along the web, then shifted longitudinally and welded back together again. This results in a deeper beam with hexagonal, circular or rhomboidal holes in the web. They are much lighter and stiffer than standard rolled sections, and offer the possibility of running the building services through them. They can also be directly made by cutting holes in standard profiles. They are often used in composite construction. This concept can be developed further by working on the shape and size of the cuttings.

Stability against overturning
Elements working under bending, especially open profiles (I, Z, U, L), are subject to a phenomenon of instability called overturning (p. 46ff.). It can be counteracted by adding lateral supports to the element at the bearing points, or stiffeners on the side of the beam.

Planar elements
Planar elements are elements in which one dimension is much smaller than the other two, like a plane. Structural elements with two dimensions can be composed of elements with one dimension or be truly two-dimensional. When more than one element is considered, the interaction between the elements is a determining factor of the behaviour of this set of elements. This leads to consider the types of connection between the elements. Components of steel construction are usually at least two-dimensional.

Portal 2D frames
Frames are the probably the most common elements in steel construction. They are composed of columns and beams attached together. Thus, they play both the role of columns and beams. They liberate space and transmit loads vertically. They can also resist horizontal loads and be part of the horizontal bracing of the whole structure.

Compared to individual elements, their global behaviour has also to be taken into account.
The inertia of the beam resists loads in the plane of the frame, while the columns are designed for the vertical loads. The column and beam are then dimensioned separately as linear elements.

The main characteristic of 2D frames, which distinguishes them from assembled column-beam systems, is the fixed connections between the columns and the beams. This leads to a smaller beam depth and to smaller deflections, as can also be seen by comparing the bending moment diagrams of pinned and fixed ended beams. It explains also why frames are often used to brace the structure, which is necessary to ensure the horizontal stability.

Number of articulations
Even though real connections are often somewhere between pinned and fixed in order to get an overview, frames can still be classified according to their end restraint conditions. The connection types associated with the examined load case also defines the buckling length of the vertical elements, which is a decisive parameter for the buckling analysis of the columns.

Articulated frames
Articulated frames are statically determinate and do not transmit moments at their connection points. They can be assembled from relatively small profiles and are able to absorb small variations due to thermal differences and settlements of support. However, they are quite sensitive to horizontal loads. They are also less efficient for bracing as they are more flexible.

Either the articulation occurs at the support points, at the connections between the vertical and the horizontal elements or at both. Rigid connections attract moments and must be specially designed to resist them. When articulations are present, the moments migrate from the connections towards the middle of the span and a deeper beam is required for the larger mid-span bending moment.

Fixed frames
When no articulation is present, the frame is statically indeterminate, unlike an articulated frame. They are very rigid and are used to cover wide spans. They are not very tolerant of differential settlements and thermal loads, but they can offer more unobstructed space and flexible use. They are also effective as bracing.

Aesthetic, light and economical as well as environmentally friendly: these are the new "cellular beams" spanning large distances up to 25 m. Such a beam weighs less than a castellated beam and has 50 % larger openings for improved component integration. Already during production the optimization of cuts and of height, combined with weld length reduction, has a beneficial influence on material loss compared with the traditional cellular beam production process.

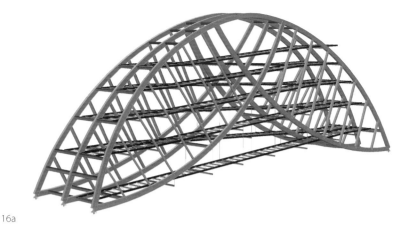

16a

17 BMW "Wave", Expo 2000, Hannover (D), Bern-
 hard Franken
 a Structural model
 b Inside view finalised project
18 Rotational grid in Red Bull Hangar 8, Salzburg (A)
 2004, Volkmar Burgstaller
 a Structural model
 b Roofing of the final project

Buckling modes
Frames are also characterised by whether
their nodes are moveable or not. The articu-
lated frames mentioned above are very simi-
lar for symmetrical load cases and their
buckling modes are almost identical. Fixed
frames with zero articulation have also a
similar buckling modes, but they buckle
under higher loads.

Bracing
Frames are often used to brace the struc-
ture, that is to say to confer horizontal stabil-
ity. Either the frames are rigid or they are
braced themselves. In steel construction,
particular elements are often used to stabi-
lise complete structures. That is why frames
play an important role in steel structures.

The skeleton of many projects is composed
of frames and bracing systems. Frame-based
structures are very efficient when, for exam-
ple, the roof and the facade of the building
lean on two longitudinal articulated frames
braced against each other and in the longi-
tudinal direction, the concrete walls act as
bracing elements.

Frames can also be designed more freely
with the help of recent advances in compu-
ter numerical control systems. The Dyna-

form shows how standard frames can be
further developed.

The use of tubular elements improves resist-
ance to torsion and buckling, but they are
difficult to connect to one another. They are
often welded together. The frame forms a
linear support for the roof structure.

2D trusses
Another way to assemble one-dimensional
elements is to build trusses. Trusses are con-
stituted of interconnected one-dimensional
elements. They can be seen as linear ele-
ments expanded in one direction which can
be vertical, horizontal or in-between. Their
standard components are members work-
ing under pure compression or tension,
as the joints are mostly treated as pinned,
but this depends on the orientation of the
main loads relatively to the truss. They can
achieve longer spans than simple one-
dimensional elements like beams or bars.

Less material is necessary compared to a
massive construction, as the plane is decom-
posed into its force vectors. Trusses offer
the possibility to run service installations
through the structure, much like cellular
beams. However, higher fabrication and
erection costs are involved. Substantial coat-

ing costs for anticorrosion and fire safety
must also be taken into account. Neverthe-
less, the aesthetic light-transparence effect
and the adaptability to the form, make
trusses one of the favoured options in steel
construction.

A necessary consideration is the stability of
the truss, that is to say, the stability of the
elements composing the truss interacting
with each other. As trusses are ideally only
loaded at their nodes, their stability can be
assured by two methods: either by the joints
(rigid connections), or through the geomet-
ric assembly (typology). For example, the tri-
angle is a very stable assembled element
compared to the square. That is why squares
are usually braced.

Specific planar trusses like vertical and hori-
zontal trusses show the general behaviour
of trusses with some differences. Vertical
trusses are often pin-jointed to ensure that
all the elements are working under pure ten-
sion or compression (trussed beams, frame-
works). Horizontal trusses are often rigidly
jointed and work like slabs with tension, com-
pression and also bending and torsion (grids).

In addition to the buckling problem already
mentioned with regard to linear elements,
the phenomenon of overturning raises
another aspect of stability. The dead loads
are also responsible for bending moments
in the different elements composing the
truss.

Trussed beams
The typology of trussed beams follows the
same logic as the typology of one-element
beams. The parallel flange beams resemble
the standard I- and H-sections. The non-par-
allel flange beams are similar to tapered
beams. Trussed beams without diagonal
elements are called Vierendeel or quadrilat-
eral beams. They offer the advantage of cre-
ating rectangular openings for windows and

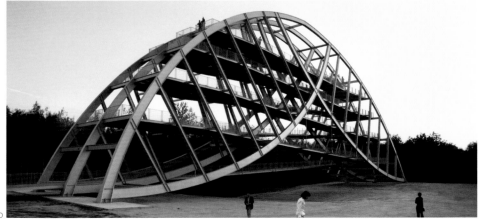

16b

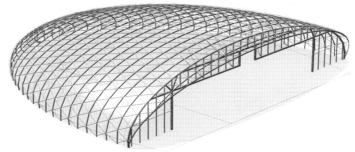

17a

18a

doors, and are therefore often used in sky-scrapers. However, they must resist bending moments due to the missing diagonals, compared to a standard framework.

Trussed beams have typical topological shapes like the N, the V and the X. These shapes can be deduced from the stress states of equivalent filled elements, in an optimisation process similar to the one explained for beams. They are also related by the problem of stability. These typologies have been presented in the earlier section about standard typologies. It should be stated that these typologies are not developed arbitrarily, but follow from structural considerations.
The Reden Bridge (p. 71, fig. 5), is comparable to a horizontal parallel-flanged trussed beam.

A new landmark, the Bitterfelder Arch has been erected on the Bitterfelder Mountain, finalised in August 2006. This architectural sculpture, some 28-metres high, 81-metres long and 14-metres wide, is a new symbol in the former coal-mining and chemical industry area. It symbolises the region's successful transformation into a centre of technological and scientific research on the one hand, and proclaims an attractive recreation area

with beautiful lakes on the other hand. The idea and the design for this impressive steel construction came from Frankfurt's sculptor Claus Bury.

The Bitterfelder Arch has two lenticular trussed beams assembled together into one arch and then translated three times through the structure. This example suits the element-based approached very well, as it is composed of several element types mentioned earlier. The idea of two lenticular two-dimensional elements meeting to form one arched-like element was already very clear at the first steps of the design process. Only the way these elements meet at the top of the arch was modified. It is remarkable how the final construction resembles the first sketch.

Trussed columns
Linear columns can be reinforced and stabilized with the help of tension cables. In the following illustration, a range of columns supporting a footpath between two buildings are reinforced by four cables spanned at the top and at the bottom of the footway.

Roof trusses
In contrast to flat surfaces, roof trusses possess a change in direction in their plane.

That is why they are not planar anymore according to Euclidean plans, but they still only need two parameters to be described. Just like for a paper ball, the change in direction increases the stability and the bracing of the structure. They can be considered as non-parallel flange beams, where the top flange follows the shape of the roof and the bottom flange carries the tensile forces. An important design factor for the roof is the free roof space, so the bottom flange has to be designed specially.

Like arches, roof trusses induce a horizontal spreading force which must be resisted by another structural element or a support. This is often realised by means of a tension member that ties the bearing points together.

Otherwise, the diagonal elements must carry bending moments and the horizontal spreading force must be absorbed by the rest of the structure.

Grids
Grids are more or less horizontal trusses, which are rigidly connected in order to ensure continuity. They are structural systems where the typology and the sections can be varied to suit the structural require-

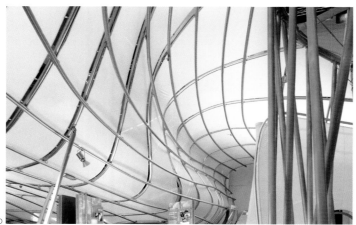

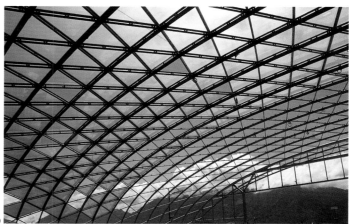

17b

18b

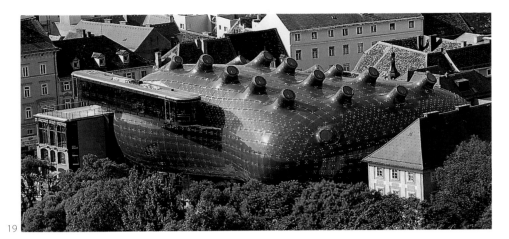

19

19 Spatial framework pinned on the bubble roof
 of the Kunsthaus Graz, Graz (A) 2003, Peter Cook
20 Design and construction of the BMW Welt,
 Munich (D) 2007, Coop Himmelb(l)au
 a Rendering of the steel structure
 b Under construction

ments. As for the total design of the structure, different approaches to optimisation can be used.

The spatial organisation of the grid and the position of its supports result from different issues of the design process. Different variants can be studied for any given grid organisation. A general rule in designing any structure is to keep the length of the load path from the point of application to the foundations to a minimum.

The connection between the different elements can be either above or in the same plane as the grid. The first solution is much easier to realise and convenient to build, but leads to a greater construction depth. The second solution possesses the opposite advantage and inconvenience. In this case, much more thought must be given to the design of the assembly.

The beam grillage of the ZDF-Fernsehgarten is made of readily available channel-shaped sections. The nodes were fabricated in one piece and are then connected to each other with linear elements. This grid is purely two-dimensional as the elements are connected in the same plane (figs. 6 and 7).

The topologies of grids can follow a number of different principles. A good principle is to rotate two similar grids relative to each other. The Red Bull Hangar 8 in Salzburg demonstrates this principle on curved surfaces. It consists of parallel ribs and a triangular net of circular tubes. The duplicated tubes intersect at the same height and this ensemble lies upon the parallel ribs (fig. 18)

Grids are very adaptable and can follow very complex surface geometries. Very complex surfaces with non-similar geodesics lines require specific fabrication of each element. This causes high production costs and is often dissuasive. However, the result is very convincing.

Domes

The principle of the arch can be generalised into two dimensions by rotating a given arch, or any other planar shape, around a vertical line. This gives birth to the well-known concept of domes and vaults. If accurately designed, these structures benefits from the principle of arches in several directions. In fact they behave almost like membranes. A membrane works under pure compression in every direction of space.

Sheets

Sheets are authentic two-dimensional steel elements. They are used when the structure has to transmit distributed loads, like at the connection points, for example. Their behaviour cannot be decomposed into the behaviour of one-dimensional elements, but must be considered globally. Contrary to the theory of beams by Stephen P. Timoshenko for linear elements, the understanding of the behaviour of sheets relies on the theory of shells and plates. This theory is much more complex, as the stress states and the behaviour laws must be assessed in the two dimensions of the surface, which is often non-planar in a Euclidean sense. In one dimension, three inner forces must be assessed. In two dimensions there are six unknowns. As for linear elements, sheets can be divided into two categories, depending on the type of forces they transmit.

In concrete construction, formwork has to keep the concrete in place while it is hardening. Often made of wood, formwork can also be made of steel. Steel offers the possibility of casting very specific shapes. Inspired by this technique, sheet elements can also be used structurally too.

Sheets under tension or compression
Planar elements are in a state of pure compression or pure tension when all the directions of the applied forces are contained in the middle plane of the steel sheet. Depending on the orientation of the force, the stress state can be uni- or biaxial. As the amplitude of the stress state usually varies, it is worthwhile optimising the thickness. Stability, which is the predominant issue in case of a pure compression state, can be controlled by stiffeners or folds.

Sheets under tension and compression
Bending moments appear whenever the directions of all the applied forces are not contained in the middle plane of the planar element. The section of large planar elements must be adapted to the diagram of bending moments for economical reasons. This can be done through stiffeners, folds or welded half profiles.

Spatial elements

Three-dimensional elements are elements in which no dimension is predominant, like a volume. They cannot be reduced in any particular dimension, or every direction plays a determining role in the design process. Structural elements with three dimensions are mostly composed of elements with one or two dimensions, as steel is rarely produced in blocks for structural engineering purposes.

Every steel construction is a three-dimensional structure composed of a set of elements with different dimensions. Some elements cannot be decomposed into subsystems, without losing the principle of the element as a whole. Those elements can be considered as authentic three-dimensional elements. In practice, they correspond mainly to what are called 3D frameworks. For global considerations like wind and seismic loads, the structures must always be considered as a whole. The design of every element depends on the analysis of the global structure.

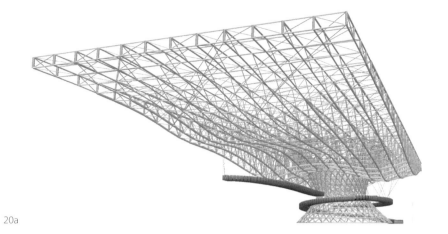

20a

Three-dimensional trusses have the advantage over two-dimensional trusses of being spatially braced. They do not need any additional bracings to be stable.

Spatial frameworks
Spatial frameworks are common elements in steel structures. They are usually inherently stable and are prefabricated to a large extent. They can be divided into a set of typologies in the manner discussed earlier.

Lattice columns
The complicated lattice column from the Stazione Metropolitana Linea 1 in Naples can be approximated by a straight column for the first step of analysis. In a further step, this straight line splits and acquires spatial dimensions. In order to determine the forces in the different branches of the tree-like column, a three dimensional model is needed. This emphasises the richness of possibilities emerging from simple ideas.

The very impressive and comprehensible tetrahedron holding a viewing point shows what can be achieved with a spatial lattice structure. The equilibrium of the global structure takes place in three-dimensional space (p. 85, fig. 27).

Lattice beams
A lattice beam is a beam where the flanges are connected by a lattice web. They are principally designed to support bending. No dimension is less important than any other and the structure works spatially. The freedom in the design of linear elements complements the freedom of the planar extensions and the freedom inherent to the spatial dimensions. The results are manifold and unlimited.
Such a lattice beam can also be an independent part of a broader structure. The spatial framework placed on the bubble roof of the Kunsthaus Graz illustrates this idea. The design of such element can be carried

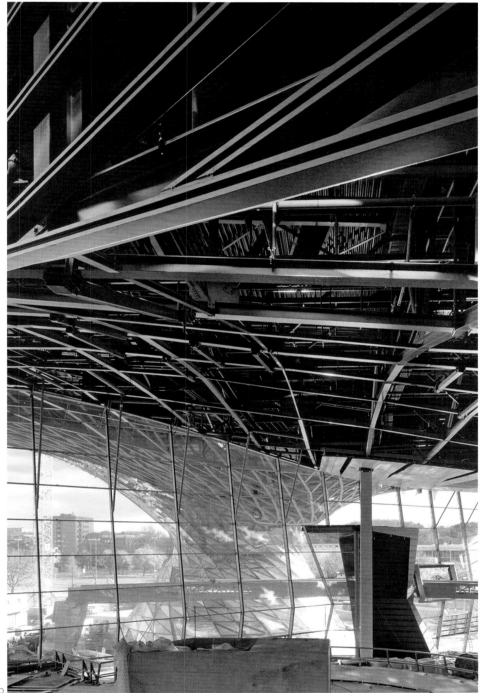

20b

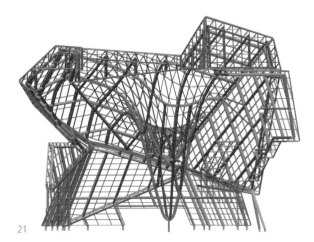

21

out independently. Only the bearing loads are necessary to design the rest of the structure. Then, it is just pinned on the global structure.

Spatial webs
Spatial webs result from the union of two-dimensional frameworks. Their stiffness is increased through the presence of the diagonal elements. They can be considered as planar frameworks with a definite thickness. Some particular shapes can be identified even if the variety of spatial webs is infinite. If we take for example two identical webs and translate them through space, we

obtain a clearly defined family of spatial webs. Then we can also distinguish whether the points of one web are located vertically to the points of the other web or not. The space between the two webs can be used. In megastructures, they can even house entire floors.

The following examples of structures with planar webs combined into one complex spatial web have in common impressive outer dimensions and huge cantilevers. The design aimed to develop the given form from the architect in accordance with load distribution. The connective behaviour

between the two webs arises from diagonal truss members (figs. 21 and 22).

The crystal in the MDC in Lyon illustrates how a complex three-dimensional framework can be generated from a two-dimensional grids of beams. This example also highlights plate behaviour. The simple logics of assembling planar trusses can be developed much further (fig. 21).
To make a reference to the site's history, the structure of the bank Dexia in Luxembourg (p. 178) had to be demonstrably built out of steel. The image of the architect of a "lattice balancing on office pins" was achieved by freely positioned V-shaped struts fixed between the top roof beams and the stabilising cables with cast steel joints. In a Z-shaped angular arrangement, the glazed roof spans over 40 m horizontally and 25 m vertically. The result is a planar structure relying on a complex set of two-dimensional elements. The structure is spatial when considered globally.

Global structures
Global structures consist of assembled one, two or even three-dimensional steel elements. The elements have been designed according to the loads on through them and they transmit those loads to the adjoining elements. Linear elements accurately designed against buckling are stable in their initial geometry. Planar elements composed by those linear elements are also stable if their connection principles assure the plane stability, and if the bracing is accurately dimensioned. The final step of the design is to assemble those elements into one huge, three-dimensional structure. There another set of stability verification calculations must be undertaken for the global system. In particular, horizontal forces like wind must be considered.

The BMW Welt in Munich is a very complex three-dimensional structure. Its design can be broken down into different vertically

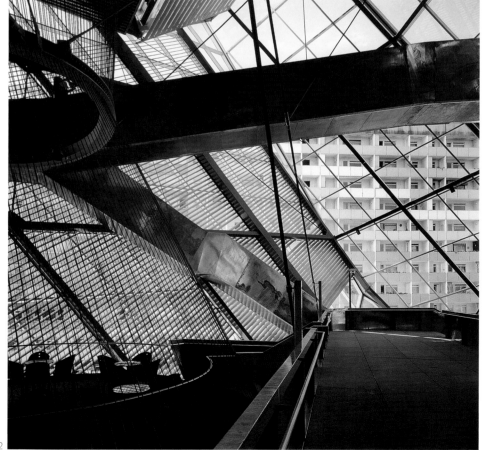

22

23a

23b

21 Musée des Confluences, Lyon (F) to be
 completed 2011, Coop Himmelb(l)au
22 The exceedingly unbalanced steel structure
 of the UFA Dresden, Dresden (D) 1998, Coop
 Himmelb(l)au
23 Node elements
 a Welded connection
 b Straight compression member pinned
 connections

stratified layers. In the cone area the structure works like a shell, whereas on the other edge it works like a spatial web on columns. Even if some elements need a particular focus at some stage of the design process, the structure must be viewed as a whole to understand how it works. This can only be done with the help of special software (fig. 20).

A set of planar elements assembled with variable angles leads to interesting analysis in three dimensions. The UFA Cinema Centre in Dresden is very striking due to its sharp corners and the global inclination of the structure. The steel structure clamped to a concrete parallelepiped concrete block seems extremely unbalanced. Nevertheless, it stands and that is very impressive (fig. 22).

The outer structure of the Kunsthaus Graz consists of glass supported by a steel structure. The complex bubble form geometry requires a global approach.

Bracing
The bracing of a global structure is ensured when at least three diverging rigid planes run through the entire structure. Those planes can be built out of frames, trusses or cross-braced column-beam systems. Steel constructions can be braced directly through the other elements of the structure, or by adding supplementary bracing elements like triangles or crossed squares. Connections that can resist high bending moments can also stabilise the structure.

The structure must also be braced globally. This consideration influences the design of the foundations.

Node elements

Node elements are similar to spatial elements but appear as a point when viewed from afar. They can be seen as three-dimensional, as no dimension is less important than any other. They are located at the intersection of the other structural elements. They are designed in order to transmit the loads between the elements in contact and can be classified into two types: bolted and welded. Their design often influences the design of the whole structure and they limit the optimisation process. Furthermore, they have also a huge impact on the aesthetics of the structure and require particular attention.
They should be designed as early as possible as their role in the final design is often determinant.

Fabrication
Elements can be either bolted or welded together. The question whether to design bolted or welded connections largely depends on the capacities and the know-how of the contractor There are also some structural design and practical considerations to take into account.

Bolted joints
Standard bolted joints consist of hexagonal headed srews that pass through and join two or more elements together. Their threads engage with nuts and washers. Bolted elements can be used for assembly in the factory or on site. Their use is widespread. They enable a rapid and efficient construction sequence. However, bolted structures are approximately 10 per cent heavier than a comparable welded alternative. Bolted joints can be either pinned or rigid, depending on the number and the location of the srews. One should keep in mind that in practice bolted connections are always in a state somewhere between rigid and pinned.

Welded joints
Welded elements are permanently attached to one another. There are often made in factories or fabrication yards. Welding on site

must be supervised by a welding expert and requires competent workers, which involves higher costs and more planning work. Welded connections can support higher loads than bolted connections. They provide almost full continuity between the elements. In this sense, they are always moment-transmitting rigid joints. Welding is generally the only way to join tubular elements or sheets effectively. Otherwise, complicated connection elements must be designed.

Types
As mentioned in the description of static systems, the extremity of a linear element possesses six degrees of freedom, three of translation and three of rotation. The different types of bearing conditions are defined through the way those degrees of freedom are treated.

Points of support
The points of support at the base of columns often take the form of a welded connection plate, which distributes the stress into the concrete foundation. The plate can be reinforced through gussets, depending on the thickness of the plate and the intensity of the support reactions. The plate is then anchored to the concrete foundation. The connection can be considered as pinned or fixed, depending on the number of anchors.

Column-column
Joints between two columns are sometimes necessary and enable both continuity and change in the form. They generally use a spliced connection.

Column-beam
The connection is made through connection plates. The articulation of the connection is controlled by two parameters: the thickness of the plates and the position of the connective elements. Rigidity increases

24
25
26

with the thickness of the plates. The closer the srews are located to the centroidal axes of the elements to be connected, the more articulated the connection becomes.

Beam-beam
The same principles as for the column-beam connection apply. Depending which parts of the beams are connected (web or flanges), the connection is rigid or articulated.

2D-truss
Joints in trusses can be either bolted or welded.

Spatial
Spatial connections are often real spatial elements and can reach high degrees of complexity. Therefore such nodes are often prefabricated in shop with small cantilevers in the orientation of the linear elements to be jointed, so that final assembly on site is reduced to simple connections between cantilever and linear elements

Floors
Floors transmit the loads of in use spaces to the bearing structure. They belong to the semi-structural elements, as their design embraces more than just structural criteria. Floors must also meet specifications in terms of thermal and acoustic performances, a certain degree of fire resistance and accommodate building services, as well as other elements like suspended ceilings.

Generally, floors consist of beams and a slab, which can be made of prefabricated elements, simple shuttering or steel composite decking with in-situ concrete or combinations of both. Especially when using prefabricated elements the often attributed function of slabs as diaphragms for horizontal stability has to be ensured by designing adequate connections between the elements themselves and the beams. The opti-

mum solution depends on the degree of prefabrication, the nature of the interaction between slabs and beams, and between steel and concrete.

The deflection of floor beams is often the critical design parameter in long spans. That means the SLS determines the cross section, which leads to some reserves for the ULS for some exceptional load cases like fire. For composite slabs, the weight of the wet concrete is most often the critical case which determines the maximum span. Concrete is relatively heavy and in the fluid state does not yet contribute to the loadbearing capacity. However, temporary propping may reduce this impact but involves more work and delays during construction. Temporary propping of beams during concreting may have a larger influence on the final deformation, as discussed in Chapter 4. Another solution to disproportionate deflection is to precamber the beams. Precambering should only compensate for deflections from dead or permanent imposed loads and not from live loads.

Facades
Facades can be seen as the multifunctional skin of a building. Their design is based on four different aspects: structural mechanics, building physics, specific material knowledge and the design of details. The materials used in facades range from metals and various glass types to different stones and synthetic or composite materials. The specific requirements result from the often complex geometries, the high demand on quality of fabrication and surface finish, the degree of prefabrication, and the resistance and durability of the end product.

The design of the interface between the main structure and the facade plays a major role, as different tolerances and differential movements have to be considered. These differential movements are a consequence

of the horizontal and vertical displacement of the main structure, temperature strains and differential settlements of the foundations. The problem of interface between the main structure and the facade is often solved by special connection details which accommodate the differential movements and tolerances.

Some of the ways steel can be used in facade structures are illustrated in the following examples.

In the roofs of the Nordpark Cable Railway in Innsbruck, the main structure and the facade structure are the same. The outlines of the steel sheets follow the complex geometry of the facade.

In the example of the facade of the BMW-Welt in Munich, the heavy loads and displacements of the roof led to the facade being designed as a flexible system. Otherwise, buckling considerations would have led to large sections being used in the facade substructure. In any case the significant loads from the roof made a rigid, non-deflecting structure inappropriate. As mentioned previously, the structure of the facade of the BMW Welt plays an important role in the overall behaviour of the structure. It forms a elastic support structure for the heavy roof and can accommodate vertical displacements.

The membrane facade on the King Fahad National Library in Riyadh, to be completed 2009, used steel directly to build the facade. Steel cables connect saddle-shaped elements together.

24 Steel deck iron sheets, UTZ Berlin, Berlin (D) 1998,
 Eisele + Fritz
25 Steel mesh cycling stadium in Munich, Munich
 (D) 1998, Dominique Perrault
26 Stainless steel facade, Milano Fair, Milano (I) 2005,
 Massimiliano Fuksas
27 Stazione Metropolitana Naples, Naples (I) 2008,
 Dominique Perrault

Computational design

Computers have become essential tools for structural engineers and designers. No longer mere drafting and calculation machines, computers provide the possibility of linking generative and analytical processes in a cyclic manner. Insights gained by structural analysis can be fed back to inform and improve the design proposal iteratively. Every aspect of the design process that can be formalised can also be tackled by computational means.

The formalised systems of computers are not inscribed into mechanical cogwheels and step reckoners, but provide a string of symbols based on certain syntax. Scripting and programming help to access this layer of description where the algorithm (the machine) and the data (the design) are represented with similar symbols and syntax.

Models

The proposed classification for the design of structural steel elements is not arbitrary. This decomposition is based on the geometry of the elements involved and reflects a fundamental approach of structural design. Depending on the precise object and of the degree of accuracy aimed in the study, the three-dimensional general mechanical theory is simplified into two or one-dimensional theories, that is to say continuum mechanics gives birth to the theory of shells and plates, or to the theory of beams.

The dimensional approach

It is important to have a clear mind about the hypothesis and the approximation held within each dimensional simplification. On the other hand, it is often necessary to model complex structures through less accurate models in the first place. Most of the complex systems can be understood through simple approximations, and com-plex models are needed only to resolve intricacies, should they arise.

The finite element method

The finite element method (FEM) is a very powerful tool to analyse structures. Even though the implementation of the FEM code is often quite complex, the principles underlying the method are not different from the general principles of structural mechanics. The method consists of approximating the continuous solution of the mechanical problem formulated at the infinitesimal scale using a discrete set of elements. In fact, the method is purely mathe-matical and can be applied to a wide range of similar problems where partial differential equations are provided.

The resulting set of discrete finite elements is called mesh and follows the geometry of the structure. The elements are connected through nodes, where the integration of the equations takes place. The complexity of the method lies in the formulation of the structural problem at each element and in the solving of the system equations. The information for each node, like the components of force and the components of displacement, are stored into two big matrices.

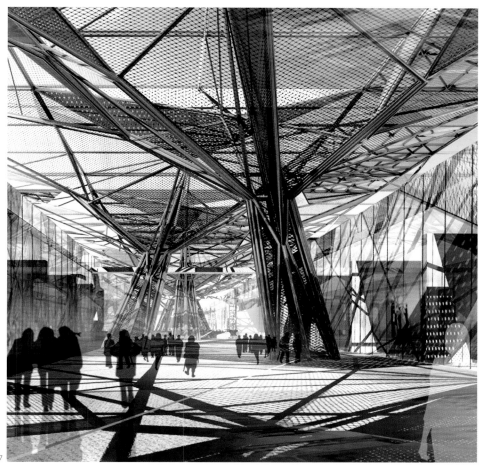

27

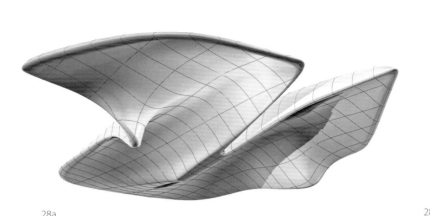

28a

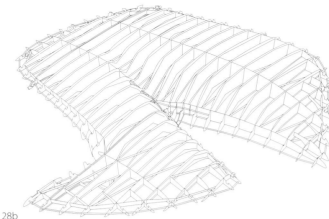

28b

Thanks to Hooke's law, this leads to a huge number of linear equations relating the components of force and the components of displacement.

The solution between the nodes is interpolated on the elements. This is why the solution is always an approximation of the continuous solution. The interpolation can be by various means, from simple linear relations to more complex functions.

Software programs

There is a very wide range of available software packages to implement FEM on structures. They all rely on the same basic principles, but differ in their complexity and accuracy. Some of them can only model structures made of linear elements. More complex software programs also allow the use of planar elements and even spatial continuums.

As steel structures can be decomposed into linear elements, – even complicated three-dimensional structures consist mostly of one-dimensional elements, FEM-software for linear elements are often adequate. Two-dimensional or spatial elements are then necessary only when dealing with genuine two or three dimensional elements like sheets or connection nodes.

Interfacing disciplines

Successful collaboration between architects and engineers implies efficient interfaces for communication and data exchange. Both the architect and the engineer work with digital tools and their inherent core logic is similar in both cases. Nevertheless the data input needs of the disciplines are different. While architects focus on volumes and surfaces, engineers work with centre lines and mid-planes. Architects are interested in space and volumes, whereas engineers try to simulate structures and their physical behaviour in the simplest way.

Off-the-shelf software packages generally cover the requirements of only one discipline but their application programming interface offers the chance to customise geometry description and automating data export. In order to streamline this process custom-written script transfer lines, curves, surfaces and volumes are generated in the 3D modelling software into nodes, elements and meshes for subsequent structural analysis.

Integrative design

Once such an interface is established it can be augmented by a feedback loop that takes analysis results as a new input parameter of the generative process. Thus generation and analysis are no longer linked in a linear process but constitute a circular connection.

The concept of circularity exploits the inherent potential of computers in design, analysis and fabrication and provides a common platform for collaboration. Scripting and programming enable fast and specific solutions, which are very important in the early design stages of a project. They offer an alternative to Building Information Modelling (BIM) which seeks to provide one single model for all parties involved in a project. The concept, borrowed from the automobile and aviation industry, often proves cumbersome in the beginning of a project, a phase which is accompanied by massive changes and multiple possible versions of a project.

The integrated design process raises questions about the responsibility and liability of the different protagonists. If data is not reproduced but shared by the different parties involved in the design process to fully exploit the digital workflow, then potential errors may not necessarily affect the initiator but appear in a later phase.

This example shows that digitalisation of planning and construction requires an appropriate legal framework where the relationship between planners and contractors is adapted to the changing technological realities.

The Hungerburgbahn by Zaha Hadid

The implementation of the stations for the Hungerburgbahn, a cable railway in Innsbruck, designed by Zaha Hadid is a good example to illustrate an integrative design process (fig. 28).

The use of conventional plans and drawings in the design of the roofs was almost entirely replaced by a three-dimensional digital model. The model provided all data necessary for planning, manufacturing and assembly. The connection between the loadbearing structure and the skin was subject to extensive investigation. The aim was to create a series of continuous and homogenous surfaces without obtrusive joints and fixings. These qualities and the specified thermal standards could only be achieved with glass. The float glass used was coated on the inside with polyurethane resin, which accounts for the coloration, in order to ensure a residual loadbearing strength in the event of breakage.

The loadbearing structure consists of a 1.25 m grid of 8 and 12 mm thick steel frames following the outlines of the roof at a distance of 60 mm. Those steel frames are connected transversely through longitudinal steel frames leading to a total depth of up to 3 m. The roof is supported by four elliptical vertical and two circular horizontal supports that are anchored in the surrounding concrete structure. The design of all four stations is based on this system, which is adapted to the various forms. The parallel ribs allowed significant simplification in the design and construction processes.

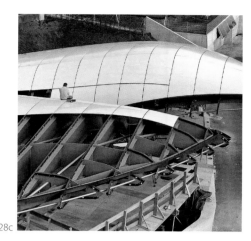

28c

In order to ensure an economic fabrication and mounting of the steel elements, all the necessary information was written directly on the steel plates. The CNC machines were controlled through a 3D model of the structure that was directly derived from the architectural and structural planning. The outer contours of the steel elements were developed from the geometry of the shell. Line drawings of the individual elements were sent to the steel construction firm so that they could be cut from large sheets. The precise positions of all elements adjoining a building component were marked by circles in the 3D model. In the production process, a hole was cut in the steel sheets at these points. These serve as markings, and some of the holes were used for bolt connections. The loadbearing capacity of the glass dictated a maximum width of 1.25 m for the panes.

The maximum length of 3.00 m was based on production factors. Over most of the roof area, the glass rests on the cross-ribs. At the ends of the roof and where great differences occur in the height of the ribs, there are additional supports in the longitudinal direction. Depending on the loading and position, the panes are supported on two, three or four edges. In view of possible snow loads of up to 300 kg/m^2 in Innsbruck, additional steel ribs were bonded to the inside face of the flat panes of glass. Since each panel has a unique double-curved cross-section, negative forms were created manually, using curved steel tubes. The steel construction was based on 3D models of the individual panes of glass cut out of the overall form in the computer-drawn model. The first layer of glass bent to shape over such a form serves merely as a support for the actual panel. The finished sheet was compared with the digital original by means of a 3D laser scanner. Various means of connecting the steel to the glass were considered. Ultimately, a

simple solution was found, consisting of a continuous linear polythene section bolted to the steel sheets. Since the sections follow the form of the ribs and the glass skin, they had to be individually made. Digital planning and modern production techniques helped to minimise the costs, however. It was possible to cut all sections from flat sheets using a five-axis cutting tool. The geometry of these sections was automatically created for this project with software specially developed by "designtoproduction".

Compact T-shaped sheet-metal elements

20 cm long were used for fixing the glass. These were bonded to the inside face and bolted to the polythene sections. The structure was efficiently implemented using modern fabrication technology in combination with digital and adapted planning methods. The technology also exerted an influence on the details: adjustable fixings, for example, were modified into simple, standardised sheet elements, while the design and manufacture of the polythene sections became more complex and were possible only with the use of intelligent, applied planning methods.

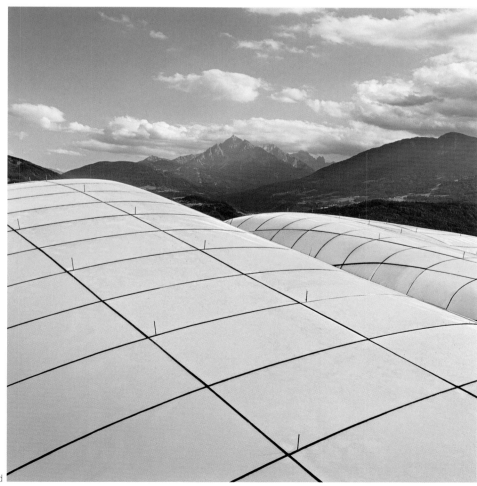

28d

29

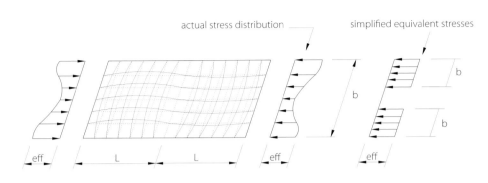

actual stress distribution simplified equivalent stresses

30

Cold formed steel members

"Cold formed steel construction" is also known as "light gauge steel construction", the two terms being synonymous. It is characterised by both the method of forming the members and the thinness of the steel used. Cold-formed members are produced from material in the form of coils (fig. 29).

An important characteristic of cold-formed sections is that they can be formed from pre-coated coil and the coating is not damaged by the manufacturing process. A wide variety of coatings are available. Thus, sections are generally produced pre-galvanised whereas cladding profiles may be produced with a wide variety of colour coatings depending on the finish required and the aggressiveness of the environment.

Cold formed sheeting profiles may be as thin as 0.4 mm and sections start at about 1.0 mm. At the upper end of the range, material as thick as 20 mm may be cold-formed but this is relatively rare and attention is concentrated at the thinner end of the range. The yield strengths used are generally in a similar range to those for hot-rolled sections but, for special applications, some extremely strong steels are available.

The thinness of the material means that cold formed sections are much more susceptible to all forms of buckling than their hot rolled counterparts and this consideration plays an important role in the design process. A form of buckling that is more or less specific to such sections is the "local buckling" of flat elements of the cross-section which is characterised by a series of buckling waves (fig .30). Local buckling may commence at a relatively low stress and, for economic design, it is generally necessary to design for the post-buckled condition. This leads to the concepts of the "effective width" and "effec-

tive section" whereby the post-buckled region is replaced by a reduced width at uniform stress. A consequence of this is that if a designer uses sections with a high width to thickness ratio, he should be prepared to see local buckles under service loads.

Local buckling is often inhibited by rolling in "intermediate stiffeners". At negligible additional cost, these delay the onset of local buckling and increase the strength of the section. They are, therefore, widely used.

Bearing these considerations in mind, some typical cold-formed sections, illustrating their practical applications are shown in many of the figures below.

Typical, relatively simple cold formed sections which are in general use for a variety of applications are the lipped channel and Z-sections. The lips serve to strengthen the flanges against premature local buckling in much the same manner as the intermediate stiffeners discussed above. The lipped channel is the basic "work horse" of cold formed section construction and a wide range of such sections are generally available from stock.

The purlin sections shown in figur 32 are developments of the generic channel and Zed sections. Purlins are mass-produced in large quantities for a specialised market and this justifies the more expensive tooling required to roll in the additional lips and folds in order to optimise the design.

Wall studs used in lightweight wall construction are often the simple C-section. A recent development is to incorporate slots at the time of rolling in order improve the thermal performance of the wall and to avoid "cold bridges".

"Structural liner trays" are also known as "cassettes". They are a particular application

of the generic lipped channel with a deep web and may be combined with a cladding profile to form the two-skin wall or roof construction. Another form of cassette wall construction will be discussed in more detail later.

Sheeting and decking profiles also started life as simple trapezoidal profiles and have evolved into more complex shapes. Long-span decking profiles are generally stiffened against local buckling in both the flanges and the web). An even more highly stiffened profile, with transverse stiffeners across a wide flange, is shown in figure 33.

1. Simple system

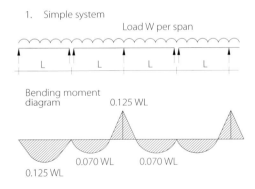

2. Sleeve system

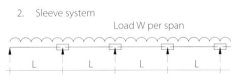

3. Overlap system

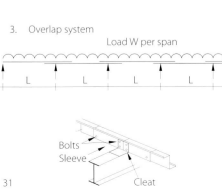

31

29 Pre-galvanised steel
30 Local buckling of a flat element giving rise to the effective width
31 Basic purlin systems
32 Simple cold formed sections either zeds or hannels
33 Highly stiffened decking profile

Pallet racking and other systems of mass-storage represent another major industry which makes extensive use of cold formed sections. The typical racking upright has a very specific cross section with arrays of holes to engage clipped connections from cold formed section beams. As with all of these examples, this upright, together with its holes, is formed and cut to length in a single continuous rolling operation.

These examples have been chosen to illustrate the potential of cold formed sections and the wide variety of shapes that can be created. Many of these examples also give rise to their own specialized technology and some of these practical applications will now be considered in more detail. It will be seen from these applications that cold formed sections are often at their best when they interact together with other materials or components.

Purlins and sheeting rails
In practical terms, purlins and sheeting rails represent the most common usage of cold-formed sections. In what follows, the term "purlin" may be deemed to include sheeting rails the distinction being that purlins generally support roof sheeting or decking whereas sheeting rails are used to support wall cladding. In many countries, hot rolled purlins are virtually unknown and it follows that purlin design has now reached a high level of sophistication and is extremely competitive.

Purlins only have meaning when they are used to support some form of cladding and this cladding provides resistance to both lateral and distortional buckling of the purlin. It follows that economic purlin design generally requires that advantage is taken of the interaction between the purlin and the cladding etc. that it supports. The problem is that there are a number of different cladding systems in general use, all providing different amounts of restraint. EN 1991-1-3 provides a simple test to quantify this interaction in specific cases and this provides a basis for design. From this starting point, many manufacturers have carried out their own research and development in order to produce safe load tables.

There are a number of possible purlin systems in use and many manufacturers offer a choice of system, depending on the profile offered and the span required. Here, we must note that generic "Zed" sections "nest" together for easier transport whereas generic "channel" sections do not. This nesting capability also has implications for the systems which may be used.

The "simple" purlin system consists of two-span lengths and uses conventional cleats to connect the purlins to the supporting structure. The bending moment diagram is dominated by the high moment over the internal support. Notwithstanding the relative thinness of the material, economic design requires that account is taken of the redistribution of bending moment following yielding with local buckling at this support. This generally necessitates that design proceeds on the basis of tests, often accompanied by sophisticated numerical design procedures. It is important to note that, when using this simple system, the joints between the two-span lengths of purlin should be staggered in order to equalise the loads on the supporting structure (frames). This means that, regardless of whether or not there is an even number of spans, there will always be a requirement for a single span condition at the ends of the construction.

In the sleeve system, the sleeves are semi-rigid and their moment-rotation behaviour is "tuned" in order to approximately equalise the hogging and sagging moments in the internal spans. With generic Zed sections, because of their nesting capability, the sleeve can be an offcut from the basic purlin section. With generic channel sections, a purpose-made sleeve is required. The end-span generally requires a section formed from thicker material.

The overlap system takes advantage of the nesting capability of generic Zed sections. At the internal supports, where the bending moment is approximately twice that in the span, twice the material is provided. Thus the strength of the structure is automatically tuned to the shape of the bending moment diagram. There is no need for any re-distribution of bending moment and relatively simple design procedures may be used. The roof of a typical industrial building often utilises three-fold interaction between the main components. As noted above, the purlins support cladding which in turn strengthens the purlins. At the same time, the purlins are supported by relatively slender portal frames and it is usual to provide "fly braces" which brace the frames against the purlins at regions of high bending moment in order to restrain the tendency of the frames to exhibit lateral torsional buckling. This technology of mutual interaction is not unusual with light gauge steel sections.

Structural systems for low-rise buildings
Worldwide, there is greatly increasing usage of cold-formed sections as the basic structural system for low-rise buildings. The USA has led the way in this development and their "Residential Steel Framing Manual" (loose leaf and continuously updated) reflects the prevailing state of the art. The specific advantages of light gauge steel framing in low rise building construction are speed of construction, a high degree of pre-fabrication and quality of construction. When steel framing first made its appearance in house construction, developers simply re-engineered timber framed construction. Thus, in wall construction,

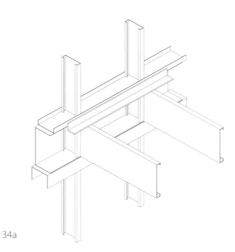

34a

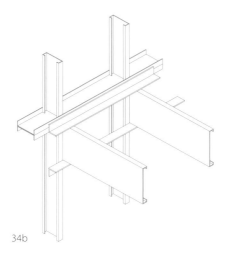

34b

34 Framing detail with:
 a Platform construction
 b Balloon construction
35 + 40 Residential house, Paris (F) 2003, Hamomic Masson
36 Global stability of a lightweight building
37 Elevation of a building with vertical X-bracing
38 + 39 Typical cassette wall in house construction

100 × 50 mm timber uprights were replaced by similar sized cold formed steel channel sections. These "wall studs" were located at the same 400 mm centres, a dimension that has little to do with the requirements of structural engineering. Many of the framing systems used today are similar to those of 30 years ago except that the stud spacing has generally been increased to 600 mm, the limitation being the spanning capability of the internal lining (e.g. plasterboard). Figuress 34 – 39 show the typical framing for a small house.

There are two basic framing systems in current use which are usually defined by the terminology "platform" and "balloon". Additional fundamental differences arise as a consequence of the degree of prefabrication that is used and whether the primary fixing technology is welding or the use of mechanical connections (srews or screws). Differences may also arise in the way that in plane wind shear (racking) forces are resisted.

In platform construction, the structure is built storey by storey so that each floor can serve as a working platform for the construction of the floor above. The walls are not structurally continuous and loads from the walls above are generally transferred through the floor structure to the walls below. A typical detail with platform construction is shown in figure 34 a.

The wall studs are connected to horizontal tracks top and bottom and the floor joists are seated on the top track of the studs below. Sufficient stiffening is incorporated in the connection to ensure the safe transfer of vertical load through the floor construction.

In balloon construction, the wall panels are continuous over two or more storeys and the floors are attached to them. It follows that loads from the floors above pass down the loadbearing studs without affecting the incoming floor construction. A typical detail with balloon construction is shown in figure 34b.

Both of the above methods of framing may use "stick" construction, in which individual members are assembled on site, or they may use varying degrees of prefabrication. Members may be cut to length on site with a hand-held saw and connections may be made by any of the usual mechanical methods such as srews, self-drilling, self-tapping screws or blind rivets.

Alternatively, wall and floor sub-frames and roof trusses may be prefabricated in the factory in purpose-made jigs. Factory-made connections may be welded or they may employ any of the conventional mechanical methods such as srews, screws or rivets. Welding has the advantage of simplicity and permanence but has the disadvantage of destroying the benefit of pre-galvanising at critical locations in the structure. Thermal insulation and some of the lining and finishing materials may also be applied to the steel sub-frames in the factory to form panels. Factory-prefabricated units are generally connected together on site by bolting.

Prefabrication of wall, floor and roof units is taken a stage further in modular or "volumetric" construction. Here, light gauge steel boxes, which may, for example, be hotel room units, are completely prefabricated in the factory before being delivered to the site. It is usual for all internal finishes, fixtures and fittings, and even the carpets, curtains and furniture, to be fitted in the factory. On site, the units are stacked side-by-side and up to several storeys high on prepared foundations and service connections made to form the complete structure. Nowadays, many "out-of-town" hotels and motels are built in this way.

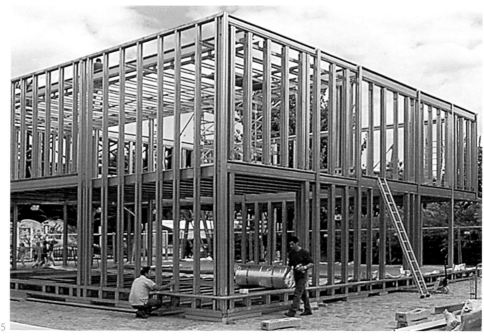

35

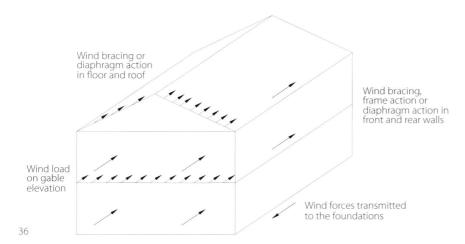

Wind bracing or diaphragm action in floor and roof

Wind bracing, frame action or diaphragm action in front and rear walls

Wind load on gable elevation

Wind forces transmitted to the foundations

36

37

Window opening

Window opening

Global stability of low-rise buildings

The requirements for the global stability of lightweight construction raise interesting problems. Figure 36 illustrates what is required to transmit wind pressure on a gable to the foundations of a typical small building. Initially, the bending resistance of the gable members gives rise to in-plane forces in the floor(s) and roof. These forces are generally transmitted to the side walls (referred to as front and rear walls in the diagram) by means of stressed skin (diaphragm) action. This is a subject that is considered in more detail later. It should not be automatically assumed that lightweight floor construction is adequately strong for this purpose. In particular, timber-based floors need careful consideration in this respect.

Attention then passes to the side walls which are subject to horizontal forces at the floor and roof levels. Generally, these are resisted by X-bracing in the plane of the wall, as shown in figure 37. This bracing system may be viewed as a vertically orientated truss. This, in turn, gives rise to the requirement for a significant holding-down force at the windward base of the truss. The weight of the building will not always be sufficient to provide this force, in which case a substantial foundation may be required. If the configuration of doors and windows leaves only a relatively narrow region of wall to be used for bracing purposes, the X-bracing may be replaced by K-bracing. In such cases, the holding-down forces and the consequential size of the foundations are increased.

Cassette wall construction

The cassette wall system is an alternative to the wall stud systems considered above. It has been pioneered in France under the acronym "CIBBAP". The basic arrangement for cassette wall construction is shown in figures 38 and 39. Lipped C-shaped cas-

settes span vertically between top and bottom tracks. Either platform or balloon construction may be used, although practical examples to date have generally used balloon construction. Cassette construction may be viewed as stud construction integrally combined with a metal lining sheet to provide a metal frame together with a flat steel wall. This flat steel wall may be external and provide the watertight skin of the building, or it may be internal with insulation and the weather-proof skin provided externally. These options are often referred to as cold-frame and warm-frame respectively, and are also available with other forms of light steel framed construction.

Light gauge steel cassettes do not readily lend themselves to stick construction and it is usual to prefabricate complete sub-frames comprising the cassettes and their top and bottom tracks in the factory. A particularly advantageous possibility is the use of press-

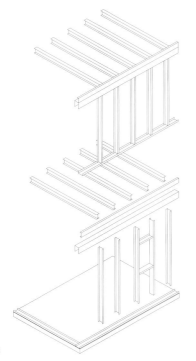

38

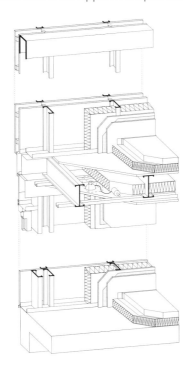

39

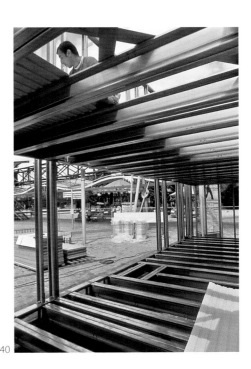

40

41

joined connections to form the seams between individual cassettes. Press-joining is quick, cheap and does not destroy the galvanising. It is considered in more detail later. With cassette construction, the structural details tend to be simpler than those with stud construction, so that fabrication and erection are particularly rapid.

The main advantages of cassette construction in comparison with wall studs may be summarised as follows:
- Simple details and rapid construction
- The wall structure is immediately water tight
- The stability problems of thin slender studs are avoided
- A rational provision for wind shear can be made without additional bracing members

The latter bullet point is particularly important and is worthy of more detailed discussion. A cassette sub-assembly is a ready-made shear panel or "diaphragm" for stressed skin construction (see later). Stressed skin design is explicitly allowed in EN1993-1-3 and the relevant clauses make it clear that the behaviour of a cassette wall panel in shear is not significantly different from that of a conventional shear panel

42

comprising trapezoidal steel sheeting framed by appropriate edge members. The main differences are (advantageously) the absence of the dominant profile distortion term from the deflection calculation and (disadvantageously) the necessity to consider local shear buckling of the wide slender flange. Cassette wall panels can, therefore, be readily designed on the basis of EN 1993-1-3 and it is found that, for most low-rise construction, a standard panel and fastener specification suffices to carry the wind shear without any special provision other than for holding down forces at the windward end of the diaphragm.

It is, of course, possible to incorporate longitudinal stiffeners in the wide flange of the cassette during the cold forming process at little extra cost. These stiffeners are particularly advantageous in resisting local shear buckling of the slender plate elements of the cross section.

Figure 41 shows a typical elevation of a cassette wall as used in typical house construction. The lines x-x show the division into prefabricated sub-panels for factory construction. The wind-shear diaphragms are also indicated by cross-hatching.

Infilled cassettes
In wall construction, it is usual to infill the cassette with thermal insulating material. In most applications to date, this has been a loose infill of mineral wool which is fitted at the factory prior to delivery of the sub-frame to site. However, most of the thermal insulating materials in common use (mineral wool lamellas, polyurethane, polystyrene and phenolic foam) have inherent rigidity and the possibility exists of pre-filling the diaphragm with rigid insulation which is bonded to the section. Advantage may then be taken of this in the design. Furthermore, bonded insulation has the added advantage of making the cassettes more resistant to

accidental impact damage and giving them a more solid "feel".

Lightweight flooring systems
In collaboration with lightweight steel framing, floor construction is logically lightweight and dry. However, there may be circumstances where heavier construction is specified, usually to meet requirements for fire and sound insulation or to increase the thermal mass. There are, therefore, three generic systems for floor construction based on light gauge steel components. Only the first two are lightweight:
- Steel joists (usually C- or Z-section) with a timber-based deck. The joists are usually on a module which coincides with studs on the supporting elevations.
- Trapezoidally profiled steel deck supported on steel primary beams and carrying a timber-based walking surface.
- Composite (steel-concrete) deck supported on steel primary beams.

Superficially, the structural engineering design is conventional and elementary. However, joist designs are rarely based on the bending resistance of the cross-section. Normally, the serviceability criteria of deflection and vibration control the design. Suspended floors can sometimes resonate with the vibrations induced by human footsteps and, although this does not usually lead to failure, it can be a source of significant discomfort. This problem tends to become more acute when lightweight construction is used.
Figure 43 shows a tried and tested means of providing a lightweight floor in dry construction with a performance which meets all of the criteria of strength, stiffness, serviceability (vibration), acoustic and thermal insulation.

Cladding systems
Nowadays, light gauge steel cladding systems are almost invariably used for industrial

2. Transfer panel
3. Resilient layer
4. Walking surface
 (floor covering over)
5. Insulation
6. False ceiling

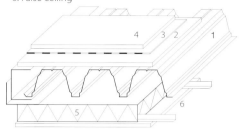

43

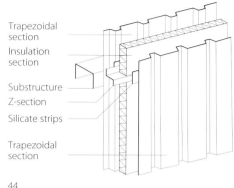

Trapezoidal section
Insulation section
Substructure
Z-section
Silicate strips
Trapezoidal section

44

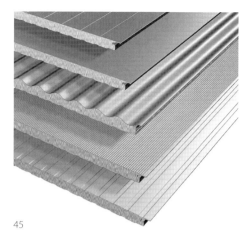

45

buildings and increasingly for commercial buildings. In some countries, they are also used for family houses. There is an increasing emphasis on high levels of thermal insulation and other aspects of building physics to the extent that the spanning capability of the cladding profile is often reduced to secondary importance. In wall construction, there is also the added emphasis of aesthetic considerations involving both the colour and the texture provided by the shape of the profile.

Complete cladding systems generally involve two metal skins with insulation sandwiched between them and incorporate a vapour barrier. In conventional applications, the two skins are kept apart by spacing members and the insulation is loose, as shown in figure 45. However, with this system, it is possible for loose insulation quilts to slip down, particularly in walls, or even to be inadvertently omitted from the construction. In recent years, problems of this nature have been highlighted by the use of thermal imaging of completed buildings.

Problems with built-up systems have contributed to a dramatic increase in the production of sandwich cladding panels consisting of two thin metal faces separated by an integral lightweight core as considered in the next section.

Metal-faced sandwich panels
The metal-faced sandwich panel is nowadays the preferred cladding solution for many practical situations, especially for the walls and roofs of industrial buildings and for controlled environment situations. Some typical panels are shown in figure 46. The basic concept is quite simple. Thin metal faces are bonded to a rigid lightweight core in such a way that the assembly acts as a unit to carry load. The metal faces may be flat, lightly profiled or fully

(trapezoidally) profiled The core material is generally chosen to offer a high level of thermal insulation and the metal faces offer protection to this relatively vulnerable element.

Technically, the situation is much more complex and the design issues are addressed in the European Product Standard EN 14509. Space does not permit these to be addressed here. A particular complication arises as a consequence of the range of core materials that are in common use. The product standard recognises the following as being sufficiently well understood for confidence to be placed in the testing and classification systems specified in the standard:

- Rigid polyurethane foam (PUR)
- Rigid polyisocyanurate foam (PIR)
- Expanded polystyrene (EPS)
- Extruded polystyrene (XPS)
- Phenolic foam (PF)
- Mineral wool (MW)
- Cellular glass (CG)

The choice of core material is dependant on the often conflicting performance requirements with regard to thermal insulation, fire resistance, load carrying capacity, self-

weight and cost. Once these issues are understood, the choice is usually fairly clear.

Controlled environment structures
Metal-faced sandwich panels are frequently used as the basis for controlled environment structures as used, for example, in the food processing industry. These often take the form of a stand alone, box-like, structure within the structure. To assist in the assembly and to promote a hygienic internal surface, wall panels may be fitted with externally-operated cam locks at the time of manufacture. Ceiling panels may span between the walls. However, if long spans are requires, internal lines of support, usually in the form of cold formed hat sections, may be suspended from the primary structure.

Connections for light gauge steel
Because of the thinness of the material, connections which act in tension are generally avoided in light gauge steel construction and connections are usually designed so that the fasteners act in shear. The main exception to this general rule concerns the fasteners used to connect the cladding to its supporting structure. Here, tensile forces under wind suction cannot be avoided and the resulting distortion of the cladding profile has to be taken into account in the design.

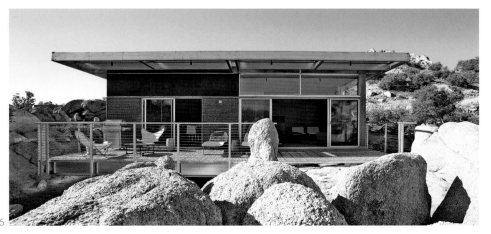

46

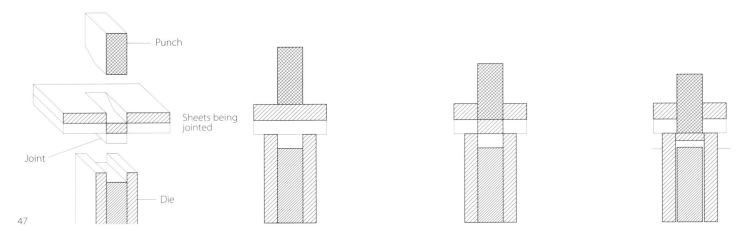

47

The two primary connection systems used in hot rolled construction, namely bolting and arc welding, are also available for cold formed construction. Bolting is widely used, the considerations being similar to those for hot rolled construction although codes of practice tend to take a more relaxed view of connection flexibility due to movement (slip) in the connection. Welding is more problematic because of the thinness of the material and its galvanised coating. Skilled welding is required in order to avoid burn-through and the protective coating is destroyed in the vicinity of the weld, which is often the location that is most vulnerable to corrosion.

There are also a wide range of proprietary mechanical fasteners available. Connections are often classified as "thin to thin" or "thin to thick". For example, thin to thin connections may be typified by the seam connections in roof sheeting and may be made be either blind rivets or self-drilling, self-tapping screws. Thin to thick connections may be typified by the connection of a roof sheeting to its supporting member and may be made by either self-drilling, self-tapping screws or fired pins.

An interesting connection, which originated in the automotive industry and has recently been employed in the factory-based prefabrication of wall panels for cassette construction is the pressed joint. The point is that the connection can be made almost instantaneously and there are no additional components so that the cost is extremely low. The principle is shown in figure 47. It is a two stage process in which, firstly, the plies to be joined are sheared by a descending punch. This punch then impacts on an anvil-shaped die with sprung side plates. During this stage, the sheared plies are compressed and spread outwards so that, when the punch is removed, they remain locked in place. This process gives rise to connections which

have a comparable strength and stiffness to proprietary mechanical fasteners.

Stressed skin design

Stressed skin (diaphragm) design has been referred to above in connection with the stability of low rise buildings. It was originally discovered in connection with cold-formed steel roof construction, the basic principles being shown in figure 48. The complete assembly of roof sheeting and its supporting structure (purlins etc.) acts rather like a deep beam. Under the side load shown, the edge members (purlins) act as the "flanges" carrying the bending moment and the sheeting acts as the "web"

carrying the shear force. Because of the great depth of the "beam", the shear field in the sheeting is generally much more significant than the axial load (flange force) in the edge members. Although other failure modes must be considered, the design is usually dominated by the strength of the fasteners, both in the seams and also connecting the sheeting to the primary structure.

Stressed skin design is now permitted in many design codes, including the Eurocode EN 1993-1-3 and this principle has been used to remove the need for wind bracing in the plane of the roof in a wide variety of

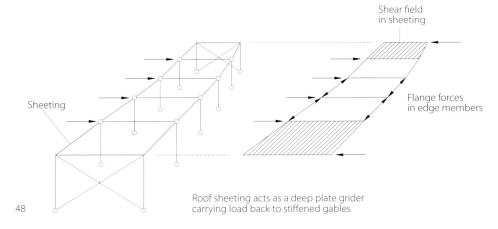

48 Roof sheeting acts as a deep plate grider carrying load back to stiffened gables

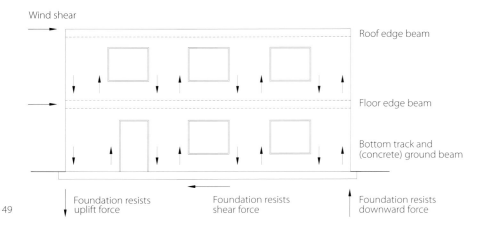

49

structures. The available design procedures take account of many practical factors such as the presence of openings for small roof lights or the passage of services etc. The use of stressed skin design is part of the basis of the "CIBBAP" cassette wall system described above. However, here, the presence of large openings for windows and doors poses particular problems. Recent research has shown how these principles can be extended. This allows a complete wall, with such large openings to be designed as a single diaphragm with holding down points at the corners of the building, as shown in figure 49. This greatly simplifies the design and, in particular, greatly

reduces the magnitude of the holding-down forces.

Frameless construction
Cold formed steel offers opportunities for innovative forms of "frameless" construction based on either shell or stressed skin principles. For example, there are a number of examples of light gauge steel hyperbolic paraboloid shell roofs in the United States. Particularly notable are the hangars for Jumbo jets at Los Angeles and San Francisco airports. When built many years ago, these were, and probably still are, the world's largest cold-formed steel primary structures. A rather simpler structural form, which has been

used in recent years in the UK, is the folded plate roof. This recent usage is based on theory that was developed in the 1970s. An early full-scale test on such a roof of 21.6 m span was made on only structural components of a 1.00 mm thick roof sheeting and cold-formed apex and valley members. This roof was designed for a working load (dead and live load) of 1.20 kN/m^2. It was tested to failure and showed a load factor of 1.93 against collapse. This was in good agreement with the theory, which was an extension of conventional stressed skin design. There is also a north-light version of this roof system, based on a similar theory, which has been used for a number or colleges of art.

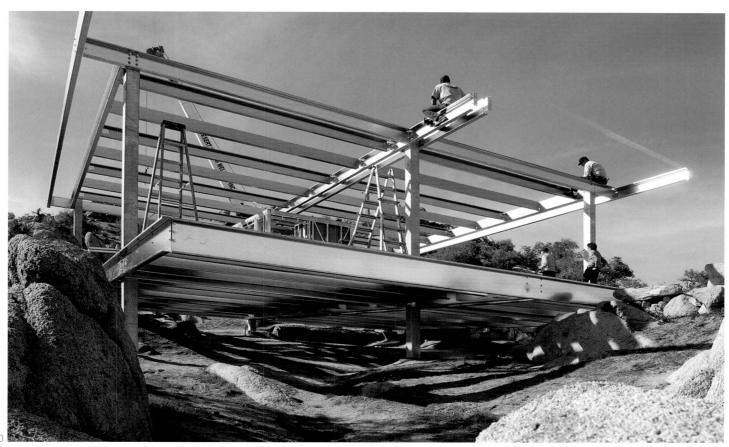

50

Steel and Refurbishment

1

Tomà Berlanda, Andrea Bruno,
Pierre Engel, Federico Mazzolani

Creating in creations

Although the consciousness of heritage arose in mid-19th century France with the inspector of historical monuments Prosper Mérimée and the architect Eugène Violet le Duc, it was not until the 1980s in Europe that an awareness of the need to conserve this heritage. The father of the renovation of old buildings, the Italian genius of details Carlo Scarpa, traced out the route towards the transformation of existing structures by anthology projects like the Castelvecchio in Verona. With the Grande Halle in the Parc de la Villette in Paris, Reichen and Robert considerably raised the standard for rehabilitation (fig. 1), explained from the educational point of view on the occasion of the exposition "Créer dans le crée" (architectural design in existing fabric) in the Centre National Georges Pompidou in Paris [1] in 1986.

Architectural design in existing fabrics

A new era of architecture in which steel is predominant has started and is still with us. In this era, London, Paris, Rome, Tokyo, Berlin, Madrid, and New York have continued to present numerous examples where architecture is designed into existing structures. Almost shyly at first, architects such as Renzo Piano, Jean Nouvel, Norman Foster, Santiago Calatrava, gmp – von Gerkan, Marg und Partner, Herzog & de Meuron, and Jean Michel Wilmotte took rapidly possession of this speciality and have shown that, during the last thirty years, renovation and conservation has become a genre of construction in its own right. The reasons for such hype are economic, structural, and cultural. In contrast to an age that preferred to demolish the existing completely, designers are no longer hesitant to accomplish their aims by employing increasingly sophisticated technologies for more and more diverse applications: museums, hotels, offices, residential units, commercial space, railway stations, airports, stadiums, a never-ending list. This

practice has become so common that it now pertains to between 45 % and 60 % of the construction projects on the market. The state of the art of such methods is explained in detail in figure 5.

The general approach to refurbishment must bear in mind the position of the architect with respect to the material authenticity of the structure confronting him. The need for a candid, perhaps shocking encounter, but free from abuse or timidity, with the buildings in their singular, objective individuality rather than with the harsh abstraction of construction types. This is

why an inclination to take a risk, is perhaps, desirable, with the clearly stated features of reversibility and temporality, a non-neutral presence of the contemporary, in the form of language, materials and technology. This condition is in most cases needed to breathe life into the architectural substance, the constructional organism in question. This is always done with the ultimate goal of restoring the material consistence of a monument, so as to preserve its memory and significance inside our society and lives. Whether for mere facade or for remodelling a profound restructuring, structural steel elements play an important role in the renova-

2

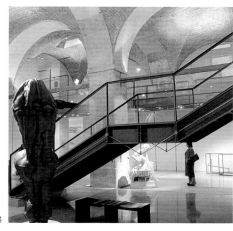

1 Refurbishing, Pavillon de l'Arsenal, Paris (F) 1988, Reichen & Robert
2 Library in the Eichstätt University, Eichstätt (D) 1996, Karl Frey
3 Supporting steel beam, Castelvecchio, Verona (I) 1964, Carlo Scarpa
4 Musée du Chiado, Lisbon (P)1994, Jean-Michel Wilmotte
5 Comprehensive matrix analysis of the various possible ways of refurbishing with steel [2]

3

4

tion of existing buildings. The rising market share of floor renovation works in existing buildings can no longer be ignored. In recent years, the increasing tendency to change the use of floor space has even accelerated this trend. Today it is not unusual to be involved in the renovation of the same building twice in less than ten years. Beyond the added value that steel entails in seminal realisations, it serves a large range of rather unpretentious or less ostentatious renovation purposes in countless less-than-prestigious projects. This, along with the effects of a general ageing of real estate in all market segments, has meant that the

building sector is increasingly involved with the strengthening, reutilisation and conversion of old buildings. Here steel plays a decisive role – not only because of the safety it provides, but also on account of its "reparability", its reinforcing features, and the advantages of dry construction.
The development of the spirit that today promotes the renovation of buildings has followed a parallel track to society's concern for the environment. In general, the introduction of sustainable development starts with quoting the Brundtland Report, which defines sustainable development as development that "meets the needs of the

present without compromising the ability of future generations to meet their own needs...". [3] This definition means that sustainable development is not possible without harmonisation of the environment, social equality, and economic efficiency. Thus, it implies that an erected building enters a cycle of construction – utilisation – destruction, the sum of the contamination produced during this cycle defines its environmental. In such an approach, rehabilitation is based upon a public interest: construction without deconstruction is the ideal for sustainable development, i.e. reutilisation of all or a part of the materials without any

Type of refurbishing work to be undertaken	Location of the refurbishing action	Level of difficulty[1]/main points be investigated		Steel types involved in the refurbishing
1. Addition or consolidation of existing foundations	Foundations or ground located under or next to an existing construction to be strengthened or temporarily protected (sheet pile screens to repair foundations)	1 to 10	Investigate the ground type and existing surrounding before deciding upon the solution to be used to consolidate the foundation	High-performance piles, sheet piles, petroleum tubes and hot-rolled steel sections
2. Vertical extensions on existing buildings	Construction added on top of an existing building in order to increase the floor area	1 to 10	Transfer vertical loads through the structure an existing building	These extensions are new buildings on existing fabrics where all the steel packages and solutions can be usefully adapted
3. Horizontal extensions alongside existing buildings	Side construction linked to an existing building carried out in order to increase floor area	1 to 2	Achieve the connection and waterproofing between the old and the new part	
4. Conservation of existing facades with reconstruction work inside	Preserved external masonry of existing buildings to be substantially reconstructed internally. Steel is used for both consolidation and internal construction	1 to 5	Ensure the stability of the existing facade during reconstruction	Temporary propping of a steel structure and an internal steel structure with composite floors, beams and columns
5. Local reinforcement of existing members	Existing beams, columns or floors made of timber, steel, reinforced or prestressed concrete. Masonry, reinforced or prestressed concrete walls	1 to 5	Strengthen members and/or reduce existing deflections according to the modified loading parameters applied to the building	Hot-rolled section, hot-rolled tube, steel sheets
6. Reinforcement to seismic and ground settlement loadings	Existing primary structure to be reinforced by adding adequate structural stability elements to take into account new load cases	1 to 10	Adapt the structure to seismic or ground settlement loadings by adding reinforcement members for strength and/or stability	HRS or built-up members in steel or composite steel and concrete constructions (beams, columns ...)
7. Repair of corrosion damage and upgrading of fire resistance	Corroded or newly exposed structural members. Members exposed to fire by a new situation such as internal refurbishing, changing their fire status	1 to 10	Treat the structural members by application of anti-corrosion protection and/or a suitable fire protection	Coating system against corrosion. Fire protection products, sprayed products or intumescent paints
8. Renovation of facade and roofing skins and components	External facade and roofing of existing buildings where alterations of the skin are needed in order to improve the facade performances	1 to 10	Create a new envelope system in order to improve aesthetic and insulation parameters of existing buildings	Light gauge steel products made of galvanized, colour coated or stainless steel sheets
9. Construction of glass roofs on existing buildings	Roof top and covering of courtyard in existing buildings where such possibilities exist	1 to 10	Cover an existing residual space or uncovered courtyard area with a transparent steel and glass structure	Structural hot-rolled or built-up members in mild or stainless steel

Comprehensive matrix analysis of the various possible ways of carrying out refurbishing using steel
[1] 1 least difficult, 10 most difficult

6a

6b

6 Different possibilities of vertical extensions
 a Straight "on top" construction without additional columns
 b Added storeys with additional columns and new foundations
7 Renovation, Couvent des Bernardins, Paris (F) 2008, Jean-Michel Wilmotte
 a Erection phase of the new steel structure
 b Interior after renovation
 c Exterior view
8 Istituto di Riposo per la Vecchiaia, Turin (I) 1981, Andrea Bruno
 a Sketch of general view
 b New facade of the extension

recycling. Classical analysis shows that the concept of sustainable development determines the lifecycle of a building and disregards the fact that this lasts for more than fifty years – the reference value for an eco-balance.

Why steel is an attractive material for renovation?
Clever reuse, preservation and protection of existing structures, in particular those of historical value, and many consolidation and restoration systems that have been seen over the last decades are all areas where steelwork plays an important role. The use of steelwork in consolidation and structural restoration gains clear advantages from the following particular features:
- As steel can be prefabricated the main elements can be shop-welded and dimensioned can comply with transportation and operational restrictions before being conveniently bolted together in the yard or on site.
- Reversibility is a basic property of steelwork, which is enhanced by the use of bolted connections, in both temporary and permanent constructions.
- The lightness of structural elements, due to the high strength-to-weight ratio, simplifies transportation and erection issues and minimises the risk of imposing heavier

loads on existing structures.
- The reduced dimensions of the structural elements are a natural consequence of steel's high structural effectiveness and simplify the substitution and integration of the new reinforcing elements into the existing fabric.
- The pleasing aesthetic of steel elements is fundamental where the structural synergy between old and new materials is combined with the architectural created by from their contrasting features.
- Ease of erection is appreciated in any project, but particularly when the intervention is urgently necessary to stop deterioration or to ensure public safety.
- Good availability and a wide choice of steel products on the market are important to satisfy all design and construction needs while offering flexibility. A wide range of products are available: from hot rolled sections in the form of plates, double-T, channels, angles and tubes to prefabricated elements like cellular beams, slim floor beams and trapezoidal sheeting.

All the above features make steelwork a most suitable technology for the structural consolidation of loadbearing elements made of masonry, reinforced concrete, timber and, of course, iron, cast iron and steel.

When facing the problem of the structural consolidation of a building, it can be useful to classify the necessary work on four levels, which correspond to the character of the interventions and, sometimes, also to the chronological order in which the consolidation operations should proceed. The proposed classification considers four levels:

- Safeguard
- Repair
- Reinforce
- Restructure

Extension to existing buildings and insertion into existing fabric

Depending on the size of the additional load, it may be necessary to re-check the loadbearing capacity of the original structure to determine whether preliminary consolidation interventions are required before adding a new part to the existing structure. This aspect is particularly important in seismic zones, where the global behaviour of the buildings is strongly influenced by the addition of new loads particularly in the upper part. The need to minimise the weight of the added structure makes steel the most suitable material.

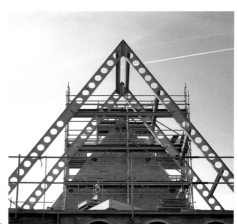

7a

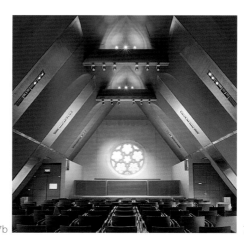

7b

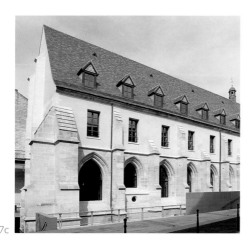

7c

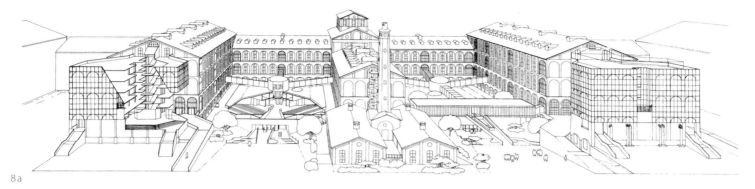

8a

Vertical extensions on existing buildings

This action is required when increasing the height of a building by one or more storeys. The main difficulty in building vertical extensions is how to support the additional dead load of the new volume added on top the existing structure. New loads must be transferred to the foundation through the structure of the existing building. In many cases the simplest solution of simply adding on top is not possible, because the structure below and its foundation are unable to carry any additional load. This makes it necessary to design a load transfer system, perhaps including new columns and foundation (fig. 6).

Steelwork is very useful in these circumsatances where, thanks to its relative "lightness" which is due to a very high strength to weight ratio, its characteristics can be fully exploited. There are many examples of such buildings to be found in Toronto. Such can be used to describe steel's potential for increasing the total building height. It was planned to add four additional storeys in the same material to an. Departing from the initial choice, it was later decided to use steel for the additional structure. Thanks to this decision, instead of the originally proposed additional four, it was possible to add eight new storeys. What was initially planned to be a ten-storey building ended up with fourteen storeys; an important increase in floor area compared to the initial plans. The brief to create new floor area in a former Carabinieri barrack and to lighten its masonry structure as part of its seismic upgrading was suitably fulfilled by a steelwork solution that consolidates and transforms this old building into the new Cultural Centre of Succivo, Caserta (Italy). The old roof has been transformed into a penthouse, inside the new roof consists of a series of Vierendeel trusses. This produces a slight increase of the top volume but an important reduction of the total weight. The new usable floor area was large enough for the envisaged activities. The erection of the prefabricated trusses was very simple and straightforward.

Special solutions are often required when the structure below is not able to take any additional load. This was the case with the Jolly Hotel in Caserta (Italy), which was originally composed of three buildings: two six-storey reinforced concrete buildings with a three-storey masonry building between them. The client wished to increase the height of the intermediate masonry building to match of the other two. As the condition-of the masonry walls, even with consolidation works, would not allow the simple addition of three similar storeys, an alternative solution based on the use of steelwork was proposed. This involved the construction of five tall portal frames from which the three new floors are suspended. The added steel frames, at the ends and in the middle of the new facade, add a considerable aesthetic bonus by their improvement of the previous architecture.

Horizontal extensions

This type of extension consists of building new volumes alongside existing structures. In these cases, aesthetic aspects, rather than structural engineering, play a major role in relating to correlate different architectural idioms. Steel structures for horizontal extensions to existing buildings allow more choice and flexibility in terms of building types and forms. This great variety of structural applications enables the architect to follow the original structural grid, with the added advantage of employing reduced dimensions for the structural elements, and to deliver new spatial solutions. This is generally done out of a profound sense of respect for constructional authenticity, for history as both a material and a tangible guideline, despite what the end results may sometimes look like.

Completed by Andrea Bruno between1977 and 1981, the Istituto di Riposo per la Vecchiaia in Turin (fig. 8) is one such project. This conversion of an old people's home is a good example of the rehabilitation of monumental buildings for public use. The term "monumental" is highly applicable to this complex of more than eight thousand square metres, the largest building erected in Turin in the 19th century. The brick structure, which defines the layout, laid out on a modular grid of piers and vaults; the design is repeated with geometric precision and, in terms of structure and form, anticipates in our modern building standards. However, the conversion of the building did not provide enough space for the functions envisaged. Therefore new blocks reiterating the divisions of the facade and with steel supporting structures were added at the heads of the pavilions. These are important spaces and are the same width as the original wings to which they are directly connected. Here, trusses span 18 m and are up to 2.5 m high. A large staircase, in steel, is placed where the two buildings meet, a consistent approach to the 19th century architecture. The outcome represents a successful synthesis of the two main factors involved in the reappropriation of historical buildings: respect for and conservation of the innate

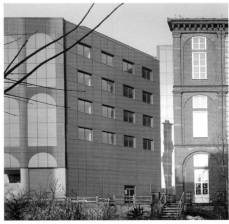

8b

9a

9 Les Brigittines, Brussels (BE) 2007, Andrea
 Bruno
 a Conceptual View
 b View on the old and new facade
10 Palazzo Carignano, Turin (I) 1992, Andrea Bruno
 a The skylight in the courtyard corresponding
 to the vertical structure of the hall
 b Cross Section of the Palazzo Carignano and
 the hypogeal conference hall
11 Las Arenas, Barcelona (E) 2007, Richard Rogers
 Partnership

architectural values of the building with no irreversible additions, and its conversion for a new use without sacrificing functionality. This is also visible in a punctual external intervention for the access to the Data Processing Centre block, where a steel structure with a transparent canopy, fills the space formerly occupied by one of the large wooden doors.

Another example is the recently renovated and extended Chapel of the Brigittines (fig. 9). Built in 1663, it stands in a critical point in the urban fabric of Brussels. Positioned between the railway and the Marolles neighbourhood, the old monument appears dominated by the tall apartment building standing behind it, which annihilated its monumentality and undermined its historical and artistic value. In 1997 the chapel became a platform for the per-

forming arts. By 1999 the need for more space in what had in the meantime developed into the City of Brussels Contemporary Arts Centre for Movement and Voice called for a new project. The competition winning idea "I am still here – I am reproducing, an unequal struggle, I am cut in two" was to strengthen the presence of the chapel, and its reason for "being there", through the creation of its double. The new extension thus replicates the lines and geometry of the existing chapel.

Its light structure contrasts with the mass and confirms the identity of the old building. The doubled volume looks like a simplified image of the church, where the fundamental constructive elements are systematically replicated. Between the two, a third element, sculptural in nature, functions as the a link between the original materiality of the facade and its modern negation. This

interstitial void between the two built volumes is the place to understand the entire organisation of the building. Here is where a staircase hanging from the roof and a set of elevators vertically access the various functions on seven floors. A 100-seat performance space, rehearsal rooms, a restaurant, offices, technical plant and facilities rooms complement the grand nave of the chapel. The loadbearing structure is made of HEB section steel portals positioned to match the structural interaxes of the existing building. These portals support the glazed infill of the side facades and of the roofing, whose mullions are hidden within the thickness of the structure.

The floors rest directly on the bracing trusses, thus obviating the need for secondary structures which would reduce the flexibility of the building. The facade cladding makes reference to the dark brown bricks and natural stone of the chapel by using contemporary materials. A large area of glazing on the left of the entrance front provide a literal reflection of the adjacent chapel and open up the new area. Weathering steel sheets start on the right hand corner and complete the perimeter of the building. In a neutral square pattern, the structure of the existing is reproduced in the new, albeit with several precisely marked and furled cut-outs, contributing to a careful interplay of shadows and light effects on the metal surface. The doubling places the old church in a self-referential duosyncratic system. Through its twin sister, the old church loses its original sacred meaning entirely, and is brought back to its pure form, to a useful and employable volume that forms the basis of a self-confident architectural gesture.

Renovation and insertions in older buildings
In general one of the main reasons for an intervention is to accommodate a new function inside the existing building. More stringen safety requirements and the wish for

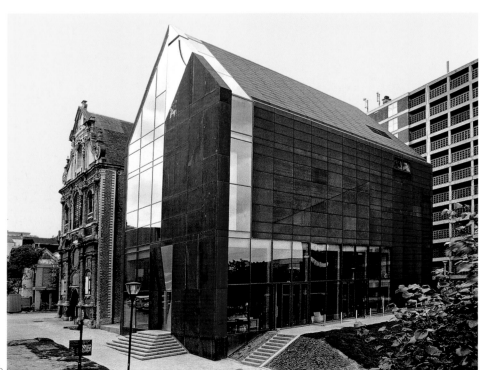

9b

10a

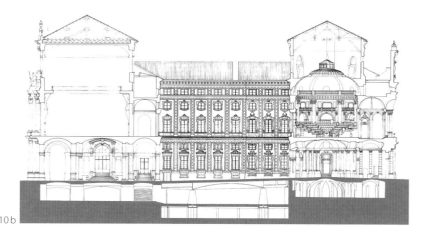

10b

wider public access usually call for a profound rethinking of circulation patterns. Vertical circulation cores, i.e. staircases and lifts, need to be updated to contemporary uses and needs. The experience in inserting or adding new vertical elements inside existing walls has proven the advantages of steel structures in such situations. Prefabrication techniques, lightness of elements, structural solidity, together with modern and rational aesthetic values form part of the vocabulary of contemporary architecture. A good example of this practice is the Collège des Bernardins renovated by the Jean-Michel Wilmotte in 2008. The project includes a totally new steel roof structure with suspended floors above the existing vault of the collège. This subject was also widely explored by Andrea Bruno for the lengthy restoration works of the Castle of Rivoli. In Rivoli, Andrea Bruno had the opportunity to experiment with what would later become a recurrent theme in his projects: the addition or insertion of steel structures and steel staircases.

In the context of a wider restoration and conversion project, in Palazzo Carignano, a monumental baroque palace in the historical heart of Turin, the opportunity arose to propose and realise a large underground hall for conferences and the cultural and scientific functions of the institutions with premises there. The design of the structure is both bold and simple. Four large reinforced concrete pillars, placed at the corners of a 42 × 40 m rectangle, In the context of four perimetral 150 cm deep steel beams (fig. 10). These are the only supporting elements for the ceiling slab, a mixed structure in steel and concrete, and their vertical axes coincide with four circular skylights on the level of the courtyard. The point of maximum concentration of structural loads thus coincides with the point at which light enters. Here four steel spheres, 60 cm in diameter, are placed as connecting ele-

ments between the horizontal and vertical structural members, celebrating the conceptual approach of the plan, and its reference to the geometrical rigour of the baroque building.

Keeping the shape of the existing structure and adding further functions

Recent major projects in which very spectacular exercises in refurbishing were carried out include Las Arenas in Barcelona by Richard Rogers and the CaixaForum in Madrid by Herzog & de Meuron (p. 154ff.). In contrast to the CaixaForum, where part of the existing building was removed and the public square was extended into this building, the strategy of Richard Rogers keeps the Barcelona arena facade at its original level but excavates the ground beneath it, introducing lower storeys in order to establish a direct relationship between the

street, which is lower than the original arena, and the new build in the mall. In both projects the use of steel greatly helped the designers in achieving their difficult goals (fig. 11).

Consolidation with steel: different levels of action

In consolidating buildings with steel there are various levels of action:
- Safeguard consolidation of buildings
- Permanent structures
- Repairing existing construction
- Reinforcing existing structures
- Restructuring existing fabrics.

Safeguard consolidation of buildings

Safeguarding is, in chronological order, the first level of consolidation of existing build-

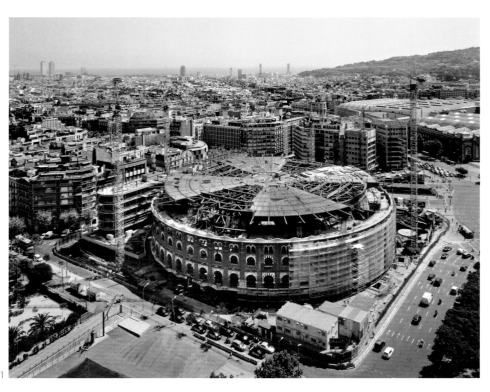

11

12

aa

12, 13 Repair and/or reinforcement of a
 reinforced concrete column with steel
14 Safeguard construction
15 Added steel structure for lift and staircases, Reina
 Sofia Museum, Madrid (E) 1990, Ian Ritchie Archi-
 tects
16 Steel seismic upgrading of a reinforced concrete
 building located in La Gaude (F)
 source: Engel, Pierre: Réhabiliter, renforcer, trans-
 former et rénover avec l'acier Art et technique de
 rénover les bâtiments avec l'acier. Paris 2010

13

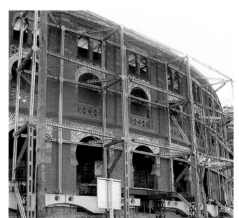

14

15

ings. It consists of a set of temporary inter-
ventions that can ensure an adequate level
of safety for both the public and the site
during the transitory phase preceding any
definitive consolidation operations. This
provision is used both for protecting the
site and for avoiding partial or total collapse
of the building in cases where damage to
the building conditions require urgent
action.

A safeguard system should be quick to
implement, flexible in use, adaptable to
narrow, hardly accessible spaces, and
reversible

The main fields of application include the
following:

- Temporary support of facades during the
 reconstruction of a new building between
 two existing ones, by means of reticular
 space structures
- Steelwork structure which supports the
 facade during the demolition of the inte-
 rior part of the building (degutting opera-
 tion); the supporting function can be tem-
 porary or part of the final structure (i.e.
 vertical trusses for stiffening the facade)
- Temporary support of building facades
 during a post-earthquake emergency
 using steel scaffolding that allows transit
 at the street level
- Temporary roofing to provide adequate
 protection of the site area from rain, snow
 and other effects of the weather during
 restoration.

Safeguard steelwork is often a combination
of heavy steel structures (welded or bolted
sections) and lighter steel sections (hollow
sections with bolted joints) flexibly config-
ured to provide active and passive protec-
tion.

Steel is particularly suitable for safeguard
interventions because of its light weight,
high degree of prefabrication, ease of trans-
port and assembly, and its reusability.

Permanent structures

The physical properties of steel can be of
considerable advantage when adding ele-
ments to existing buildings. Its great resist-
ance to tension and light weight make steel
preferable to reinforced concrete. Com-
pared to other building materials, for exam-
ple wood, steel has a longer life cycle and
this can be of some value when replacing
existing structural elements.

Returning to other aspects of the restoration
and conversion of the Palazzo Carignano
mentioned earlier: the arrangement of four
perimetral steel beams on a central group of
four in-situ reinforced concrete pillars cast in
specially manufactured steel formwork was
chosen to achieve maximum flexibility of
the available space. The steel beams were
IPE sections, welded on site and perforated
to further reduce their weight. Two rows of
needle-like shear studs were welded to the
top flanges of the steel beams to form a
structural connection with the 20-cm-thick
reinforced concrete roof. The ribs of the cen-
tral ellipse, which converge on the centre
of the courtyard, celebrate the conceptual
approach of the plan, and its reference to
the geometrical rigour of the baroque
building. This is further underscored by
the detailed design of the supporting steel
frames of the skylights. The motif of the
eight-pointed star is derived from the origi-
nal ornamental decoration of the baroque
brick facades of the courtyard, bringing to
full circle the relationship between the old
building and new insertion.

In a further instance of inserting a new
function inside the courtyard of an existing
building, but where it was not possible to
excavate below ground floor level, steel
structures were chosen for their aesthetic
value. While working on the refurbishment
and transformation of the Palazzo Mazzonis
in Turin to house the collections of the
newly founded Museum of Oriental Arts,
it was decided to cover the building's
11 × 17 m courtyard with a steel framed

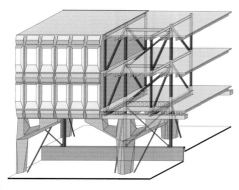

16

structure. Four lines of four cruciform columns carry a framework of H-section steel beams, 20 cm deep, above which a glazed roof and mechanical louvres were placed. The smaller, lighter dimensions of the structural elements contribute to the abstraction of the architectural image. The stainless steel elements are bolted together and left visible in order to display how they were put together.

Structures can be of all types, and when faced with the problem of access to an ancient Roman circus as was the case in Tarragona, it may be decided to cut through the existing walls even though they are medieval stone masonry. A narrow cut between earth and sky now marks the point where the visitors can pass through the different archaeological stratifications. This historical filter is furtherenhanced by the building of a 12-metre-high door which underscores the potential of the passage. The steel framework of the pivoting leaf has a tubular core and 6 horizontal winglets which support the thin bronze cladding of the door.

The decision to replace the the decayed wooden trusses of the roof of the Manica Lunga in the Castle of Rivoli with steel ones, was based on the speed with which the new elements could be produced and the relative ease of assembling them on site. The structure is made of metal ribs supporting a central vault running the full length of the building. Seven metres wide and two metres high, they have the same outline as the ancient ones and the technological plant, electricity and air treatment, were placed under them to liberate internal space. The overhead natural lighting comes through two windows, 140 m in length and screened with light intensity controlled blinds. To avoid overloading the existing walls, the ribs have one fixed and one sliding footing, the latter consisting of a stain-

less steel plate bearing on Teflon. The need to refurbish the original walls prevented them being modified to accommodate the vertical circulation and service elements. It was therefore decided to place these outside the building, inside steel frameworks.

Repairing existing construction
Repair is the second level of consolidation of existing buildings. It involves a series of operations carried out on the building to restore the structural efficiency it had before the damage occurred. Repairing, unlike safeguarding, represents a definitive operation carried out after the emergence of damage caused by clearly identified factors that normally produce their effects over a long period of time and, therefore, do not require urgent interventions. It provides a simple means of restoring structural performance, and of reaching a minimum safety level, without introducing any additional strengthening in building structures damaged by atmospheric agents, age or the ravages of time.
Within the scope of repair, there are numerous technological consolidation systems based on the use of steelwork, improving the structural behaviour of masonry, reinforced concrete and timber building structures. By means of "prefabricated" types of technology, ad hoc solutions designed to achieve optimum results and tailored to specific requirements (figs. 12 and13).

Reinforcing existing structures
This involves improving structural performance to enable the building to fulfil new functional requirements or environmental conditions.
This consolidation level does not produce a significant change in the structural model, but introduces new elements that are able to statically integrate the existing ones without substantially altering the mass and the stiffness distribution of the building.
In contrast to simple repair work, reinforcing

can be carried out with various degree of intensity, according to the increase of strength required for the building by the new conditions and any existing damage. From the point of view of seismic action, the strengthening operation can be separated in two levels: simple improvements and upgrading interventions.

Improvement intervention is required to obtain a higher safety level. In this case, the reinforcing intervention acts on a single part or on the whole, but without excessively modifying the building's structural model and, therefore, its global behaviour. Improvement interventions can be also carried out on single structural elements when they are affected by design errors or poor execution.

Seismic upgrading intervention is characterised by a set of operations that enable the structure to comply with the latest earthquake design standards. It can also require a major revision of the structural model, with a complete modification of the global seismic behaviour. In such a case, this intervention has to be classified from the structural point of view within the restructuring operations (fig. 16). Reinforcing is required when:
· Buildings are subjected to heavier loading conditions, this is often due to a change of use that means an increase of live loads.
· Existing constructions are located in an area recently included in a new seismic zone and therefore subject to more stringent earthquake loading conditions.

In some codes a rigorous distinction is drawn between simple improvement and seismic up-grading interventions. Improvements measures can be adopted in the following cases:
· A change of use occurs
· Where design errors or execution defects must be eliminated

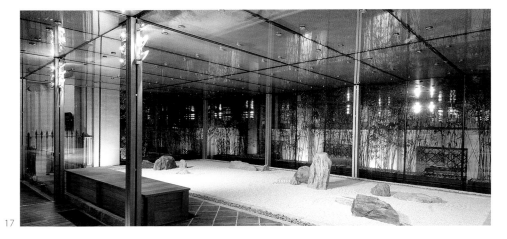

17

17 Renovation, Palazzo Mazzonis, Turin (I) 2008,
 Andrea Bruno
18, 19 Consolidation solutions for various wooden
 members by means of steel elements
 source: Engel, Pierre: Réhabiliter, renforcer, trans-
 former et rénover avec l'acier Art et technique de
 rénover les bâtiments avec l'acier. Paris 2010
20 Reinforcement around an opening
21 CaxiaForum, Madrid (E) 2008, Herzog &
 de Meuron
 a Existing building before "surgical intervention"
 b Exterior view after completion

• Where consolidation is applied to monumental buildings that are not suitable for interventions.

Seismic upgrading is compulsory in the following circumstances:
• Adding storeys or amplification of the construction, with an increase in volume or area
• Loads are increased due to the change of use
• Transformations substantially modify the structural model in comparison with the original one or, in general, when they affect the global behaviour, as in restructuring projects.

The different levels of reinforcing, from simple improvement to upgrading, can be carried out using the same technological consolidation systems as for repair work, but with a more consistent intensity. Steelwork is commonly used to improve the static behaviour of both masonry and reinforced concrete buildings. Bracing systems are often used for seismic upgrading of both masonry and reinforced concrete structures. Innovative bracing systems are based on the use of steel eccentric bracing (EB), steel buckling restrained bracing (BRB) or low yield steel stiffened panels.

Restructuring existing fabrics
Reuse of existing buildings for new application represents, in the hierarchical order, the more general consolidation level of existing buildings. It consists of the partial or total modification of the distribution of functions, lay-out and volumetric dimensions, together with the change of other original features of the building, including a drastic change of the structural system. There are four different kinds of restructuring interventions: degutting, insertion, addition and lightening.
• Gutting precedes the partial or total replacement of an internal part of a building with new structures of a different type. It is carried out when architectural or town-planning conditions require the complete conservation of the building facades, whereas the interior layout can be altered to meet new functional requirements. functional reasons.
• Insertion represents the introduction of new structures or structural elements into the existing volume. Additional intermediate floors or mezzanines are created in order to increase the usable floor area within the limits of a given volume.
• Extension is carried out to meet new functional requirements, involving an increase in the original volume of the building,

which may be done by extending it horizontally or vertically (fig. 15).
• Lightening, the opposite to vertical addition, can include the demolition of one or more storeys at the top of a building due to the need to reduce stresses in the structure. This can also be achieved by replacing the original floors, roofs or other structural elements with new components made of lighter materials. The replacement of heavy wooden floors with light steel I-section beams and corrugated steel sheets or old roofs with steel trusses is very common.

Restructuring is appropriate where the modification of the layout of a building requires the introduction of new volumes and new areas, or where the loadbearing structure requires modification to meet the provisions of a new code. It is also necessary for severely damaged buildings which require the upgrading or complete revision of the structural model.

Consolidation of structural systems with steel

Conserving existing buildings and integrating them with new, clearly distinguishable

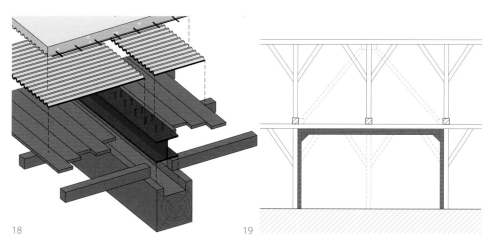

18

19

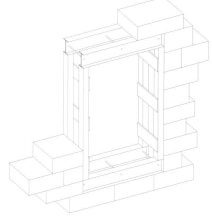

20

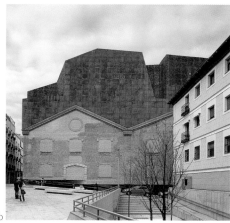

21a 21b

and reversible works represents a classic restructuring operation, which should be based on the modern theory of restoration. A logical application of the restoration principles undoubtedly shows that steel and its technology have the necessary prerequisites making it a modern material with "reversible" characteristics, particularly suited harmonising with the ancient materials and thus forming an integrated structural system.

An established method of improving the loadbearing capacity of masonry involves injecting pressurised mortar or cement grout, which in some cases can be better integrated by inserting steel rods in drilled holes. The use of stainless steel is advisable here in order to avoid future damage due to corrosion. But this system is not reversible and, therefore, it is contrary to the basic principle of restoration.

On observing some old masonry buildings during demolition, it becomes clear that steel frames were originally used for reinforcing the masonry itself. It could therefore be said that steelwork represent the most suitable consolidation system

Masonry columns, when damaged, are usually repaired by means of steel hoops (fig. 12). The lateral restraining action of the hoops produce a noticeable increase in the vertical load capacity.

In case of circular columns the hoops can be made by using vertical plates with a rectangular cross section, which are prestressed by horizontal steel rings. In the past, this prestressing operation was performed by heating the rings to a high temperature and using the shortening due to cooling to introduce the lateral prestress into the column. Nowadays, two half-rings can be prestressed by means of srews. In case of square or rectangular cross sections, angle shapes can be used as vertical elements at the corners. They can be connected in different ways: by internal ties integrated by batten plates, by channels connected by

external ties, or by horizontal rings.
When it is necessary to transfer a significant part of the total vertical load acting on a masonry panel to a new steel structure, the new steel columns can be inserted into specially formed grooves or simply bonded to the masonry. Where openings have to be made, the strength of the missing masonry can be compensated for recovered by installing a steel beam across the top or a steel frame around the opening (fig. 20). Masonry arches can also be reinforced with steel. In older masonry buildings the ends of timber floor beams are usually built into the walls. It is very often necessary to strengthen the wooden beams and floorboards because of loss of effective cross-section due to wet rot, dry rot or woodworm.

Many systems have been proposed to improve the bending strength of beams. There are two main ways to do this, depending on whether it is easier to work from the bottom or top of the beams in order to introduce additional steel elements.

In the first case, the steel can be added in different forms, from the simple plate at the bottom to the hot-rolled double T sections or cold-formed profiles, which can be designed to suit the features of the structure to be consolidated (fig. 18). When the original lower part of the beam must be preserved because it is of historical interest, it is necessary to follow the second route and to work from the top of the beam. Either way, the final result is a composite wood-steel system, which considerably increases the strength and rigidity of the original structure. In all cases, the composite action between the new and the old material must be guaranteed by using appropriate connecting systems, which may range from simple ties to various types of studs.

Wooden trusses do not last forever and may degrade over time. In some cases, they can be repaired by adding steel plates at the connections or along the elements. In many cases it is not convenient to make this kind

of repair and the best solution is to replace the whole wooden truss system with a new roof structure made of steel profiles. Further advantage can be gained by the addition of hot-rolled steel members in one or two directions. In some cases, if these members are interconnected by the appropriate ties and a perimetral member created with further channels, angles or plates and prestressed by srews, an efficient integrated structure can be formed, which may also lead to an increase in the load capacity of the existing supporting columns.

The strengthening or repair of reinforced concrete beam-to-column joints is usually achieved by attaching angles and batten plates to the outside of the reinforced concrete members. The steelwork is welded in place and sometimes glued to the concrete surface. The dimensions and number of the additional elements depend on the required increase in shear and bending capacity.

Reinforced concrete beams can be stiffened and strengthened by attaching steel plates or profiles, which are connected to the concrete by srews or ties and glue. The same system can be used for strengthening floors composed of reinforced concrete and clay blocks. Mixed concrete and brick floors can be strengthened by the following methods:

- Plating the bottom of the individual concrete beams with steel plates, without breaking the horizontal ties
- Reinforcing the individual concrete beams by means of steel sections
- Inserting suitably encased H-profiles between concrete beams
- Strengthening with double H-beams placed below and supporting the underside of each concrete beam.

The capacity of a reinforced concrete structure to resist horizontal loading can be improved by inserting steel braces into the grid of concrete members. A reticular shear-wall can be constructed as a composite structure by integrating steel section brac-

22 Ministère de la Culture et de la Communication,
 Paris (F) 2005, Francis Soler
 a Detailed view of one of the 450 facade plates
 of duplex stainless steel
 b One of the netting elements
 c View of the finalized facade
23 Extension of Theater 11, Oerlikon (A) 2006,
 EM2N architects
 a Exterior
 b Detailed section of facade, scale 1:20

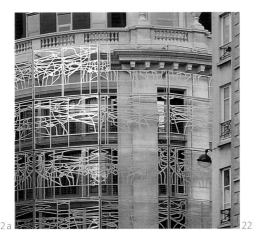
22a

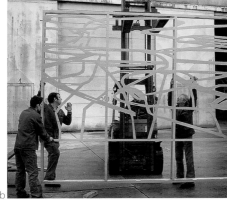
22b

ing between the concrete frame member and the connection between both materials can be ensured by srews or ties and the perimetral frame of the steel diagonals. Together with the advantage of easy erection, this system allows openings for doors or windows, by using – if necessary – appropriate shapes for the diagonals or introducing only one diagonal per frame.

Refurbishing of building envelopes

When considering the outside appearance of renovation projects, the designer is always faced with the problem of how to relate the new to the old. There are no universal guidelines to solving this issue, and every case is different. Although it should be pointed out that the contemporary intervention should be easily recognisable and have its own architectural dignity. This is where the properties of steel as a cladding can be exploited to advantage. Thin metal sheets can be precisely detailed and delivered to site, but if need arises they can be easily modified to cover parts of walls where shelter from the effects of weather is required or to highlight the modern additions. The relative ease with which steel plates can be fitted and also removed when necessary is a further reason for the use of this material. Lastly, amid the diffused current trend of thought that links weathering steel to restoration projects, it is indeed worthwhile mentioning that the decision to employ weathering steel is due to its natural authenticity as a material, like copper in the past, and not to its wide appreciation. All materials like copper, marble, stone and brick are basic construction materials in that they reveal the effects of time, and that is why they deserve careful consideration in how they are used.

The doors leading into the Castle of Rivoli, the portal crossing the ancient walls of Tarragona, and the main entry door to Palazzo

Mazzonis are all clad in metal. The projects span twenty-five years, over which time laser techniques for cutting and perforating metal have significantly evolved, but the idea stays the same. Be it copper, bronze or naturally rusted steel, the detailing, while employing the most up-to-date technologies, has retained the original approach. The new function of the building is visible right from the entrance, a signal to all the users that something has changed in the "life" of the existing structure.

Cladding is effective in doing this. Again in Palazzo Mazzonis, around the corner from the entrance, we find the blind side facade on via S. Agostino, 6-metres-wide and 16 high. Left incomplete for over 50 years, it is today clad with steel sheets. The modular system which carries the metal plates is completely hidden and the overall assembly appears as a continuous curtain wall. Only the change in type of steel, between weathering steel and stainless plates, allows for a variation in the image, but the observer's attention is centred on the glazed eye, where images of the collection are dis-

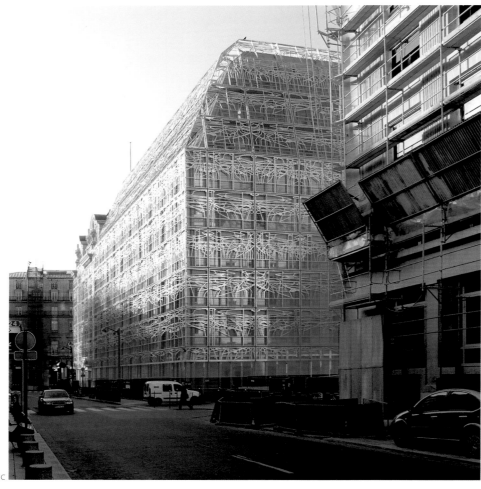
22c

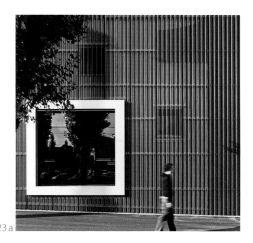

23 a

played. It has a similar impact on the viewer as the cladding of the modern addition to the Chapel of the Brigittines mentioned earlier. Glass planes on the left hand of the entrance elevation provide a literal reflection of the adjacent chapel and open up the new area, establishing a physical connection between the old and the new. Weathering steel sheets start on the right hand corner of the main elevation and complete the perimeter of the building. The 4 mm thick sheets are mounted on box-like supports hung on a steel posts structure. In a neutral square pattern, the image of the existing is reproduced on the new, albeit with several precisely marked and furled cut-outs, contributing to a careful interplay of shadows and light effects on the metal surface.

Added steel facade and cladding elements
Steel, in all its various types and designs, offers the designer a wide range of enveloping solutions, which is convincingly demonstrated by Francis Soler in the project to unite two buildings of different epochs located in the quarter of the Palais Royal in Paris and designated for the Ministry of Culture. Francis Soler invented a unifying netting of stainless steel covering the entire facade towards the periphery of the Îlot des Bons Enfants (fig. 22). The final step of a difficult rehabilitation, this intervention presents another facet of the use of steel to renovate facades.
This measure of "smoothing" and comprehensive revision lends the new ensemble a homogeneous architectural expression. All the light entering the buildings is cut up and shaped by the facade netting. It strikes the resin floor, the hazel colour of which resembles a bed of sand. The resin surface – transparent and uniform – is reflective and directs the light far into the corridors, which are entirely covered by a bordered raspberry-coloured carpet. Lasers were used to cut the netting elements out of stainless steel sheets measuring 3020 × 3800 × 12 mm

thick, which were then welded into stiffening frames. They have a 60 % with an average weight of 30 kg/m^2 and are composed of six digitally distorted motifs inspired by the frescoes of Giulio Romano.
The stainless steel mesh is supported by articulated brackets attached to the existing stone facades by chemical anchors. They form part of a simple but effective triangular support arrangement that transfers only direct and shear forces to the original building. The material's nature lends the facade a great deal of continuity and requires limited maintenance. The satin-finish to the stainless steel gives the facade an ever-changing appearance, since colour and reflections depend on the colour of the sky as well as the actual light intensity (fig. 22).

Adding an insulating steel skin to an existing building
Adding a supplementary envelope to an existing facade may be done for several reasons. On the one hand, it may be already justified by architectural aesthetics or a change of identity. On the other hand, the insulation of the building, which often fails to meet the desired thermal performance level, often provides a second convincing reason to embark on a project. The realisation of this enveloping technology implies an architectural redefinition of the facade along with the technological exercise of achieving the required thermal characteristics, load resistance, and an acceptable method of mounting. The new skin is connected to the old facade by Z-shaped galvanised steel purlins. In the case of a regular carcass plugs and gauge pieces can be employed, but where there are obvious plumb line deflections adjustable purlins are used. In order to connect the purlins to the carcass, plugs are used for conventional carcasses and tapping screws for metal backgrounds. The areas around openings such as mullions and doorposts, window lintels, and other ledges require meticulous detailing to

ensure that insulation and moisture barriers are effective and will not become a weak point of the structure. There are different types of insulation. Rock wool and expanded or extruded polystyrene are mounted directly onto the surface to be renovated using srews and large washers. They are better than mineral wool because they are non-sliding and water-repellent. Aesthetic enhancement and improvement of the building envelope are issues that can be solved easily by any one of a wide choice of steel envelopes available to designers.

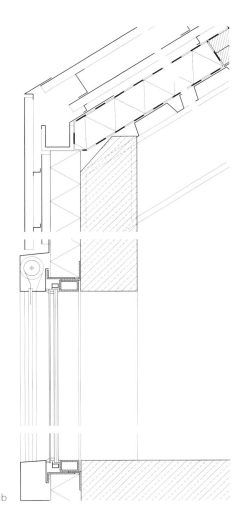

23 b

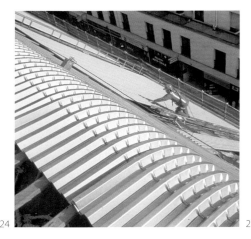

24

25

There is an almost endless range of colours and textures, such as colour-coated steels and stainless steels, to name but two. In the majority of cases the goals are to make a building more efficient and give it a new architectural signature.

Much more than mere resurfacing, the renovation of facades often includes important internal restructuring measures completed by installation of a new insulating skin with a noticeably improved heat insulating performance. The two most common techniques are: mounting an additional envelope onto adjustable purlins to get a gap for insulating material and simply mounting an insulated sandwich panel directly to the carcass by means of galvanised steel spacers. Here, the objective is to cover a concrete structure of precast concrete slabs and mineral aggregate. The absence of heat insulation as well as the aesthetically unfavourable aspect made it essential to renew the facade. Compliance with the latest thermal insulation standards and the aesthetic appearance desired for the new facade can be achieved by the use of composite panels with pre-varnished surfaces and injected polyurethane foam up to 80 mm thick. The insulating composite panel is attached to the posts of the original concrete framework every 1800 mm by means of galvanised plug-connected steel spacers. Being impervious, the composite panels are mounted with self-tapping screws onto the spacers designed to plumb the facade.

Use of weathering steel on landmark buildings.
The sober touch that weathering steel, often referred to as Corten or Indaten, brings to refurbishment projects is much appreciated by architects. The material can be seen on two interesting projects, the Palazzo Chigi, Formello and the Palazzo Mazzonis, Turin. The intervention on the Palazzo Chigi, a late medieval complex with a complicated history, finds its pivotal centre in the reuse of the tower. The decision to insert a new stair-

case to allow visitors to reach a panoramic viewing point was linked with the wish to highlight the different stratifications of the building.

This is why a steel skeleton frame of HEB 100 post and beam elements climbs autonomously in the void of the old tower until it reaches the top level where it stretches out to create a cantilevered platform. The structural details are reduced to a minimal expression, from the open-jointed paving, to the face-mounted, full-height H-section columns carrying the steel-framed floor and roof. The architectonic purity of this welded steel frame is heightened by grinding the welds flat and finishing the steel in its oxidised colour, which is matched by the weathering steel plates that clad the top of the structure.

A combination of weathering and stainless steel is the used to create the only source of variation in the continuous curtain wall cladding on the blind side facade of the Palazzo Mazzonis.

Refurbishing of roofs using steel components
Since the construction of the Chrysler Building in the 1920s, stainless steel has acquired an aura of nobility for the construction of roofs and facades

Better Roofs with Stainless Steel
Used in 0.5 and 0.7 mm thick sheets in ferritic quality, stainless steel for roofs is shaped and welded like other metal roofing materials, such as zinc or copper. With a density which differs only slightly from such traditional materials, stainless steel is more resistant and has a lower coefficient of thermal expansion. These favourable parameters explain the longer life of stainless steel compared to other common roof and facade products. Capable of achieving a high modulus of resistance, stainless steel can also be used in a corrugated sheet version. Steel corrugated roof sheets and cladding have the advantage of rigidity and do not require

roof lathing as they can span between roof purlins at 2.5 m centres (fig. 24). Standing seam roofs or those with upright joints made of stainless steel are installed with special fixings in traditional manner by roofers and are the preferred alternative to zinc roofs.

Rehabilitation of conventional tile or slate roofs by replacing them with corrugated sheets of stainless steel has several advantages. On the one hand, you can keep the original supports, such as beams and rafters, and smooth-plane them if necessary; on the other hand, the self-weight of such roofing (8 daN/m^2) is often less than that of the existing one. Corrugated stainless steel sheeting is available in lengths of up to 12 m. These sheets can be used to construct an impervious roof of almost the same colour as zinc with the same form as roofs with roof ledges. The installation of additional insulation of varying thickness is another trump card of this type of renovation.

Mounting of second roof systems made of colour-coated steel
The renovation of roofs made of asbestos cement is still a difficult issue. On the one hand, there are rules and regulations regarding asbestos which require its disposal in special waste storage facilities; on the other hand, asbestos removal, apart from the costs involved and the special necessary, causes interruptions in site operations and the building's use. One solution is to cover the existing roof with a second one made of colour-coated steel and to make additional use of this by fitting an insulating layer in between old and new. First, punched galvanised steel spacers are fixed on the original rafters or roof purlins through the existing roof. These spacers are mounted at about 600 mm centres and support the second roof purlins on which the roof shell is mounted by means of self-tapping srews.

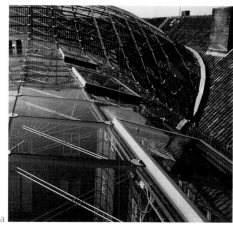

26 a

26 b

The insulation is laid on the old roof. This provides insulation in accordance with latest standards, which have been raised in the new thermal regulations released in most countries with the goal of saving energy for financial and ecological reasons (figs. 24 and 25).

Roofing with steel-glass structures
Historical buildings often provide residual open-air space such as patios or inner courtyards. The shortage of available floor area as well as the impossibility of extending such buildings with complementary elements (extension or addition of storeys) compels the designer to resort to ingenious ways of utilising such space.

In contrast to a reuse of basement storeys or the construction of additional basement levels by the rather difficult exercise of underpinning, the roofing of residual space with glass is an easy way to create new floor space. Mounting such roofs is by far the easiest of such exercises. The archetype of this is definitely the old shopping arcade in Paris, the "passage couvert", a typical example of 19th century architecture which lets in light whilst providing protection against the weather. There are countless others - hotel patios, lobbies in office buildings. The most famous of them have been realised in museums such as the Louvre with its Cours Puget, Marly, and Khorsabad by the architect Ieoh Ming Pei, the British Museum in London by Norman Foster, the museum of the history of Hamburg by the German architects Volkwin Marg and Meinhart von Gerkan (fig. 26).

24 Troughed roof cladding made of stainless steel on a conventional roof
25 Detailed view of mounting onto an fibre cement roof
26 Museum of the History of Hamburg, Hamburg (D)1989, gmp – von Gerkan, Marg und Partner
 a Glass roofing
 b Section
 c Gridframe structure consisting of flat steel sections

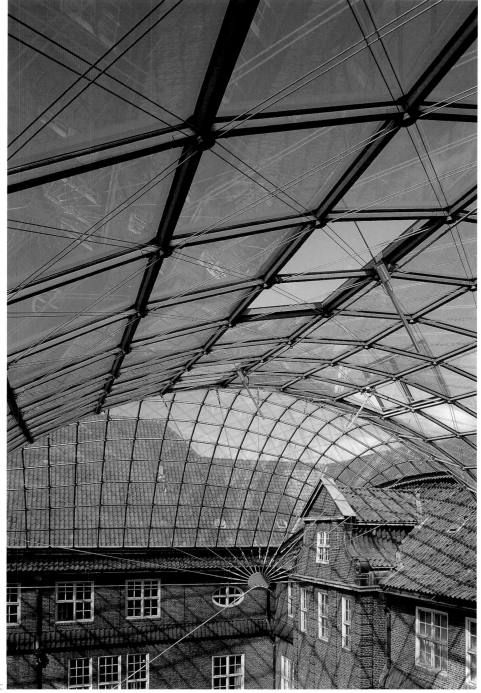

26 c

Steel – Process and Products

1

2

Alexander Reichel, Gerald Schnell

This chapter describes a wide range of steel products and how they are made. The starting point is the production of pig iron and its refinement into commercial iron and steel. The text then follows the various methods of further treatment and processing into semi-finished products before discussing finished steel products and solutions and the techniques for connecting steel elements.

An understanding of steel production is essential to appreciate the countless subtleties of steel's properties, possibilities, limits and market availability. Steel offers a wide range of possibilities to designers in the construction industry. It is the ideal material for industrially prefabricated standard products characterised by reduced costs combined with high quality.

Today, this classic approach to the manufacturing of steel products is complemented by its opposite, the use of computer numerical control (CNC) to realise customised solutions that are both individual and cost effective.

Crude steel production

The blast furnace process, pig iron and cast iron

Iron is one of the most abundant elements in the Earth's crust. However, as a base metal it is not generally found in its pure state but as iron oxide, carbonate or sulphide. Rock, from which iron can be extracted economically is called iron ore, and its iron content is over 20 %. Most of the ores exploited have an iron contents between 30 and 65 %. The residual fraction of rock is called gangue material.

In a blast furnace, the iron oxide is converted to iron by reduction with carbon monoxide produced from carbon. During this reaction, carbon and carbon monoxide are oxidised partially into carbon dioxide (CO_2). A mix of ore and carbon in the form of coke – the charge – is fed from the top into the blast

furnace while hot air – the forced air – is supplied from the bottom through hot-air distribution pipes. Coke is coal heated whilst hermetically sealed to extract components of the coal such as tar, benzene, sulphur, and ammonia.

In order to ensure air supply to the ore, coke and ore are crushed to appropriate sizes and subsequently sintered with lime, i.e. caked into a conglomerate. A properly prepared charge requires less reducing agent and therefore less CO_2. As an alternative solution, the ore can be supplied in the form of pellets, a granular material with beads of about 10–15 mm in diameter.

The carbon reacts with the oxygen of the forced air at the bottom of the furnace and produces hot gas at temperatures of over 2000 °C, mainly composed of carbon monoxide and nitrogen. This hot gas, which has a high reducing potential, flows upwards through the charge, heating the top-charged solids to melting temperature, and reducing the iron oxide into metallic iron. Carbon dioxide produced during iron oxide reduction is partially regenerated, i.e. reacts with solid carbon to form carbon monoxide, in the lower part of the blast furnace. This reaction is known as Boudouard or solution loss reaction.

The process can be expressed as follows:

1. $C + 0.5\,O_2 \longrightarrow CO$
Strong exothermal reaction of carbon with hot air
2.1 $3\,Fe_2O_3 + CO \longrightarrow 2\,Fe_3O_4 + CO_2$
Reduction of hematite to magnetite
2.2 $x\,Fe_3O_4 + CO \longrightarrow 3\,Fe_xO + (2x - 1)\,CO_2$
Reduction of magnetite to wustite
2.3 $Fe_xO + CO \longrightarrow x\,Fe + CO_2$
Reduction of wustite to metallic iron
3. $CO_2 + C \longrightarrow 2\,CO$
Regeneration of carbon dioxide (Boudouard reaction).

The two first steps of iron ore reduction (2.1, 2.2) take mainly place in upper part of fur-

nace while the last step (2.3) proceeds essentially in lower part of furnace (fig. 3).

Both carbon oxides emerge from the top section of the blast furnace shaft as so-called blast furnace gas. Carbon monoxide is combustible and is ignited to preheat the forced air in the hot blast furnace.

The pig iron can be tapped in the bottom section of the blast furnace after every 2 to 4 hours. The resulting secondary substance – primarily calcium and silicon oxides – called slag results from the lime of the charge, the gangue material of the ore, and the other elements in the coke. Since it is lighter, slag floats on the liquid pig iron. This is tapped at a higher point and is a precious starting material for many industries, such as for cement production (CEM III, blast furnace cement) or road construction. During production of iron, the slag is used for sequestering of a part of the sulphur which comes along with the coke and is completely undesirable.

Related to the weight of the generated pig iron, approximately 1/3 is slag.

A blast furnace works for an average of between 10 and 15 years before the refractory lining made of fireclay brick has to be replaced. A modern blast furnace may produce up to 20,000 tonnes of pig iron every day, which requires appropriate bulk material handling logistics.

Due to other oxides contained in the ore the resulting pig iron is not pure iron. Pig iron contains, in addition to large amounts of carbon, several undesirable substances such as silicon, manganese, phosphorus, and sulphur. The carbon content is about 3.5 to 4.7 %. Therefore pig iron is brittle, has a low tensile strength and tends to crack if unevenly heated. It cannot be hot- or cold-worked.

Methods of producing iron have been known since ancient times. However, it was

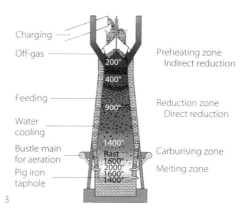

Charging
Off-gas
Feeding
Water cooling
Bustle main for aeration
Pig iron taphole

200°
400°
900°
1400°
Rast
1600°
2000°
1600°
1400°

Preheating zone
Indirect reduction

Reduction zone
Direct reduction

Carburising zone

Melting zone

3

1 Iron ore depot in Rotterdam, iron ores of different origins are of different colours
2 Blast furnaces of a steelworks
3 The blast-furnace process
4 DRI (direct reduced iron): The reduction of iron ore with the gases carbon monoxide and hydrogen produce a spongy product with large pore volume. Sponge iron is further processed in the electric arc furnace. As the ore is reduced in a solid state, the initial form (here pellets fig. 4) is retained.
5 Tapping raw iron in the furnace
6 Melting scrap in the electric arc furnace

only in the 18th century, when hard coal replaced the charcoal previously used for metallurgical processes, that the production of large quantities of iron became possible. But the pig iron produced in this way could not be forged because of its high carbon content. Therefore, the carbon was removed by oxidation in refining furnaces to produce forging grade steel.

Pig iron shows a very high resistance to compression – about 100 times higher than that of rock. Early designs in cast iron took advantage of this characteristic, showing shapes that are subject to compression loading, such as an arch. For bending and tensile loads, however, this is not the right material.
Cast iron is defined as a ferrous alloy with more than 2 % carbon as the main alloying element and is produced by melting pig iron whilst adding steel and foundry scrap. Adding more steel reduces the carbon content. The melting point of cast iron is low due to its high carbon content; this makes it very castable. However, due to its brittleness it cannot be shaped by plastic deformation, e.g. by rolling; it can be machined only by metal cutting. The characteristics of cast iron are mainly determined by the form of its graphite inclusions.

There are three main types of cast iron: grey cast iron (GJL), cast iron (GJS), and malleable cast iron (GJM). Grey cast iron has lamellar graphite inclusions and is the equivalent of ancient cast iron. Its advantages are high corrosion resistance thanks to the outer skin, as well as lower costs. Typical is the low tensile strength, but malleable cast iron, with its nodular graphite inclusions, may show characteristics similar to steel. To produce malleable cast iron, graphite is separated through tempering. Some types of malleable cast iron are weldable.

Beside the blast furnace process, the direct reduction process is gaining importance in ironmaking. The established process reduces ore in solid state into pig iron using hydrogen and carbon monoxide as reducing agents mainly extracted from natural gas. The product is sponge iron (DRI, direct reduced iron) which can be refined into steel in an electric arc furnace. These processes deliver less pig iron than the blast furnace route. The ore required as starting material must be of a higher quality. The advantages are the use of more-favourable reducing agents and less investment cost, as a coking plant is not required.

Today, all process gases accumulating in integrated steel works are either directly

used in steelmaking or passed on to power plants for the generation of electric power. Meanwhile, CO_2 emissions have been reduced.

Blast furnace gas recirculation is a new development where the carbon monoxide reducing agent is returned into the blast furnace, however separating the gases is a complex process.
A future prospect in iron production is the direct conversion of ore into steel without the detour via pig iron.

Converter process and steel properties
Production of most steel grades from hot metal requires reaching a carbon content around 0.02 to 0.03 %. The operation to reach this state is called refining.
Refining is carried out by injection of pure oxygen in a converter vessel containing typically 150 to 350 tonnes of liquid steel. In the basic oxygen process, oxygen can be blown through a vertical top-lance onto the liquid hot metal, or from the bottom of the vessel through porous plugs or tuyeres. The combined process cumulates the assets of both techniques: control of blowing conditions, energy supplied by local post-combustion of carbon monoxide from decarburisation, good stirring of the liquid bath (fig. 8).

4

5

6

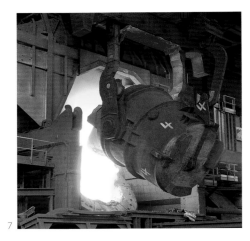

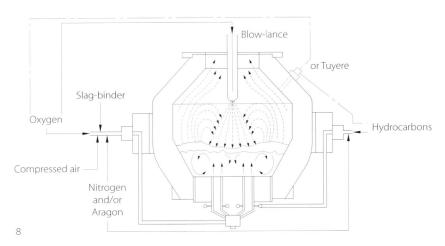

In addition to the carbon, the converter also oxidises other elements such as silicon, manganese or phosphorus.

The issuing oxidised compounds form the slag or, in the case of carbon, leave the furnace in the off-gases. Control of slag formation and characteristics is vital for metallurgy and process stability: e.g. lime is added in order to ensure enough fluidity of the slag and a good dephosphorisation capacity. Depending on the desired steel quality, it may be necessary to desulphurise the melt first as the converter is not an efficient way of removing sulphur.

The heat released during the process is generated by several oxidising reactions including decarburisation, desilication or dephosphorisation. This energy is sufficient to raise the liquid bath temperature from hot metal temperature of typically between 1250 to 1350 °C to the desired temperature of typically 1600 to 1700 °C and to melt solid scrap added at a rate of up to 300 kg per tonne of liquid steel.

The oxygen content in the melt resulting from refining is removed by deoxidising at the tapping stage in the ladle with the addition of aluminium, manganese, and silicon.

Electric arc furnace

The electric arc furnace (EAF) is used to produce crude steel principally from steel scrap as the most important raw material, as well as from pig iron or direct reduced iron (DRI). About 40 % of today's global steel production is made by this method, which is mainly based on electrical energy. The melting process accounts for around 70 % of the total energy requirement. The fact that scrap steel can be used for steel production without any deterioration of quality makes it a sustainable building material.

Scrap is easily separated by magnetism and can be crushed before the next stage. As a valuable raw material it is inspected, classified and sorted on the basis of the waste content, residual metallic elements and haz-

ardous materials. Waste may reduce the necessary electrical conductivity. Residual metallic elements like copper, tin, molybdenum, chromium, nickel are critical because they cannot be removed during the process.

In the interests of safety, the scrap in the EAF must be free of inflammable or explosive materials and closed containers or vessels. Radioactive contaminants are screened for and excluded at the entrance of almost every steel plant.

Usually, a mix of scrap types is used in the electric arc furnace to reduce melting time and to control the content of metallic elements.

The electric arc between graphite electrodes and scrap develops a very high temperature plasma in which temperatures may be of the order of 10,000–15,000 °C in the hottest regions, dropping to local ambient temperature of, say, 2000 °C at the boundary. Thus, all alloyed steels can be melted, even high-alloy steels. Preheating of scrap before melting can reduce the energy consumption in the electric arc furnace. The metallic elements other than iron can be removed during the final tapping similar to the liquid steel arriving from other routes. Adding alloying elements to the liquid steel is often carried out during subsequent treatment in a ladle furnace. Before casting, the dissolved gas (hydrogen, nitrogen) content of the steel can be reduced in a vacuum furnace. The world's largest steel producer alone recycled about 40 million tonnes of scrap in 2007. Despite its high use of electricity, the production of steel by the electric arc furnace process consumes roughly half the energy required for the blast furnace process. Nevertheless, the latter must continue to be used because the demand for steel exceeds the existing available quantities of recycled steel. The steel used for construction today forms the reserves of steel for subsequent decades or centuries.

Alloying elements

Steel properties may be influenced by the alloying elements, which affect the crystal lattice, and by thermomechanical treatments, which can also affect the configuration of the microstructure.

Carbon is the most important alloying element of steel, which may be defined according to its carbon content as follows:
* Unalloyed steel, C < 0.2 % and total amount of alloying elements < 5 %
* Low-alloy steel, C > 0.2 % and total amount of alloying elements < 5 %
* High-alloy steel, C > 0.2 % with total amount of alloying elements > 5 %

The chemical composition of steel can be precisely adjusted. Carbon content significantly affects steel properties; the slightest modification changes material properties. A high carbon content increases the hardness and tensile strength of steel, while making it more brittle, with less ductility and weldability. Normal carbon steel e.g. S355 has a higher carbon content (about 0.20 %–0.24 %) than S235 (about 0.17 %–0.20 %). However, the increase in yield strength may alternatively be obtained by specific hot-rolling processes.

The weldability of steel is inversely proportional to a property known as hardenability, which measures the ease of forming martensite during heat treatment. The hardenability of a steel depends on its chemical composition, with greater quantities of carbon and other alloying elements resulting in a higher hardenability and thus a lower weldability. In order to be able to judge alloys made up of many distinct materials, a measure known as the carbon equivalent content (CEV) is used to compare the relative weldabilities of different alloys by comparing their properties to plain carbon steel.

The steel types that are important for struc-

9

10

tural engineering are general structural steels, which are fine grained and particularly easily weldable, and high-grade steels, including weathering steel. In addition to corrosion resistance, the alloying elements can improve many other steel properties, such as toughness or even the final appearance of a galvanised steel surface. For instance, the silicon content affects the surface appearance as well as the thickness of zinc coatings.

Alloying weathering steel

Weathering steels develop a thick and dense patina that retards further oxidation of the layers beneath. Paradoxically, this natural purplish brown layer is exactly that of the oxidation process to be avoided. However, permanent humidity renders this protection ineffective. The fraction of alloying elements – mainly copper, chromium, and phosphorus – for weathering steels is below 1 %. Environmental conditions and the intended lifespan should be taken into consideration in dimensioning steel thickness, which is normally between 2 – 6 mm for facade use.

Where weathering steel is used, contact corrosion (e.g. on bolted connections) has to be avoided, especially at joints and fastenings. When combining weathering steel with other materials, it should be borne in mind that rain may cause stains or wash-out effects on them. Weathering steels are of good weldability; the welding consumables should also be of a weathering type. The weld seams can be subjected to subsequent special treatment in order to accelerate the development of patina and to achieve a uniform appearance.

Although weathering steels are slightly more expensive than classic carbon steel, they can be used in an economic way since further anticorrosion measures can be omitted.

Alloyed stainless steel

Steel with a minimum chromium content of 10.5 % and less than 1.2 % carbon besides other alloying elements is called stainless steel; however, such steel is non-corroding only under particular environmental conditions. Steel with a chromium content of more than 17 % is highly resistant to corrosion conditions encountered in construction. A passive layer with a high content of chromium oxide develops on the surface and protects the layers below against corrosion. The passive film has self-healing properties. Further increase of chromium content above 17 % or the addition of nickel, molybdenum, and other alloying (Ti, Nb, Mn, N, Cu, Si, Al, V) elements also improve corrosion

resistance and other physical properties in specific conditions. For example, steel for sea water applications will requires higher chromium (> 18 %), molybdenum additions (> 2.5 %) and preferably nitrogen additions to achieve adequate corrosion resistance. The wide range of stainless alloys available makes it possible to design using an alloy which perfectly suits the conditions under which it will be used. The numerous grades of stainless steel can be classified according their precise metallurgical structures into five main groups as in European standard EN 10088.

For ferritic stainless steels titanium, niobium or zirconium are commonly used to stabilise the ferritic grain size and capture residual

	European standard EN 10088	American standard ASTM	
Ferritic stainless steels	1.4003	410S	
Carbon: 0.02 to 0.06 %	1.4016	430	
Chromium: 10.5 to 29 %	1.4510	430Ti	
Molybdenum: 0 to 4 %	1.4526	436	400 series
	1.4520	439	
	1.4509	441	
	1.4521	444	
Martensitic stainless steels	1.4034	420	
Carbon: below 0.1 %	1.4057	431	
Chromium: 10.5 to 17 %	1.4542	630	
Austenitic stainless steels	1.4618	17-4Mn	
• Common austenitic:	1.4310	301	
Carbon: 0.015 to 0.10 %	1.4318	301L/NL	
Chromium: 16 to 21 %	1.4372	301	
Molybdenum, copper, aluminium: 0 to 4 %	1.4301	304	300 series
• refractiry austenitic, examplary composition:	1.4307	304L	
Carbon: max. 0.20 %	1.4401	316	
Chromium: 20 to 25 %	1.4404	316L	
Nickel: 10 to 20 %	1.4571	316Ti	
• low-nickel austenitic			
Nickel: below 5 %	1.4618	201L	200 series
Duplex stainless steels	1.4362	2304	
or austenoferritic (or "duplex")			
Carbon: 0.02 %			
Nickel: 4 to 5.5 %			
Chromium: 22/25 %			
possible Molybdenum additions up to 3.5 %	1.4462	2205	

11

12

Usual structural steel grade designations according to EN 10027-1: 2005, EN 10025-2: 2004, EN10025-4: 2004. Example: EN 10025-2: 2004 S 355 J2 + Z35 +M

S	355	J2		+	Z35	+M
Steel group	Mechanical characteristics	Mechanical characteristics – group 1 (notch toughness)			Special requirements	Treatment conditions
S = structural steel	XXX = min. yield strength [MPa]	min. 27 J JR J0 J2	min. 40 J KR K0 K2	temp. °C 20 0 -20	Z 15 = min. 15 % reduction of area Z 25 = min. 25 % reduction of area Z 35 = min. 35 % reduction of area	+M = thermo-mechanical rolling +N = normalised rolling +AR = as rolled

carbon content to improve their corrosion and welding behaviour.

Most ferritic steels are suitable for indoor use. However, new developments permit their application in the building envelope and for structural products, including some 12 % chromium grades intended for external application.

Martensitic stainless steels are mainly used for tooling, cutting tools and springs. In construction their application is limited to wires and bars.

Austenitic stainless steels account for 70 % of global stainless steel production. The presence of nickel improves corrosion resistance in some applications but mainly stabilises the more compact crystallographic microstructure, which guarantees high ductility at all temperatures, including cryogenic applications. Molybdenum additions enhance their resistance to corrosion in very aggressive media like sea water. As their closely packed microstructure limits the diffusion of single atoms at elevated temperatures, austenitic stainless steels exhibit better strength and stiffness retention than carbon steels above about 550 °C.

Low-nickel austenitics, or "200 series", are chromium manganese steels with low nickel content of 1– 5 %. Most of them have the ductility of the nickel-chromium austenitic grades but reduced corrosion resistance properties.

Austenoferritic steel, also called "duplex" steels, have a two-phase austenite and ferrite microstructure. Thanks to their low nickel, high chromium and possible molybdenum content, duplex materials are less sensitive to highly speculative nickel prices and offers excellent qualities for high strength, high corrosion resistance applications at an optimised cost price.

Each of these families has specific physical and mechanical properties: hardness, yield stress, breaking strength, elongation, etc. For example, austenitic stainless steels have

expansion coefficients higher than other steels. On the other hand their thermal conductivity is lower.

In addition to product-related commercial names of stainless steel, the European standard EN 10088 defines five-digit numeric codes to identify stainless steel types, whereas the American designation uses three-digit numeric codes. In the AISI standard, the letter L indicates low carbon content, which is a sign of even better corrosion resistance. For example, 1.4301 (or ASTM 304) corresponds to an austenitic stainless steel with 18 % chromium and 10 % nickel, also known as 18/10. The European standard also indicates the composition, in detail: for example X5CrNi18-10 for 1.4301. The main grades used in the building sector are austenitic ferritic or duplex stainless steels.

Steel casting – ingot casting – continuous casting

Crude steel is cast in slabs, blooms, billets or ingots, either in stationary moulds or – as usual today – by means of continuous casting. The process of shaping liquid steel for the first time is called primary shaping. Usually this is followed by reshaping the steel several times to produce semi-finished products as well as finished products. A relatively new process for shaping steel, in addition to casting, is the sintering of steel powder into complex shapes, which is still under development and may create alternatives for the future.

The older ingot casting process is still used, especially for very large pieces of steel. The moulds admit and cast the liquid steel and define the preliminary form of the cast steel as blocks, slabs or other shapes. However, steel can be cast immediately in the final shape by using individual moulds out of sand or ceramic. An application in construction is the economic design and fabrication of complicated joints in three-dimensional structures. Cast steel is weldable and tougher than pig iron but its castability

is inferior due to a higher melting point, which results in larger minimum cross-sections and higher manufacturing costs.

Industrial installations tend to be run on a continuous basis. In the case of steel casting, the liquid steel flows out of the ladle into a tundish, which serves as a distributor for the parallel casting moulds and as buffer while the ladles are switched. Passing a sliding gate to stop the flow if necessary, the liquid steel is shaped and cooled down in the mould, which is open at the bottom, gaining a thin skin of solidified steel around the still-molten core of what is now called a strand. In the secondary cooling zone supported by rollers, the vertical strand is turned into the horizontal to be cast continuously and further processed. Casting machines need a radius of 8 –12 m to manage the movement from liquid vertical flow to solidified horizontal strand.

Common forms of cast steel for linear products are square billets, rectangular blooms or beam blanks with a rough I-shape. The basic material for flat products is mainly slab of different dimension. In mini-mills, which are compact steel works based on electric arc furnaces, advanced thin slab casters help to simplify downstream processing. Recent developments on strip casters try to cast the slab directly into the required thickness reducing or even eliminating the need for subsequent hot rolling.

After the casting, the strand is cut to length by flame or oxygen cutting and the intermediate product can be placed in storage, traded or directly processed into further shapes.

Crude steel processing – forming and rolling

As the terms suggest, hot and cold forming of steel takes place at different tempera-

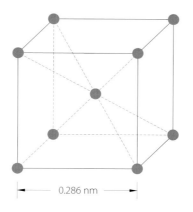

13 Cubic face-centred α-iron, ferrite, carbon content less than 0.02 %, occurs in low temperature area

14 Cubic-surface-centred γ-iron, austenite, carbon content under 2 %, occurs in higher temperature area

15 Iron-carbon phase diagram
 States of steel and iron in relation to temperature and carbon content
 Source: Polytechnic of Mechanical Engineering, www.maschinenbau-fh.de

13 | 0.286 nm |

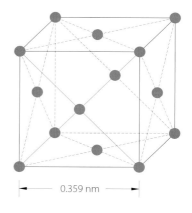

14 | 0.359 nm |

tures. Exceeding the recrystallisation temperature of a steel, which is determined by the alloying elements present, causes recrystallisation to take place, changing the crystalline structure of the material and therefore its properties. Working steel above this temperature is called hot forming.

Heat treatment – hot forming and hot rolling
Apart from the chemical composition, the crystalline structure of steel is significantly affected by the rate of cooling and subsequent thermal treatment. These processes are known as annealing, hardening and tempering. They can be used to get obtain closer-grained structure and to reduce internal material strains so as to produce the desired degree of toughness.

The iron-carbon phase diagram (fig. 15) relates the different crystalline structures of steel to carbon content and temperature. The distinction is drawn between face-centred cubic austenitic γ-steels and body-centred cubic ferritic α-steels (figs. 13 and 14). As can be seen between 911 °C and 1392 °C in the iron-carbon phase diagram, pure iron exhibits a face-centred crystalline structure (austenite region); above and below this temperature range it has a body-centred structure (ferrite region). Steel in the austenite region can dissolve higher amounts of carbon (up to 2 %), which makes austenitic steels tougher. The rate of cooling is decisive for the crystalline structure of the final product.
Rapid cooling down or quenching from the austenite region hardens the steel. Having no time to diffuse from the structure, the carbon atoms do not leave the crystal lattice, which results in the formation of the much harder martensite. However, the accompanied structural deformations make the steel more brittle. Internal material strains results can be relieved to some extent by subsequent tempering (re-annealing in the ferrite region). During this operation,

some of the carbon atoms can diffuse from the very hard martensite structure. Quenching is carried out with water, oil, or air. Steel that has been subjected to hardening and tempering provides high toughness and tensile strength.

During normalising, a form of annealing, the steel is heated up to temperatures above the line GS in the iron-carbon diagram, above the ferrite region, and held there for a period of time. During subsequent slow and controlled cooling in air, the atoms form into a normal structure. Full annealing involves a period of even slower cooling in a

furnace. Both processes reduce possible structural irregularities as well as internal material strain due to production and a homogenised close-grained structure develops. Other annealing types, such as soft-annealing and stress-relief annealing, use lower temperature ranges for annealing, e.g. in order to relieve internal material strain due to cold forming or welding.
For the most part, the thermal treatment follows the shaping of the steel. However, it can be carried out during hot rolling processes, as well. This is termed a thermomechanical treatment. Properties that are of intrinsic contradistinction from an alloying

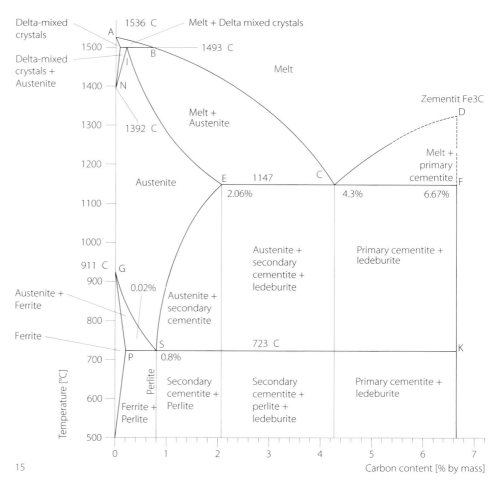

15

16

17

point of view, such as high hardness and good weldability, can be combined using this techniques. Thermal treatment by quenching and self-tempering (QST), which involves quenching at 850 °C with subsequent tempering to 600 °C, can improve the yield strength of such treated steel compared to conventional structural steel over the entire material thickness. At the same time such fine-grained high-strength steel provides very good weldability due to its lower carbon content influencing mainly the CEV as the parameter for weldability. High strength S355 steel, which is treated thermomechanically, has a carbon content

of about 0.12 %, whereas a conventional S355 has about 0.2 to 0.24 % of carbon for the same yield strength

Hot rolling is carried out in a temperature range between 800 °C and 1200 °C using cylindrical rollers that are arranged to suit the final product. On the one hand hot rolling is aimed at shaping the steel or at least at reducing the thickness in the case of flat steel. On the other hand, it also seeks to achieve specific metallurgical effects. There are three main types of rolling techniques which are applied in different areas of the iron-carbon phase diagram:

- Conventional rolling (AR): The steel temperature after the last pass is around 900–1100 °C.
- Normalising rolling (N): The finishing temperature is lower than for conventional rolling, which results in a strong microstructure.
- Thermomechanical rolling (M): Performs specific reductions at particular temperatures during several rolling phases to give a stronger microstructure.

The compression of the crystalline structure resulting from hot forming improves the steel properties without the hardening that would accompany cold rolling. During thermomechanical reshaping, alterations of the structure are subject to thorough inspection. Especially with more complex shapes like H sections, selective cooling of certain parts of the steel profile can influence the final crystallisation as can quenching and self-tempering.

Hot rolling is used for sections and merchant bars as well as for seamless pipes, wire, reinforcing bars, rails, heavy and medium plates and sheets (hot rolled coils or HRC) down to a minimum thickness of approximately 1.5 mm. The width of the future coils is determined by hot rolling. Nevertheless, hot rolling involves more than just changing the dimension or shape of the steel; it also has huge influence on metallurgical properties.

During forging of steel – the oldest method of reshaping hot steel – the material is first soaked (heated to a constant temperature for a specific period of time) then reshaped when glowing by hammering and pressing until the desired shape is reached. Today, this process is still ideal for manufacturing shapes that cannot be achieved by rolling or that are too awkward. Forging can be used for ingots weighing up to 500 t. This method is also used to manufacture the

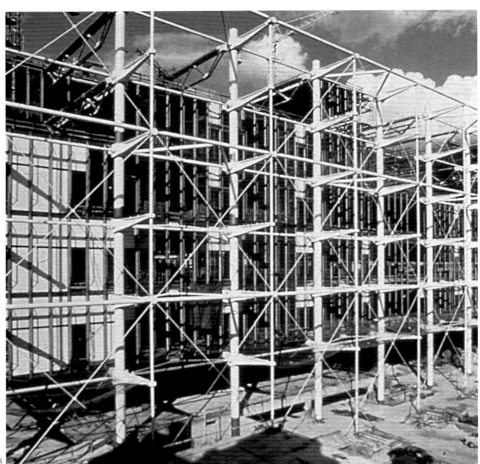

18

19

20

16 Slab at the oven exit before hot rolling process
17 Slab discaling
18 Gerberettes, fabricated from normally calcined
 and strengthened cast steel.
 Centre George Pompidou, Paris (F) 1977,
 Renzo Piano + Richard Rogers
19 Continuous casting of beam blanks in six paralllel
 strands
20 Front of a beam blank strand after cutting

end anchorages on cable-stayed or suspension structures.

Sections that cannot be rolled because of their complex form are often extruded. Here, a soaked ingot is extruded through a die. Despite some technical limitations, such as stress concentrations at fillet radii and lower productivity, this process is an effective way of manufacturing solid and hollow sections for applications like facade profiles.

Cold forming
Cold forming does not change the crystalline structure; therefore this type of reshaping greatly affects the steel properties. Deformation of the crystal lattice during plastic deformation (flowing) leads to an increase in strength with a reduction in ductility. A combination of cold forming and subsequent thermal treatment allows precise selection of the material properties.

Like hot rolling, cold rolling is also performed with cylindrical rollers. It seeks to achieve a reduction of thickness by a combination of compressive and tensile forces. Furthermore, it provides an improved surface quality which can be made even smoother by cold rolling. Cold rolling provides a very high dimensional accuracy of the order of hundredths of millimetres in sheet thickness. The process is mainly used to manufacture flat products, such as sheets and sheet metal components and for their subsequent profiling after coating. Cold-formed sections have little in reserve for reshaping due to their varying internal stresses. They always show larger corner radii. As a further cold forming process, edge bending is used to manufacture section sheets, panels and facade elements as well as diverse coverings and further individual forms based on flat rolled steel.

Deep drawing involves reshaping of sheet metal with a punch, pressure ring and die.

This produces a hollow open on one side e.g. a trough. The hardening typical of cold forming process then occurs.

A hydro-mechanical variant of deep drawing has a die that relies on a liquid to produce the required back pressure, which results in lower costs for small batches. Hydroforming allows a greater variety of shapes and achieves a better surface finish than deep drawing.

Explosive forming is another variant of deep drawing and presses the sheet metal onto a die. Here, the pressure is created by an explosion – in most cases under water. Prior to this, a vacuum is generated between the sheet metal and the die so that there is no resistance to the exerted pressure. It is possible to manufacture very complex shapes even of large material thickness (up to 60 mm) and in small batches. Embossing is possible, as well.

Embossing – pressing a die onto the workpiece – results in an impression in the sheet metal. It is possible to produce individual embossing patterns. Light embossments can be realised also in certain organic coatings, where they have suitable characteristics and are sufficiently thick.

Drawing
Hot rolled rod wire is drawn through a single or a series of profiled or simple round tapered openings (drawing dies) to obtain the required shape and diameter. In addition to various bar and pipe sections, this process is mainly used to manufacture wires, as hot rolling cannot be used to manufacture diameters below 5 mm.
Starting with diameters of 5 – 55 mm , the wire rod is drawn down in several stages. The final wire can be anything from 53 mm down to 0.1 mm in diameter. Due to the section reduction and the cold deformation, the initial wire strength is increased signifi-

cantly. In some cases, where the reduction is too much, the wire must be subjected to intermediate thermal treatment to prevent it from breaking due to strain hardening. Wire is the starting material for the manufacture of cables, strands, fabrics, screws, nuts and rivets. Furthermore, wire is used to produce steel fibres (p. 125).

Continuous coil coatings – corrosion protection before processing

Coats are designed to protect the steel against corrosion and provide a choice of individual colour and surface aesthetics. There are also intumescent fire-resisting coatings (p. 128).
The main selection criteria for a type of coating used in construction are the required corrosion prevention, resistance to abrasion and scratches, and durability after reshaping. To these may be added resistance to UV radiation and weathering and finally, perhaps most important in architecture, aesthetics. Recent developments foresee a photovoltaic function for coatings. Stain repellent coatings are already available on the market.
Types of coatings include organic, metallic, non-metallic inorganic and special coatings like vacuum plasma. Depending on the required corrosion resistance, the designer can combine a metallic coating first with a organic coating applied later, which is the most popular approach in coil coating. Unlike conventional painting, coil coating is a fully integrated industrial process in most steel industries.

Continuous coil coating process
Coil coating is a highly accurate, optimised, continuous industrial process to protect sheet steel or wire steel against corrosion before being shaped by profiling, bending and other forming techniques. However, every step in the process – pickling, cold

21

22

rolling, annealing, electrolytic, hot dip or organic coating – is an independent process in its own right.

Focusing on the role flat steel plays in construction products, the principal materials are cold rolled coil, and to a lesser extent, hot rolled coil steel. As the first step, the coils are spliced head to tail, which means the end of the first coil is joined to the beginning of the following coil to create an endless strip as basis of the continuous process. To pass from those discontinuous independent processes mentioned above into the continuous process, intermediate strip buffers are installed within the production line to temporarily decouple different operations. Strip or loop accumulators are racks with several rollers over which the strip runs. By varying the distance of the rollers or finally the loop size, the total length of the strip can be adjusted. So, even though one end of the buffer may be on hold, the opposite end can continue to run for a certain time. The process speed when adjusted by the buffers can range from 100 m/min for standard organic coatings up to 150 m/min for metallic coating, for instance.

The first surface treatment in the continuous process cleans the strip. In the continuous pickling process the strip passes through a heated acid bath, usually hydrochloric acid. Afterwards the strip is carefully rinsed and dried.

Residual internal stresses due to previous processes and other mechanical working can be adjusted by the continuous annealing and processing line (CAPL), which ensures the final desired mechanical properties. Annealing involves heat treatment of the steel at a temperature of about 700 – 800 °C, which may then be followed by tempering. This continuous annealing process resembles a sequence of furnace loop accumulators. This process takes only a few minutes and provides excellent results. Alternatively, the traditional batch annealing

process can be used in which a stack of complete coils are all heat-treated at the same time.

Afterwards, the strip passes through a skin pass mill where it is given the desired elongation, surface texture and flatness. Side trimmers then cut the strip to the required width before the automatic and the final visual inspections. These inspections are in addition to all the interim quality control measures carried out after every major operation within the continuous coil coating process.

Metallic coil coatings

In general, there are two main metallic coating processes. Electroplated steel uses the electrostatic attraction between the steel and coating material, which is most often zinc or zinc alloy. The strip passes though several electro-deposition cells with insoluble anodes to acquire the desired thickness of coating, which clings solidly to the steel. Compared to hot dip galvanising, the zone of highly resistant iron-zinc compounds between the coating and the steel substrate is less well developed, mainly due to the lower treatment temperature. Electroplated steel provides excellent surface quality and perform very well during further processing involving any movement of the steel.

Hot dip galvanising is applied mainly to cold rolled coils, whereas galvanising of hot rolled coils has only become popular in the recent times. As an integrated part of the process, the preheated strip often comes directly from the CAPL, and is then guided through the "zinc pot". A roller at the bottom of the pot turns the strip so that it leaves the pot vertically to ascend into the cooling tower. High speed air from "air knives" blow off the molten coating just after the steel leaves the bath. They permit an exact adjustment of the remaining coat thickness. Subsequently the coated strip is cooled down and goes for inspection and further surface treatment.

The resulting surface appearance is mainly influenced by the initial temperature, cooling speed, exact chemical composition of the bath and finally by the silicon and phosphor content of the steel.

The most common metallic coatings in construction are pure zinc (Z), zinc-aluminium (ZA) containing about 5 % of aluminium, and finally aluminium-zinc (AZ) containing 55 % aluminium and about 1.6 % silicon. At least in Europe figures following the abbreviation of the coating indicate the weight per square metre in g/m^2 of the coating. Zinc provides excellent corrosion protection due to passive layers of zinc oxide and zinc carbonate developing at the surface and to the cathodic effect it develops in conjunction with steel. This effect also protects cutting edges and small scratches without any further treatment. However, the edge cutting protection is limited up to a certain steel sheet thickness depending mainly on the coat thickness applied. Nevertheless, the effect makes the handling and tailoring of construction elements on their sides much easier.

Aluminium protects the steel substrate by creating a shield between the surface and the atmosphere. This barrier is very stable because the aluminium oxide coating that forms on the surface is insoluble in most environments, thus ensuring long-lasting resistance. The combined action of aluminium and zinc gives remarkable protection against corrosion. The zinc supplies the same cathodic effect as with galvanisation, while the aluminium builds up a skeleton, which provides better resistance to abrasion and weathering. Furthermore, zinc salts block up the pores of the aluminium skeleton to create an even more solid barrier between the environment and the steel core.

Organic coil coatings

Organic coatings may be applied to uncoated or metal-coated steel. After pre-

21 Hot dip galvanized steel sheets in coils
22 Coil coating line with two-colored coating on
 front and back side and with loop accumulator
 in front
23 Coated steel sheets are fed through a roll former
24 Sheet metal profiles
 a flat
 b striped
 c grooved
 d micro-profiling
 e trapezoid profiling
 f corrugated profiling
25 The structure is formed solely by 3.2 mm thick
 profiled sheets, neither columns nor beams
 are used.
 Steel House, Tokyo (J) 2007, Kengo Kuma

23

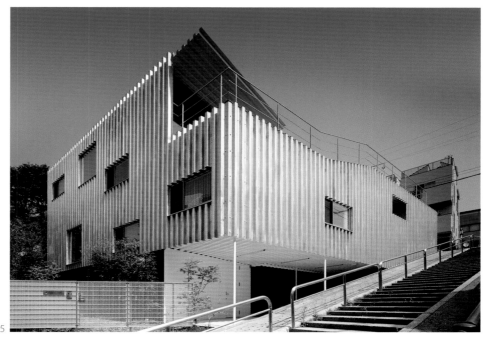

24 f

paring the steel by cleaning, degreasing and surface treatment, the coating is applied to the strip by rollers. A set of three rollers applies the liquid paint to the steel. The pickup roller rotates partially immersed in a bath of liquid paint. A smaller roller, which regulates the amount of paint picked up, runs in contact with the surface of the pickup roller just after it emerges from the bath. The pickup roller transfers paint to the applicator roller, which finally applies the paint to the strip. This process takes place on both sides of the strip independently so that they may have different coatings and colours.

The most important coatings in construction are based on saturated polyester (SP), polyurethanes (PUR), polyvinylfluoride (PVDF) and polyvinylchloride (PVC). Common layer thicknesses for external application range from 25 to 60 µm, including a primer of about 5 µm. Only plastisol (PVC) coatings provide layer thicknesses of up to 200 µm, which even allow a slightly embossed or leather-like appearance of the surface. All coatings are tolerant of further processing like profiling and provide generally good resistance against weathering, especially against UV. Further important properties include resistance to mechanical abrasion and hardness of the coating, its adhesion to the substrate as well as corrosion resistance in different environments. The right corrosion protection system may be a combination of metallic and organic coatings and must be designed to suit local conditions and provide the required service life.

Organic coated steel or prepainted steel is used in construction in external application for cladding, roofing, tiles etc. However, products based on organic-coated steel also have a variety of internal applications, e.g. false ceilings, lights, metal furniture, air conditioning, presentation racks and radiators. The process can offer a wide range of col-

ours and surfaces, including smooth, orange peel effect, grained, textured or embossed, which are obtainable in several finishes (saturated, metallic, pearly etc.) and gloss (from mat to high gloss). Compared to post-painting, continuous coil coating provides many of the advantages of an industrial process: enhanced productivity resulting in lower cost, a controlled process providing higher quality, a more sustainable method of production reducing environmental impact, and creating a healthy and safe working environment in the plants, on site and throughout the whole life cycle.

Semi-finished products – based on flat products

The starting material for these semi-finished may be called plate or sheet, depending on its thickness. Sheets are "cut to length" from hot rolled coil (HRC) or cold rolled coil (CRC) Hot dipped galvanised (HDG) and organi-

cally coated sheets are available as semi-finished products.
Flat products also include cold sections made from sheet metal or flats by cold forming.

Plates or heavy plates

Plates or heavy plates start at a thickness of 4.75 mm and can go up to 1000 mm. Heavy plates are usually subject to hot rolling on reversing quarto mills. Therefore these plates are sometimes called "reversing mill plates" or "quarto plates", referring to the four rollers needed for the process. Due to their limited thickness, ranging from 3.00 – 4.75 mm, thin plates might be rolled on one-dimensional rolling stands.
Plate widths can go up to 5100 mm. The width is produced by rolling in three phases, turning the plate in between the phases. Plates and heavy plates are used as starting material to manufacture any shape by means of cold and hot forming or by means of welding. This is the way larger beams for

25

Flat-rolled products (plates, sheets, strips)

Type	Thickness [mm]	Properties
Heavy plate	> 4.75 mm	floor plates, 3–20 mm
Medium plate	3.00–4.75 mm	
Light plate	0.35–3.00 mm	untreated = black plate with improved surface finish = coil-coated (e.g. aluminising, hot-dip galvanising, hot-dip galvanising + plastic coating)
Cold-formed sections		Sections made from flat-rolled steel with almost identical thickness. Formed by rolling (0.4–8.0 mm thick) and folding (up to 20 mm thick). DIN 59413, DASt-Ri 016 plus works standards. Many different shapes and dimensions.
Profiled sheets		Corrugated and trapezoidal profiles; made from roll-profiled light plates with a high load-carrying capacity. 500–1050 mm wide, 10–200 mm deep, 0.65–1.50 mm material thickness, sheet lengths up to 22 m. (Ref: Stahlbau-Arbeitshilfe 44 & 44.2, DIN 18807 parts 1–3, June 1987 ed.)

26

26 Forms of supply for rolled products for use in structural steelwork
27 Perforated sheet
28 Expanded metal
29 Expanded metal
30 Facade of expanded metal.
 Theatre in Nijar, Almeria (E) 2006,
 MGM Arquitectos

bridges and steel framed structures are manufactured, e.g. as box or plate girders made of plates.

Sheets & profiled sheets
Hot rolled coils can go down to a minimum thickness of about 1.5 mm, whereas cold rolled sheets can provide a thickness ranging from 0.35–3 mm, with 0.6–1.25 mm being the most common for applications in the building envelope. The maximum width of coil steel is about 1800 mm.
Flat sheet metal tends to buckle. However, folding the sheet so that it has trapezoidal or other corrugations gives it stability in the direction of folding.

Steel sheet profiling uses stainless steel or coated coils as the base material. This means the shaping is done after coating and not before, as with manual painting systems.

Profiles come in numerous shapes including trapezoidal, corrugated or sinusoidal and liner trays for double skin facade. For more premium application, steel siding panels, micro-sinusoidal or cassettes are made by profiling, folding or bending. Individual shapes can be supplied on demand, however they are quite costly compared to standardised shapes.

Profiling is done by cold forming on several adaptable rolling stands. For long sheets with simple forms, there are also mobile rolling devices on trucks or trailers to roll sheets on site. Planning needs to take into account that, once the sheets are profiled, they can only be stacked and, if moved, transportation constraints may limit their length to about 18 m to 22 m.
Generally, profiled sheets can be loaded on one axis only. For a given span, the load capacity depends on the spacing and depth of the profile and the sheet thickness. For deep-rolled sheets, e.g. for roofing applications, local buckling of the web may limit

load capacity. Therefore, single or cascades of stiffening corrugations are rolled into the web.

Floor sheets for composite concrete slabs have perpendicular ribs embossed to improve composite action between concrete and steel sheet. If the supporting steel beams have shop-welded shear connectors on their top flanges, the sheets often have holes to fit over the studs. In this case the spacing of any profile stiffening must be large enough to allow the shear connectors to work correctly.
Other methods use through-deck welding so that shear connectors are welded on site through the sheet or directly attached mechanical fastenings (p. 132). The cross section of the steel floor sheets can be taken into account in the design. The critical load case is usually the weight of the fresh concrete. Additional temporary propping might be required during concreting.
Basic steel sheets with standard colours can usually be delivered within a few days. More specialised products have to be ordered a few weeks in advance, depending on colour, profile and coil material. Especially for roof application or even aesthetic facades steel sheets can be curved either by pure bending or by notch bending, which entails repeatedly pitching the sheet several times by the required angle. However, minimum radii have to be respected.

Sandwich panels
Sandwich panels are produced in a continuously process from two profiled steel sheets between which insulation is foamed or glued to create a fully composite unit. Standardised sandwich elements represent a most cost-effective solution for building walls and roofs. The sandwich elements, available in standard widths of up to 1.2 m, provide finished indoor and insulated outdoor surfaces. The insulation may be PU or mineral wool, depending on the fire regula-

tions. The thickness of the insulating material varies in accordance with the required U-values and the quality of the insulation. They are mounted onto a supporting substructure, or directly onto the main structure depending on the required spans and loads. The element joints are wind-tight. Used as a roof, they can be exposed to direct rain provided they have a minimum incline of 7°. Supplementary weatherproofing, except for the transverse joints, is not required. The elements have tongue and groove joints for quick assembly. Surfaces are available with different coats. In addition to the standard profile, they are offered as micro-profile or polished.
Sandwich panels are generally produced to order as the available range of backsheets (colour, coating, profiling), insulation material and thickness, and outer sheets is huge. Accurate cutting to length is essential to ensure the elements fit together properly. Standard and regular products based on the usual length of 16 m generally have technical certificates and shorter delivery times.

Structured and perforated sheets
Structured sheets provide surfaces with patterns and stampings, e.g. bulb plate, channelled plate, and slotted plate. They are mainly used as anti-slip surfaces.

The holes in perforated plates are made by punching, piercing, or drilling. Perforated plates of up to 30 mm in thickness are available. All steel qualities can be perforated. They are supplied as plates or coils. Plates are available with or without peripheral holes. The width of the intact border should be stated upon ordering. Perforated coil is cut through the holes – a small section of the longitudinal sides is left without holes: In addition to round and rectangular holes, other types of holes, such as triangular or cruciform, or even combinations of different hole types are available. It is also possible to

27 28 29

manufacture customised patterns. Perforations may be very small (< 1 mm), but the minimum diameter should not be less than the plate thickness. Perforated plates can have their edges bent or be reshaped into sheets with trapezoidal or sinusoidal corrugations. For a use as stair treads and flooring, they are available with a structure, e.g. small upstands formed around the holes. Further applications for perforated sheet steel are external cladding, e.g. sunscreen elements. In internal applications, the perforation of liner trays or the web of trapezoidal profiles of roof system can enhance sound absorption.

Cold rolled sections

Cold-rolled sections are made from sheet metal by edge bending, drawing, folding or cold rolling. Individual cross section types can be manufactured. Many sections are made to order, others are available from catalogues.

The sections exhibit the increased strength typical of cold forming, particularly at the bending points.

Cold-rolled sections, with their optimum ratio of load capacity to weight, play an important role in light-gauge steel construction, for instance as supporting structures in roofs and facades. They have a high slenderness ratio due to their flanges and webs being thin relative to the overall section height. Hence these sections do not normally reach their plastic yield strength as failure occurs before then due to local buckling.

Owing to their light weight and easy handling during construction, they offer an alternative to timber structures or to hot rolled sections, as shown in the case study of the house in Mombert (p. 162ff.).

Expanded metal

Expanded metal is manufactured by pulling apart a metal plate with staggered slits. Gratings with the typical lozenge-haped

holes are the result. The resulting geometry is three-dimensional, which makes the expanded metal look transparent from one angle and closed from another. In addition, they are available as flat rolled steel. Transparency varies with the amount of open area, which may reach up to 90 %. As with sheet metal, expanded metal can be subjected to shaping and edge bending. Compared to wire fabric and even to perforated plates, expanded metal sheets are less expensive. Moreover, compared to fabrics, they are inherently stable. They are mainly used as air-permeable external cladding and as screen and sunscreen elements, as balus-

trade infills, and even as lightly loaded floor grids and steps.

Semi-finished products – hot rolled sections

There are about 70,000 different rolled steel products. Sections are standardised according to their cross sections, and in most cases manufacture of special profiles is economic only for large quantities, or if specific applications justify the additional expenditure. Most sections are manufactured in accordance with European, American, British,

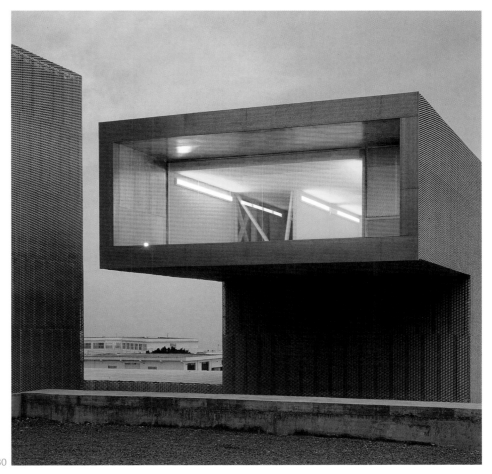

30

31

32

33

Japanese, and Russian standards. Despite a high accuracy of manufacture, the dimensions of sections will vary within the tolerances allowed in the standards and this should be taken into consideration when designing components to fit together. In some cases the eccentricities arising from manufacturing tolerances may have to be considered in the design using second-order theory.

Open sections

The basic material for hot rolled sections is mostly billets, blooms or beam blanks produced in the continuous casting process, using liquid steel coming mainly from an electric arc furnace.

In the walking furnace, the basic material is heated to a temperature of about 1350 °C, either coming directly from casting to reduce energy costs or from intermediate stock to decouple the casting and rolling processes. The hot steel blanks then pass through several rolling stands to achieve their final shape. The chamber size of the finishing rolling stand determines dimension of the section. By varying the distance of the rollers for the flange and the web of the section, the different section types in one series can be rolled within one chamber. This also explains the slight variations in the dimensions of HEA, HEAA, HEB and HEM of the 300 series. Only the HEB 300 has an exact height and width of 300 mm, the derived sections have flange and web thicknesses that differ slightly from the basic dimension. After being cut to length in the hot or cold state and cooling down, the beams are straightened and dispatched.

Wide-flanged I beams (HE) with a square H cross section can be used to carry heavy loads as columns and beams. Similar but lighter sections are called HEA or HEAA, standard sections are called HEB, and reinforced sections are called HEM. HD sections are mainly for columns, HL with extra wide

flanges (no more square cross section) for high bending loads, HP mainly for foundations and piling. Please note that only in the HEB series does the actual section depth corresponds to the designated value.

Standard sections IPN and U/UPN correspond to the IPE and UPE sections; they have tapering inner flange faces that are not ideal for attaching threaded fasteners. They are less expensive than sections with parallel flanges. Special cone-shaped washers are available for use with threaded fasteners. The slender IPE sections are particularly suitable for resisting bending stresses, e.g. as a beam. When loaded in direct compression, these sections are susceptible to buckling on their weaker axis and therefore they are less suitable as columns, especially if there is no lateral restraint.

For the most part, U sections are arranged in pairs because of their asymmetric shape. Halved IPE sections are used as T sections.

The largest standardised hot rolled profile available at the moment has a section depth of 1118 mm. Lengths are mainly determined by transportation restrictions. Nevertheless, the most common lengths on the market are 12 m to 18 m with intermediate steps of 2 m. Provided the order exceeds a minimum tonnage, certain sales catalogues offer lengths of up to 33 m and even longer products are available on demand.

The section tables not only show the dimensions of the cross sections but give information on the weight (e.g. for loading calculations and cost estimates) as well as on the surface area of each section in m^2/m (for calculating the painted surface area). Another area-related parameter is the ratio Hp/A, in which Hp is the heated perimeter (a measure of the area exposed to heat in a fire) and A is the cross sectional area. A small Hp/A ratio saves on painting costs and indicates a slower build-up of heat in the full cross-section in a fire.

Hot rolled sections are also the basic material for several derivative standardised beams. For instance, in order to manufacture cellular beams, the rolled section is cut into two specially shaped halves along in its web, which are then shifted longitudinally relative to one another to create a deeper beam with web openings, and subsequently reconnected by welding.

The final shape of the web openings may be hexagonal, round, or more recently lenticular, through which even rectangular ducts can pass.

For the same weight per metre, a cellular beam is considerably stiffer than the original beam, as it is 1.5 times deeper. Furthermore, the final mechanical properties might be optimised using different section types and steel qualities in the bottom and the top sections of the cellular beam.

Hot rolled sections are also the basic material for producing integrated floor beams, which were developed to fit into flat ceiling slabs. Their common characteristic is a wider bottom flange designed for improved support of the transverse slab elements. They are manufactured either from split H sections with a wider steel plate then welded onto the web (IFB: integrated floor beam), or a wide steel plate is welded onto a standard section (SFB: slim floor beam) to provide a wider, stiffer bottom flange. Incorporating the main parts of the beams in concrete also improves their behaviour in fire, as only the bottom flange is directly exposed the heat. Recent developments are focused on improving the composite action of these beams in order to enhance stiffness. Modified and standard sections often form part of complete and more complex floor systems, which are described later (p. 133ff.).

Hollow sections

For the most part, hollow sections are used as columns and in lattice girders. A range of wall thicknesses allow a member to be

Designation	min./max. dimensions (h x b)		Weight [kg/m]	Euronorm EN
Overview of customary European standardised steel sections – forms and applications, dimensions and weights				
Sections with parallel flanges				
• IPE	IPE 80	(80 × 46 mm)	6.0 kg/m	EN 10025-2: 2004
parallel flange I-sections	IPE 600	(600 × 220 mm)	122.0 kg/m	EN 10025-4: 2004
• IPN	IPN 80	(80 × 42 mm)	5.9 kg/m	EN 10025-2: 2004
taper flange I-sections	IPN 600	(600 × 215 mm)	199.0 kg/m	EN 10225: 2001

IPE sections are slender, lighter sections for low loads. Owing to the limited flange width, there is a risk of buckling, and IPEs are therefore chiefly used as beams – are less suitable as struts or columns. Frequently used in multi-storey construction. Owing to the tapered internal flange surfaces, these sections are seldom used for bolted constructions, but tend to be welded. Can be used for secondary components, e.g. purlins. Standard sections are less expensive than sections with parallel flanges, but are still only rarely used these days.

IPE IPN

Wide-flange beams				
• HEA	HEA 100	(96 × 100 mm)	16.7 kg/m	EN 10034
wide I-beam, light series	HEA 1000	(990 × 300 mm)	272.0 kg/m	
• HEB	HEB 100	(100 × 100 mm)	20.4 kg/m	EN 10034
wide I-beam, standard series	HEA 1000	(1000 × 300 mm)	314.0 kg/m	
• HEM heavy series	HEM 100	(120 × 106 mm)	41.8 kg/m	EN 10034
wide I-beam, heavy series	HEM 1000	(1008 × 302 mm)	349.0 kg/m	
• HD	HD 260	(260 × 260 mm)	93.0 kg/m	EN 10025-2: 2004
wide-flange columns	HD 400	(399 × 401 mm)	314.0 kg/m	EN 10025-4: 2004
• HL	HL 920	(921 × 420 mm)	387.0 kg/m	EN 10025-2: 2004
extra wide-flange beams	HL 1100	(1100 × 400 mm)	390.0 kg/m	EN 10025-4: 2004

For high loads (columns, beams), parallel flanges, radiused corners.
High buckling stability owing to wide flange and therefore also suitable for transverse loads.
Compact, square cross-section especially for the HD series.
Caution: The profile designation only matches the actual section depth in the case of the HEB series, e.g. HEB 200.
In the HEB series depth and width are identical for the 100 – 300 mm sections; above this the width remains constant at 300 mm. The same applies to the HEA and HEM series.

HEA HEB HEM

Standard sections (tapered flanges)				
• U	U 40	(40 × 20 mm)	2.65 kg/m	EN 10025-2: 2004
tapered flange channels	U 65	(65 × 42 mm)	7.09 kg/m	
• UPE	UPE 80	(80 × 50 mm)	7.90 kg/m	EN 10025-2: 2004
parallel flange channels	UPE 400	(400 × 115 mm)	72.20 kg/m	
• UPN	UPN 50	(50 × 38 mm)	5.59 kg/m	EN 10025-2: 2004
tapered flange channels	UPN 400	(400 × 110 mm)	71.80 kg/m	

Owing to the tapered internal flange surfaces, these sections are seldom used for bolted constructions, but tend to be welded.
Can be used for secondary components, e.g. purlins.
Standard sections are less expensive than sections with parallel flanges, but are still only rarely used these days.

U UPE UPN

Overview of customary British section ranges – forms and applications, dimensions and weights				
• UB	UB 127 × 76 × 13	(127 mm × 76 mm)	13.0 kg/m	EN 10025-2: 2004
universal beams	UB 914 × 419 × 388	(921 mm × 420 mm)	388.0 kg/m	EN 10025-4: 2004
• UC	UC 152 × 152 × 23	(152.4 mm × 152.2 mm)	23.0 kg/m	EN 10025-2: 2004
universal columns	UC 356 × 406 × 634	(474.6 mm × 424.0 mm)	634.0 kg/m	EN 10225:2001
• J	J 76 × 76 × 13	(76.2 mm × 76.2 mm)	12.8 kg/m	EN 10025-2: 2004
tapered flange I-sections	J 254 × 114 × 37	(254 mm × 114.3 mm)	37.2 kg/m	

UB UC J

Overview of customary American section ranges – forms and applications, dimensions and weights				
• S (metric)	S 75 × 8.5	(76 mm × 59 mm)	8.5 kg/m	A572/A709/A992
standard beams	S 610 × 180	(622 mm × 204 mm)	180.0 kg/m	
• W	W 100 × 100 × 19.3	(106 mm × 103 mm)	19.3 kg/m	A572/A709/A992
wide flange beams	W 1100 × 400 × 499	(1118 mm × 405 mm)	499.0 kg/m	
• HP	HP 200 × 43	(200 mm × 205 mm)	43.0 kg/m	A572/A709/A992
wide flange bearing piles	HP 360 × 174	(361 mm × 378 mm)	174.0 kg/m	A913

S W HP

```
L    L    ⊥    ⊔    ⌐    ─
1    2    3    4    5    6

L    L    ⊥    ⊔    ⌐    O
7    8    9    10   11   12

L    L         ⊔    ⌐    ⊔    ⊏
13   14        15   16   17   18
```

Angles and small sections (see below)

34

strengthened where loading demands without changing the overall dimensions. Hollow sections have a high buckling strength. Their Hp/A ratio is the very small; however, compared to open cross sections they 1.5 – 2 times more expensive and their joints are much more complicated. There are cold formed and hot formed hollow sections. Cold formed sections are less expensive and of less weight, whereas hot formed sections provide more buckling strength.

Seamless tubes are mainly products using two different processes; pilger rolling mill and plug rolling mill. They are used in applications with specific requirements like pipelines and are often the basic material for hollow sections of different shapes. Welded tubes with longitudinal seams can sometimes be substituted for seamless hollow sections in cases where appearance is not the only requirement. The seams can be ground smooth so that no major differ-

ence is observed. These tubes are produced from steel sheets or hot rolled coils, which are curved along the longitudinal axes of the tube.
Spiral tube products mainly from coils of different thickness and have a spiral seam around the tube. Galvanised coil steel ducts are produced by welding or joining technology suitable for the galvanised base material and are mainly used in air conditioning systems.

Overview of customary European standardised steel sections – forms and applications, dimensions and weights

Designation	min./max. dimensions (h x b)		Weight [kg/m] [1]	Euronorm EN
Hollow sections[1]	**(Wall thicknesses vary)**			
RRW/RRK square	RRW 40 × 40	(40 × 40 mm)	4.4 kg/m	EN 10220
	RRW 400 × 400	(400 × 400 mm)	191.0 kg/m	
RRW/RRK rectangular	RRW 50 × 30	(50 × 30 mm)	4.4 kg/m	EN 10210
	RRW 400 × 200	(400 × 200 mm)	141.0 kg/m	hot forming
ROR circular	ROR 38	(38 mm)	2.0 kg/m	EN 10219
	ROR 600	(600 mm)	114.0 kg/m	cold forming

square rectangular circular

[1] Weight depends on wall thickness
The external dimensions can be maintained but the wall thickness varied to cope with different loads.
From the structural viewpoint, circular hollow sections have an optimum column cross-section, a small surface development (favourable U/A value, less painting required). Ideal for concentric loads on columns and for lattice beams. Often used for exposed forms of construction. We distinguish between RRK (cold-worked), lightweight and inexpensive, and RRW (hot-worked), with good buckling resistance due to upset corners.

Bars [2]

RND (round section)	RND 5.5	(Ø 5,5 mm)	0.2 kg/m	EN 10060
	RND 400	(Ø 400 mm)	986.4 kg/m	
VKT (square section)	VKT 6	(6 × 6 mm)	0.3 kg/m	EN 10059
	VKT 200	(200 × 200 mm)	314.0 kg/m	
FL (flat)	5 × 10	(5 × 10 mm)	0.4 kg/m	EN 10058
	60 × 150	(60 × 150 mm)	70.7 kg/m	

max. 150 mm

[2] Hexagonal and custom sections are also classed as bars.
Solid bars are very uneconomic as struts, but they can achieve a high fire resistance class when used in conjunction with suitable fire protection systems. Solid bars are primarily used as ties. The narrow flat saves space, but the ends must be widened or thickened with additional plates to compensate for weakening due to holes. When provided with a thread at each end, round bars can be lengthened by joining with screwed sleeves.

Angles and small sections

Common sections for general metalworking requirements (balustrades, canopies, simple doors and windows, etc.)

1 Equal angle – radiused corners	7 Equal angle – sharp corners	13 Equal angle – cold-rolled	EN 10055
2 Unequal angle – radiused corners	8 Unequal angle – sharp corners	14 Unequal angle – cold-rolled	
3 T-section – radiused corners, long stalk	9 T-section – sharp corners	15 Plain channel – cold-rolled	EN 10056
4 Channel	10 Plain channel	16 Z-section – cold-rolled	
5 Z-section – standard section	11 Z-section – sharp corners	17 Outwardly lipped channel – cold-rolled	
6 Flat	12 Balustrade tube	18 Inwardly lipped channel – cold-rolled	

31 Structure of welded HEB sections
 Conversion of mine building, Peißenberg (D)
 2004, Reichel Architekten
32 Structure using cellular beams
33 Lattice-beam grid made of hollow sections with
 roof covering of timber sandwich panels
 Hall 13 built for EXPO 2000, Hannover (D) 1997,
 Ackermann und Partner Architekten
34 Load-bearing walls of 8 mm-thick steel sheets,
 the flanges are visible in floor and ceiling
 Werk- und Denklabor Pauker, Friedberg (D) 2008,
 hiendlschieneis architektenpartnerschaft
35 Stainless steel fabric, weave type: spiral wave
36 Stainless steel grid, layered
37 Facade of metal mesh
 MPreis shopping centre, Wattens (A) 2003,
 Dominique Perrault Architectes

35

36

Steel bars

Steel bars include round bars and square bars, as well as flat bars, and special-type sections. For the most part, steel bars are used as ties. Round bars can be joined longitudinally by threaded connectors. Common ranges of dimensions are 10–130 mm diameter for round bars and a peripheral length of 30–160 mm for square bars, with square or round corners. Length are similar to other hot rolled sections, usually up to 12–16 m or even longer on order.

Concrete reinforcement – bars and fibres

Steel reinforcing bars (rebars) are produced from steel billets by hot rolling to shape the steel into reinforcing bars. The typical transverse and longitudinal ribs considerably improve the composite action between concrete and steel.

Rebars are produced in different diameters ranging from 6 – 55 mm and to various national standards. Rebars can be purchased in coils (up to 5 t) or as straight bars usually up to 24 m length. Reinforcement with smaller diameters for better crack control in the concrete are often welded together as mesh reinforcement.

Concrete has a good compressive strength but cannot provide the tensile strength needed for most buildings and civil works. Rebars give concrete tensile strength. Therefore almost all structural concrete in buildings and civil engineering works incorporates some form of steel reinforcement. Most rebar produced nowadays has a minimum yield strength around 500 N/mm². In projects with high anticorrosion requirements, steel reinforcement bars can be galvanised or coated with epoxy. In the latter case, the coated bars cannot be welded and special couplers are needed to connect the bars. For specific projects like liquid natural gas tanks and other cryogenic applications, some special rebar products with sufficient toughness at low temperatures are available on the market which can fulfil strength and

ductility specifications down to 165 °C. Steel bars, hot rolled and cold drawn wire or strands are also used for prestressed concrete, on site and in precasting yards.

Another method of reinforcing concrete is steel fibres, small pieces of shaped steel wire 3 – 6 cm long and 0.5 –1.5 mm in diameter, which are added to the fresh concrete at rates of between 10 kg/m³ and 120 kg/m³, depending on the application and purpose. In certain circumstances, steel fibres may replace conventional bending reinforcement, especially in conjunction with profiled steel deck sheets act as shear reinforcement or just improve cracking behaviour. The main applications are industrial floorings, jointless screeds and foundations.

Fabrics and meshwork

Steel fabrics are manufactured from round or flat hot-rolled wires, from bars, from steel rope and braided wires. They are made up of longitudinal warp threads and transverse weft threads, the same arrangement as textile fabrics. Appearance depends on the type of fabric selected. Plain weave describes a fabric with identical top and bottom faces. Such fabrics are supplied in

lengths, rolls, or as single sheets, or made up to individual requirements. Depending on their thickness, further cutting to shape may be impossible.

Apart from appearance, the following criteria are of importance for the structure of steel fabrics:
• Mesh size: clearance between two adjacent wires
• Wire diameter prior to interweaving (may change slightly during machining)
• Thickness of fabric (depends on the wire diameter)
• Fineness of fabric (mesh): number of meshes per inch, bearing in mind that manufacturers may use different inch rates as basis (French inch = 27.07 mm, British inch = 25.4 mm)
• Meshes/m
• Open area: as a percentage of the total surface area

Beside fabrics, further types of meshworks and screens are available (laid and knitted fabric).

Laid fabrics are plain layers of wire connected at their crossing points by welding or pressing. Examples include ordinary welded wire meshes as well as steel netting. Knitted steel fabrics – composed similarly to

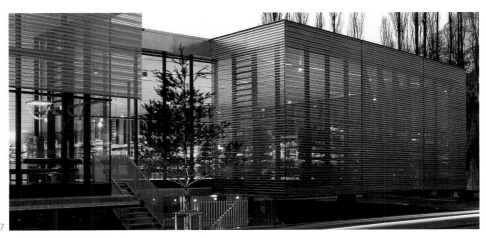

37

38 Ways of weaving metal fabrics
 a basket-weave, b ribbed weave
 c twilled, d twilled ribbed
 e ribbed armoured
 f long mesh
 g five-strand twilled
 h multiplex
39 Types of wire rope (cable)
 i Parallel-wire rope
 j locked-coil rope
 k strand rope for secondary purposes
 l bundle of parallel prestressing wires
40 Zinc bloom crystals, typical cristalline structure
 of galvanised surfaces
41 Components being lifted out of the hot-dip
 galvanising tank
42 Fire test to establish rating of a cellular beam

knitwear – are basically use for mechanical filter technology and, in contrast to fabrics, their strength is very low. Therefore in architecture they can only be used in if protected, e.g. in the air space between panels. For corrosion and maintenance reasons, fabrics and meshworks are mainly based on stainless steel wire and strand.

In architecture, fields of application for fabrics include sunscreen elements, external claddings, suspended ceilings, balustrade infills, as well as metallic curtains and floor coverings. Manufacturers offer compatible fastening systems. By way of example, rods woven or pushed into the hem of the fabric can be fitted onto a substructure, or the fabric can be set into a frame to form movable sunscreen elements. If they are used outside, temperature-dependent variations in length and deformations caused by wind must be accommodated by the elasticity of the structures, by building in tension springs and J-bolts.

Gratings

Gratings are composed of bearing bars and weaker stabilising cross bars arranged orthogonally, with the result that they span in one direction only. Therefore, special attention must be paid to the direction of span of square gratings. The bars are set into a border edging of binder bars. It is possible to further profile gratings to obtain an anti-slip surface.

The first value in the mesh size, e.g. 11/30, indicates the clear distance between the bearing bars, and the second the clear distance between the cross bars.

The stabilising elements of press gratings are forced under pressure into the bearing bars. Welded press gratings have twisted squares bars as the stabilising elements. They provide more stability than standard press gratings and allow cutouts. The bearing bars and stabilising elements of full gratings are of the same thickness. Due to their low carrying capacity, they are used for non-structural purposes like balustrade infills. Louvre gratings with angled stabilising elements can provide a closed appearance for stairs or footbridges.

Ropes

Steel ropes are manufactured from cold-drawn wire. A rope-making machine lays (usually helically winds) several wires around a core wire. Since a rope is composed of many single wires, the chance of a complete failure of the whole cross section is much less than with a tie made from a full bar. There are three basic rope types encountered in structural engineering:

- Open spiral ropes are made from round wires are used for trussing, as guy ropes, balustrade ropes, suspension and tensioning rope in nets, as well as in lightweight membrane structures.
- In case of full-locked coil rope, a layer of z-shaped wires encloses the bundle of round wires to protect them against corrosion and penetration of foreign materials. Such cables are therefore suitable for highly demanding uses in outdoor environments.
- Cable laid ropes consist of several small diameter round stranded ropes wound around one another, sometimes with a core. They have a low modulus of elasticity and are more likely to be used as flexible and continuous ropes, for example in hoists or on balustrades.

Paint coatings and batch galvanising – corrosion protection after processing

Unlike the continuous coil coating process discussed earlier, the paints and coatings described here are mainly applied after steel fabrication operations consisting mainly of cutting, drilling, bending and welding have been completed. These corrosion protection techniques are relevant for structural steel elements which have to be first built-up in

40 41

the fabrication shop and then protected with a individual coating system, either by the fabricator, in a specialist paint shop or on site. Even though the elements may be identical and painted one after the other, the process cannot be described as continuous, as is the case when coating coil steel. The items are processed as single elements, after which they need only to be assembled on site. However, the corrosion protection systems are similar to those employed in continuous processes and include metallic coatings, principally hot dip galvanisation, and organic paint coatings. Combinations of both, called duplex systems, are used more rarely than in coil coatings and only in special cases.

Hot dip galvanising of structural elements
Before immersion in the molten zinc bath, the surface of the steel element to be hot dip batch galvanised must be degreased in an acid or alkali bath, pickled, usually in hydrochloric acid, and then fluxed. The zinc in the bath is kept at a temperature of 440 – 460 °C and its content of additional elements is limited to about 1.5 %. The dimensions of the bath, usually $18 \times 2.2 \times 3.6$ m deep, define the maximum dimension of the components to be galvanised. The designer should consult the galvaniser to ensure that the components can be galvanised in the bath. Larger components can be dipped on both sides. To galvanise components safely and effectively, the designer must observe some basic detailing rules: vent holes, run-off and inlet openings have to be provided ensure free flow of liquids during the surface treatment and galvanisation phases. The molten zinc must form a resistant bond with the whole of the steel surface. Air pockets have therefore to be avoided by careful detailing.

Today's generation of structural steels are basically all suitable for hot dip galvanising. The initial condition of the steel surface, zinc-iron reaction and final appearance and

thickness of the coating depend on the steel composition, bath temperature and precise composition, and the immersion time and speed (5m/min recommended). With the right choice of the above parameters, a solid zinc-iron alloy between 5 and 150 μm thick develops at the steel surface and is mainly responsible for the good corrosion resistance.
Excess zinc that does not react with the steel remains on the component's surface as a pure zinc coating. Sometimes the iron-zinc reaction layer extends to the outer surface, resulting in a dull appearance. If a bright metallic look is desired post-treatments like quenching or special zinc melts alloys should be considered. If the galvanised steel is to remain visible after installation, then it should be borne in mind that a mixture of steels may result in an uneven appearance. Galvanised steel with a low silicon and phosphorous content has a pleasing metallic appearance. As the zinc coating hardens, the characteristic bright spangles or zinc bloom crystals form. In general, a high rate of cooling causes the development of smaller spangles.
Galvanising does not hide blemishes in the steel. Even if welds are ground smooth before galvanising, they may remain visible afterwards due to metallurgical changes.

Other ways of galvanising steel include thermal spraying with zinc, zinc-rich paints and soldering with a zinc-alloy stick, but are mainly restricted to repairs. According to ISO 1461, repair is required when the imperfection in the zinc coating exceeds 0.5 % of the total surface area or a single defect exceeds 10 cm².
Thermal spray with or without subsequent sealing is by far the most expensive method of repair due to its complexity. Therefore its use is limited, especially on site. However, it provides good protection even though there may be no development of a iron-zinc alloy layer as in the hot dip process.
More common are repairing systems based on zinc-rich paints containing zinc powder, which are equally effective. The quality depends largely on the surface preparation. Complexity of use and poor quality repairs mean soldering is becoming less popular.

If galvanised components are subsequently covered with a compatible organic coating, the result is a duplex system. The lifetime of the corrosion protection provided is longer than the simple sum of both actions alone. It is important not to damage the zinc layer when preparing and cleaning the substrate for the organic coat. To this end, the surface is wet ground with an ammoniac wetting

During the last 50 years, the steel industry has invested strongly in research and development focused on construction.
New steel grades and properties, better knowledge of structural behaviour, improvements in design codes, fire engineering and safety and several market development solutions are among the impressive results of these programmes, which have also involved steel fabricators and other steel manufacturers.

agent, then subjected to mechanical grinding, or wet blasting with hot water, steam blasting, or sweep blasting, depending on the age and condition of the zinc. Sweep blasting is a gentle sand blasting technique designed to abrade the surface without causing heavy damage. Nevertheless, it abrades the zinc slightly and, consequently, the thickness of the zinc layer should be dimensioned accordingly.

Duplex systems are used if a particularly long period of protection or a coloured finish is required. Higher initial costs may be offset by lower maintenance requirements.

Paints for structural elements

Paints are composed of several components, mainly binder (matrix), pigments and fillers, a solvent based on water or an organic chemical, and additives. Binder, pigments and fillers, as the solids content of the coating, remain in place once the solvent has evaporated. The most important differences between acrylic resin and epoxy resin paints are the binder used and the way the film is formed. Acrylic paints may harden by oxidation or by simple physical drying, like PVC based paints. Epoxies and polyurethanes harden by chemical reaction.

Depending of the degree of exposure to corrosive attack, the finished coating system may consist of several layers. For outside application and severe indoor environments for the most part these are:
- One or several primary coats,
- An intermediate coat,
- One or several final coats,
- Optional extra edge protection to compensate for the paint running away from edges due to surface tension effects.

The number of coats depends on the overall thickness required. The dry thickness of the entire system is typically between 160 μm and 320 μm. The primer ensures good adhesion of the system to the steel surface. Furthermore, it contributes to the corrosion protection mainly provided by the intermediate coat. They contain zinc powder and other fillers like micaceous iron to build-up a barrier against corrosive atmospheres. Top coats define the appearance, including the colour of the paint system, and protect against weathering and UV radiation, which might otherwise attack the solvent. For low corrosive environment, e.g. inside a building, the primary coats may be sufficient. Furthermore, new developments in the paint and coating industry now offer coating systems that can provide low to medium corrosion protection with just two or even one layer to reduce coating costs.

The coating may be thinner at the edges of the steel due to poor application techniques and liquid paint's tendency to run away from sharp features. If higher corrosion protection is required the edges or critical areas may have to be painted with an additional layer.

Before applying the system, contaminants and blemishes such as loose mill scale, rust, detached old paint or grease must be removed from the ground, e.g. by shot blasting or pickling (chemical cleaning). Partial preparation preserves intact coats. A specific roughness value should be achieved to ensure good adhesion of the coat.

Paint systems are applied by means of spray-coating or painting, either manually or in a closed room by use of spray-coating and suction devices.

Special coatings and surface treatments

Powder coating

In powder coating, solvent-free paint powder is applied electrostatically and then cured. In some systems the positively charged workpiece attracts the negatively charged powder. Having reached a particular thickness of layer, the opposing charges cancel one another out so that no more particles are deposited. During curing, the powder melts and turns into a liquid coating. Cooling results in a resistant coat with a consistent appearance. This process can only be used in the factory, in special spray booths for the most part, but not on site.

Fire protection – intumescent coatings

Intumescent coatings are designed to chemically react in the event of a fire to protect the steel and lengthen the time taken for it to reach its critical failure temperature. Depending on the environment surrounding the structure, required specification, product characteristics and the final dry-layer thickness, intumescent paints can provide 30, 60 or 90 minutes fire resistance for steel structures.

Intumescent coatings are normally applied by airless spray. A primary coat provides protection against corrosion on top of which insulating layers of up to 3.5 mm thickness expand to ensure the steel continues to function adequately for the specified period in the event of fire. The maximal applicable wet-layer thickness determinates the number of spraying operations to ensure final resistance. These coating compositions are based on organic resin binders, which are typically acrylated rubber or epoxy. The resins are filled with active ingredients, which react in a fire to form a thermally insulating carbonaceous char or foam. The char can expand up to 50 times the original coating thickness, and helps to reduce the rate of heating of the steel.

The coatings can be used on open and closed profiles for internal and external steelwork, but the coating thickness needed varies greatly, and the exact amount of paint required for each individual steel section must be estimated accurately. Hp/A calculations are used to calculate the exact amount of paint needed for a specific steel section. The top coat, which is optional for internal, non-visible application, remains stable at ambient temperatures.

43

44

Metallic deposit (plating) and cladding (overlayers)

Composite sheets have been developed which combine the good mechanical properties of steel with the desired appearance and surface properties. Again there are two basic processes for coating the steel. Metallic coatings can be applied by electro-deposition. In addition to zinc mentioned above, the most common metals used are cadmium, nickel, chromium, tin, copper, brass and silver.

Cladding means the covering of a steel core with thin, roll-bonded layers of other metals by hot or cold rolling similar to other coil coating processes. Roll bonding techniques can provide multilayer composite materials with adapted and optimised characteristic and properties. However, their application in construction is mainly restricted to special application or very exclusive facades and interior design.

Enamelling

The main process for applying inorganic, non-metallic coatings to steel is enamelling. Enamel is an opalescent glassy material with a smooth surface produced by melting its components (mainly silicon) at high temperature. It is used mainly on hot or cold rolled steel.

Enamel is applied in one or two layers each between 0.1 and 0.15 mm thick and fired. The method of coating depends on the form and purpose of the workpiece. After final shaping of the steel, you can coat the workpiece by dipping it into a blend of powdered enamel and water, spraying, or applying the powder electrostatically in a similar way to powder coating. Firing then bonds the enamel to the steel chemically. The enamel also bonds mechanically to the steel, therefore the steel must be dimensioned to prevent undesirable deformations after cooling, especially on light facade panels. Enamellled steel is weldable without restriction, which simplifies the shaping of the require elements.

The main advantages of enamelled steel are the very good resistance in severely corrosive conditions, durability with respect to weathering including UV resistance and good resistance to abrasion and scratching. From the aesthetic point of view, the designer has an unlimited choice of colours and printed effects.

Enamelled panels are often used as wall and facade panels. Another field of application in architecture is sanitary objects, for enamel has good hygienic and antibacterial properties.

The high colour fastness of enamelled panels even allows later replacement of individual facade units without any colour differences. Maintenance demands are low and the easy cleaning properties of enamelled steel makes it ideal for public spaces.

Plasma vacuum: a new and innovative technology

Firing plasma can be used to deposit at a low pressure "vacuum" almost any chemical element, such as copper, titanium or aluminium onto the steel surface. This process is used, for example, to colour stainless steel, for self-cleaning facade materials or for antibacterial surfaces. Such coats are very durable and resistant to deformation. The technique is already known but recently a

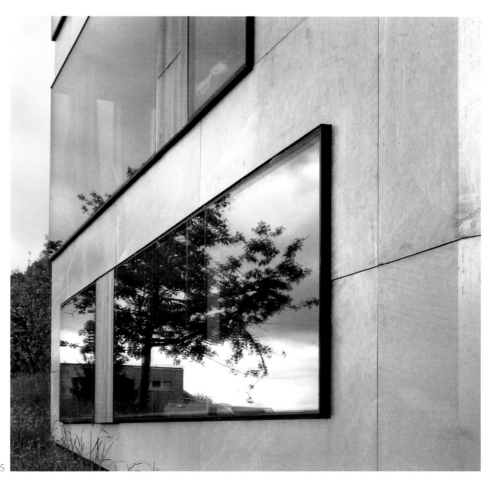

45

46

47

48

process was invented to apply it to continuous coil coating. Until now, only single sheets had been coated, more or less manually, using furnaces. The new process will provide new opportunities and applications in construction.

Surface treatment of stainless steel

The main mechanical surface treatments for stainless steel are brushing, sandblasting, shot peening, water jet machining, grinding, polishing and engraving.

Sandblasted surfaces are less sensitive to abrasion. Numerical control techniques allow partial blasting, which gives scope for surface designing with patterns or texts of different textures.

There are several engraving processes, such as chemical engraving, which allow the reproduction of original pictures and drawings. Etching techniques cover several chemical machining processes designed to remove rust from steel surfaces.

Machining and joining

Cutting and machining

There are two basic methods of cutting: mechanical cutting tools, such as shearing machines, drilling machines and sawing machines, and physical-chemical tools. The latter include thermal processes, such as laser, oxygen, arc and plasma cutting. Mechanical machining includes turning, planing, milling, grinding, drilling and punching. During punching (nibbling), you may carry out non-cutting machining, such as bending up of ventilating slits or edge bending.

Numerically controlled cutting is a cost-effective way of manufacturing individual shapes, for ornamental structures or customised sections. CNC milling can be used to create three-dimensional shapes. Here, the workpiece is clamped into a machine and a cutting tool scans it exactly line-by-line. Digitising of design is becoming more and more important in the production of structural steelwork and can make extremely complicated structures very simple to realise.

Plasma cutting

Plasma cutting can be used to cut electrically conductive materials. Plasma is a very hot, electrically conductive gas. The temperatures prevailing inside the plasma arc range up to 30,000 °C and cause material to melt; this produces slightly wider kerfs than laser cutting. Cutting speed and accuracy are extremely high and materials up to 160 mm thick can be cut.

Laser cutting

Laser cutting is a thermal cutting process for materials up to 20 mm thick. Lasers can be used to realise really minute geometries. In addition to sheet metal, laser cutting can also cut three-dimensional bodies such as pipes. Three-dimensional bodies can also be shaped with rotary shears (fig. 48). This technology offers great scope for further development.

The kerfs are very narrow (0.2 – 0.4 mm) and the cut edges are right-angled. Even for small-scale manufacture, this technology is economically advantageous.

Water jet cutting

Water jet cutting is a mechanical cutting process which uses a water jet of 6000 bar to cut the workpiece. The steel is cut cold so as to avoid creating internal strains in the material.

Despite its relative expense, the fine cutting quality makes this machining method attractive. For abrasive water jet cutting, a cutting agent is added to the water jet to increase the cutting performance and avoid disturbance to the material structure. This makes the method particularly suitable for cutting of composite materials.

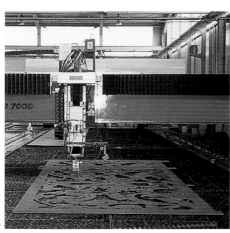

49

50

51

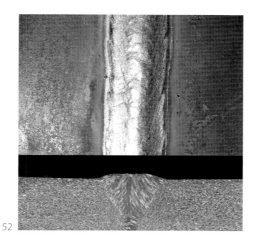

52

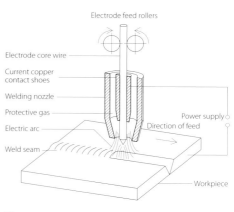

53

46, 49 Lasercutting of weather-proof steel sheets
 Bus shelter Ländtorplatz, Landshut (D) 1997,
 Hild & Kaltwasser
47, 50 Plasma cutting of steel
 Screen to parking deck Salvatorgarage,
 Munich (D) 2006, Peter Haimerl
48, 51 Laser cutting of steel tubes as solar protection
 Fa. Trumpf, Ditzingen (D) 2007, Barkow Leibinger
52 Good quality weld seam, elevation and section
53 Schematic diagram of gas-shielded metal-arc
 welding

Welding

Welding means fusing together of two steels of the same or similar properties by liquefaction or plastic deformation. This is carried out with or without the addition of another material to fill the weld seam – namely the filler wire. By creating a continuous power flux, welding provides the optimum connection between steel components, such as forming full bending moment joints.

On-site welding of coated steel should be avoided as it may lead to damage of the zinc or the anticorrosive coating. Shop welding can make good use of sophisticated factory equipment, e.g. for preheating and provides better quality. As far as possible, work on-site should be limited to assembling.

Not all steels are weldable. Weldability does not depend only on the carbon content but also on other factors, such as the exact chemical composition, sensitivity to brittle fracture, deoxidising type and thermal treatment. In order to be able to evaluate the relative weldabilities of different alloys, a measure known as the carbon equivalent value (CEV) has been developed.

There is a trade-off between material strength and weldability: low alloy steels have limited strength while high alloy steels often exhibit poor weldability. However, thermomechanical rolling produces high strength steel without a substantially higher carbon equivalent value and therefore preserves excellent weldability, even in thick products.

Besides the thermal treatment before and after welding, the type of weld seam is also of particular importance. Full penetration welding should be preferred. The type of weld (e.g. square butt weld, double-V butt weld) to be used and the width required depend on the thickness of sheet metal as well as on the joint geometry.

Weld finish is important to the appearance of the final structure and should be specified in advance.

If the weld seam is to be invisible in a large steel surface, it can be ground until it is virtually beyond recognition. In contrast, designers can also use welds seams as a design element.

Furthermore, the appearance of a weld seam affects the costs. So, a filled weld is less expensive than a ground groove weld.

If welding on existing steel structures, attention should be paid to a probable weakening of the components under load by local temperature rise.

There are two principal welding techniques used in the construction industry: arc welding and inert gas welding.

In arc welding, an arc initiated between two electrodes generates enough heat to melt the materials of both workpieces. Here, the workpiece is one electrode and the filler wire is the other.

Inert gas welding is arc welding with a flow of gas to prevent the metals from reacting with the outside air. Tungsten inert-gas welding initiates the arc between a tungsten electrode and the material; the filler wire is added separately. The weld seams are high quality. Flash butt welding initiates the arc between the metal components to be joined – additional filler wire is not required. This technique is suitable for welding on smaller components, e.g. shear connectors.

Bolted connections

On site, bolting has advantages over welding. Bolted connections are easier to handle and, to a large extent, are unaffected by the weather. Moreover, such a detachable connection promotes good recyclability of the components.

From the large range of available products, the only threaded fasteners used in structural connections are hexagon head bolts and countersunk head bolts with a hex socket. Close tolerance bolts are available for use as fitted bolts in drilled holes without clearance. There are also black bolts, which fit into holes a little larger than the bolt diameter and allow for a certain tolerance. Fitted bolts should be used where no displacement of the components to be connected is allowed.

A washer is always to be positioned beneath the nut; high-strength bolts require a second washer beneath the bolt head. Washers provide optimum support for the nut or bolt head and an even bearing pressure on the material.

The fixing of thin sheet metal and facade elements requires fasteners that drill their own hole, screw and are set in one operation. Ordinary threaded fasteners only screw a thread into a predrilled hole. Both fastener types do not require any nuts.

The bolt designation is made up as follows: bolt type – type of thread – diameter of thread – bolt material. For example: high-strength fitted bolt M 20 10.9 means: High-strength fitted bolt with a 20 mm diameter metric made of a grade 10.9 material. Here, the figure to the left of the dot is 1/100 of the ultimate tensile stress of the bolt in N/mm^2, i.e. 1000 N/mm^2 in this example, whereas the figure to the right of the dot indicates one tenth of the ratio of the yield stress to ultimate tensile stress, expressed as a percentage.

Direct fastening

Powder-actuated fasteners are studs, also known as nails, or threaded studs used to fasten components consisting of steel, wood, insulation and in some cases plastic directly onto steel, concrete or masonry. The powder-actuated fasteners are driven in a single operation.

54

55

56

The energy released as the propellant expands is transferred onto a piston and from this piston onto the fastener. This piston principle together with a high driving velocity (maximum 100 m/sec) can drive fasteners directly into hard materials like steel. The driving process deforms the base material plastically. The anchor mechanism relies on a combination of clamping, welding and interlocking.

The energy required to drive the fasteners is usually generated by propellant cartridges using powder, or alternatively by gas or compressed air.

One of the main features of direct fastening technology is the high speed of working. It is possible to fasten up to 600 fasteners per hour with consistent fastening quality. The fastener and the fastening tool must be chosen to suit the components to be fastened. Commercial fastening tools permit the fastening of fasteners with a shank diameter of up to 5 mm in solid steel. Sufficient accessibility to press the tool right up to the base material must be considered during the planning process.

A typical installation in steel construction is sheet metal for siding and decking as well as

other steel profile components. A special product is the blunt tip fastener. These threaded fasteners are driven in a small pre-drilled hole. One of the advantages of this system is that there is no penetration of the rear side of the base material, thus an existing coating is not damaged.

Depending on the construction requirements for outdoor applications or humid environments, stainless steel fasteners or appropriate sealing caps should to be used. Regulations and approvals for direct fastening tools are country-specific and have to be followed, as well as the manufacturer's guidelines.

Rivets
Riveting uses compression to create a permanent connection. Since this causes excessive noise and is expensive, classical full riveting is used virtually exclusively for the restoration of historic steel structures. Here, the protruding shaft of the red-hot rivet is upset (deformed) using a large amount of force to form a second head. The rivet contracts during cooling, increasing the contact pressure between the components. Blind or POP riveting allows work to be carried out from one side only, e.g. for structures with cavities. The POP rivet is set into the rivet hole and a mandrel on this blind rivet is pulled toward the side of assembly, resulting in contraction of the rivet which forces together both sheets. At a predetermined breaking point the mandrel breaks off and can be pulled out. Rivets are typically used to join or add strengthening plates to members in historic steel structures. Special bolts are available to replace old rivets. They have rivet heads to maintain a traditional appearance and can be precisely pre-stressed to ensure the same load bearing behaviour as the initial rivets. Today, rivets are mainly used to join thin plates, e.g. for the construction of facades.

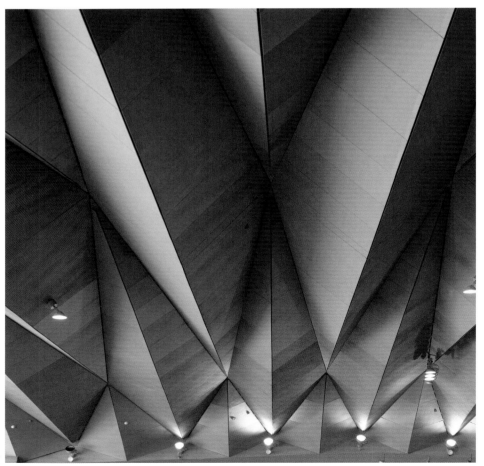

57

58

59

54 Riveted connection: flange splice plates
55 Bolted beam splice
56 Examples of glued joints
57 Yokohama International Port Terminal,
 Yokohama (J) 2002, Foreign Office Architects
 The connection of all web plates to the flanges
 was done using direct fastening technology. The
 complete steel structure remains visible. To
 ensure the required fire resistance, stainless steel
 fasteners with a high temperature resistance
 were used.
58, 59 Typical examples of the connection of metal
 sheeting to the steel structure of the facades and
 floor slabs

Gluing

Adhesive bonding is another way to join steel components to each other and other materials. This is a relatively new technique and is still being developed. For the time being, the low thermal stability of the adhesive is an obstacle and therefore adhesive bonding is used far less in structural engineering than in vehicle manufacturing. Gluing technology has mainly contributed to the development of sandwich panels and other composite materials composed of several layers of different products. One established application in structural engineering is sandwich materials that provide two final coating layers and one intermediate core layer, e.g. sandwich elements made of steel plate and polyurethane. This allows, for example, a fire wall to be built with steel plates encased in foam glass where the components are joined together by special adhesives.

Clinching

Clinching is a non-continuous method of joining in which the joined points are produced by punching two or more steel sheets together simultaneously by means of a punch and die. This procedure allows materials of different natures or non-weldable materials (e.g. organic coated steel) to be joined. It does not require prior drilling of the component or the use of additional material. Since the join does not need to be heated, there is no thermal damage. With suitable precautions, it preserves the corrosion resistance of the coatings; it has been observed that even after joining, the coating may in some cases be thinner but it is still present over the entire surface of the clinched point. It is a clean process that produces no fumes or slag; it is relatively quiet and uses little energy. It can be easily automated and integrated into various types of manufacturing line, such as roll forming. The following guidelines must be observed for clinching:

• The thinner sheet should not be less than half the thickness of the thicker sheet.
• The maximum thickness after joining is 6 mm.
• This maximum thickness decreases if the mechanical properties of the steel increase.

Constructive systems

In addition to the production of steel and supply of construction-related products, the steel industry is continuously extending its range of goods and services for the construction market. Complete construction systems have been developed out of many of the steel elements described in this book. Clients can take advantage of an increasing number of complex technical solutions for facade, roof or even floor applications. These systems contain not only the steel elements but also all other materials and accessories necessary for realisation and fulfilling of the desired functions.

Facade systems

Facade systems, for instance, are a well established and often used solution in industrial buildings. In order to structure the huge surfaces of these buildings the designer has two main architectural means: colours and moulded surfaces. Sandwich panels with a wide colour range and different shapes of decking sheet but common joint design and visible or non-visible fastening can offer both these means. Double-skin systems with trays as the inner leaf, optional intermediate substructure and final decking are even more flexible. Although systems based on sandwich panels may comply with fire requirements too, double skin systems have the additional advantage of allowing precise adaptation for other demands like acoustic and thermal behaviour. Furthermore, depending on the system, the orientation of the profiling can be varied from strict horizontal, through diagonal to simple vertical.

More sophisticated systems provide a wide range for the design of the external skin, either as siding, interlaced tiles or the more common cassette panels. Stainless steel can have benefits as the basic material and may be an option.

There are even more valuable facade solutions based on sandwich panels with specific joint design and dedicated sub-structures that focus on projects like office buildings and allow the easy integration of window or other openings.

Roof systems

Similar to facade systems, roof systems may cover all the different layers in a roof composition from the supporting structure, to insulation and final decking. Most often, they are based on a modular concept, which can be adapted to particular needs without a great deal of effort. Depending on the loads and the roof slope, purlins made from cold rolled profiles or deep rolled supporting sheets determine the maximum span of the system. There are also curved roofs where the steel sheets are either curved by pure bending or by notch bending, which permits even lower minimum radii. For simple applications, as in agriculture with no thermal requirements, special systems are available to deal with the problem of condensation. There are more advanced solutions based on sandwich panels, which integrate the supporting and insulation functions directly in one element. Higher performance solutions are, however, based on multilayer conceptions with final tightness ensured either by PVC plastics covering or more aesthetic profiled sheets. Some systems provide the possibility to vegetate the roof or are even equipped with solar photovoltaic systems from the beginning.

Floor systems

Steel buildings are often skeleton structures with, most often, a uniaxial floor system. The

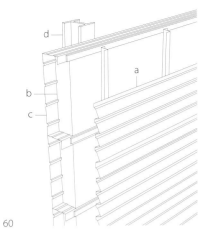

60

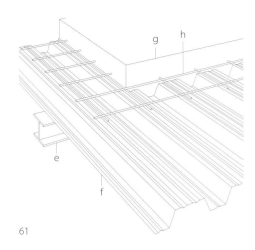

61

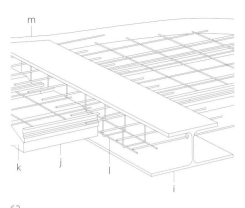

62

infilling between the beams, their connections and the final finishing layer, such as concrete topping, influence the horizontal load transfer and stiffening behaviour of the slabs; depending on the system, additional bracing in the floor level may therefore be required. The reduced quantity of in-situ concrete or mortar, which increases the dry-construction content and reduces the weight, is the main advantage.

The most common floor system in steel construction is the combination of composite (cellular) beams with composite floor sheets including in-situ concrete, with the sheets acting as permanent formwork. Concreting is also often the critical load case for the decking and therefore temporary propping may be necessary. Due to the composite action however, the final load capacity increases significantly. Furthermore, the steel in the sheet can replace some of the slab reinforcement. The remaining reinforcement will however determine the final fire resistance.

Systems using deep rolled sheets in combination with composite beams cannot mobilise the composite action of the sheets due to their disproportionate deformations. Nevertheless, the steel cross section influences

the overall capacity positively by a simple additive action. Car parks are one of the most important fields of application for those systems.

Using integrated floor beams (IFB) or slim floor beams (SFB), the supporting steel structure is integrated into the depth of the floor slab. This avoids downstand beams and presents an almost flat soffit, while reducing overall floor thickness. As only the lower flange is directly exposed to heat in a fire, this form of construction has a favourable influence on fire resistance.
These beams are often combined with prefabricated and prestressed hollow core slabs or planks, or deep rolled sheets with in-situ concrete, both of which are supported on the wider bottom flange of the beams. Hollow-core planks can span up to 12–16 m, whereas integrated beams cover the shorter span of the rectangular design grid with about 6–9 m.
Another alternative for the infilling is composite elements providing spans up to 7 m without any propping and an overall depth of 20–25 cm. These composite elements are composed of a profiled steel sheet similar to tray profiles familiar from facade construction, an insulating layer of mineral wool and reinforced concrete on the top, either pre-

fabricated or made on site. The mineral wool considerably reduces the weight of the elements, improves fire resistance and enhances thermal performance. The soffit can be left exposed using coated steel sheets and perforated for acoustic reasons if needed.
In all systems, floor weights are optimised with overall depths of 25–40 cm, depending on span and load.

Steel supply chain

As there is a huge variety of steel products, qualities and applications, it is useful to know the principal factors influencing and determining the steel logistics and supply chain.

There are four principal routes of steel supply:
· Direct delivery from the steel mill
· Delivery by distribution networks for steel products or general metal products.
· Delivery by steel processing companies like profilers, tube makers, and other businesses concerned with metal forming and shaping of steel. They buy semi-finished products from steel mills for resale with added value.

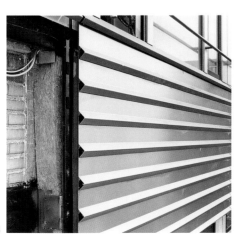

63

64

65

60 Isometric drawing: facade systems
 a profile sheet, b insulation, c steel pan,
 d column (steel beam shown here)
61 Isometric drawing: composite floor slab
 e flat ceiling beam, f profiled sheet
 g in-situ concrete, h reinforcement
62 Isometric drawing: integrated floor beam
 i slim floor beam, j tray
 k insulation, l reinforcement, m in-situ concrete
63 Facade cladding made from stainless steel panels
64 Floor system using composite floor slabs
65 Floor system using integrated floor beam
66 Lifting capacities related to jib length for a 35 t
 mobile crane
67 Crane at a construction site
68 Transport of the pedestrian bridge "Simone de
 Beauvoir" in Paris. With its length of 304 m this is
 one of the longest bridges over the Seine in Paris. 66

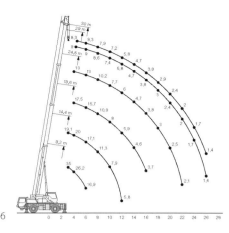

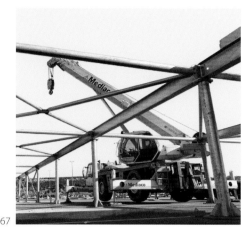

67

• Deliveries by construction companies or
contractors themselves, for instance steel
fabricators.

Which of these possibilities is selected
depends on the products used and on the
size, complexity and geographical situation
of the project.
It would be too complex to explain the
detailed supply chain for all steel products
in the different geographical markets. For
instance, in Europe 90 % of steel beams and
sections are supplied by distribution net-
works. In the case of steel plates for certain
applications like bridges, steel comes
directly from the mills, as certificates have
to be provided for particular steel grades.

For large projects extending over a relatively
long period, the production schedules of
the steelworks and mills can be matched to
the project programme, enabling the lead-
in times for steel orders not to cause delays
to the works.
Furthermore, the concept and detailed
design of these projects is often based on
specific, optimised steel grades, which
require subsequently technical certifications
or at least agreements with supervisory
authorities if they do not fit to local regula-
tions or standards.

Taking into account the required steel quan-
tities for medium-sized projects and the
large range of products involved (beams,
angles, tubes, plates for welded beams) and
the impact of delays on construction and
subsequently deliveries, steel fabricators
prefer to purchase the steel from distribu-
tors who have a large stock of different steel
products at their disposal.
Distributors offer additional or complemen-
tary services for the steel fabricator, like cut-
ting to length, drilling or pre-chambering.
There are even companies providing com-
pletely finished major parts and steel ele-
ments, for example car parks or bridges, for 68

direct delivery to site. Paints, fire protection
and anticorrosion coatings may be also
applied, at least partly, in the workshop.
Steel sheets, e.g. for the envelope, are pro-
duced mainly on demand due to the large
variety of combinations of colour, coatings,
shapes and finally required length. The stock
for their manufacture is held as coated coil,
therefore the timeframe for deliveries depends
on the selected solution. Delivery might take
a few days for the more common shapes
and colours or several weeks for more com-
plex ones. In all cases products should be
ordered after an analysis by the construction
company, architect or engineering office.

The potential suppliers or manufacturers
should be consulted as part of this analysis.
Accessories for edge and corner details can
be manufactured and delivered fairly quickly
once detailed drawings are available.

For smaller projects, it is useful to check with
the construction company which tech-
niques of production, transport and con-
struction are available and suitable for the
size and scale of the project. Dialogue in an
early stage of a project between architects,
construction companies and suppliers is
always very helpful and sometimes essential
to avoid needless difficulties in steel supply.

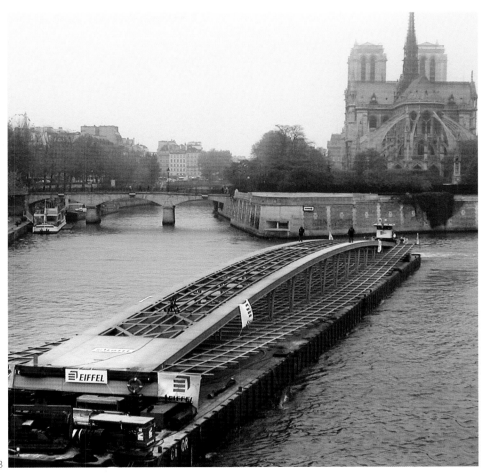

Case studies

30 St Mary Axe

High-rise Office Building
London, GB 2003

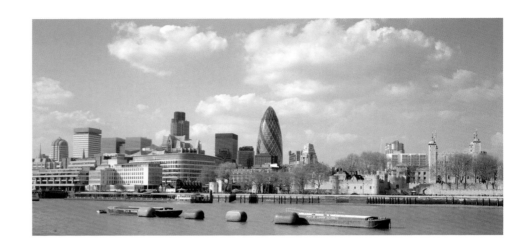

Architects:
Foster + Partners, London
Structural engineers:
Arup, London

Set in the middle of the financial centre, London´s first sustainable skyscraper has already become an immediately recognisable addition to the city's skyline. With its distinctive shape this office tower is a response to the tight site conditions and makes the structure to appear more slender than conventional rectangular high-rise developments.

Rising 180 metres above a new public plaza, this 41-storey tower has 33 office floors with areas for special use at its base and in its apex. The diameter initially widens from its base until, from level 17 onwards, the building begins to taper towards the apex. While at the top of the building are a restaurant and a bar that afford a unique view over the city, the double-height plinth houses the reception areas and various retail outlets. The aerodynamic form is designed to reduce wind loads on the structure and the facade, and to allow pressure differentials along the face of the building to be exploited for natural ventilation.

The diagonal tubular steel struts and horizontal ties on the facade create a rigid tube – referred to as a diagrid. The diagrid provides vertical support to the floors to create a column-free space within.

Two concentric rings of load-bearing columns carry the circular plan form. The complex steel frame is built up of a series of two-storey A-frames. These consist of two 508 mm diameter tubular steel diagonal struts with wall thicknesses from 32 to 40 mm; a 250/250 mm SHS tie and steel nodes. The frames are connected to the core by means of rolled steel radial downstand beams and composite floor slabs that brace the lattice horizontally.

The lines of the diagonal lattice grid are also adopted in the facade design, with the storey-height glazing articulated into triangular and rhomboid elements. This system allows the differences in circumference between one floor and the next to be accommodated by simple means.

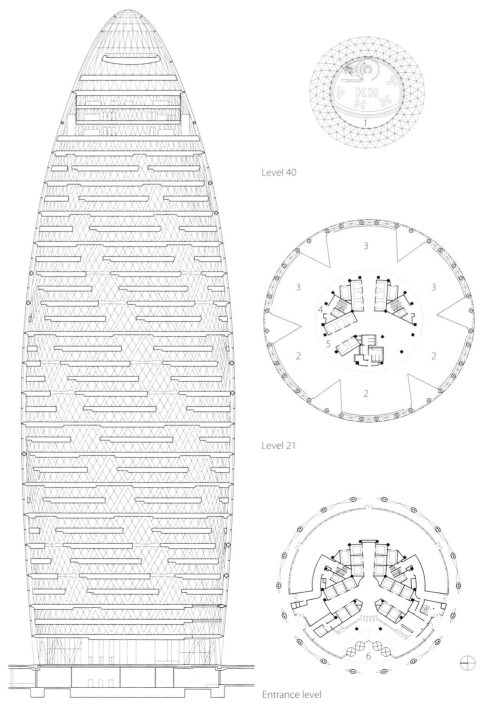

Level 40

Level 21

Entrance level

Schematic section • Floor plans
scale 1:1000
Axonometric of the facade joint
Vertical section
scale 1:20

1 bar
2 meeting rooms
3 offices
4 library
5 reception
6 entrance
7 diagonal struts:
 Ø 273 – 508/40 mm
 steel tube

8 bearer for the glazing:
 60 mm steel plate
9 ties:
 300/250 mm steel SHS
10 secondary floor beam:
 steel I-beam 540 mm deep
11 floor beam with sliding
 support:
 steel I-beam 540 mm deep
12 threaded rods for limiting
 extension M36
13 50 mm node
14 65 mm steel plate for tangen-
 tial connection
15 glazing:
 10 mm toughened glass
 16 mm cavity
 2× 5 mm laminated

safety glass
16 fresh air intake in every floor
17 column cladding:
 3 mm aluminium plate
18 condensation drainage
19 160 mm composit slab
20 air supply/air extract
21 stale air exhausted into
 the cavity of the
 double facade
22 sliding window:
 2× 5 mm laminated safety
 glass
23 stale air from the offices
 through the elevated
 floor element
24 fresh air into offices through
 suspended ceiling

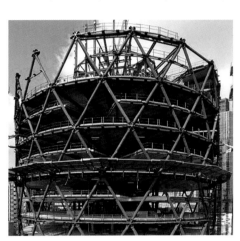

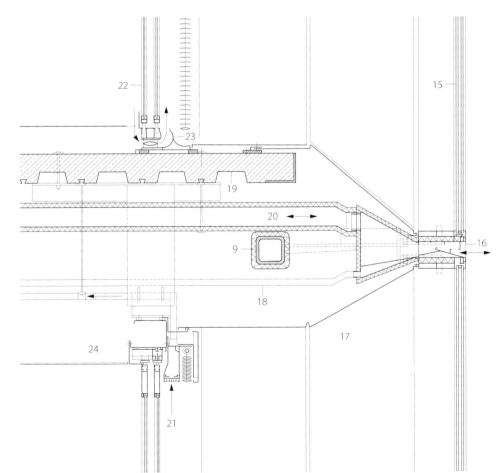

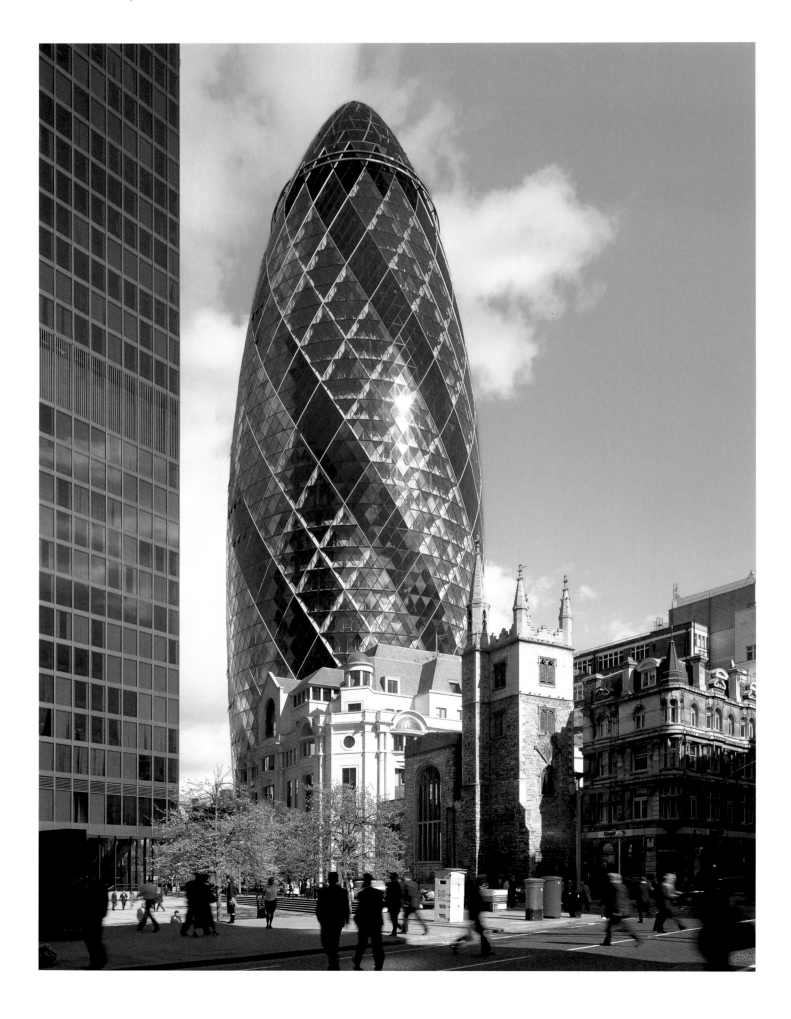

Shanghai World Financial Centre

Multi-functional High-rise Building
Shanghai, RC 2007

Architects:
Kohn Pedersen Fox Associates, New York
Structural engineers:
Leslie E. Robertson Associates, New York

The Shanghai World Financial Centre (SWFC)
is located in the Finance and Trade Zone in
the Pudong New Area of Shanghai. This
landmark rises 101 storeys above the city
skyline and is 492 m high. Its appearance
combines two intersecting arcs and a square
prism – forms representing the ancient Chi-
nese symbols for earth and sky.
A virtual city within a city, the SWFC houses
a mix of office and retail uses, as well as a
hotel on the 79th to 93rd floors. Occupying
the tower's uppermost floors, the SWFC Sky
Arena offers visitors aerial views of down-
town Shanghai and the winding river below
as well as a walk on the 100th-floor Sky Walk.
Originally conceived in 1993, the project
was put on hold during the Asian financial
crisis of the late 1990s and was later rede-
signed to its current height – 32 m higher
than previously. The new, taller structure not
only had to be made lighter, but also needed
to resist higher wind loads and had to utilise
the existing foundations constructed prior
to the project delay. High-strength steel was
used for the main structure of the building
to reduce its weight. There are three paral-
lel and interacting structural systems: The
mega-structure, consisting of the major
structural columns, the major diagonals, and
the belt trusses to form a braced frame (1);
the concrete walls of the services core (2); as
created by the outrigger trusses, the interac-
tion between these concrete walls and the
mega-columns (3).
The diagonals of the mega-structure are
formed from welded boxed of structural
steel. These steel boxes are in-filled with
concrete, thus providing increased stiffness,
non-linear structural behaviour, and struc-
tural damping. The columns of the mega-
structure are of composite structural steel
and reinforced concrete, one at each of the
four corners of the rectilinear base and six as
the floor plan morphs into a six-sided form
at higher altitudes.
Evacuation floors are located at every twelve
storeys in the event of emergency.

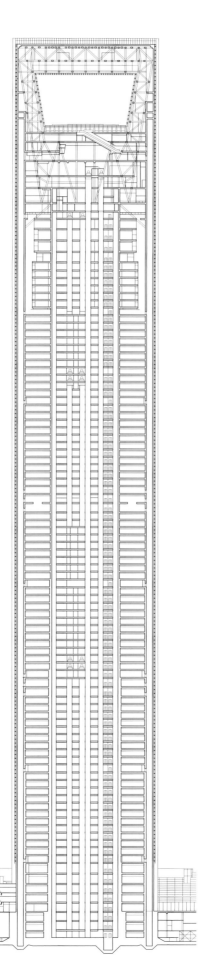

aa

Section scale 1:2000
Floor plans scale 1:1500

Level 100
Sky Walk

Level 94
Sky Area

Level 83
Hotel

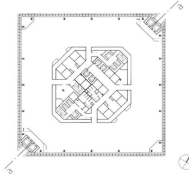

Level 7
Office

Vertical section Sky Walk
Horizontal section · Vertical section facade
scale 1:20

1 multi-pane glazing panel of
 2× 5 mm toughened safety glass
 with stainless steel coating on lower surface
2 post 212/120 mm aluminium extrusion
3 3 mm anodized aluminium extrusion
 electro-polished finish
4 2× 6 mm laminated safety glass + cavity 12 mm +
 6 mm tempered glass
5 3 mm aluminium sheet with reflective coating
 glued to resin panel
6 120/285 mm aluminium extrusion mullion
7 2× 12 mm laminated tempered glass
 with non-slip finish
8 2× 19 mm laminated tempered glass
 with non slip finish
9 steel I-beam 610 mm deep
10 steel I-beam 529 mm deep
 (W530 × 74)
11 floor construction:
 metal deck, 150 mm raised floor
 150 mm concrete slab
12 edge girder, steel I-beam 608 mm deep
 (W610 × 113)
 with fire protection spray
13 3 mm rigid aluminium sheet, varnished
 75 mm insulation
14 sound-damping element ceiling, suspended
15 internal sunscreen
16 1.5 mm galvanized steel sheet
17 megacolumn

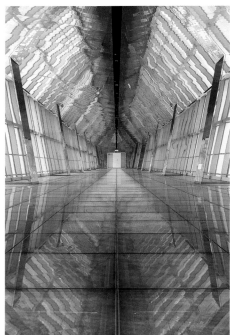

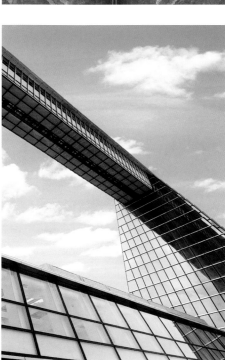

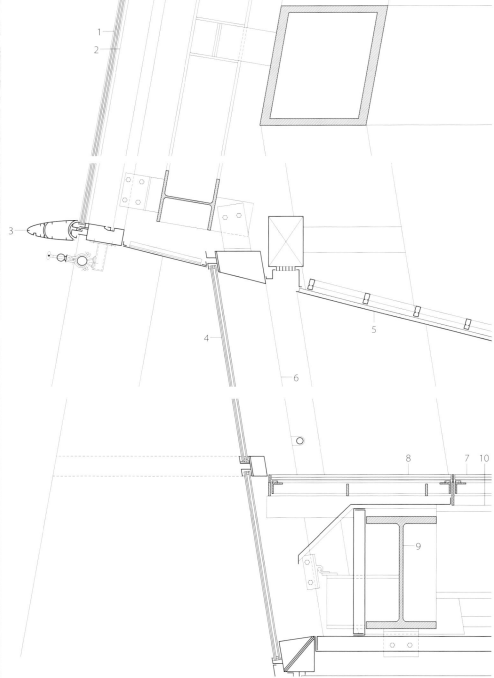

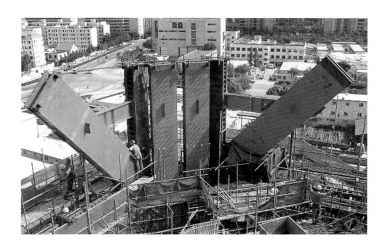

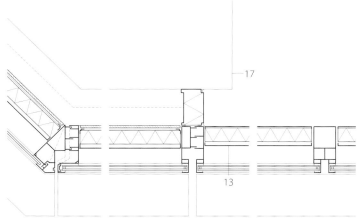

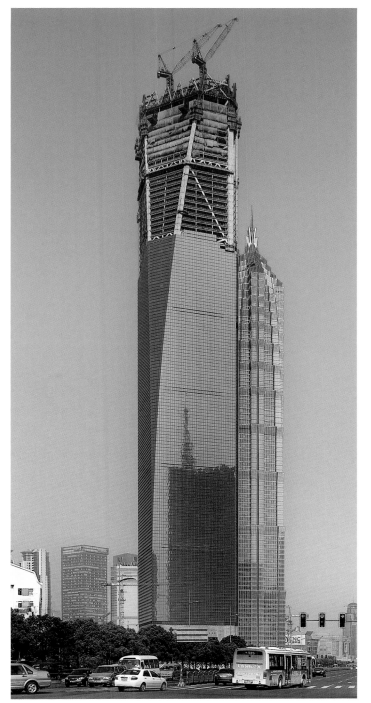

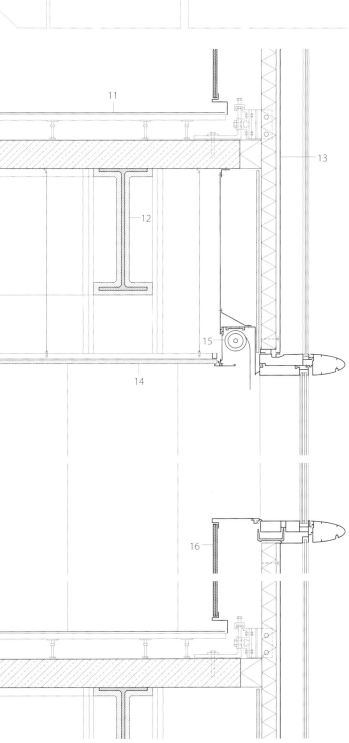

Naberezhnaya Tower

High-rise Office Building
Moscow, RUS 2007

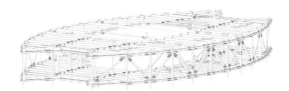

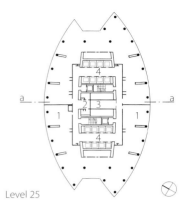

Level 25

Architects and structural engineers:
ENKA Structural and Architectural Design
Group, Istanbul

Located in the city of Moscow the Nabe-
rezhnaya Tower known as Plot No. 10 is part
of the Moscow International Business Centre
(MICB). It is composed of three towers of dif-
ferent heights sharing the same five floors
underground. The tallest tower reaches a
height of 268 m.

The complex includes shops, a restaurant
and the connecting central core public area.
Vestibules, reception groups and administra-
tive rooms are on the ground and mezza-
nine floors. Open-plan offices extend from
the 2nd to the 58th floor, interrupted by a
technical level on the 26th floor. The build-
ing has a cast-in-place reinforced-concrete
core with steel perimeter columns and a
composite floor. The structural solution used
in this building ensured that the maximum
lateral drift at the top is limited to 1/500
of its height. Built-up steel box columns
arranged at the tower perimeter do not
directly transfer lateral loads. They resist ver-
tical loads only. At the 26th and the 59th
storeys of the building, cantilever trusses
(outriggers) between the core and the
perimeter columns are designed to restrict
lateral displacement of the core under wind
effects. At these storeys, belt trusses are
installed between the perimeter columns to
distribute the vertical loads transferred by
the outriggers. For the non-loadbearing
substructures (curtain walls) aluminum and
tinted glass are used to.

Plot No. 10 is the first project where a special
high strength steel was used and special
tests were carried out to examine its per-
formance under the Russian weather con-
ditions of -20 °C, influencing especially the
toughness of steel selected.

Highly effective fireproof compounds with a
certified fire safety performance are applied
to the surface of the structural steelwork,
which weighs a total of 13,500 t. The fire
protection of the steel columns has been
ensured by concrete encasement. This
achieves a fire resistance rating of at least
four hours for the steel structure.

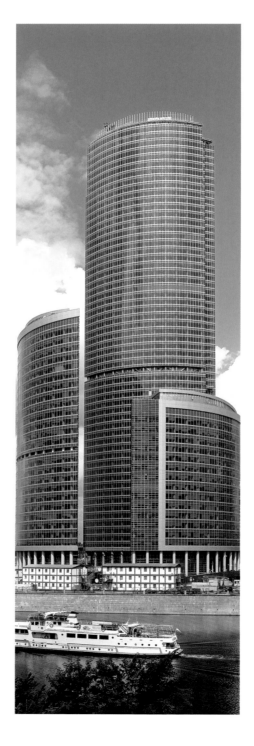

aa

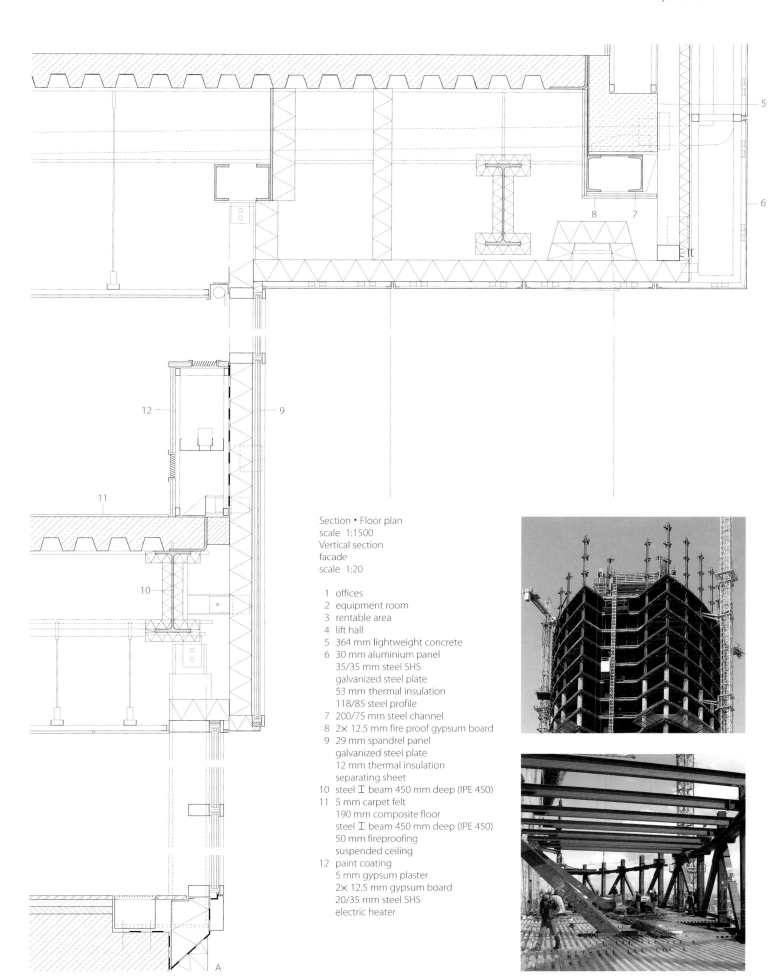

Section • Floor plan
scale 1:1500
Vertical section
facade
scale 1:20

1 offices
2 equipment room
3 rentable area
4 lift hall
5 364 mm lightweight concrete
6 30 mm aluminium panel
 35/35 mm steel SHS
 galvanized steel plate
 53 mm thermal insulation
 118/85 steel profile
7 200/75 mm steel channel
8 2× 12.5 mm fire proof gypsum board
9 29 mm spandrel panel
 galvanized steel plate
 12 mm thermal insulation
 separating sheet
10 steel I beam 450 mm deep (IPE 450)
11 5 mm carpet felt
 190 mm composite floor
 steel I beam 450 mm deep (IPE 450)
 50 mm fireproofing
 suspended ceiling
12 paint coating
 5 mm gypsum plaster
 2× 12.5 mm gypsum board
 20/35 mm steel SHS
 electric heater

New York Times Building

High-rise Office Building
New York, USA 2007

Architects:
Renzo Piano Building Workshop, Paris
FXFowle Architects, New York
Structural engineers:
Thornton Tomassetti, New York

The New York Times has moved out of its used publishing house on 43rd Street where it has been since 1913 and is now at home in a seemingly transparent skyscraper. Compared with many office towers that are demonstrations of wealth and power or that try to catch the eye with bizarre gestures, the new Times Building may seem relatively modest. At its base, as well at its termination at the top of the tower is demonstrates lightness and openness.

The primary lateral load resisting structure consists of a braced steel core with outrigger levels that extend to the outer columns on the two mechanical services levels half way up and at the top of the tower. With this steel-grid construction, it was possible to exploit the full depth of the building to transmit lateral loads.

A unique aspect of this building's design is the exposed steel at its north and south faces. This serves both aesthetic and functional purposes, as it is integral to the architectural design and takes a major part of the load. Columns in four corner notches are brought outside the building envelope. The elegant vertical external bracing system does not serve primarily to transmit code governing loads, but to control movement of the building. High strength steel rods were used in the X-bracing to keep the exposed systems light and elegant.

Unlike the internal steelwork, the external structure is tailormade and formulates clearly the members of the construction, making the building to appear lighter with increasing height.

Elaborate lighting studies, the installation of a cogenerating unit, an underfloor cooling system, and the addition of a second skin demonstrate a striving for sustainability. The outer sun screen of ceramic tubes was an architectural concept that aims at more slender proportions and – through a special mix of transparency and reflection – at capturng changing weather and daylight conditions in the facade.

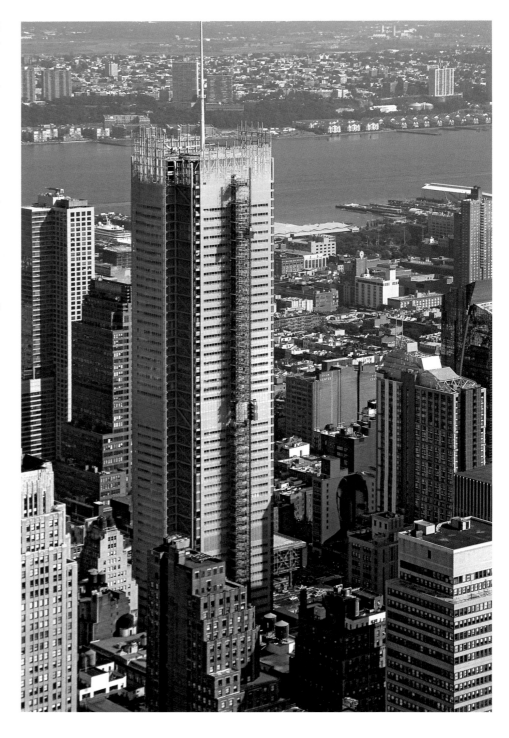

Site plan
scale 1:10 000
Section
Standard Floor plans
scale 1:1500

1 NY Times Building
2 lobby
3 lifts to NY Times
4 tenants' lifts
5 shop
6 garden
7 auditorium
8 loading area
9 newsroom
10 cafeteria
11 service storey

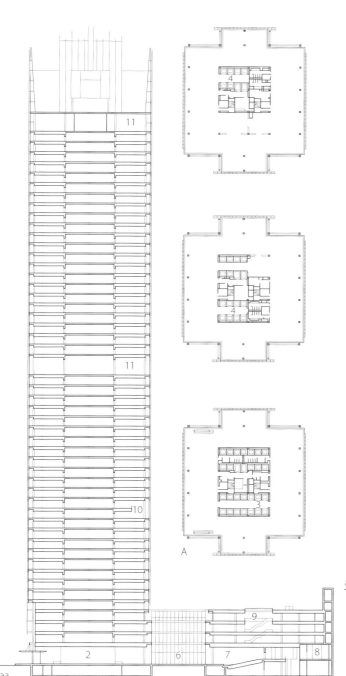

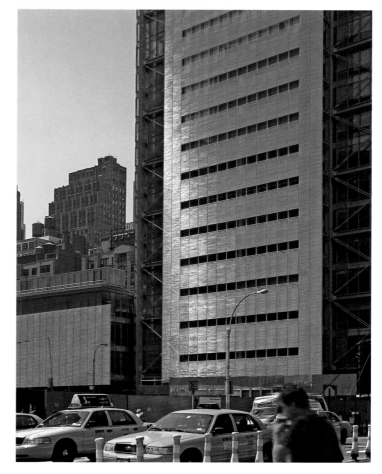

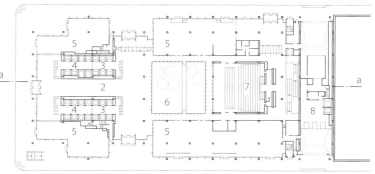

Vertical section
Horizontal section
scale 1:100
Vertical section
sectional detail of facade
scale 1:20

1 Ø 38 mm glazed ceramic tube
 (aluminium silicate) fixed to
 extruded aluminium section
 more closely spaced below
 floor (as sunscreen) than at
 balustrade level
2 2× 125 mm aluminium girder

comb section, painted
3 aluminium fixing piece,
 milled and painted
4 51/9.5 mm aluminium strut,
 milled and painted
5 double glazing:
 6 mm float glass
 13.2 mm cavity
 6 mm partially toughened
 glass (lower floors in laminated
 safety glass)
6 aluminium connecting plate,
 painted
7 Ø 9.5 mm adjustable tube,
 painted
8 cladding to edge of floor:

rigid sheet aluminium,
painted (printed glass in
recessed facade corners
where no ceramic tubes
outside)
9 heated-/cooled-air inlet
10 raised floor construction:
 carpet on 20 mm fibreboard
11 150 mm metal deck
12 steel I-beam 400 mm deep
 with fire-resisting spray on
 proofing
13 steel I-beam 600 mm deep
 with fire-resisting spray on
 proofing
14 automatic sunblind internally

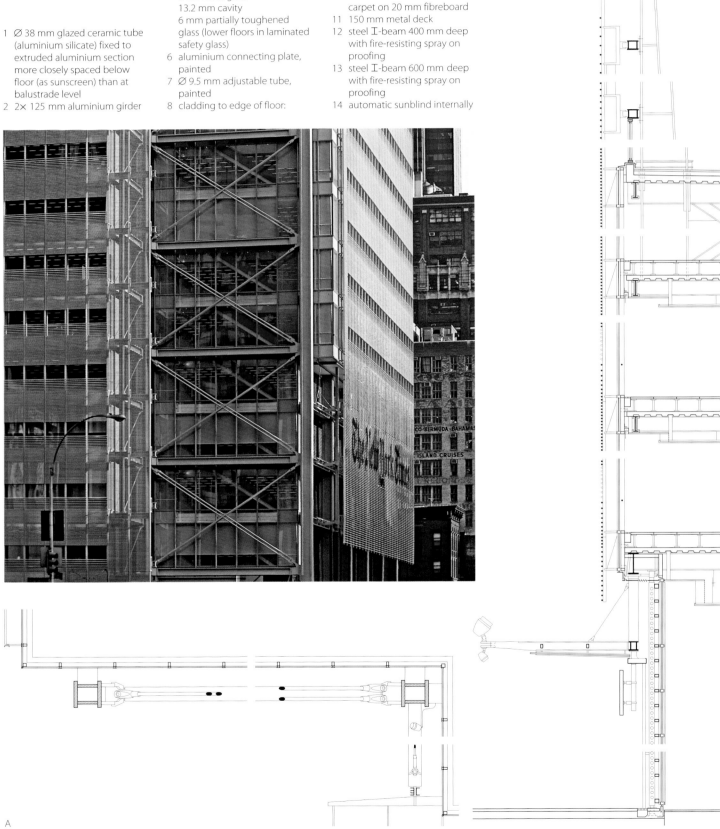

A

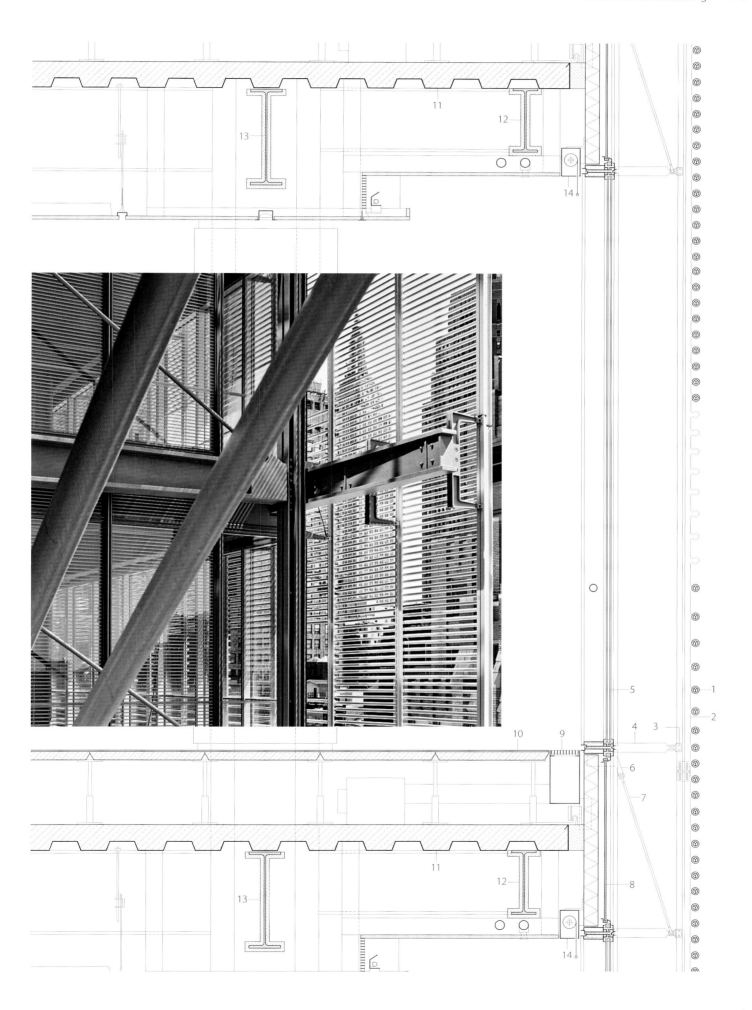

Aspire Tower

Multi-functional High-rise Building
Doha, QA 2006

Architects:
AREP Groupe, Paris
Structural engineers:
Arup, London

The 15th Asian Games in Doha (Qatar), held in 2006, were the largest in the event's 55-year history. The centrepiece is the hyperbolic Aspire Tower, shaped like a colossal torch. The 62-metre-high lattice shell at the top of the tower held the symbolic flame for the duration of the games. Rising to a height of 300 m, the tower's concept is based on a very clear organisation of its component parts. The central concrete core supports the clusters (modules) of accommodation floors and the external envelope. Each cluster cantilevers up to 11.3 m from the core independently, with no columns to the ground. The floor system combines the advantages of steel and concrete. Steel beams support the concrete floor slabs, which act compositely with the steel decking. The special design of the decking allows it to serve as a self-supporting formwork and replace some or even all of the slab reinforcement. The general arrangement consists of primary beams spanning radially between steel columns and the core, with circumferential secondary beams. Load transfer systems cantilevering from the core support the steel columns in each cluster. The presidential apartments, museum, and restaurant floors are carried by steel brackets, while the five-star hotel, in contrast, is supported by a system of vertical trusses concealed within the walls between the hotel rooms. The inner lines of the vertical trusses are in turn supported at their bases by a reinforced concrete corbel ring projecting from the core. The building is clad entirely in a stainless steel mesh that filters the light to achieve maximum thermal efficiency and comfort while giving guests panoramic views of the city. To cope with wind resistance, the permeability of the tower increases with height. The prefabricated trapezoid mesh is prestressed within individual frames spanning 8.1 m between horizontal ring trusses. It is both bottom beared and top hung, with horizontal movement joints. The cladding is horizontally restrained.

Health Club

Hotel

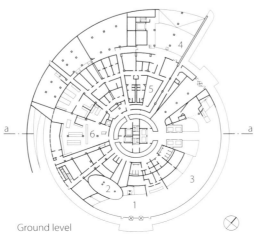

Ground level

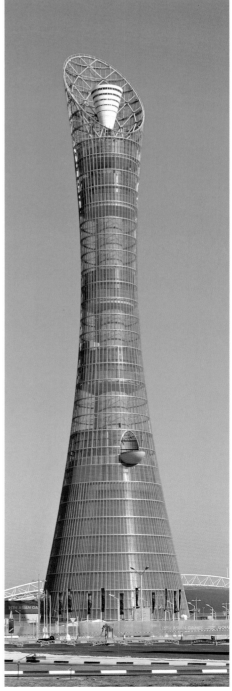

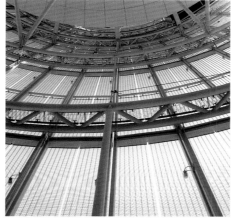

Floor plans · Section
scale 1:1500
Vertical section facade
scale 1:20

1 entrance
2 shop
3 lobby
4 delivery
5 laundry
6 kitchen
7 bedroom
8 bathroom
9 pool
10 fitness area
11 sauna
12 changing room
13 hotel
14 offices
15 health club;
 juice bar
16 presidential

apartments
17 sports museum
18 revolving restaurant
19 panoramic floor
20 Ø 250 mm
 steel strut
21 double glazing:
 12 mm + 16 mm
 cavity + 12 mm
22 vertical steel mul-
 lions 250/100 mm
23 circular truss,
 Ø 273/25 mm
 steel tube
24 maintenance
 walkway: 35 mm
 steel grating
25 Ø 20 mm steel
 tension rod
26 stainless steel mesh
27 steel mullions
 150/100 mm

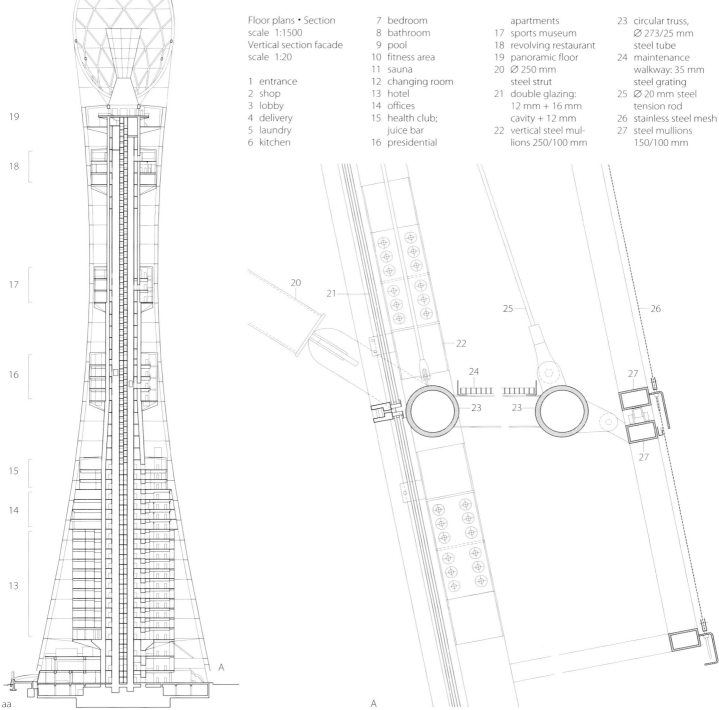

New Museum of Contemporary Art

Museum
New York, USA 2007

Architects:
SANAA / Kazuyo Sejima + Ryue Nishizawa,
Tokyo
Structural engineers:
Guy Nordenson and Associates, New York
SAPS – Sasaki and Partners, Tokyo

Situated in Bowery in the south of Manhattan, the new museum was erected on a site only 20 m wide. An extensive spatial programme has been distributed vertically over nine levels, creating a 53-metre-high tower that forms an urban landmark. By articulating the structure into a series of individual stacked boxes offset from each other, the overall volume is visually reduced.
At only a few points the building opens to the outside world. A room-high glazing on the ground floor mediates between life in the Bowery and the activities in the museum, while the glazed front to the multipurpose space on the sixth floor affords a panoramic view over the rooftops. The offset arrangement of the boxes allowed the creation of skylights oriented in different directions over the three gallery levels. Also the offices are designed unusual: they have an exposed steel structure with a sprayed fire-resistant coating, and partitions consisting of polycarbonate slabs.
The shifted boxes are the primary structure of the building. Demands for flexibility in the galleries and the offset of the core from the centre predetermined that there could be neither continuous interior columns, nor could the volumes cantilever from the core. However, since the exterior walls are opaque, it was possible to place in them a series of full height trusses that wrap around the individual boxes. These trusses transfer all the loads from the setbacks and provide most of the lateral restraint to the building. Some trusses form clear spans adjacent to the skylights, while others provide open corners. As a result, accumulated gravity load is constantly moving around corners but never moving directly vertical to the foundation. The only continuous vertical structure is in the central elevator core.
A homogeneous skin of aluminium mesh wraps the building and consists of a total of 988 mesh panels, which are fixed with stainless-steel clips at a distance of 76 mm from the actual facade.

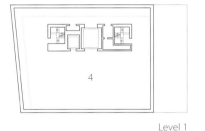

Level 1

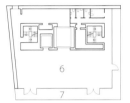

Level 6

Site plan
scale 1:5000

Floor plans
Sections
scale 1:750

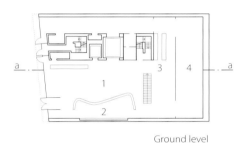

Ground level

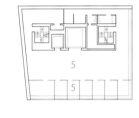

Level 5

1 entrance hall
2 museum shop
3 cafe
4 exhibition space
5 offices
6 multipurpose
7 roof terrace
8 mechanical
 services
9 education centre

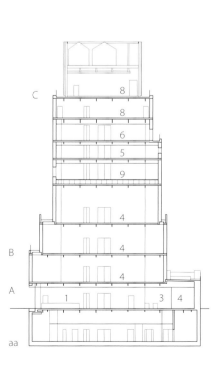

aa

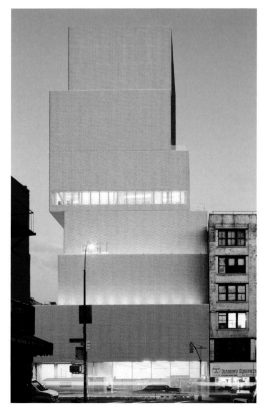

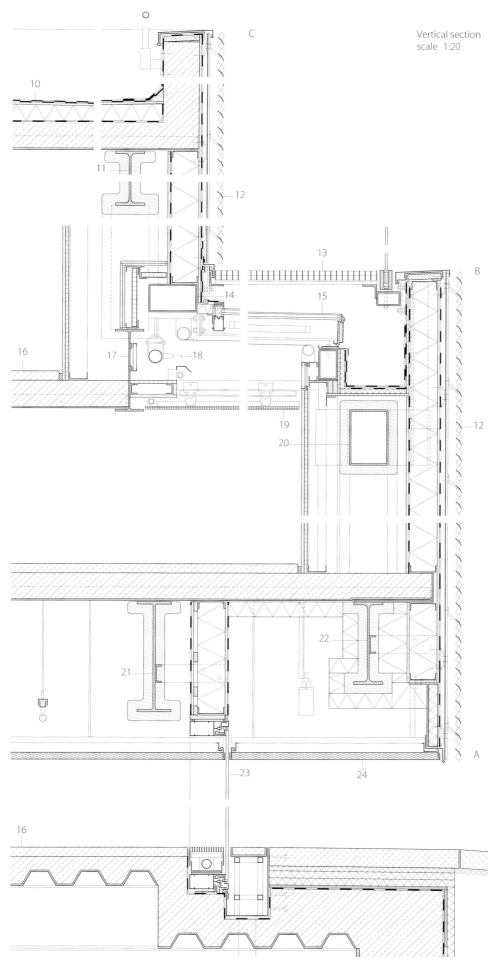

Vertical section
scale 1:20

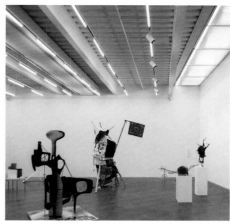

10 5.6 mm two-layer bituminous membrane with
 white plastic chippings, 13 mm waterproof
 gypsum-based composite board, 140–100 mm
 thermal insulation, 2.3 mm bituminous layer,
 159 mm reinforced concrete composite slab on
 76 mm trapezoidal-section metal sheeting
11 steel I-beam 300 mm deep (W12 × 26) with
 exposed fire-resistant sprayed coat
12 3 mm anodized aluminium expanded-metal
 mesh panels (2,133.6/2,895.6/38 mm) fixed with
 stainless steel clips, 13 mm extruded ribbed-
 aluminium sheeting, 24 mm ventilated cavity,
 moisture-diffusing windbreak, 16 mm plaster-
 board (1 1/2-hr. FR), framed metal supporting
 structure with 140 mm mineral-wool thermal
 insulation, vapour-retarding layer, 16 mm plas-
 terboard (1 1/2-hr. FR)
13 50 mm metal grating as maintenance walkway
14 150/250 mm steel RHS with
15 skylight: 6 mm toughened glass + 16 mm cavity
 + 2× 5 mm laminated safety glass with dot-pat-
 tern surface print 20 %
16 51 mm polished concrete, 159 mm reinforced
 concrete composite floor on 76 mm trapezoidal-
 section metal sheeting
17 steel I-beam 450 mm deep (W18 × 35)
18 sprinkler plant
19 16 mm polycarbonate sheeting
20 300/200 mm steel RHS with fire-resisting sprayed
 coat
21 steel I-beam 600 mm deep (W24 × 55) with
 fire-resisting sprayed coat
22 steel I-beam 450 mm deep (W18 × 40) with
 fire-resisting sprayed coat
23 19 mm laminated safety glass (flint glass) in
 anodized-aluminium post
24 suspended soffit: aluminium mesh on framed
 steel support

CaixaForum

Cultural Forum
Madrid, E 2008

Architects:
Herzog & de Meuron, Basel
Structural engineers:
WGG Schnetzer Puskas Ingenieure, Basel
NB35, Madrid

The transformation of a former power station into a cultural forum has made the CaixaForum an attractive new centre for many contemporary art exhibitions. The acquisition and demolition of a petrol filling station now allows a view of the Paseo del Prado as well as the creation of a plaza, which draws pedestrians to visit the forum and at the same time links it to the museum mile in Madrid. A vertical garden on one side of the plaza contrasts with the exciting structure of the overall layout which is rather stringent as far as the colours go. This vertical planting covers the fire-proof wall of an adjacent building and builds a "bridge" to the nearby botanical garden.

The original brick building has been completely redeveloped; all the windows were walled up using the same kind of brickwork; the roof of the double-gable building was taken down, and the interior of the building was completely gutted. The entire brickwork shell has been suspended, splitting the building into two distinct parts. The granite plinth to the external walls was removed, and replaced with a concrete structure designed to stabilise the entire building, to help stabilise the crumbling brickwork, and to provide the building with a new base. On top of the old, elevated building there now rises a huge two-floor overhanging steel superstructure supported by three column-type seatings, that develops free space accessible from several sides underneath, thus, extending the plaza towards the building interior. Here the foyer, the auditoriums, and the large-scale exhibition and other function rooms are located. The cladding of rusted cast-iron sheets gives the building its special identity. The rooms in the roof space are clad with perforated steel plates, the perforation is similar to the microstructure of rust, creating magical patterns of light and shadow. Recesses as well as diagonals introduce movement into the surfaces whilst at the same time imitating the surrounding roofscape.

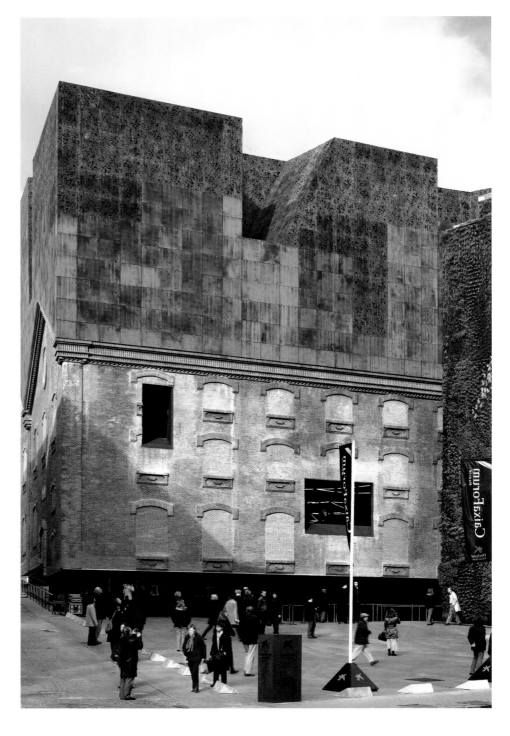

Floor plans • Sections
scale 1:750

 1 bottom foyer
 2 auditorium
 3 main stair
 4 multipurpose 1
 5 multipurpose 2
 6 top foyer
 7 main entrance
 8 covered plaza
 9 offices
10 café & restaurant

aa bb

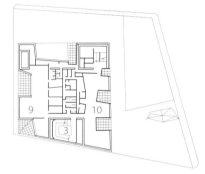

Level 4

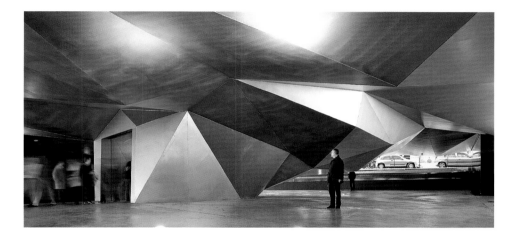

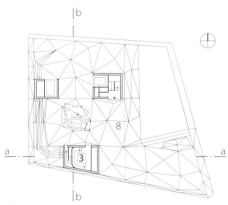

Ground level

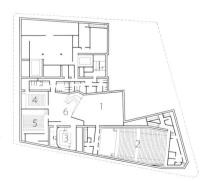

Basement

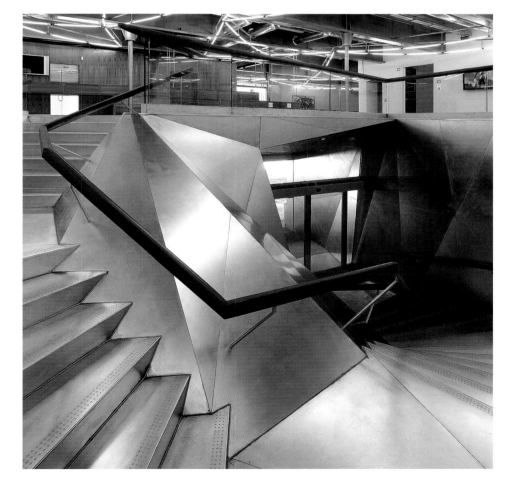

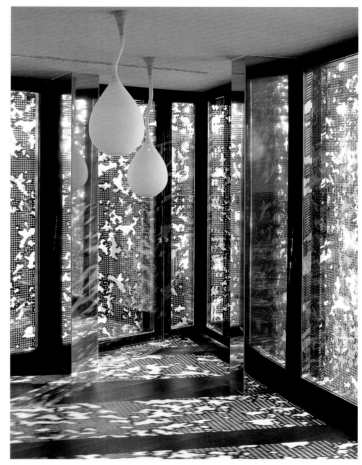

Horizontal section • Vertical section
facade and roof
scale 1:10

1 cladding 9/11 mm perforated cast
 iron panels with 1000 × 1000 mm
 airspace
 black corrugated metal sheet 12 mm
 water-proofing membrane
 50 mm insulation mineralwool
 100 mm acoustic panel of steel sheet with
 insulation mineralwool
 frame of 30/30 mm steel SHS
 15 mm gypsum board
2 30/60 mm steel angle
3 130/55 mm steel channel
4 40/40 mm steel SHS
5 50/60 mm steel angle
6 aluminium profile point fastener
7 steel I-beam 300 mm deep
8 roofing 9/11 perforated cast
 iron panels cast in 1000 × 1000 mm moulds
 with corrugated sandsurface
 airspace
 12 mm corrugated steel sheet
 waterproofing membrane
 40 mm mineralwool insulation
 80 mm acoustic panel of steel sheet with
 mineralwool insulation
 frame of 30/30 mm steel SHS
 15 mm gypsum board
9 girder, steel I-beam 300 mm deep
10 160/80/6 mm box shaped steel beam
11 160/50/40 mm steel block
12 steel flashing
13 connecting steel plate
14 100/60/5 mm steel RHS

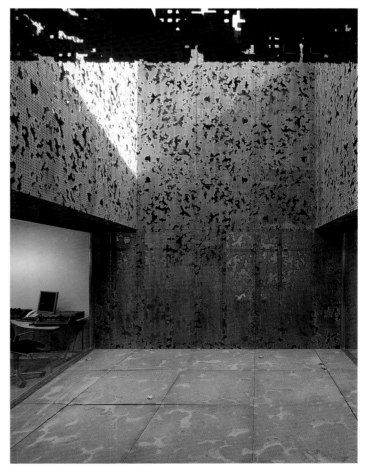

Collège des Bernardins

School and Cultural Centre
Paris, F 2008

Architects:
Wilmotte & Associés SA d'Architecture, Paris
Hervé Baptiste, Historical Buildings Architect,
Paris
Structural engineers:
Bureau Michel Bancon, Paris

The Collège des Bernardins is located in Paris – on the left bank of the River Seine in the Latin Quarter. As it was founded in 1245 by the Abbé de Clairvaux, with the objective of housing students af the university, the building's organisation follows the pattern of typical Cistercian architecture. Because it was built on marshy ground, the designers were faced with foundation problems. This led to the use of infill underneath the structure in order to support the foundations. The diocese of Paris re-purchased this building in 2001 and redesignated it as the Ècole Cathédrale and cultural centre. Since the French Revolution, it had served different purposes such as depot, butcher, and fire station.
The renovation started with the strengthening of the footings by means of 322 micropiles made of 89 mm diameter tubular steel driven 5 m deep with the objective of clearing the cellars that had remained filled for seven centuries.
The wooden floors have been replaced with composite steel and concrete flooring. Thus, the floor of the attic is supported by HEB 1000 girders resting on the masonry of the eaves walls. A composite slab has been positioned on these girders and has been provided with shear connection in order to achieve composite action between the slab and the beams.
The transformation of the roof of the Collège into an auditorium required a new roof made with steel which copies exactly the original medieval shape.
Sensitively designed by the architects, the rehabilitation of this emblematic heritage displays a high level of understanding of the interaction between modern structure and traditional architecture. Despite the sizable intervention, using plenty of steel, none of this is visible in the final result. Even with close inspection, no suggestion of steel can be found. However, this material is omnipresent throughout the building, from the foundations up to the suspended floors above the 18th century vaults.

Section · Floor plans
scale 1:2000
Detail of connection
scale 1:50

1 entrance
2 garden
3 side entrance
4 moat
5 exhibition
6 reception
7 book shop

8 concert hall
9 multipurpose
10 conference room
11 offices
12 technical room
13 steel I-beam 180 mm
 deep (HEA 180)
14 steel I-beam 200 mm
 deep (HEA 200)
15 Ø 168.3/7.1 mm
 steel tube
16 Ø 80 mm steel tube

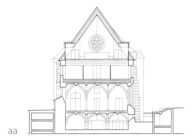

aa

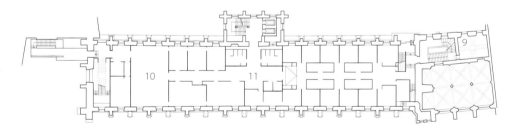

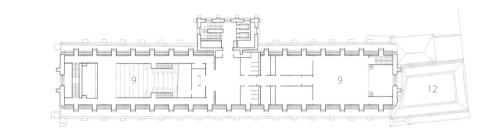

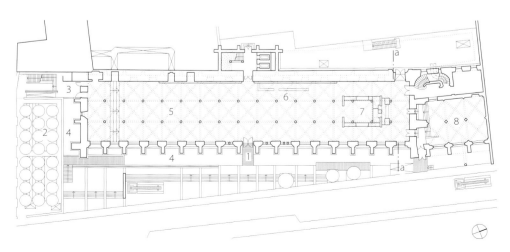

Each of the 24 m span girders supports a pair of tie bars from which the structure of the first floor is suspended. In this suspended floor, the points where beams intersect coincide with the vault layout in order to improve the column stability by introducing a steel needle exactly above the original columns.

This layout prevents inappropriate loads on the vaults and stabilises the slender stone columns of just 27 cm in diameter.

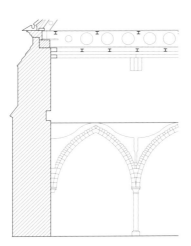
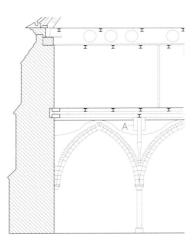
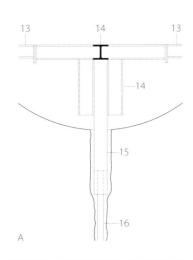

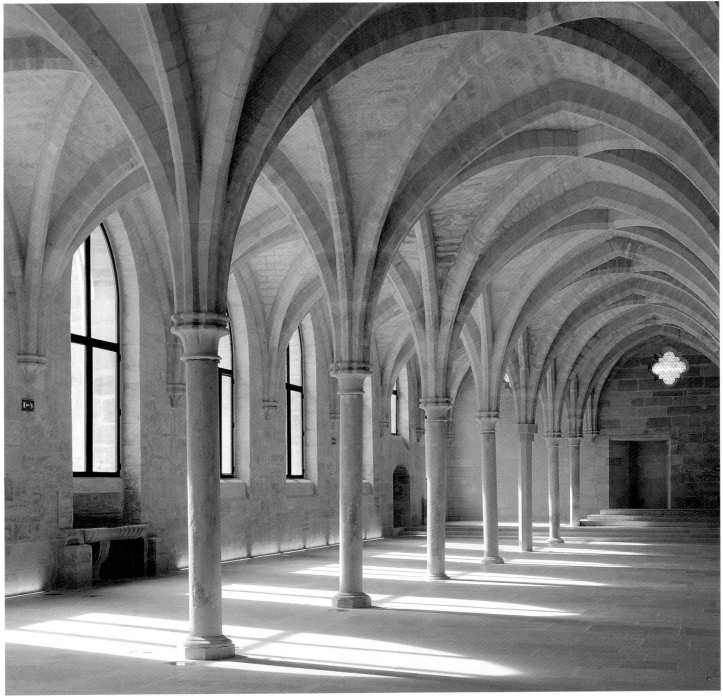

Tevfik Seno Arda School

Public Building
Izmit, TR 2006

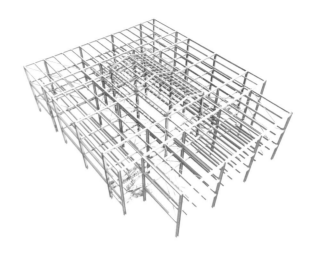

Architects:
UMO Architecture, Istanbul
Structural engineers:
Seza Engineering, Istanbul

In August 1999, an earthquake destroyed the town of Bingöl in Turkey killing (among others) more than 50 children buried in the rubble of a school. In 2004, during a conference of the European Convention for Steel Construction a resolution was adopted to design an earthquake-resistant school and to provide finance from an endowment fund for construction.

From the very beginning, fitness for purpose and functionality were the focal points; the design was to be modular, allowing other versions of the building to be erected elsewhere. The structural analysis of the building was based on specifications for buildings in disaster areas and meets the values for earthquake region 1. An innovative fire-protection concept was drawn up with the help of the European standards.

The school covers an area of 28.80 × 36 m. It has a spacious three-storey atrium for 16 classes including the required special or auxiliary rooms. All class and special rooms get sufficient natural light and air through the window openings in the exterior walls, whilst the glass roof is the natural light source for the gallery-type walkways and the central patio, which is used as break room when the weather is bad.

Steel construction is the solution for the basic requirement of earthquake resistance; i.e. steel is used for for the structural framework, the facades, and the structural interior including the floor. The building, which has an overall height of 10.20 m and a storey height of 3.60 m, is composed of structural frames spanning 7.20 m in both directions and designed to dampen horizontal forces. The floor slabs are steel/concrete composite construction. The foundations are 50 cm thick concrete slab footings (in accordance with local regulations) and anchored in the soil. The column bases are fixed by anchor bolts to reduce horizontal displacement. Bolted connections and prefabrication allows the building to be erected quickly and safely on site.

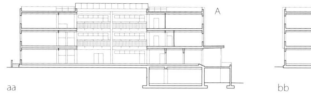

aa bb

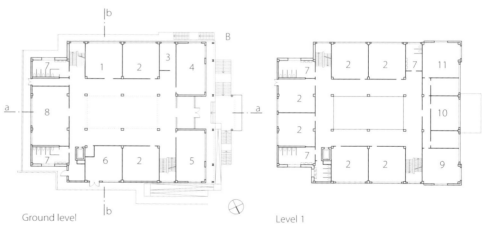

Ground level Level 1

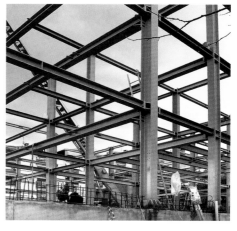

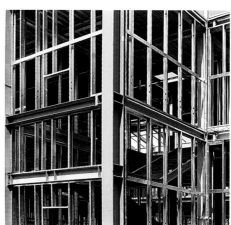

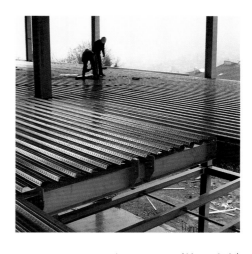

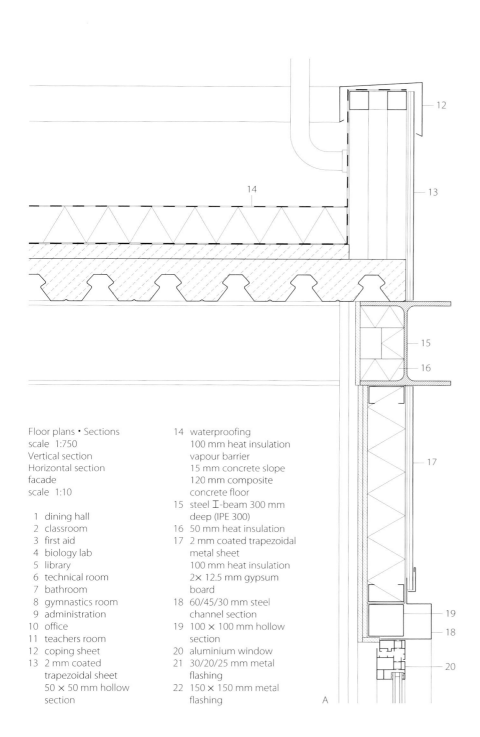

Floor plans • Sections
scale 1:750
Vertical section
Horizontal section
facade
scale 1:10

1 dining hall
2 classroom
3 first aid
4 biology lab
5 library
6 technical room
7 bathroom
8 gymnastics room
9 administration
10 office
11 teachers room
12 coping sheet
13 2 mm coated
 trapezoidal sheet
 50 × 50 mm hollow
 section

14 waterproofing
 100 mm heat insulation
 vapour barrier
 15 mm concrete slope
 120 mm composite
 concrete floor
15 steel I-beam 300 mm
 deep (IPE 300)
16 50 mm heat insulation
17 2 mm coated trapezoidal
 metal sheet
 100 mm heat insulation
 2× 12.5 mm gypsum
 board
18 60/45/30 mm steel
 channel section
19 100 × 100 mm hollow
 section
20 aluminium window
21 30/20/25 mm metal
 flashing
22 150 × 150 mm metal
 flashing

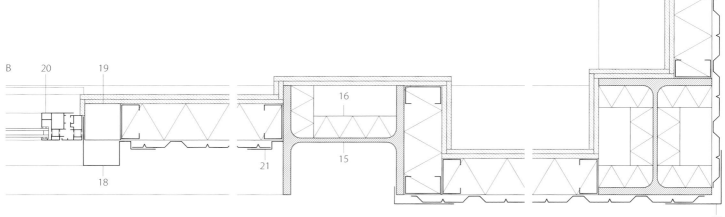

House in Montbert

Single-family House
Montbert, F 2008

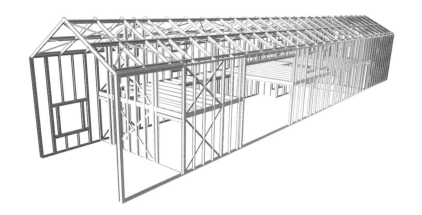

Architects:
Berranger & Vincent Architectes, Nantes
Structural frame supplier:
ArcelorMittal Construction

About 20 km to the south of Nantes a two-storey building clad with corrugated sheet metal emerges from the fields and meadows – this is the home of a young farmer and his family. Its design is based on the idea of a habitable shed and aims at expressing simplicity and bonding with the rural environment. Furthermore, the design refers to the historic example of a "longère" – a long farmhouse or fisherman's hut with a gently pitched roof, a clear ground-floor structure, and only very few openings in the facade. However, this approach has been implemented only on the road-side elevation to comply with the owner's request for a modern dwelling with flowing transitions between indoor and outdoor space.
Since both, the time frame and the budget for project realisation were tight, the architects opted for a light steel construction. Industrialised prefabrication process as well as connections made the assembly very efficient and permitted effective control over costs. The cold rolled steel sections with thicknesses down to 6 mm offer many advantages: they have an excellent strength to weight ratio and load capacity and can be rapidly assembled in the works and erected on site. Combined with cost-conscious interior design, the low budget proved adequate to create 189 m^2 of attractive living space on two floors.

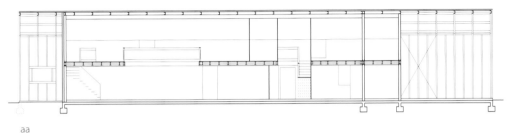

aa

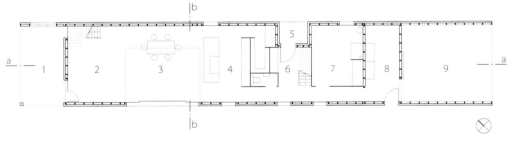

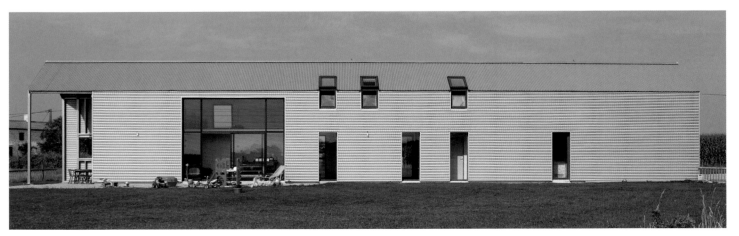

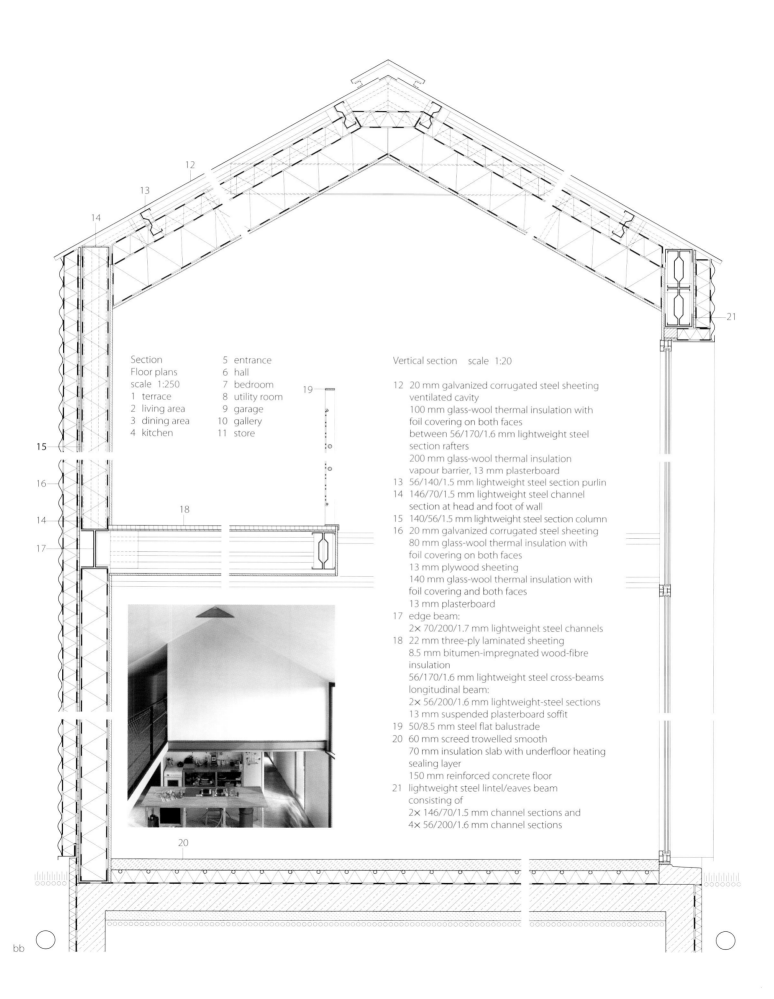

Section
Floor plans
scale 1:250

1 terrace
2 living area
3 dining area
4 kitchen
5 entrance
6 hall
7 bedroom
8 utility room
9 garage
10 gallery
11 store

Vertical section scale 1:20

12 20 mm galvanized corrugated steel sheeting
ventilated cavity
100 mm glass-wool thermal insulation with
foil covering on both faces
between 56/170/1.6 mm lightweight steel
section rafters
200 mm glass-wool thermal insulation
vapour barrier, 13 mm plasterboard
13 56/140/1.5 mm lightweight steel section purlin
14 146/70/1.5 mm lightweight steel channel
section at head and foot of wall
15 140/56/1.5 mm lightweight steel section column
16 20 mm galvanized corrugated steel sheeting
80 mm glass-wool thermal insulation with
foil covering on both faces
13 mm plywood sheeting
140 mm glass-wool thermal insulation with
foil covering and both faces
13 mm plasterboard
17 edge beam:
2× 70/200/1.7 mm lightweight steel channels
18 22 mm three-ply laminated sheeting
8.5 mm bitumen-impregnated wood-fibre
insulation
56/170/1.6 mm lightweight steel cross-beams
longitudinal beam:
2× 56/200/1.6 mm lightweight-steel sections
13 mm suspended plasterboard soffit
19 50/8.5 mm steel flat balustrade
20 60 mm screed trowelled smooth
70 mm insulation slab with underfloor heating
sealing layer
150 mm reinforced concrete floor
21 lightweight steel lintel/eaves beam
consisting of
2× 146/70/1.5 mm channel sections and
4× 56/200/1.6 mm channel sections

bb

Refúgio São Chico

Weekend House
São Francisco de Paula, BR 2007

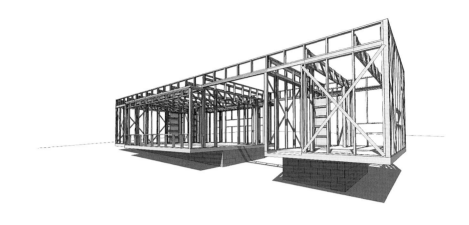

Architects:
Studio Paralelo, Porto Alegre
Structural engineers:
Formac, Chile

Situated in São Francisco de Paula, a mountainous region of Rio Grande do Sul in the south of Brasil, this small weekend retreat, designed and planned for a young journalist, is embedded in a tropical forest, 100 km from Porto Alegre. Gently integrated into 1600 m² site, that consists of well-preserved, mature forest, the entire construction area occupies only 82 m².

Two interlocking rectangular boxes of different textures rest on a reinforced concrete slab which is raised above the ground to protect it from damp. The larger one is covered with corrugated steel sheeting and contains the more private areas with an ensuite bedroom at each end. By contrast, the smaller, wooden box crosses the metallic pavilion and houses the social and service areas. A spacious dining- and livingroom opens up to the north side and allows daylight to enter. This more transparent, common area also features a laundry, a kitchen as well as a storage room that are integrated in the other end of the wooden box. By opting for an open kitchen, a smooth transition of cooking- and living zone has been created. From the intersection of these two structures a long wooden deck configures the entrance area and developes into a terrace that hovers above the vegetation.

Based on a simple light steel frame system, the construction follows a structural logic of 1.20 × 1.20 m modules. The simplicity of the steel frame design and the prefabrication helped to reduce time on site and optimized the control over the construction process. As the workshop in which the prefabrication took place is located in Porto Alegre, where the architects are also based, daily supervision was possible. All these conditions accelerated the assembly process and the entire building was erected within a period of eight weeks. The intention of this project was to adapt this hideaway carefully to the characteristic landscape rather than competing with it.

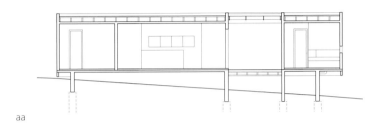

aa

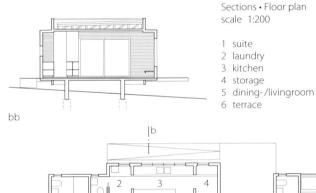

bb

Sections · Floor plan
scale 1:200

1 suite
2 laundry
3 kitchen
4 storage
5 dining-/livingroom
6 terrace

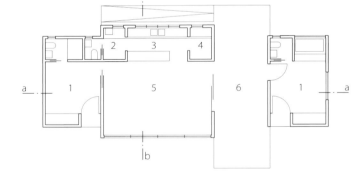

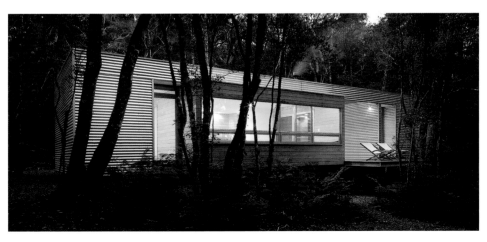

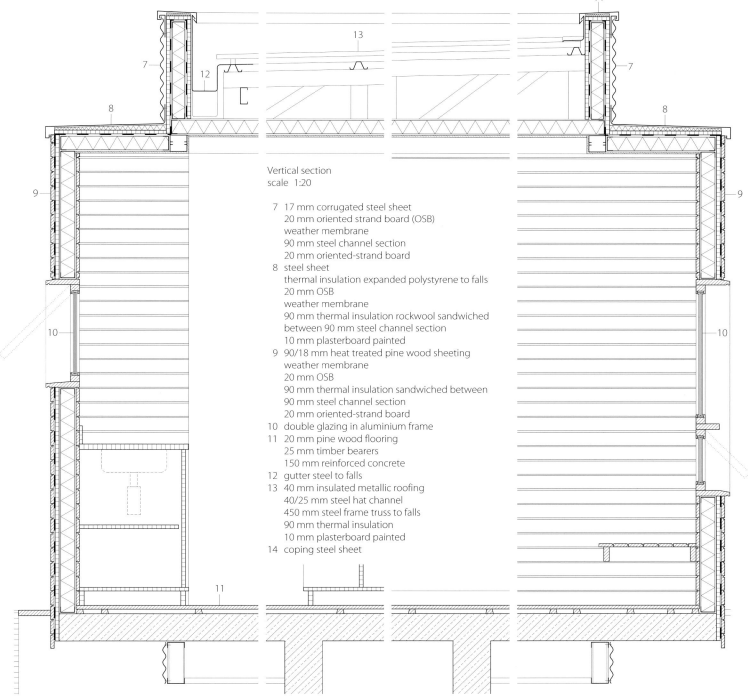

Vertical section
scale 1:20

7 17 mm corrugated steel sheet
 20 mm oriented strand board (OSB)
 weather membrane
 90 mm steel channel section
 20 mm oriented-strand board
8 steel sheet
 thermal insulation expanded polystyrene to falls
 20 mm OSB
 weather membrane
 90 mm thermal insulation rockwool sandwiched
 between 90 mm steel channel section
 10 mm plasterboard painted
9 90/18 mm heat treated pine wood sheeting
 weather membrane
 20 mm OSB
 90 mm thermal insulation sandwiched between
 90 mm steel channel section
 20 mm oriented-strand board
10 double glazing in aluminium frame
11 20 mm pine wood flooring
 25 mm timber bearers
 150 mm reinforced concrete
12 gutter steel to falls
13 40 mm insulated metallic roofing
 40/25 mm steel hat channel
 450 mm steel frame truss to falls
 90 mm thermal insulation
 10 mm plasterboard painted
14 coping steel sheet

Montevideo

High-rise Housing and Office Block
Rotterdam, NL 2005

Architects:
Mecanoo architecten, Delft
Structural engineers:
ABT, Delft

With the transfer of harbour operations to the mouth of the River Meuse, the port in the city of Rotterdam became redundant. This allowed the development of a new urban district with housing and offices on the former harbour area.

The architects were commissioned to draw up a concept for a top-quality high-rise residential block on the south bank of the Wilhelmina Pier, close to the tower structures already completed on the north bank.

Today, the tallest housing block in the Netherlands stands at the end of the pier from where ocean liners of the Holland-America Line once sailed to New York. In recollection of the history of this site, the 152-metre-high tower carries the name Montevideo.

The building is a composition of stacked, overlapping volumes and makes reference to the classic high-rise developments of the 1920s and 30s, with their brick facades, loggias and roof terraces. The first two storeys have a steel structure, which supports the tower and the lower volume which cantilevers out by 16 metres towards the water. The next 27 storeys above the steel plinth were constructed in reinforced concrete, using a climbing shutter system. From the 28th storey upwards, the structure is again steel, which allowed a free configuration of the dwellings at the top of the high-rise block with many possible variations in the internal layout. Altogether there are 192 apartments, comprising 54 different types, with varying room heights.

The development also contains offices and communal facilities. Residents can take advantage of a wide range of internal services, such as a swimming pool, a health and fitness centre, restaurants and hotel suites. Parking space is provided in a two-storey basement garage. The windows, balconies and loggias are laid out rhythmically over the face of the building. The diagonals of the steel frame supporting the top floors can be discerned through the windows.

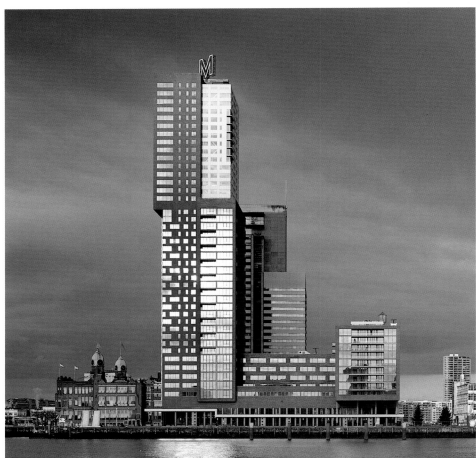

Ground level

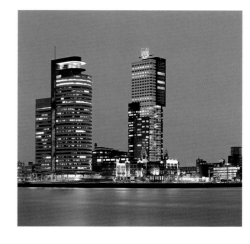

Site plan
scale 1:7500
Section · Floor plans
scale 1:1000

1 access to
 dwellings in tower
2 access to "water"
 apartments
3 access to offices
4 access to
 basement garage
5 bicycle store

6 rentable areas
7 "city" apartments
8 "water" apartments
9 "sky" apartments
10 penthouse
11 "loft" apartments
12 services level
13 offices
14 hotel suites
15 storage
16 fitness centre
17 swimming pool
18 parking

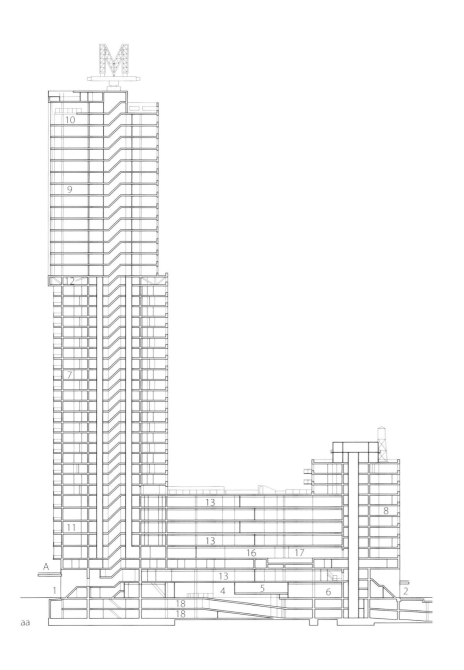

aa

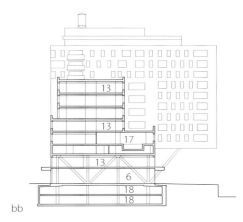

bb

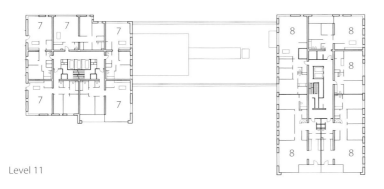

Level 11

Level 35

Level 42

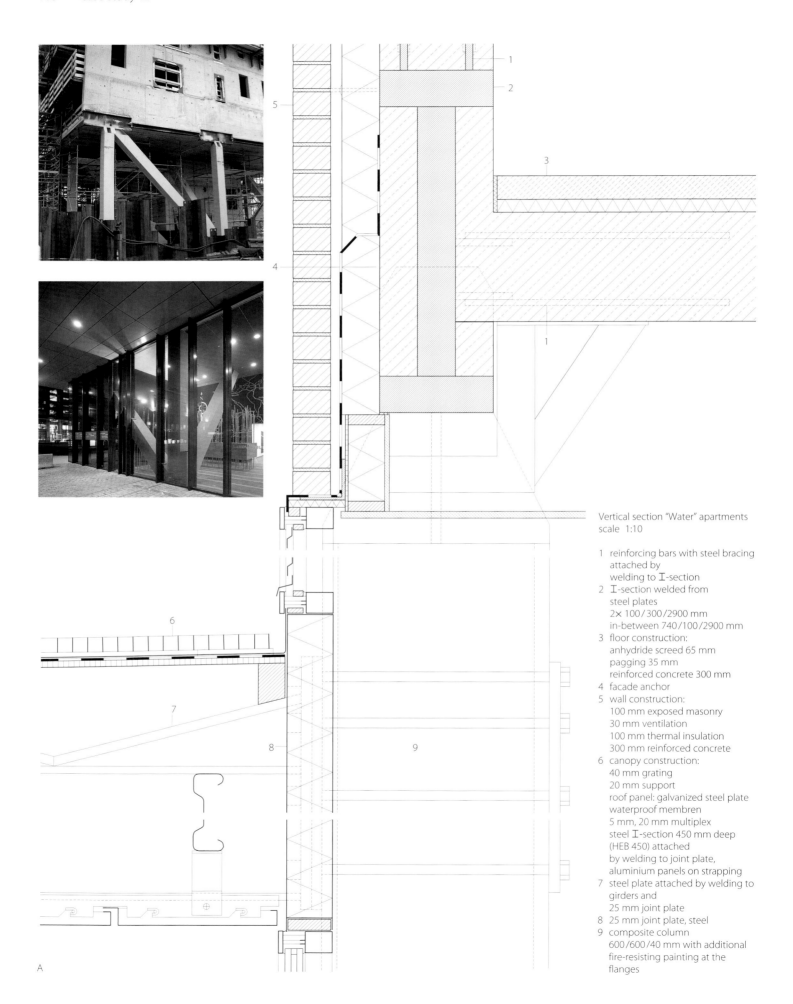

Vertical section "Water" apartments
scale 1:10

1 reinforcing bars with steel bracing
 attached by
 welding to I-section
2 I-section welded from
 steel plates
 2× 100 / 300 / 2900 mm
 in-between 740 / 100 / 2900 mm
3 floor construction:
 anhydride screed 65 mm
 pagging 35 mm
 reinforced concrete 300 mm
4 facade anchor
5 wall construction:
 100 mm exposed masonry
 30 mm ventilation
 100 mm thermal insulation
 300 mm reinforced concrete
6 canopy construction:
 40 mm grating
 20 mm support
 roof panel: galvanized steel plate
 waterproof membren
 5 mm, 20 mm multiplex
 steel I-section 450 mm deep
 (HEB 450) attached
 by welding to joint plate,
 aluminium panels on strapping
7 steel plate attached by welding to
 girders and
 25 mm joint plate
8 25 mm joint plate, steel
9 composite column
 600 / 600 / 40 mm with additional
 fire-resisting painting at the
 flanges

A

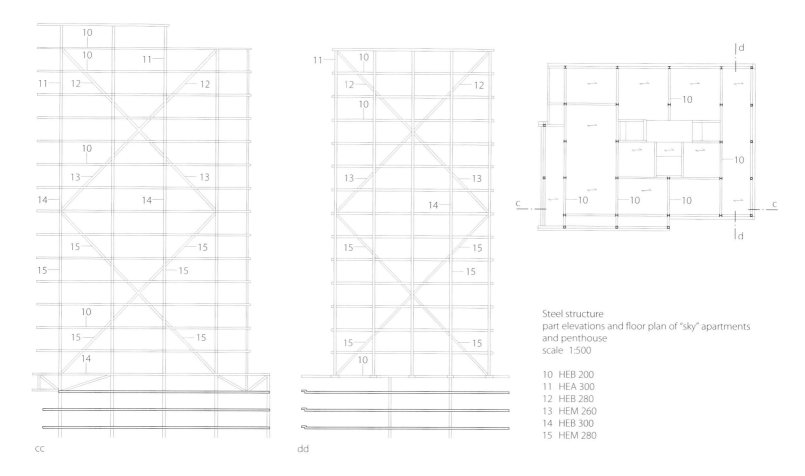

Steel structure
part elevations and floor plan of "sky" apartments
and penthouse
scale 1:500

10 HEB 200
11 HEA 300
12 HEB 280
13 HEM 260
14 HEB 300
15 HEM 280

cc dd

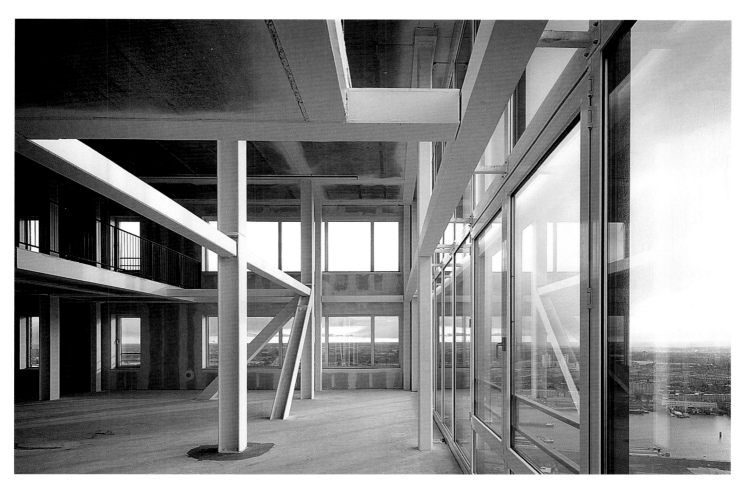

Rectorate Office Building

Office Building
Cayenne, French Guyana, GUY 2007

Architects:
Christian Hauvette, Paris
Structural engineers:
Cera Ingenierie, Nantes

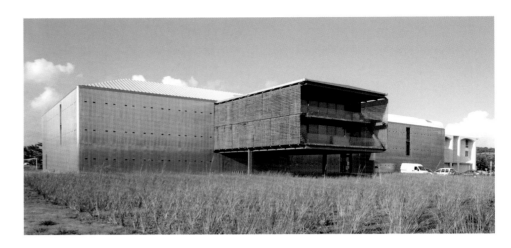

The new office building for the Ministry of Education in French-Guyana is designed as an extension of a renovated building from the 1980s.

Organized around patios, the main building containing the new rectorate is a rectangular object surrounding the renovated building. Two of its faces have a "drawer", one containing the raised ministry offices, the other the computer services.

The project combines imported components and local materials. As a result, this building, which uses sustainable, recyclable and renewable materials, is, on the one hand, pre-fabricated, delivered in containers and assembled on site and, on the other hand, is, in part, the work of carpenters using the magnificent, readily available regional woods.

The extension is a steel construction resting on reinforced concrete slabs. The main building is covered with stainless steel cladding, which shelters the external steel duckboard alleyways that run around the building. Forming the building structure itself are standard laminated steel beams and square tubes. On the external side, the joists are run under the alleyways to connect with external columns. On the patio side, cantilevered joists support fixed solar shading systems.

The facade of the "drawers" is made of wooden solar shading systems supported by cantilevered beams.

The distinguishing features of the Rectorate Offices pavilion are its long spans and the long cantilever overhanging the garden. Two double-height tubular steel trusses are cantilevered 9 m beyond the last column and are integrated into the facade. The structure's lightness minimizes the impact of the columns and leaves the fine detail of the framework exposed. The pleasure of working in the building has been accentuated by the incorporation of fast-growing plants into the architecture, as well by the trees planted in the surrounding gardens.

aa

bb

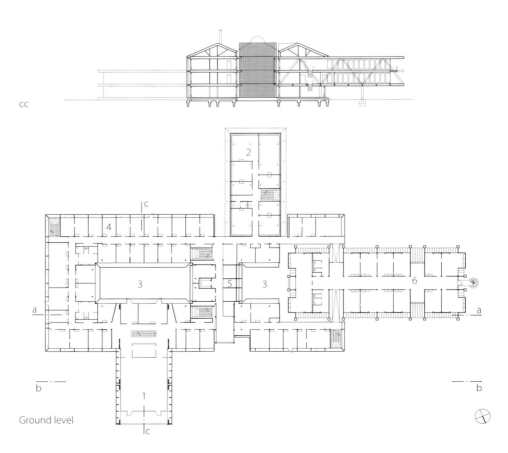

cc

Ground level

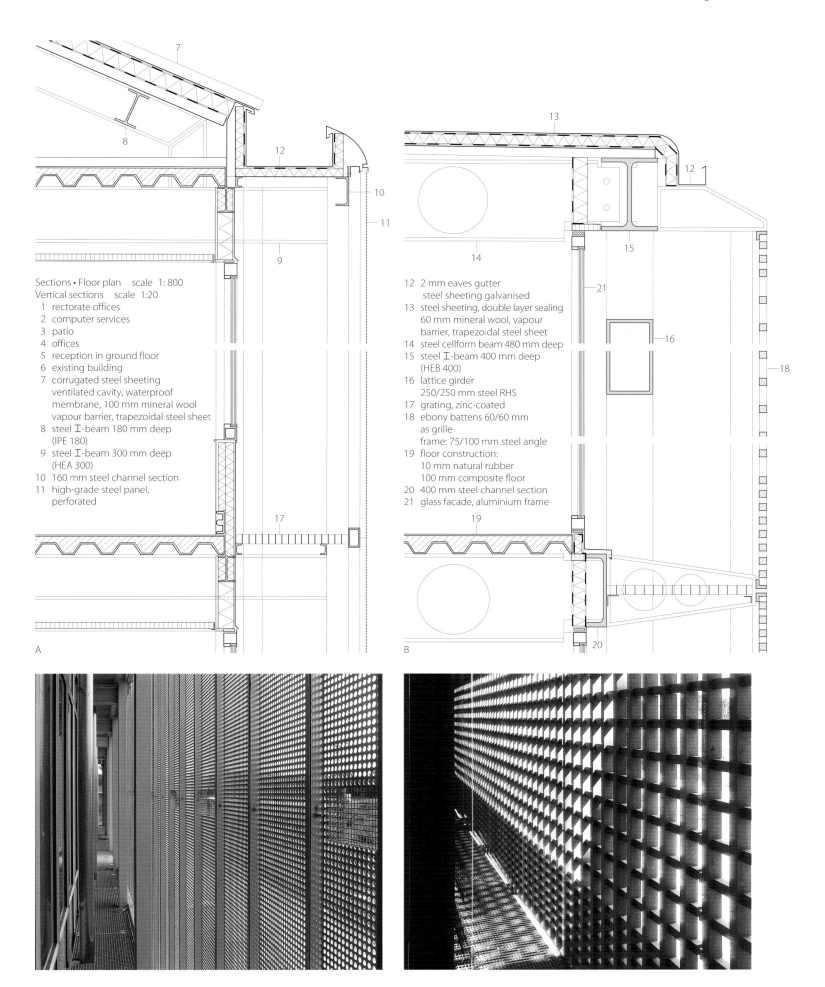

Sections · Floor plan scale 1:800
Vertical sections scale 1:20
1 rectorate offices
2 computer services
3 patio
4 offices
5 reception in ground floor
6 existing building
7 corrugated steel sheeting
 ventilated cavity, waterproof
 membrane, 100 mm mineral wool
 vapour barrier, trapezoidal steel sheet
8 steel I-beam 180 mm deep
 (IPE 180)
9 steel I-beam 300 mm deep
 (HEA 300)
10 160 mm steel channel section
11 high-grade steel panel,
 perforated

12 2 mm eaves gutter
 steel sheeting galvanised
13 steel sheeting, double layer sealing
 60 mm mineral wool, vapour
 barrier, trapezoidal steel sheet
14 steel cellform beam 480 mm deep
15 steel I-beam 400 mm deep
 (HEB 400)
16 lattice girder
 250/250 mm steel RHS
17 grating, zinc-coated
18 ebony battens 60/60 mm
 as grille
 frame: 75/100 mm steel angle
19 floor construction:
 10 mm natural rubber
 100 mm composite floor
20 400 mm steel channel section
21 glass facade, aluminium frame

Head Office PLL LOT

Office Building
Warsaw, PL 2002

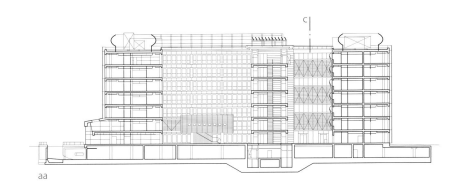

aa

Architects:
APA Kuryłowicz & Associates, Warsaw
Structural engineers:
PRO-INVEST Sp. z o.o., Warsaw

The head office of PLL LOT, Poland's largest airline, is in close proximity to Warsaw Airport. A vertical running axis crosses the first floor of the rectangular building, configuring the spacious entrance area of the main lobby, which is accessible from two central entrances that stand opposite each other. Furthermore this level contains a clients reception area and equipment rooms at the north-western part of the building. A spacious restaurant as well as conference rooms and offices are arranged around an atrium area.

The well-structured seven-storey block is completely enclosed in glass. A cube elevated on stilts with facades and ceiling made of bluish translucent figured glass offers space for exhibitions and events.

The dominating design feature is the point-supported glass wall extending over the full height of the building and allowing a high incidence of light. The insulating glass panels are mounted on a structure of steel hollow sections.

Two steel bridges on each floor connect the two wings. Instead of balustrades, a wide-meshed, stainless steel mesh is spanned between the floors to provide an anti-fall guard. The filigree glass roof also allows a lot of daylight to enter the huge, imposing lobby and creates a bright, pleasant atmosphere. Steel girders spanning 15 m and up to 1200 mm deep support the glass roof over this area. Their curved shape refers to a modern aircraft wing. From the outside the lobby is clearly silhouetted against the rest of the building, since the building envelope to the office area is a double-facade and therefore less transparent.

Depending on the altitude of the sun and the perspective, the building's reflective facade can render it almost invisible. Numerous steel elements – required structurally or for decorative effect only – together with the glass used give the building an industrial expression, but it nevertheless has a light and airy appearance.

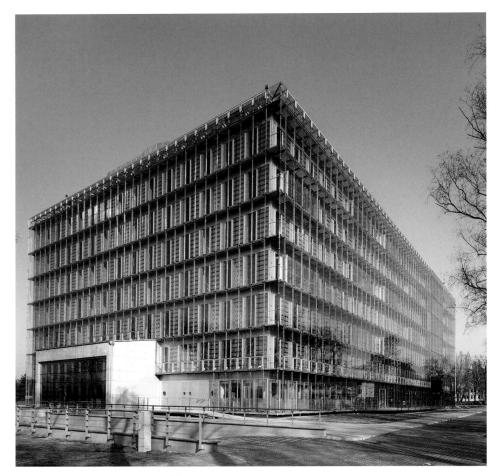

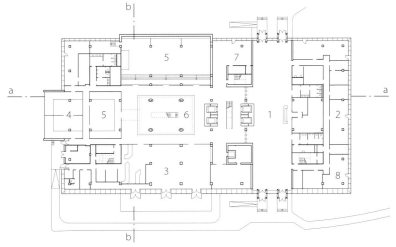

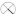

Sections · Floor plan
scale 1:1000
Vertical section roof and facade
scale 1:50

1 main lobby
2 clients reception
3 restaurant
4 offices
5 conference hall
6 atrium area
7 cloakroom
8 equipment rooms

9 10 mm toughened glass + 16 mm cavity +
 14 mm laminated safety glass
10 max. 1240 mm welded steel openwork
 plate girder
11 Ø 193.7 mm tubular steel purlins
12 3 mm steel cord mesh
13 50 mm wooden flooring
 max. 196.5 mm openwork steel girder
14 Ø 711 mm tubular steel girder
15 Ø 161.9 mm tubular steel
16 Ø 25 mm tubular steel
17 welded steel knot of 16 mm plate and
 Ø 12.5 mm steel tube

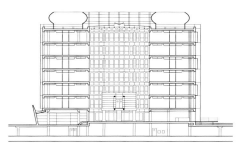

bb

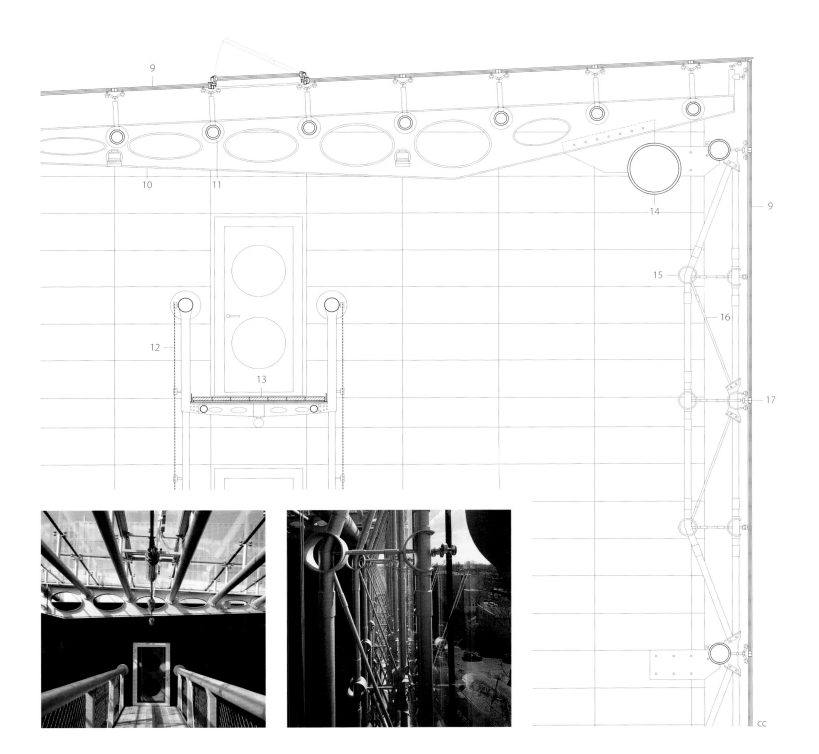

cc

Kraanspoor

Office Building
Amsterdam, NL 2007

Architects:
OTH Ontwerpgroep Trude Hooykaas,
Amsterdam
Structural engineers:
Aronsohn raadgevende ingenieurs,
Amsterdam

From a distance, the new office building constructed on top of a derelict crane track on the north bank of river IJ appears to float over the water above the impressive concrete colossus as a seamless combination of old and new. The abandoned crane track, 270 m long, 13.5 m high and 8.5 m wide, used to be surmounted by two gigantic shipyard cranes. Fully respecting its foundations, the new building is elevated three metres above the crane way by slender steel columns. The challenge was to maximise the floor area of the new building without having to make radical modifications to the existing concrete structure, while still fully exploiting load-carrying capacity. A lightweight steel frame, innovative floor system and lightweight facades were necessary to add a third floor of extra office space.
The main steel structure is assembled from 23 m modules divided into three fields of 7.67 m with tubular bracing members. The thin, light prefabricated floor system is composed of integrated IPE 270 sections with concrete-encased bottom flanges. Beam web openings allow to be positioned exactly where they are needed thus cables and pipes, offering flexibility when reconfiguring floor plans. The new building is characterised by its double-skin climate facade. Combined with the sunblocking glass, the slats can reduce the solar heat energy entering the building. It was essential to create a glass facade that would provide high levels of daylight. A hydrothermal heating and cooling system uses the water pumped up from the IJ.
The four double portal frames of the concrete crane track find reuse as stairwells. A separate, specially designed, prefabricated steel structure includes new stairs and a panorama lift. The architects have arrived at a unique ingenious solution that (re-)creates and preserves industrial heritage. At the same time it offers all the advantages of a flexible, demountable and highly environmentally sustainable building.

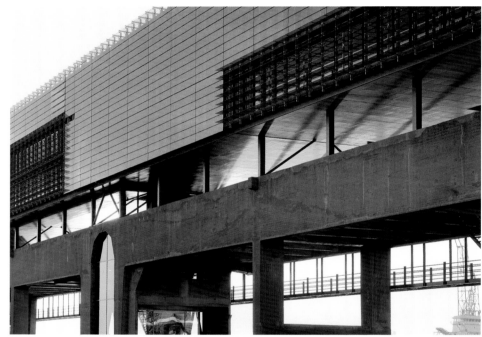

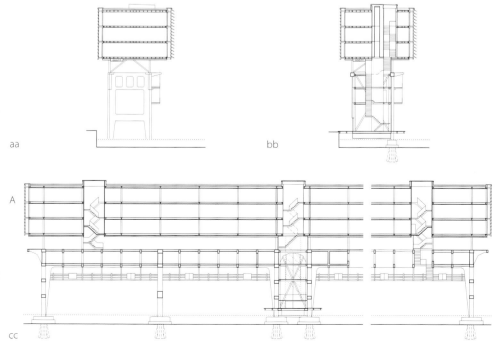

aa

bb

A

cc

Site plan
scale 1:15 000
Floor plans · Sections
scale 1:750
Schematic heating and ventilation
diagramm

1 entrance
2 building services
3 reception
4 offices

This climate facade allows for natural
ventilation of the offices and acts as a
buffer against heat in summer and
cold in winter. Floor convectors pre-
vent cold air drop and cold radiation.

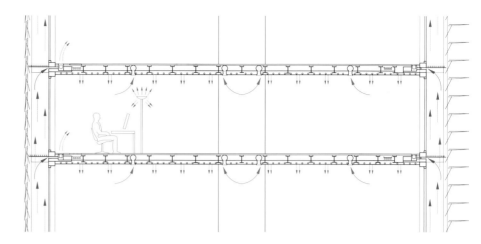

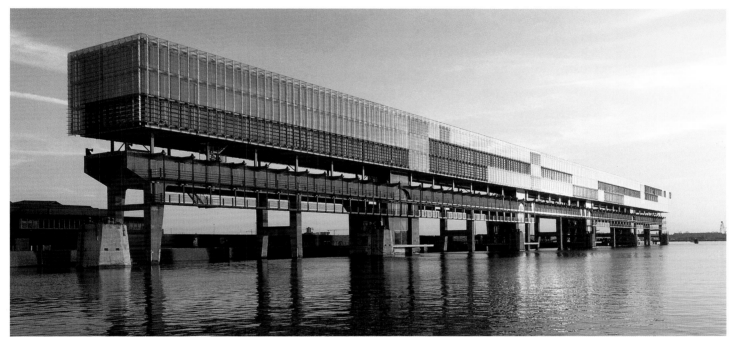

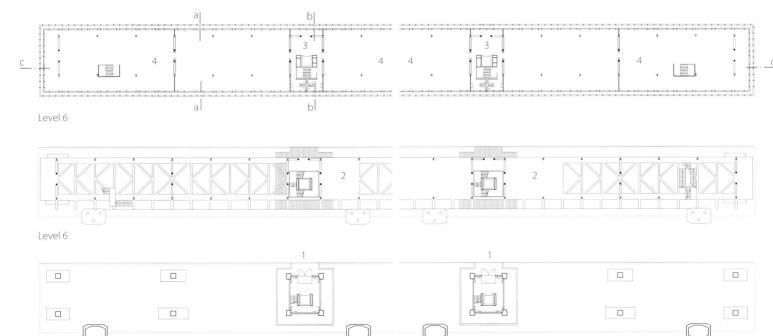

Level 6

Level 6

Access level

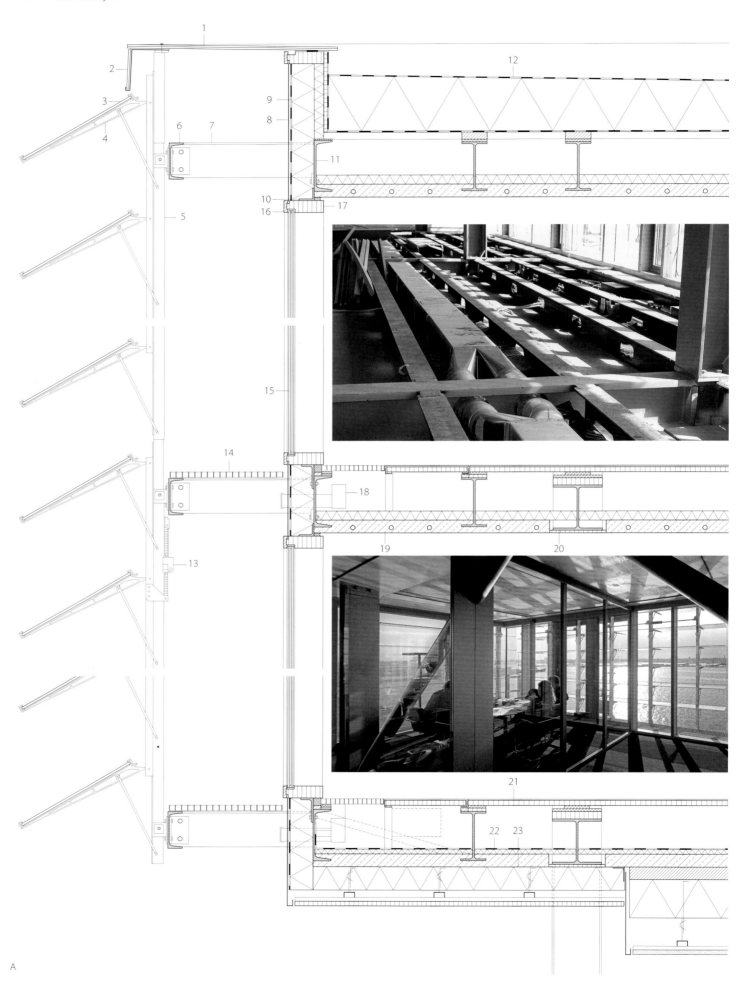

A

Vertical section
facade
scale 1:20

1 20 mm laminated
 safety glass, coated
2 12 mm toughened glass,
 coated
3 12 mm toughened glass
 slats, screen print pattern
4 aluminium glass slat holder
5 aluminium profile
6 200/40/40 steel channel
 section
7 80/80/9 mm steel T-section,
 galvanized coated
8 3 mm aluminium plate,
 enamelled
9 water-repellent vapour-
 permeable foil
 120 mm mineral wool
10 80/80 mm steel angle with
 elongated hole and plastic
 ring for sliding mount
11 280/95/10 mm galvanized
 channel steel section
12 plastic membrane as seal
 insulation to falls
 vapour barrier
 40 mm corrugated metal
 steel I-beam 270 mm
 deep (IPE 270)
 50 mm insulation
 70 mm concrete slab with
 concrete core aviation
13 motor for glass slat facade
14 grate width 24 mm
15 double glazing:
 12 mm toughened glass +
 air cavity + 8 mm laminated
 saftey glass
16 wooden trim
17 window frame, laminated
 timber wood, glued
18 convector heater grate
19 70 mm concrete light-weight
 flooring with plastic piping
 for hydrothermal heating/
 cooling, and steel I-beam
 270 mm deep (IPE 270)
20 steel I-beam 270 mm deep
 (IPE 270)
 3 mm aluminium plate
 enamelled
21 carpet
 30 mm veneer plywood
 15 mm rubber granulate mat
22 fleece; 25 mm mineral fibre
 sound absorption board
23 130 mm mineral wool
 thermal insulation
 ceiling joists
 14 mm wood fibre board,
 painted

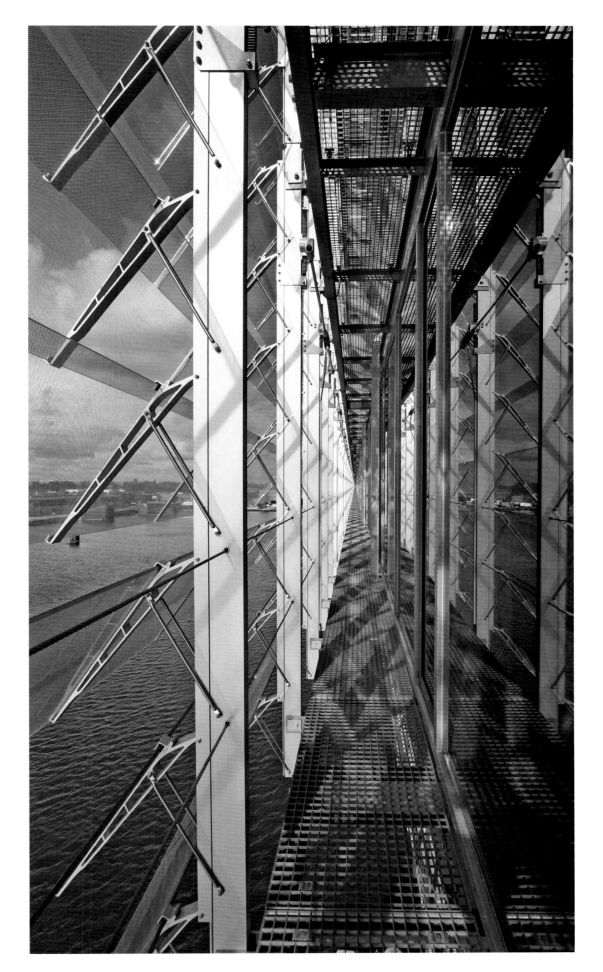

Dexia B.I.L.

Office Building
Esch-Belval, L 2007

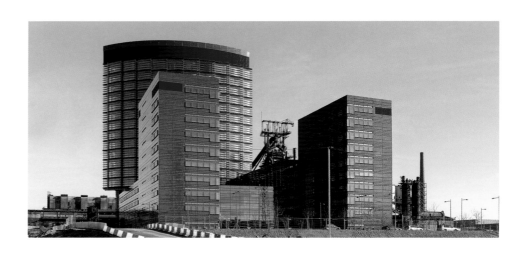

Architects:
Claude Vasconi and Associates, Paris
Structural engineers:
Simon & Christiansen, Capellen and
Bollinger + Grohman, Frankfurt a. M.

In Esch-Belval in southern Luxembourg, the new Dexia – Banque Internationale à Luxembourg administration complex is located on the brownfield site of a former Arcelor Mittal steelworks. New green space, residential and office blocks are created on the 127 ha site among several preserved symbols of its industrial heritage, such as blast furnaces and brick chimneys. The 75 m high office tower, with a cross section like a curved disc, and two nine-storey wings, dominates the new complex. At the centre is an atrium, which also serves as event and exhibition space.

Both wings are designed as steel skeletons around a stiff concrete core. The high-rise has a reinforced concrete supporting structure. Simply supported composite floor slabs provide floor spaces with spans of 15 m without intervening supports thus offering maximum flexibility for floor layout. Load transfer is through the central reinforced concrete core, which houses the lift shafts and services. The west-facing facade of the Dexia Tower is double-skinned with a naturally ventilated cavity. In plan this facade describes a serrated curve. The opaque surfaces of all the buildings are covered with red enamelled steel panels whose thickness are 2 mm with side lengths of up to 1.5 m. Another special feature of the building is the steel-glass roof structure of the atrium. This is based on a continuous lattice of welded primary and secondary elements trussed with longitudinal and transverse tension members. Circular hollow section struts connect the lattice with the truss. The struts are formed of four individual tubes combined by a bent cast element at the node and support the lattice at 3 m centres. The continuous lattice, which is made of welded I-sections and is linked to the circular hollow bottom truss member, directly supports the glazing. By avoiding the use of a secondary supporting structure, the roof gives a remarkable impression of clear space.

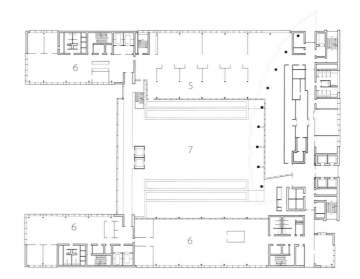

Level 2

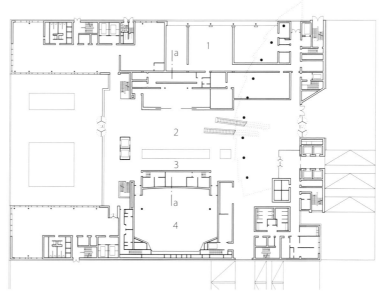

Ground level

Floor plans scale 1:1000
Vertical section atrium scale 1:400
Detail sections atrium scale 1:10
Node element on primary girder

 1 parking
 2 atrium
 3 reception
 4 auditorium
 5 cafeteria
 6 offices
 7 airspace atrium
 8 steel girder 290 mm deep
 9 Ø 50 mm hinge bolt
10 Ø 88.90 mm steel tube
11 connection with right /
 left-handed thread
12 joint grouted with permanently elastic material

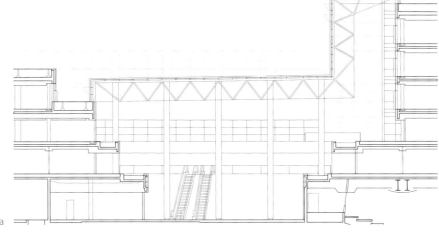

aa

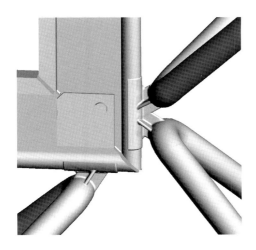

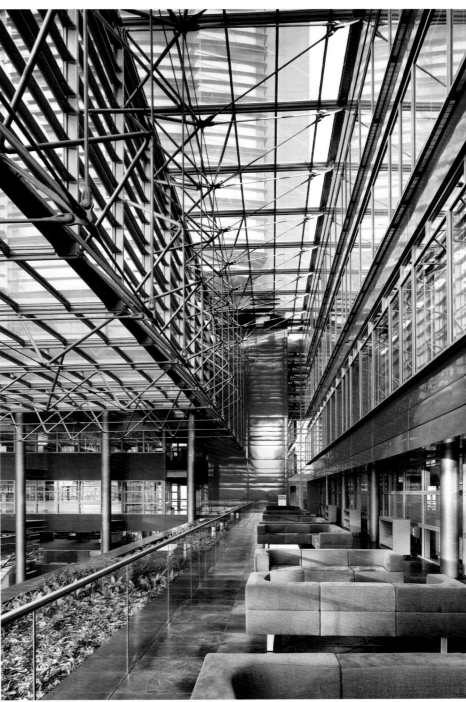

Antwerp Law Courts

Public Building
Antwerp, B 2007

Architects:
Richard Rogers Partnership, London
VK Studio, Roeselare
Structural engineers:
Ove Arup & Partners, London

Antwerpen has got a new landmark. A series of shining waves have dramatically changed the view from the city centre. The building is planned to form a catalyst for a larger urban development in the so-called "new south" of the city. The law courts complex was not designed simply as a spectacular monument, though; it was to form a gateway to the city and link between the old urban centre an the new development areas. Transparency, flexibility and technology are the key concepts of the project as well as the enviromental aspects including an effective use of energy.

A large, radiant yellow staircase was designed to attract and welcome the inhabitants of Antwerp into the transparent main hall. Extending in a star-like form from the main hall are six wings. The whole is crowned by a stricking, crystalline roof structure adjoining the parabolic roofs over the courtrooms.

The structural concept, materials and construction method used for the roofs are the result of extensive analyses. For example, wind tunnel tests determined the most unfavourable wind loads, and analysed the disturbance caused by the wind in the surrounding area. In the final analysis, a hyperbolic paraboloid appeared to be the best option. This model has a great advantage: it can be constructed using linear elements, onto which the finishing elements can be simply connected. In physical terms, each roof is built of four connected surfaces, each of them being a hyperbolic paraboloid or "hypershell". The method of the connected quadrants allowed the roofs to be constructed off-site and assembled as finished products in a minimum of time, without the use of scaffolding. The perimeter of each quadrant is made out of steel, making it relatively easy to attach secondary finishing elements. These stainless steel shell roofs function as membranes – in other words, normal forces transfer all loads to the underlying structures.

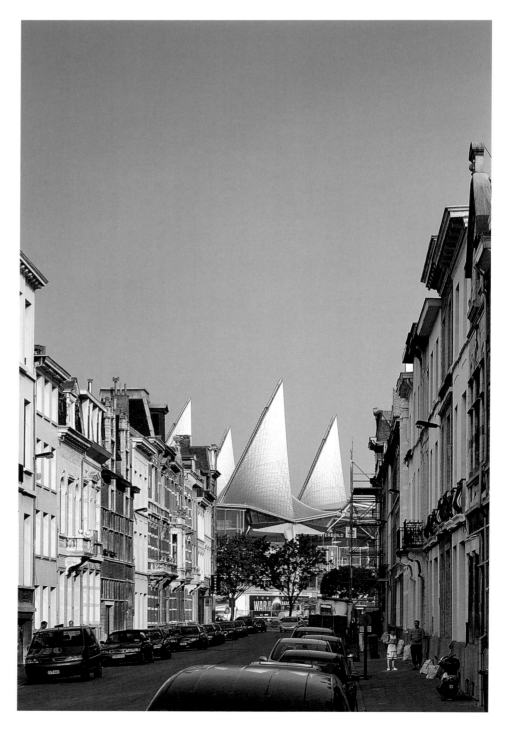

Section • Floor plans
scale 1:1500
1 entrance hall
2 courtroom
3 judge

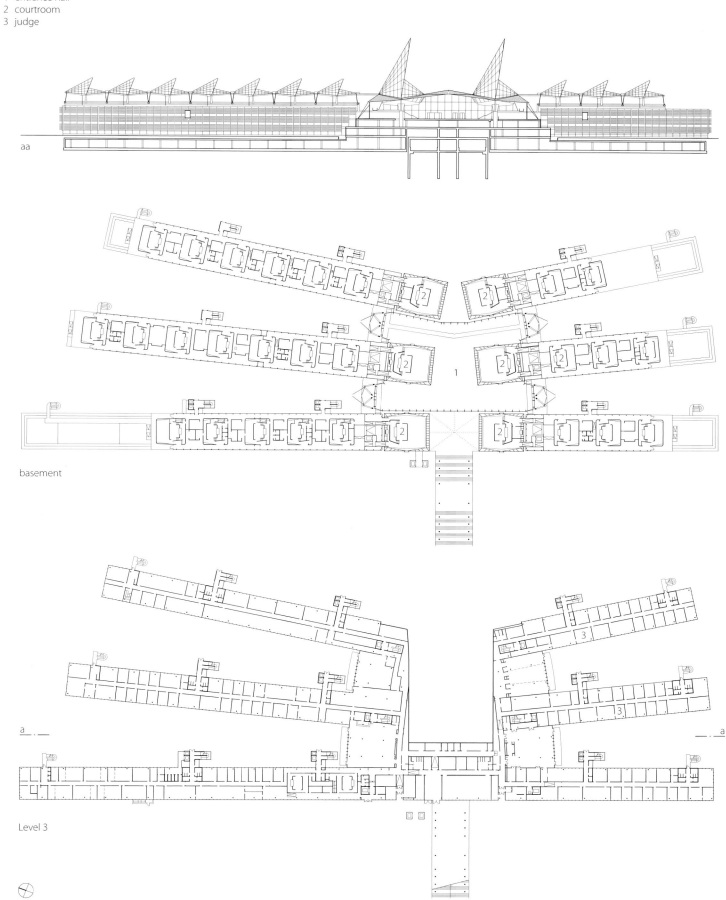

aa

basement

a ___ ___ a

Level 3

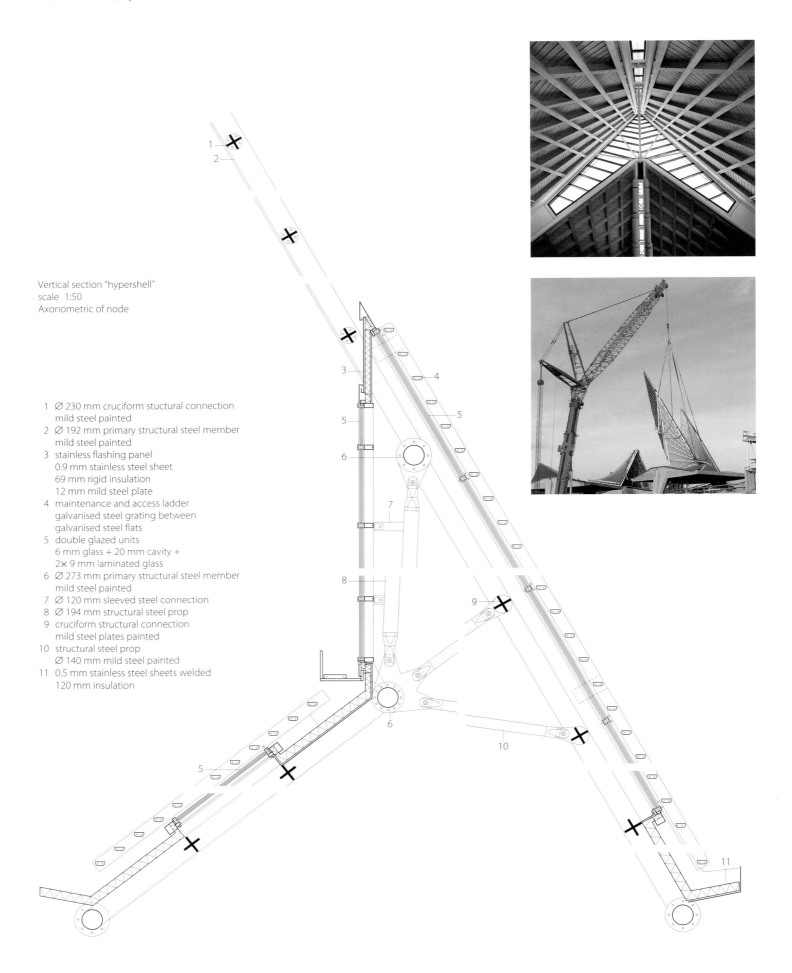

Vertical section "hypershell"
scale 1:50
Axonometric of node

1 Ø 230 mm cruciform stuctural connection
 mild steel painted
2 Ø 192 mm primary structural steel member
 mild steel painted
3 stainless flashing panel
 0.9 mm stainless steel sheet
 69 mm rigid insulation
 12 mm mild steel plate
4 maintenance and access ladder
 galvanised steel grating between
 galvanised steel flats
5 double glazed units
 6 mm glass + 20 mm cavity +
 2× 9 mm laminated glass
6 Ø 273 mm primary structural steel member
 mild steel painted
7 Ø 120 mm sleeved steel connection
8 Ø 194 mm structural steel prop
9 cruciform structural connection
 mild steel plates painted
10 structural steel prop
 Ø 140 mm mild steel painted
11 0.5 mm stainless steel sheets welded
 120 mm insulation

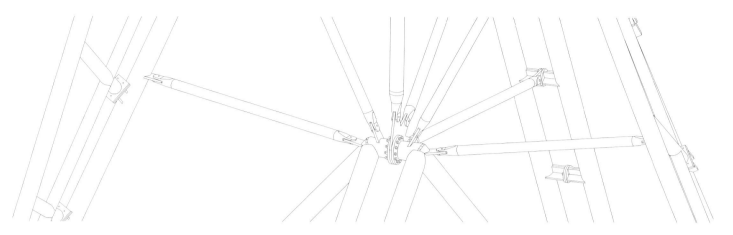

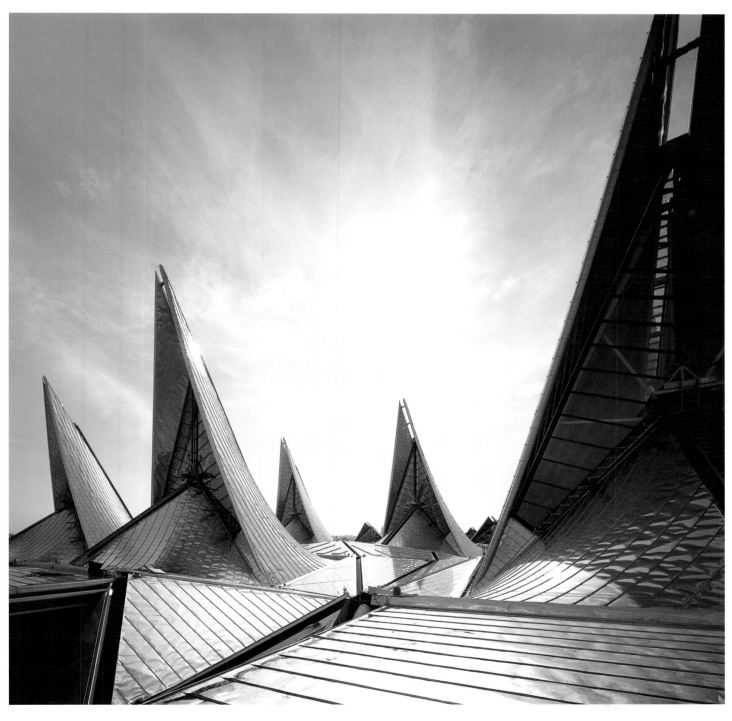

Sophysa – Office and Production Building

Industrial Building
Besançon, F 2007

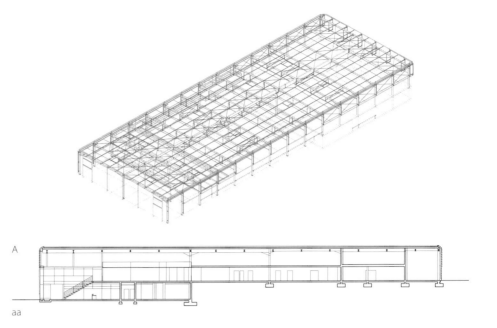

Architects:
METRA & Associés, Paris
Structural engineers:
Frachon-Soder, Dole

In this new production centre in Besançon, about 160 km north of Geneva, neurological implants for the medical industry are manu-factured. The two-floor building with a steel structure is built into the slope of a hill which falls slightly to the south-west. The production facility is entered through a dou-ble-height hall. The meeting rooms and offices are on the lower level of this two-sto-rey part of the building, while the 400 m² clean room with a surrounding gallery and production facilities are on the upper floor. Reflecting the highly sensitive nature of the implants, the interior conveys a cool and clean atmosphere emphasised by the use of materials, such as stainless steel and glass. These qualities also influence the building envelope. Facade bands made of stainless steel coated with aluminum-zinc give a dis-tinctive identity to this building with its clear-cut silhouette. The cladding constantly plays with views and reflections, creating a synergy between interior and exterior. The bands in the upper part of the building are completely closed flat against the facade whereas those in the lower area are swivelled slightly open. They are fixed at an angle that takes into account the angle of the sun, the views and the type of activities they protect. A structure made of zinc-coated steel tubes carries these perforated sunscreen louvers.

A

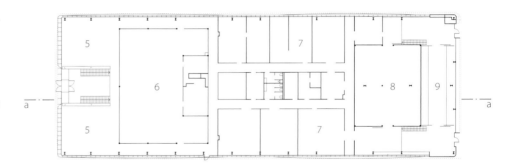

aa

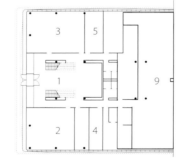

Section · Floor plans
scale 1:750

1 entrance hall
2 restaurant
3 meeting room
4 dressing rooms
5 offices
6 clean room
7 production area
8 storage
9 technical rooms

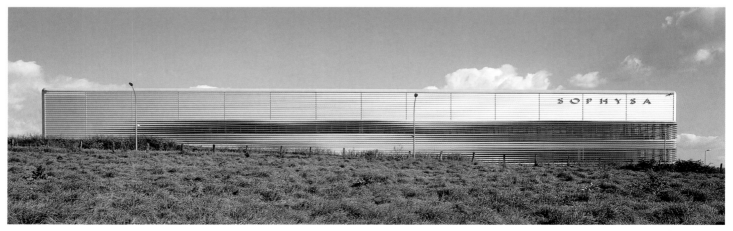

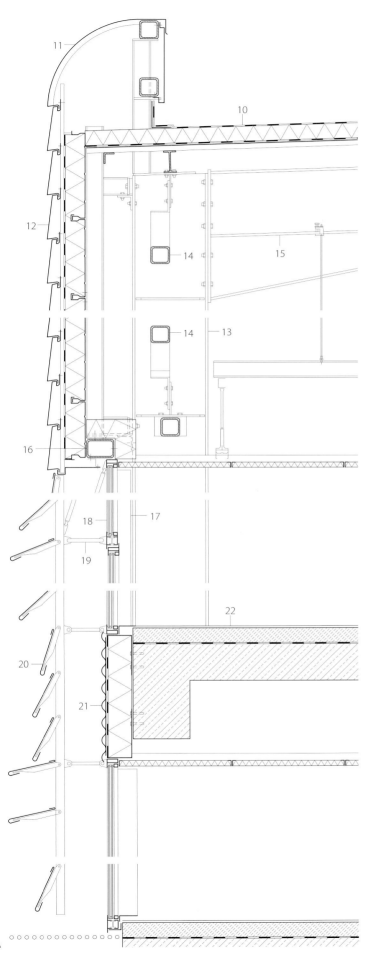

Vertical section
scale 1:20

10 roof construction:
 2 mm autoprotected waterproof
 layer, 70 mm heat insulation
 vapour barrier, 40 mm trapezoidal
 sheet, steel I-section 360 mm
 deep (IPE 360)
11 roof parapet: 1 mm bent grey
 powder coated steel plate
12 1 mm steel cladding aluminium-
 zinc coated, substructure 21 mm
 aluminum Z-sections
 vapour barrier
 110 mm heat insulation, steel
 I-section 100 mm deep (HEA 100)
13 steel I-section 400 mm deep

(IPE 400)
14 stiffening
 100/100/5 mm steel tube SHS
15 steel I-section 360 mm deep
 (IPE 360)
16 transverse beam
 150/100/5 mm steel tube RHS
17 bracing, 70/10/2680 mm steel plate
18 insulated double glazing
19 195/20/3 mm double steel plate,
 zinc coated
20 240/5400/1 mm shading steel
 plate, aluminium-zinc coated
21 76/18/0.75 mm facing corrugated
 steel sheet
22 floor covering linoleum
 80 mm screed
 200 mm hollow concrete floor

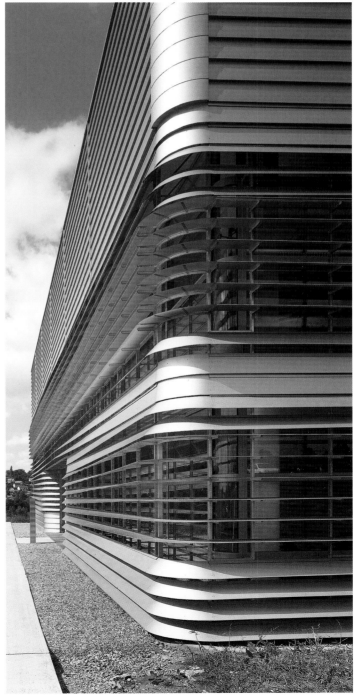

Windscreen-Wiper Factory

Industrial Building
Bietigheim-Bissingen, D 2003

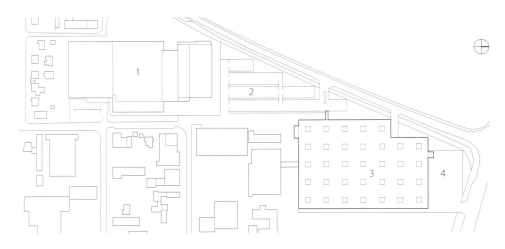

Architects:
Ackermann und Partner Architekten, Munich
Structural engineers:
Christoph Ackermann, Munich
G. Lachenmann, Vaihingen a. d. Enz

Valeo designs, manufactures and sells components, integrated systems and modules for cars and heavy lorries. Its German headquarters are located near Stuttgart, where many well known automobile manufacturers have a presence. A long-term restructuring programme for one of the Valeo sites and the erection of two new halls were the subject of a special study.

The architects Ackermann und Partner were awarded their translation of the company philosophy and for the flexibility of the modular structures they proposed.

The concept called for had to place the production process in the foreground and allow the works site to be restructured in a number of stages. The overall concept for the new factory comprises a modular structure based on a 24.50 × 24.50 m grid. The roof was designed as a plate structure with prestressed steel rod bracing, which stabilizes the upper flange of the lattice girders and transmits wind loads to the concrete cores and vertical bracing.

Media runs and infrastructure service systems are suspended from the ceilings throughout to guarantee maximum flexibility in the production areas. The same principle was also used in the offices. Electrical and data cables beneath the ceiling are connected to the desks through spine-like, suspended, movable ducts. This obviated the need for an expensive hollow-floor construction. The workplaces further away from the facades receive daylight from roof lanterns laid out within a 7 × 7 m grid. In the production hall, the roof lights are vertically glazed at the sides with translucent glass to avoid glare.

The continuity of the architectural form called for a facade concept that could be adapted to meet all situations. A fully glazed facade was designed to create an impression of transparency and spaciousness and to communicate the idea of equality among all employees, whether in the production hall or the offices.

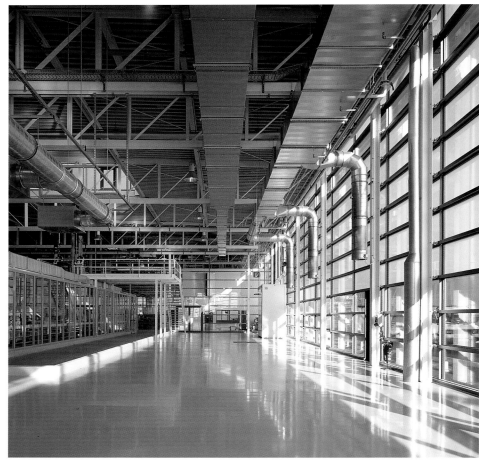

Preliminary design:
diagram of functions
and material flow lines
defined in the brief

Site plan
scale 1:5000

1 motor works
2 parking area
3 wiper works
4 logistics yard

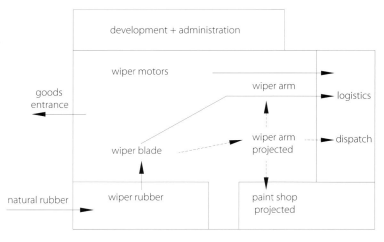

Sections · Floor plan
scale 1:1000

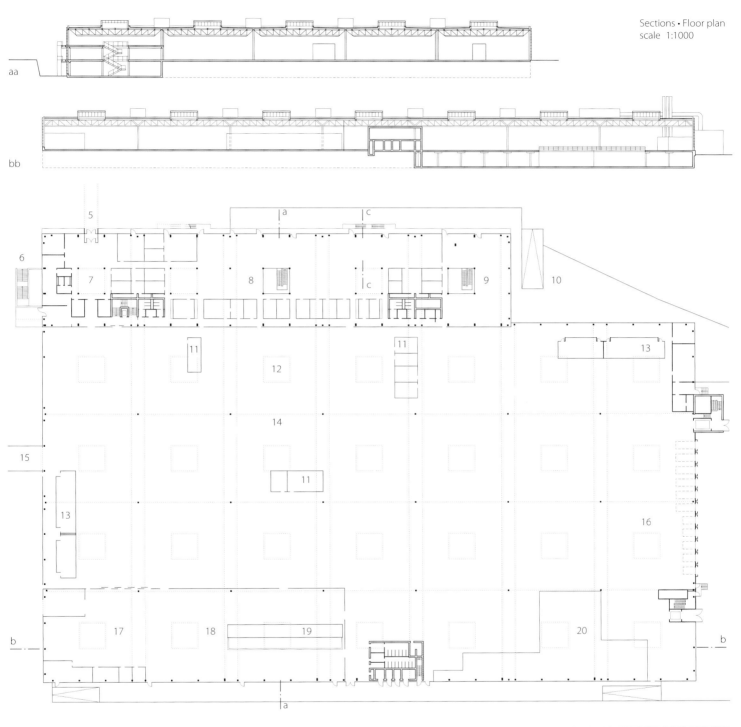

aa

bb

5 visitors' entrance
6 staff entrance in basement
7 entrance hall
8 administration offices
9 development offices
10 deliveries for laboratory and services
in basement
11 decentralized office units
12 roof lights
13 glazed rest rooms
14 principal beams
15 link to existing building;
goods entrance
16 dispatch
17 central control systems
18 extrusion (windscreen-wiper rubber)
19 bromide bath (wiper rubber)
20 space for future paint shop

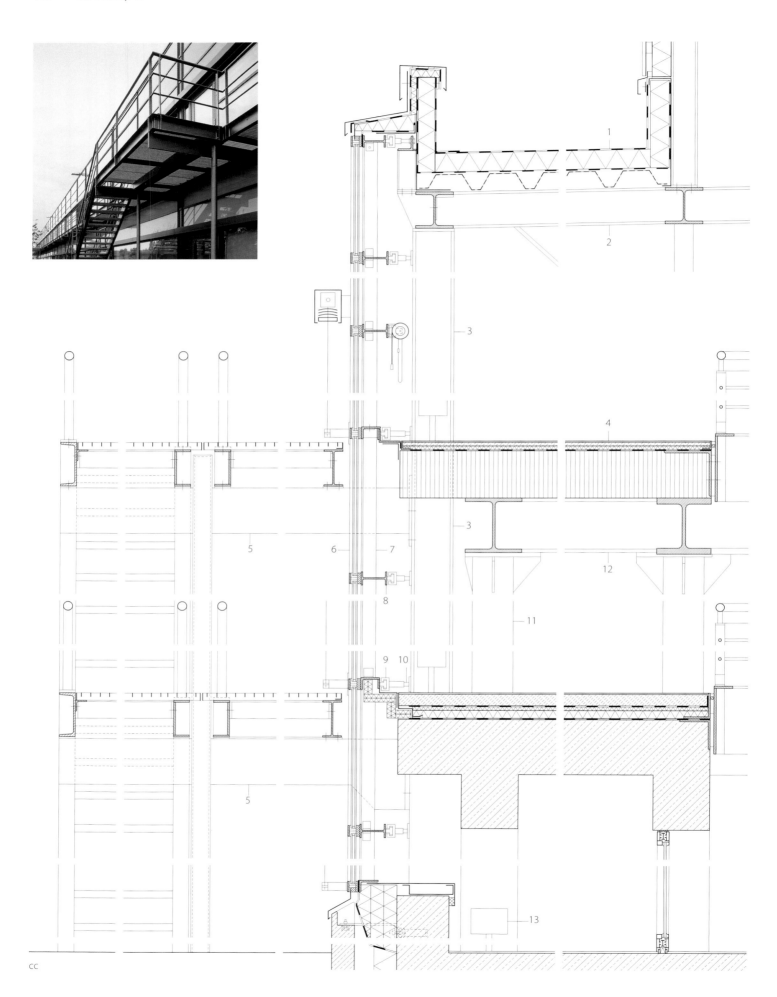

Vertical section scale 1:20
Isometric of structure:
the ventilation ducts pass through
the main beams through V-shaped
openings above the columns

1 fluoro-polyolefin
 plastic sealing layer
 120 mm mineralwool on
 vapour barrier
 1 mm perforated acoustic ribbed
 metal sheeting
2 200 mm I-beams: upper chord of
 trussed girder (HEB 200)
3 primary structure: steel I-column
 220 mm deep (HEB 220)
4 5 mm carpeting on 20 mm
 dry-screed elements
 20 mm impact-sound
 insulation; separating layer
 260 mm vertically stacked plank
 floor
5 250/25 mm steel-plate bracket
 for escape balcony
6 cover strip to aluminium facade
7 70 mm steel T-section post,
 mechanically stressed
8 steel I-section rail 140 mm deep
 (IPE 140), mechanically stressed
9 aluminium section allowing
 horizontal movement
10 stainless-steel threaded bolt
11 secondary structure:
 Ø 216/30 mm steel tube
12 secondary structure: steel I-beam
 300 mm deep (HEB 300)
13 convector

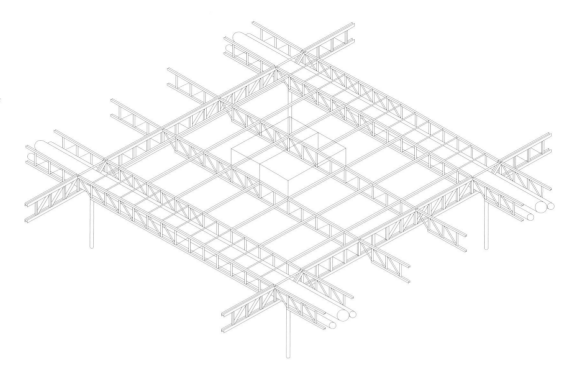

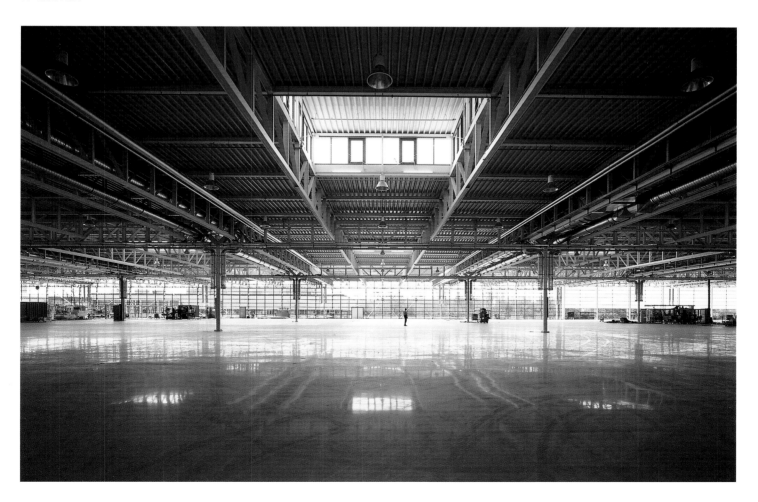

Gare de Strasbourg

Railway Station
Strasbourg, F 2007

Architect:
Jean-Marie Duthilleul &
François Bonnefille, Paris
Structural engineers:
RFR, Paris

The connection to the TGV network short-
ens the distance between Strasbourg and
Paris by reducing the journey time to less
than two and a half hours and should
increase passenger numbers. To adapt Stras-
bourg's historic railway station to suit its
new importance and function, the owner
(SNCF) had the building and its dismal fore-
court redesigned.
Curved steel and glass elements form the
120-metre long, 25-metre high, arched
structure. Its transparent glass skin and fili-
gree steel framework develops a new space
and provides a roofed extension to the old
station. The challenge here was not only to
retain the visibility of the existing but also to
comply with a conservation order, prohibit-
ing any physical connection between the
old and the new buildings.
The toroidal glass surface rests on a primary
structure of 16 main arches stabilized with
stainless steel cables, radially aligned toward
the building, every 9 m, and supported by
pinned columns. Between the arches, there
is a secondary structure made of stabilizing
elements trussed with tension rods, at
4.50 m spaces, designed to receive the ter-
tiary structure which is also curved.
Primary and secondary structures are con-
nected by an extensive system of prestressed
tension rods that serve horizontal stiffening,
and stabilize the entire structural framework.
The supporting envelope is composed of
curved glass elements. A new process –
known as cold lamination – leads to better
results in terms of appearance and statics.
Here, layers of plane glass and intermediate
layers re composed to a laminated safety glass
"sandwich", fixed to a bending frame, and
bent to the desired shape to be subsequently
baked as a bent composite to keep this shape.
Sunshading is provided by a two-colour,
white from the outside and black when inside,
screen-print on the glass in the upper parts
of the building. A solar control film and a
low-emissivity interior coating complete this
protection throughout the glazed envelope.

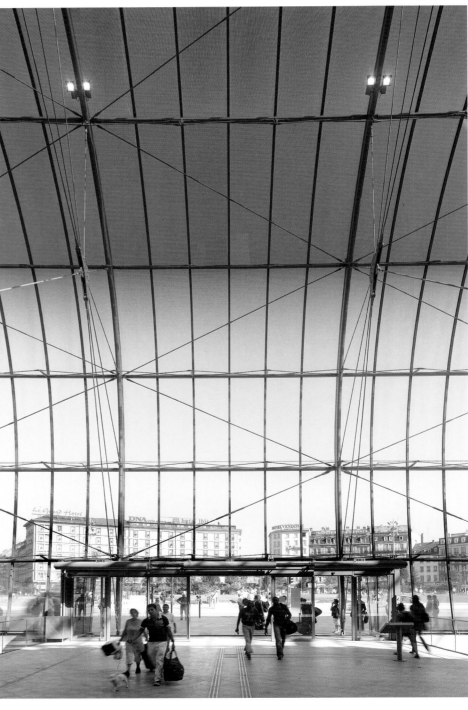

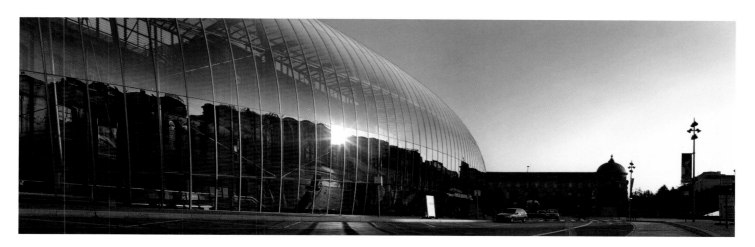

Site plan scale 1:10 000
Sections • Floor plan scale 1:1000

1 main entrance
2 departure hall
3 shops
4 offices
5 lobby
6 multi-purpose space
7 ticket offices SNCF
8 acess to public transportation

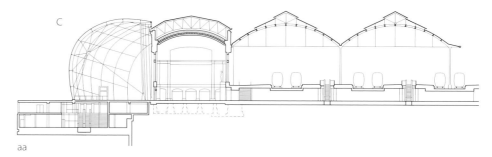

aa

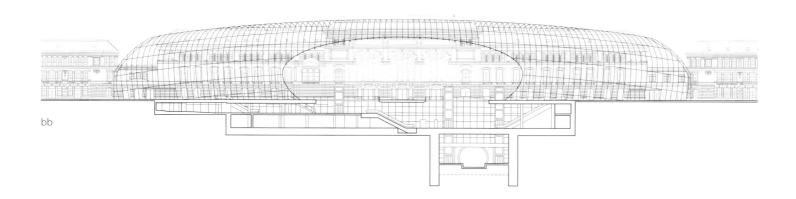

bb

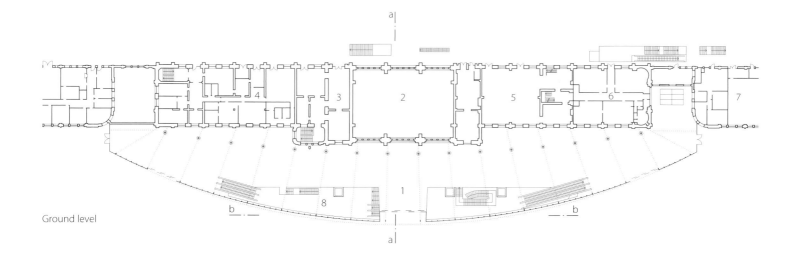

Ground level

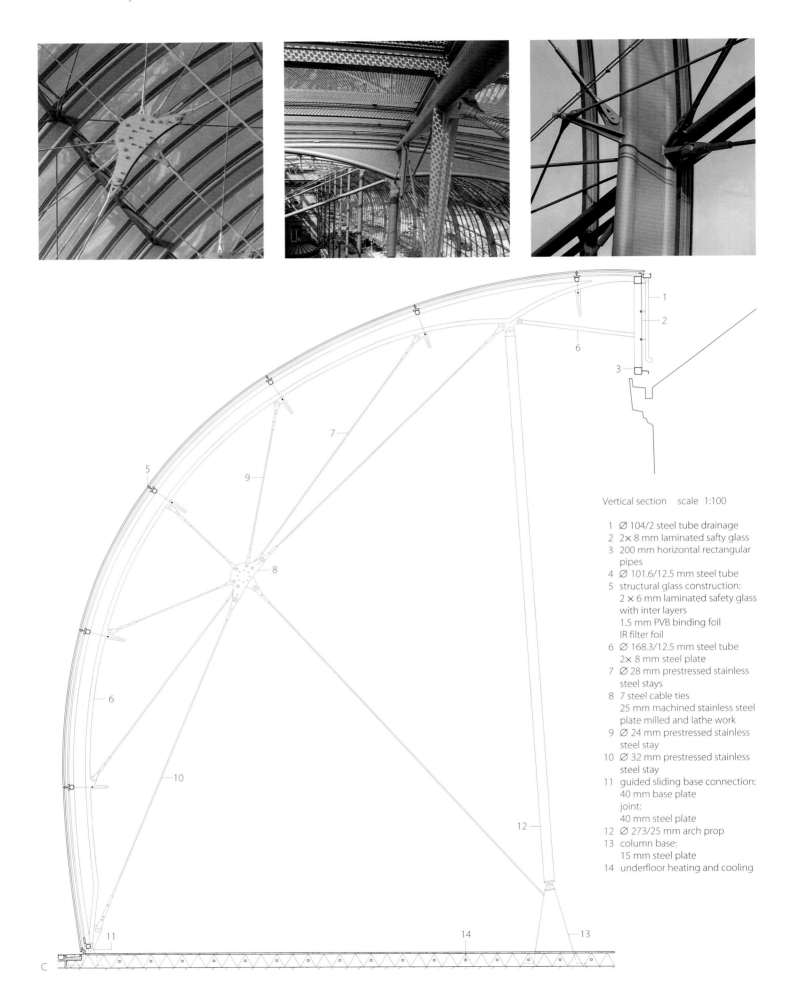

Vertical section scale 1:100

1 Ø 104/2 steel tube drainage
2 2× 8 mm laminated safty glass
3 200 mm horizontal rectangular
 pipes
4 Ø 101.6/12.5 mm steel tube
5 structural glass construction:
 2 × 6 mm laminated safety glass
 with inter layers
 1.5 mm PVB binding foil
 IR filter foil
6 Ø 168.3/12.5 mm steel tube
 2× 8 mm steel plate
7 Ø 28 mm prestressed stainless
 steel stays
8 7 steel cable ties
 25 mm machined stainless steel
 plate milled and lathe work
9 Ø 24 mm prestressed stainless
 steel stay
10 Ø 32 mm prestressed stainless
 steel stay
11 guided sliding base connection:
 40 mm base plate
 joint:
 40 mm steel plate
12 Ø 273/25 mm arch prop
13 column base:
 15 mm steel plate
14 underfloor heating and cooling

Isometric details:
glass support arraggements
drainage concept

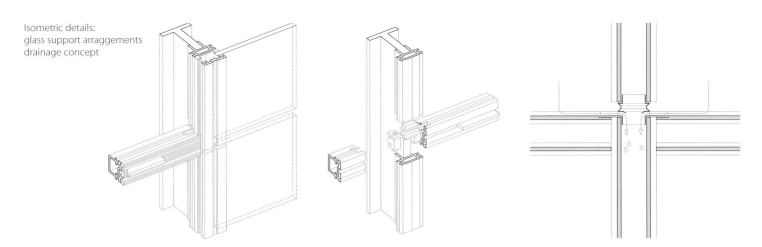

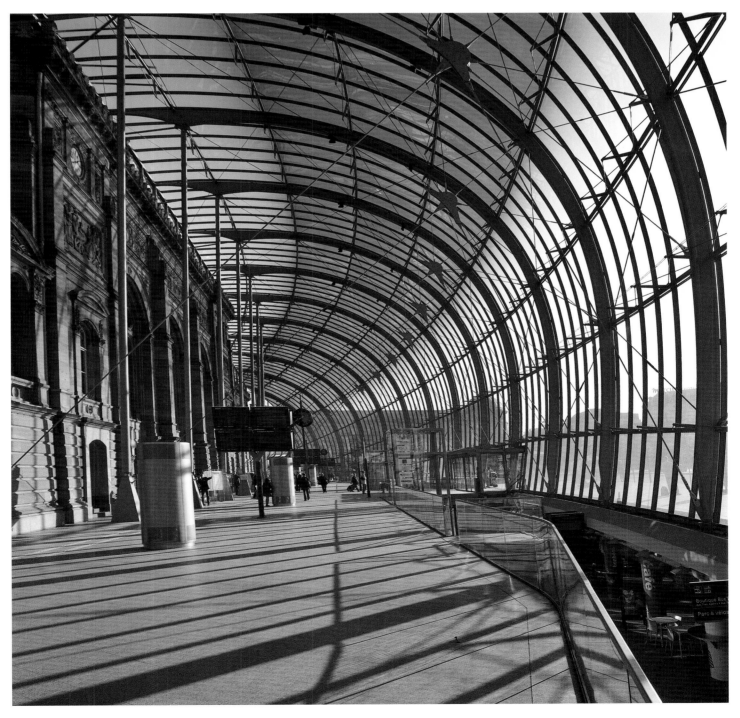

Terminal 4, Bajaras Airport

Airport Terminal
Madrid, E 2005

Architects:
Richard Rogers Partnership, London
Estudio Lamela, Madrid
Structural engineers:
Anthony Hunt Associates, London
TPS, Croydon mit OTEP / HCA, Madrid

Siteplan scale 1:100 000
Floor plans scale 1:7500
Cross-section through satellite structure
Cross-section through terminal
Longitudinal section through terminal
scale 1:2000

1 existing terminals
2 new terminal
3 satellite
4 parking block
5 airport service
6 automatic luggage check-in
7 shops
8 departures / Boarding area
9 local transport
10 check-in area

The extension of Barajas Airport in Madrid
has increased the capacity to 70 million pas-
sengers a year. The present project com-
prises the terminal and satellite buildings
and many important ancillary facilities con-
taining more than a million square metres of
functional floor area. Given the scale of the
building, which is more than a kilometre in
length, the architectural design demanded a
structure that would be both modular and
elegant, and that would emphasize the
strongly linear concept.
For the main buildings, an infinitely extend-
able, repetitive structure was chosen, con-
sisting of large-scale modules based on an
18 × 9 m structural grid. The main terminal
and the satellite building, with their linear
layout and clear spatial sequences, are dis-
tinguished by rows of narrow, wave-like roof
elements supported by central, branching
columns.
These gull-wing profiles are designed to
follow the stress pattern. The primary
beams, at 9 m centres, consist of tapering,
curved steel-plate girders 1.50 m deep
over the central area of each bay, reducing
to 1.10 m in depth over the canyons and
75 cm over the external column supports.
Curved secondary steel beams at roughly
3.50 m centres span between the primary
girders, which in turn support purlins
and the roof cladding. A steel frame con-
struction was chosen because its compo-
nent nature facilitates fabrication and
erection.
The primary vertical support to the roof is in
the form of tapering V-columns laid out in
pairs at 18 m centres along the spine of
each building. The outer edge of the roof is
borne by canted columns at 18 m centres.
These consist of pairs of oval-shaped hollow
sections which diverge to form a Y-shape.
The linear features of the building sug-
gested that the design of the supporting
structure to the glazed facades should be
predominantly horizontal, with no signifi-
cant vertical elements.

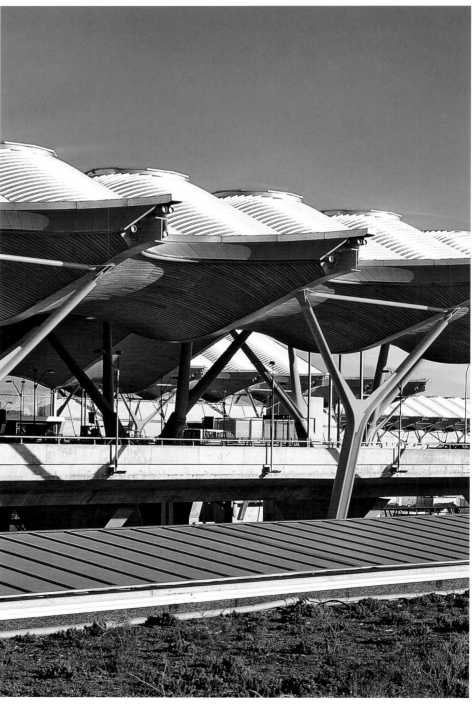

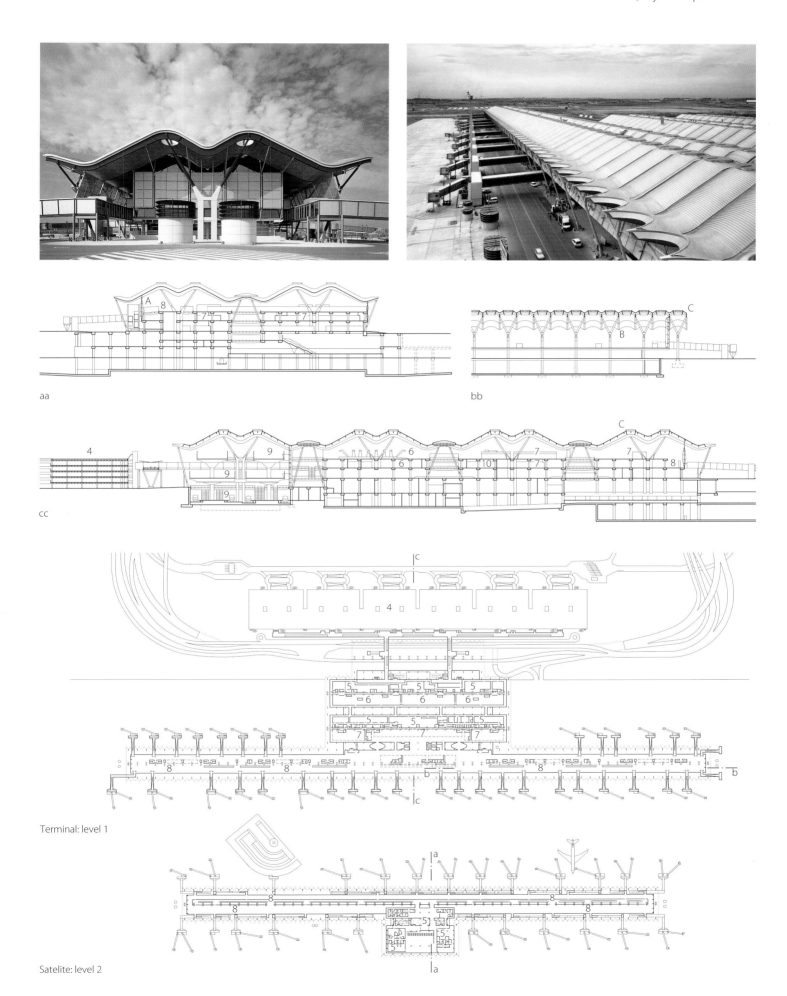

aa

bb

cc

Terminal: level 1

Satelite: level 2

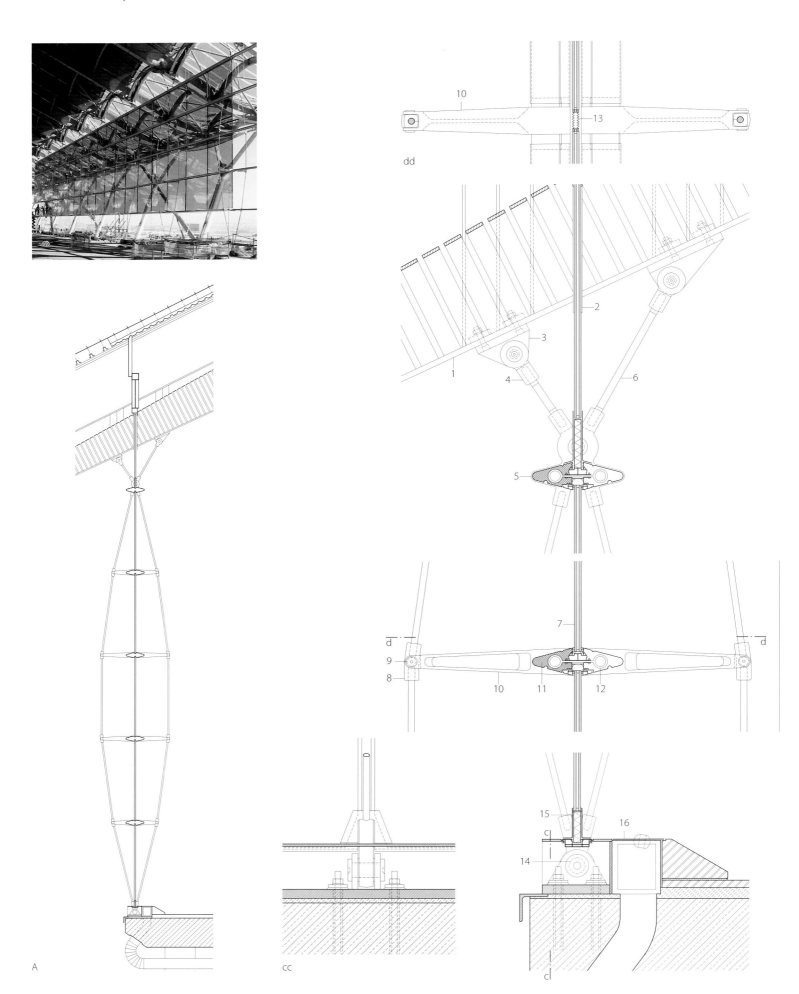

dd

10
13

2
3
1
4
6
5

7
d d
9
8
10 11 12

15
c 16
14
c

A cc c

B C

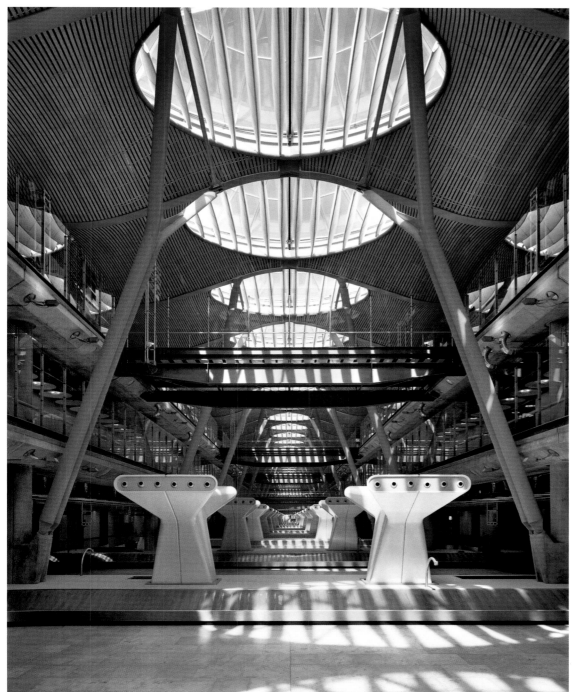

Sections scale 1:100
Sectional details scale 1:20

1 steel main beam:
 500/30 mm flange
2 stainless steel section
3 45 mm steel fixing plate
4 stainless steel forked
 head
5 anodized-aluminium sec-
 tion
6 Ø 38 mm stainless steel
 rod
7 low-E glazing:
 12 mm toughened glass
 12 mm cavity
 12 mm laminated
 safety glass
8 polished stainless steel
 cross-coupling
9 polished stainless steel
 fixing disc
10 polished cast stainless
 steel compression bar
11 polyurethene foam filling
12 Ø 76 mm steel tube
 with steel flat
13 neoprene section
14 Ø 80 mm stainless-steel
 bolt
15 naturally anodized
 aluminium cover strip
16 naturally anodized
 to air supply duct
17 0.9 mm aluminium
 sheet
18 steel I-section
 260 mm deep
19 welded steel main beam:
 500/30 mm flange 15 mm
 web 690–1440 mm deep
20 100 mm steel channel
 section
21 60/60/4 mm steel SHS
22 steel I-beam 500 mm
 deep
23 60/40/2 mm steel RHS
24 12/20/20/1 mm galva-
 nized steel cover strip
25 100/5 mm bamboo strips

Fiera Milano

Commercial Building
Milan, I 2005

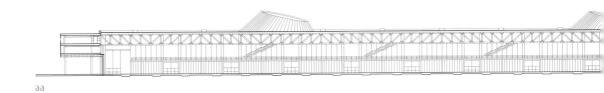

aa

Architects:
Massimiliano and Doriana Fuksas, Rome
Structural engineers:
Schlaich Bergermann und Partner, Stuttgart
MERO International, Würzburg

The new exhibition centre "Fiera Milano" is located in the north-west of Milan and covers an exhibition area of about two million square metres. Inspired by the nearby Alps, the architect has developed a language reminiscent of craters, mountains, and volcanos. The design derives its excitement from the contrast between the rectangular volumes of the straight forward steel halls and the dramatically curved roofs. Two roofs designed as arbitrarily curved, free-form surfaces lend the Fiera Milano its character: The "Logo" – the roof of the reception hall – is at the same time the symbol of the new trade fair. The "Vela" – the roof of the 1300-m-long boulevard – at its central point provides access to the eight single- and two-storey halls. In order to absorb distortions due to differences in temperature, the roof is sectionalised in twelve segments of about 100 m in length. For the most part, tree-like supports made of welded steel tubes with six diagonal struts support the roof of this access route.

The clearly structured facades of the halls are made of high-grade stainless steel panels and reflect the dissected geometry of the boulevard roof. Functional areas of cubic and round shapes along the access route mark the way.

Since the arbitrarily curved roof geometry of both roofs required the individual fabrication of junctions and bars, each element is used at only one point in the structural framework.

Division of the junctions into so-called junction plates provides for a bar connection of high load-bearing flexibility and rigidity.

A rhomboid-shaped grid with a mean lateral length of about 1.8 m produces the sculptured geometry of both roofs. Diagonal braces are designed to deal with cambering in the roof construction, which at places is quite extreme. They dissect the rhombic rectangles into plain triangles. This allowed flat panes to be used, avoiding the expense of specially produced curved glass.

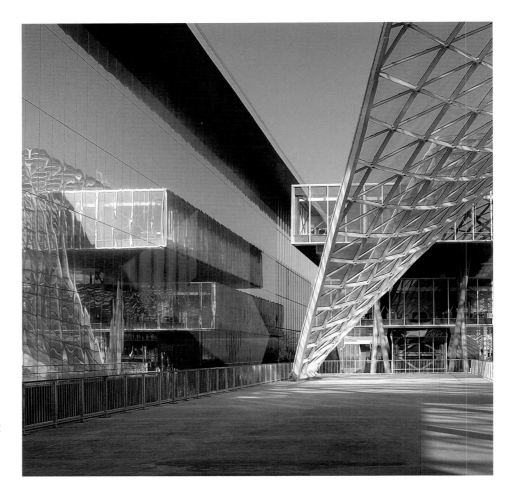

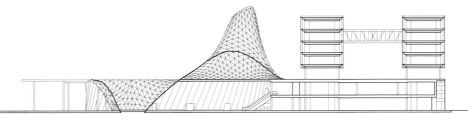

bb

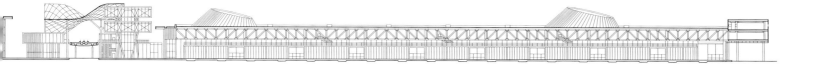

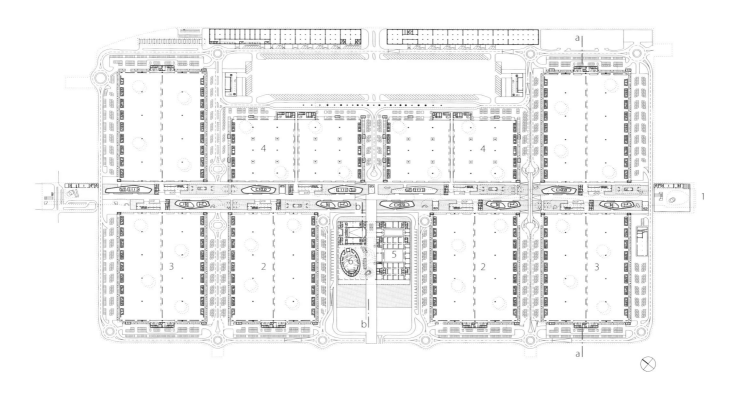

Sections
scale 1:1500
Site plan
scale 1:3000

1 main entrance
2 typical exhibition hall
3 atypical exhibition hall
4 two-storey exhibiton hall
5 service center
6 auditorium

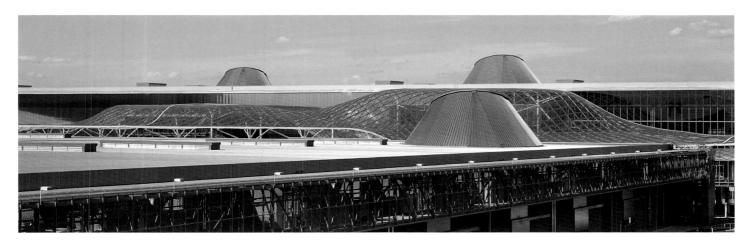

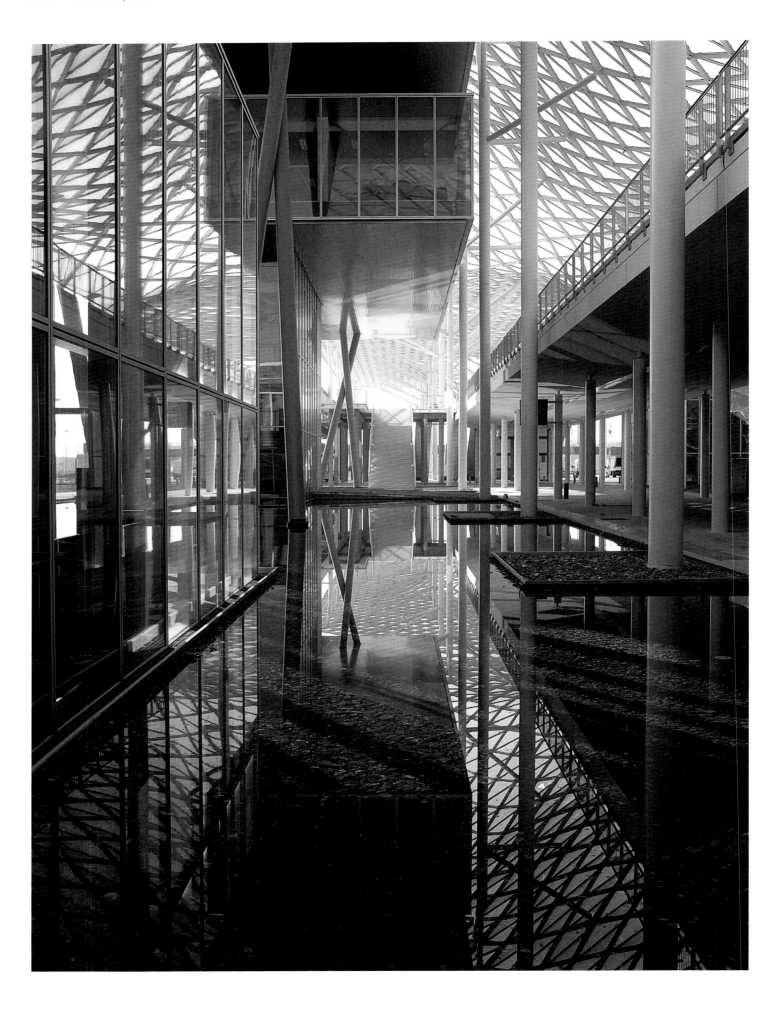

Vertical section
roof and tree column
scale 1:50
Horizontal section
Vertical section
two-part node
scale 1:10

1 2 × 8 mm heat-toughened
 glass
2 Ø 200 mm × 82 mm
 double bowl node
3 Ø 400 mm steel plate
 Ø 350 mm steel plate
4 Ø 200 mm support node
5 2× Ø 400 mm steel plate

6 Ø 273/20 mm steel hollow
 section
7 Ø 100 mm drainpipe
8 Ø 508/20 mm steel hollow
 section
9 bolts M 20... 37
10 160/200 mm steel T-section
 grider

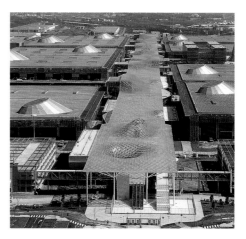

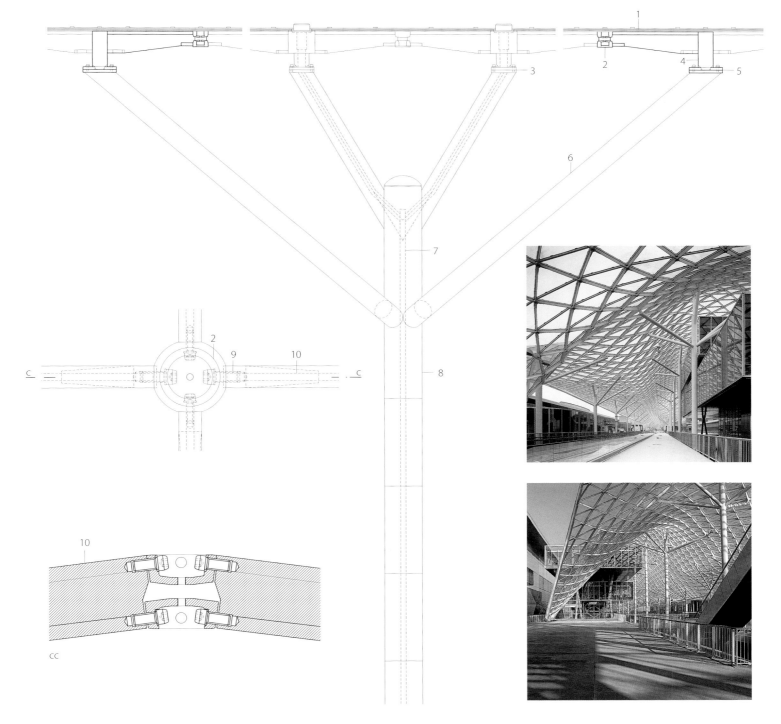

BMW Welt

Commercial Building
Munich, D 2007

Architects:
COOP HIMMELB(L)AU, Vienna
Wolf D. Prix / W. Dreibholz & Partner ZT
Structural engineers:
Bollinger + Grohmann, Frankfurt a. M.

Site plan
scale 1:10 000
Section · Floor plan
scale 1:1250

1 BMW Welt
2 BMW Museum
3 BMW Headquaters
4 BMW Plant

5 entrance
6 double cone
7 hall with car
 exhibition
8 car delivery area
9 exclusive
 delivery area
10 restaurant
11 auditorium

This multi-functional delivery complex also contains an exhibition/events centre and several restaurants and is located in north Munich close to the group's headquarters, the production plant, the BMW Museum and other architectural icons, such as the 1972 Olympics Stadium. Resting on very few supports, the building with its waves and fluent forms creates an impression of light and weightlessness. This challenging design was only feasible by choosing steel as the main structural material.

The cloud-like roof appears to emerge from a tornado, a double cone of steel and glass. This part of the building supports the 16,000 m² roof construction, which is fitted with approximately 6300 m² of photovoltaic panels for electricity generation. Supported only on this double cone, the catering and forums core and eleven rocker columns, this "roof cloud" with a weight of about 4000 t seems almost to hover. The spherical bearings provide restraint-free support to the rocker columns and thus avoid imposing additional stresses on the roof.

A structural depth of approx. 8 m allows a maximum span of about 60 m to be achieved. The roof structure is based on a 5 × 5 m module and is made up of a top and bottom steel grid interconnected to form a space frame. In spite of the structure's complexity, the framework is manufactured from standard rolled sections. Most of the connections were bolted using high strength bolts and were prefabricated in the workshop, which meant that only large elements had to be put together on the building site. The double cone of BMW Welt leads to a continuous ring girder, which – as a triangular space truss made out of hollow sections – serves to stiffen the construction. The ring girder evenly distributes the load of the roof structure and the modified post-and-beam construction of the double cone transfers this load into the foundations. On account of dynamic twist the construction consists of individually made rectangular tubes.

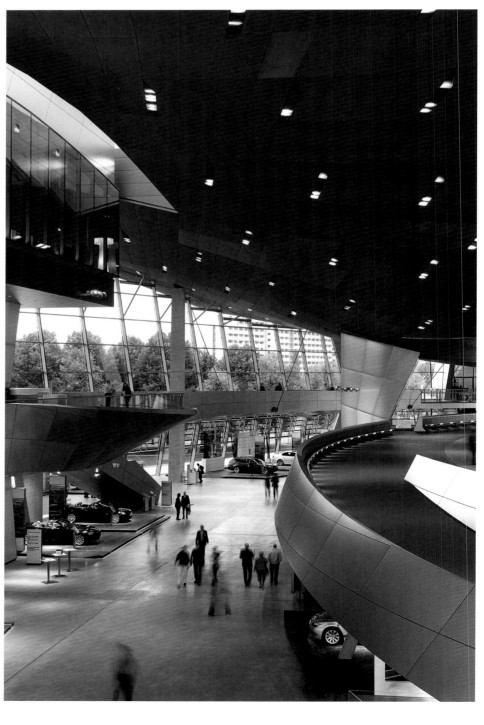

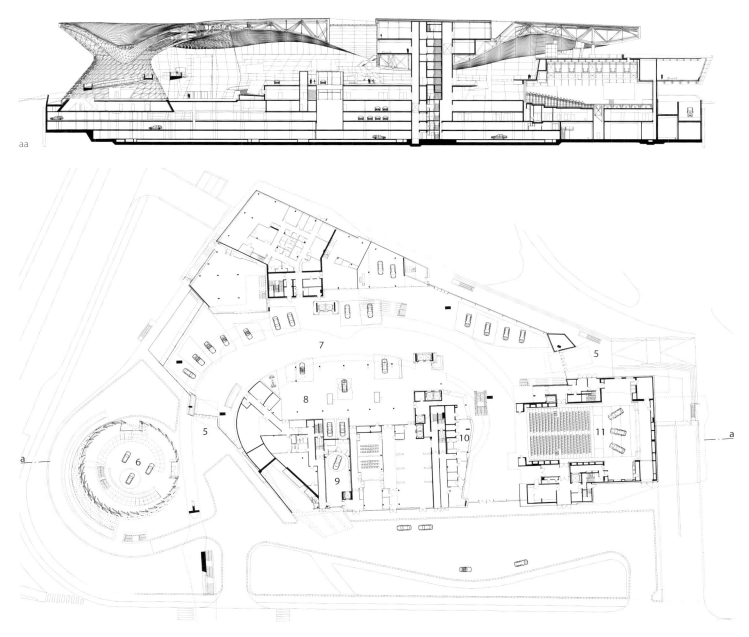

aa

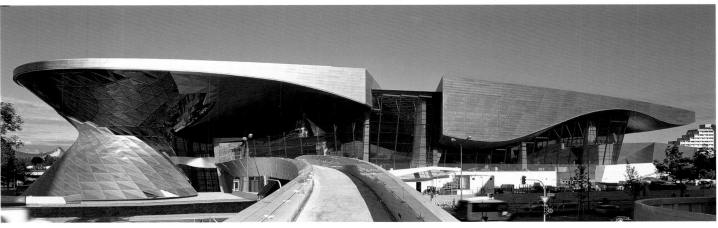

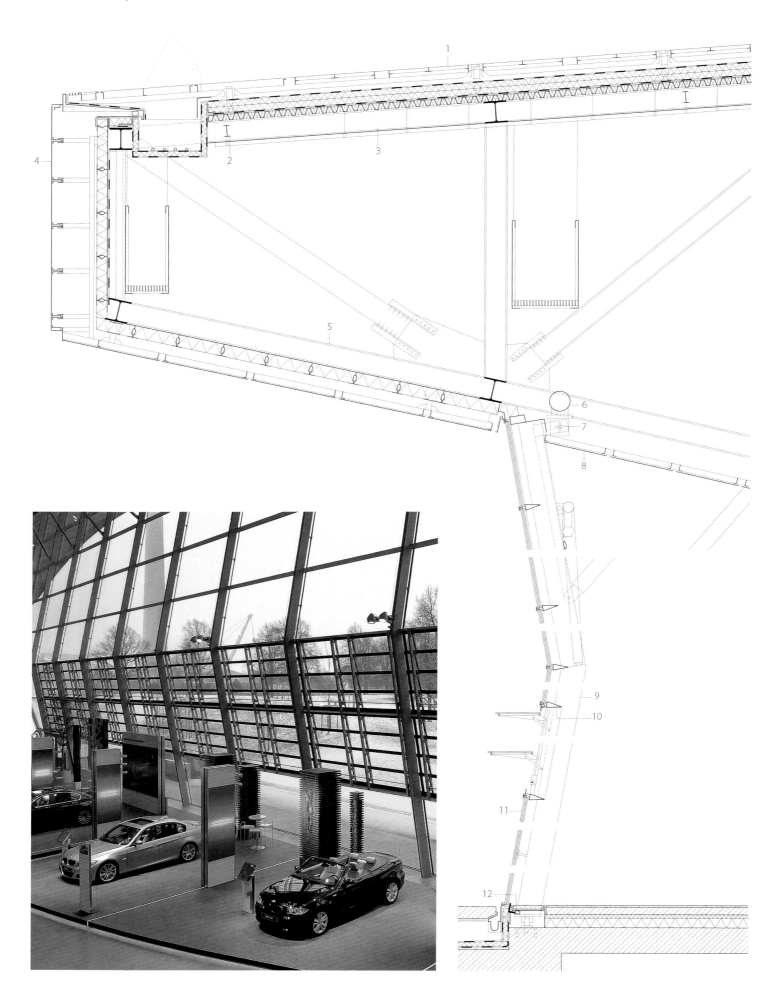

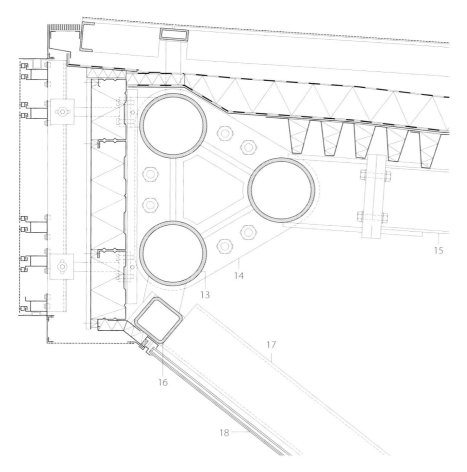

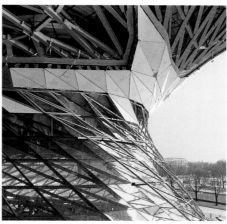

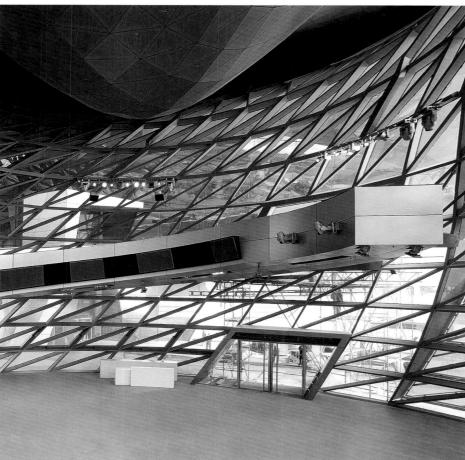

Vertical section facade scale 1:50
Vertical section roof edge of double cone scale 1:20

1 1000/1650 mm photovoltaic modules
 waterproof membrane, 180 mm thermal
 insulation, vapour barrier
 sheet steel, 160 mm trapezoidal sheet metal
2 steel I-beam 140 mm deep (IPE 140)
 for technical installation
3 upper girder steel I-beam 300 mm deep (IPE 300)
4 constructional facade design:
 3 mm perforated high-grade steel
 attached by angle irons to
 flat steel and fixing profile
5 three-dimensional framework
 steel I-beam 300 mm deep (IPE 300)
6 cross beam, 260 mm steel tube
7 connection of roof structure to facade
 displaceable in vertical direction
8 2 mm perforated high-grade steel
9 posts 320/120 folded, welded
 out of 15 mm steel plate, heated/cooled
10 200/80 mm triangular beam welded
 out of 10 mm steel plate, heated/cooled
11 2× 8 mm float glass + 16 mm
 cavity + toughened safety glass 10 mm
12 tubular steel, heating circuit with hexagon cap nut
13 edge girder, 356 mm steel tube
14 flange sheet, 30 mm panel joint
15 roof girder, steel steel I-beam 360 mm deep
 (IPE 360 mm)
16 edge profile on double-cone facade,
 200/200 steel SHS
17 facade of double cone, 300/100 mm steel RHS
 in part with integrated heating/cooling,
 sprinkler system, electrical ducting
18 white glass, 2× 6 mm heat-strengthened glass +
 16 mm cavity + 8 mm toughened glass

Veles e Vents

Hospitality Building
Valencia, ES 2006

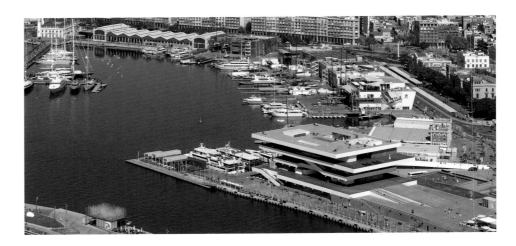

Architect:
David Chipperfield Architects, London
b720 Arquitectos, Barcelona
Structural engineers:
Brufau, Obiol, Moya & Associats S.L.,
Barcelona

Veles e Vents – Sail and Winds is the spotless white landmark called located in the harbour of the Spanish town Valencia. This spectacular viewing pavilion is the centrepiece of a programme to upgrade the urban environment at Valencia's industrial port and make it more attractive to the public. With bars and restaurants, lounges, public spectator decks, VIP areas, as well as offices for the management it provides a base for all the America's Cup sponsors, as well as being a venue where the public can watch the racing.

Simple and clear structures with just a few key details enabled the architects to reach their usual high level of quality within a limited time of 11 months from winning the competition.

The four-floor building composed of a series of stacked and shifted horizontal planes, the lower ones shaded by the levels above, perfectly fulfils the building's function, opening up the view beyond what is a rather unprepossessing port area. These cantilevered floor slabs, reaching out to 15 m, create the the outdoor viewing decks. Nearly 60 % of the building's floor area is outside. A spectacular ramp leads to the first upper floor, which is open to the public, whereas the VIPs comes into the building through the ground-level foyer and travel to the upper floors by lift – after prior admission control. Clean, powerful forms and a reduced palette of materials are combined in this timeless modern masterpiece. The building's predominant whiteness is produced by white painted steel that decorates and covers the supporting concrete structure, and white metal ceiling panels. The saltwater enviroment necessitated the use of a special anti-corrosion treatment. After sandblasting the steel sheets were given an epoxy zinc priming, achieving their final appearance through a polyoxygen corrosion protection layer. A solid timber decking and the glass balustrade frame an unobstructed view of the canal that links the port to the offshore racing courses.

Level 3

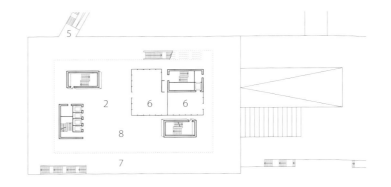

Level 1

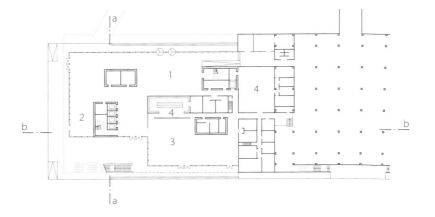

Ground level

Site plan
scale 1:30 000
Floor plans • Sections
scale 1:1250

 1 lobby
 2 bar
 3 restaurant
 4 kitchen
 5 storage
 6 access ramp
 7 boutique
 8 spectator deck
 9 public deck
10 restaurant terrace
11 wellness
12 club

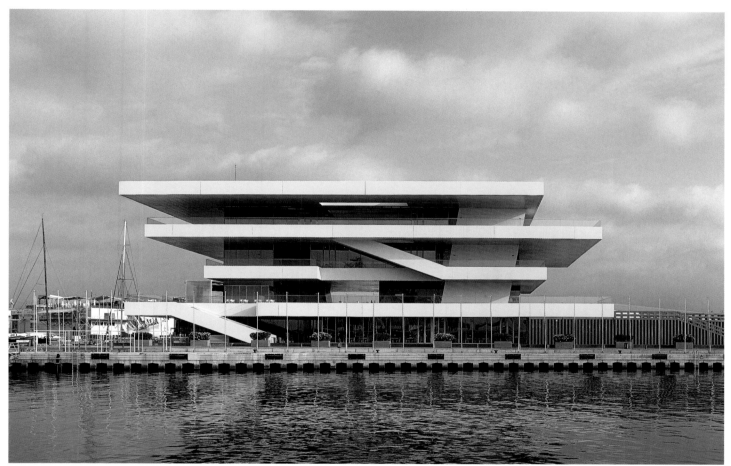

aa bb

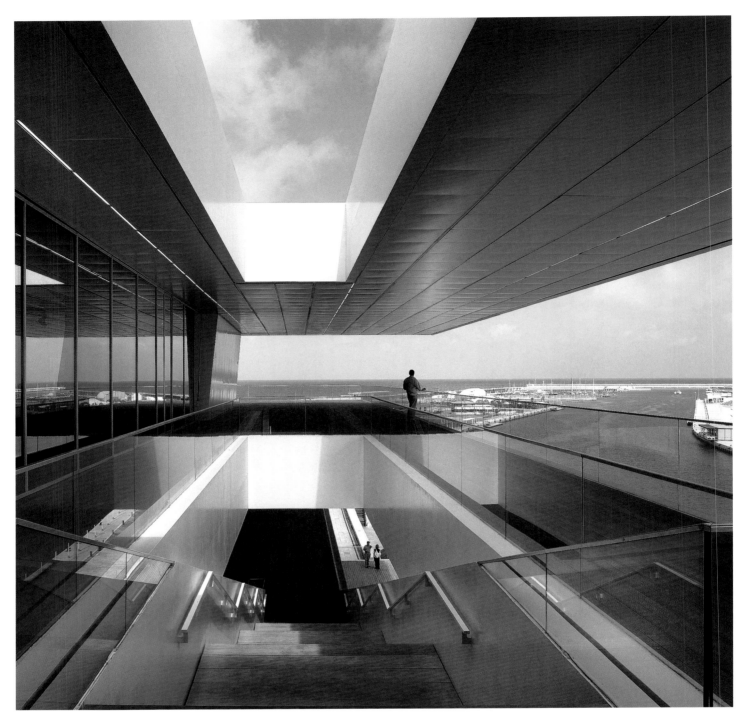

A

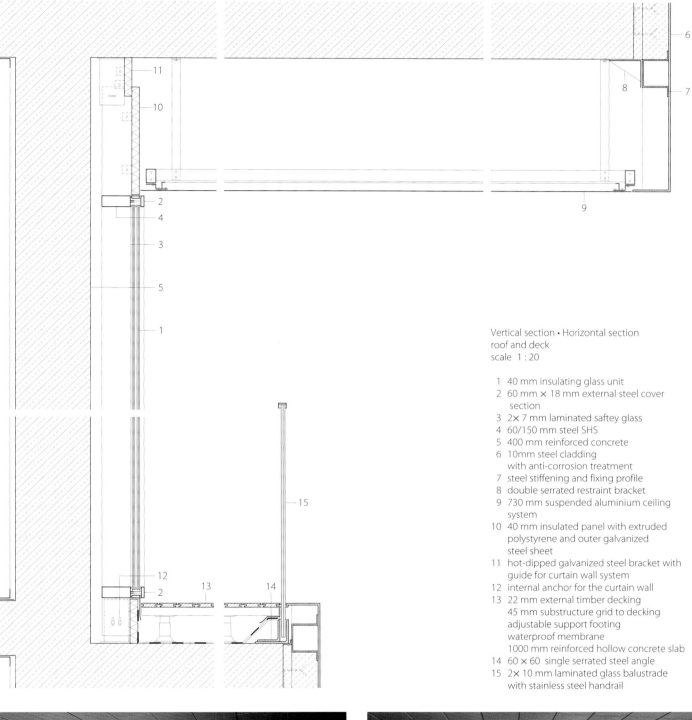

Vertical section · Horizontal section
roof and deck
scale 1 : 20

1 40 mm insulating glass unit
2 60 mm × 18 mm external steel cover
 section
3 2× 7 mm laminated saftey glass
4 60/150 mm steel SHS
5 400 mm reinforced concrete
6 10mm steel cladding
 with anti-corrosion treatment
7 steel stiffening and fixing profile
8 double serrated restraint bracket
9 730 mm suspended aluminium ceiling
 system
10 40 mm insulated panel with extruded
 polystyrene and outer galvanized
 steel sheet
11 hot-dipped galvanized steel bracket with
 guide for curtain wall system
12 internal anchor for the curtain wall
13 22 mm external timber decking
 45 mm substructure grid to decking
 adjustable support footing
 waterproof membrane
 1000 mm reinforced hollow concrete slab
14 60 × 60 single serrated steel angle
15 2× 10 mm laminated glass balustrade
 with stainless steel handrail

Green Point Stadium

Multipurpose Stadium
Cape Town, ZA 2009

Architects:
gmp – von Gerkan, Marg und Partner,
Berlin/Cape Town
Structural engineers:
Schlaich, Bergermann & Partner, Stuttgart

Cape Town is the southernmost venue of
the World Cup 2010. Conditions for the
games will be less than ideal, as winter in
South Africa's Western Province is marked
by low temperatures, strong winds and
heavy rainfall. Located close to the sea, the
Green Point Stadium is exposed to very
strong winds that challenge its roof and
facade to protect visitors against the
elements. The three-tier stadium will be
the venue for soccer and rugby matches
and provides seating for approximately
68,000 spectators.

The roof construction is a combination of a
suspended roof and a radial steel cable truss
structure. The oval roof consists of an outer
compression ring, radial suspension cable
trusses and an inner tension ring. A second-
ary structure sits on the primary roof struc-
ture and determines the shape of the upper
roof skin. Radial trusses with a cantilever por-
tion are projecting inwards beyond the
inner ring. The depths of the trusses are
varied so that the fall on the upper roof sur-
face is always outwards and towards the
lowest points of the compression ring, thus
ensuring efficient self-drainage of the roof.
The higher end point of the cantilevers form
the inner edge of the roof. Additional cir-
cumferential elements stiffen the truss gird-
ers and support the outer cladding panels.
The primary structure is stabilised by the
weight of the elevated structure carrying the
upper roof skin and the glass cladding
panels. The underside of the roof is formed
with a diaphanous membrane. Technical
equipment and ducts for the public address
system and pitch floodlighting are con-
cealed in the space between the glass roof
skin and the membrane. During the night,
the roof turns into a spectacular light object.
The outer skin of the stadium consists of a
lightweight membrane made of open-mesh
PTFE. This material creates a smooth skin,
allows views between inside and outside
and helps to reduce the impact of wind
and rain.

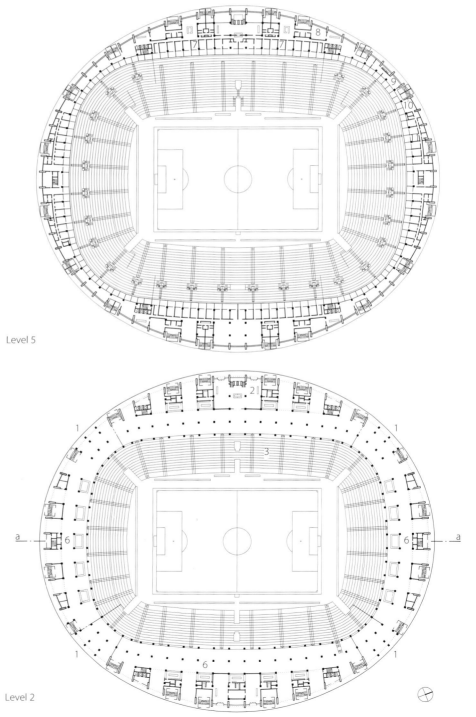

Level 5

Level 2

Floor plans • Section
scale 1:2500
Schematic drawing roof construction

1 access
2 VIP foyer
3 VIP seats
4 stairs to upper tier
5 stairs to middle
 and lower tier
6 kiosk
7 VIP lounge
8 kitchen
9 administration
10 reporter booths
11 media centre
12 players' entrance
13 basement garage

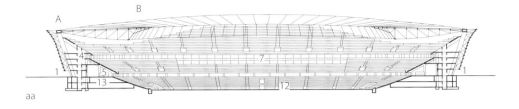

aa

transparent
glazing

translucent
glazing

lighting

cantilevers

primary
girders

compression
ring

tension
ring

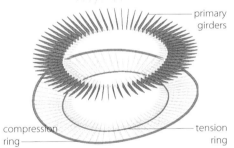

primary roof
structure

diaphanous
membrane

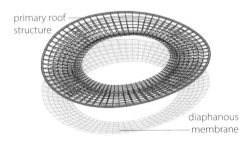

primary columns

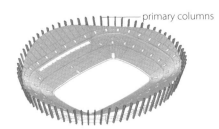

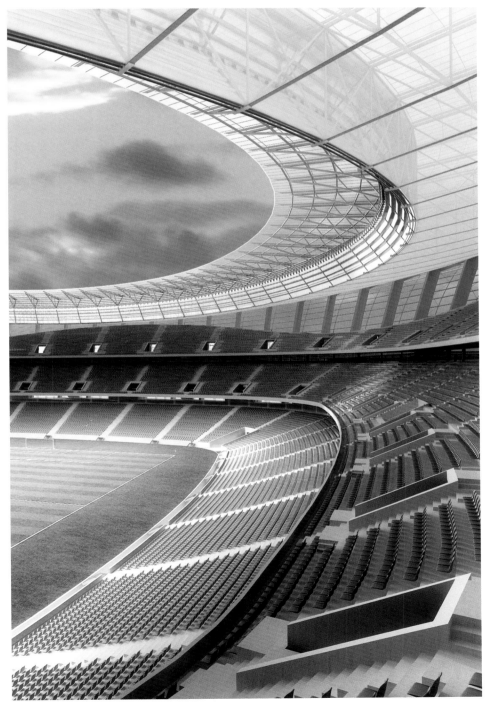

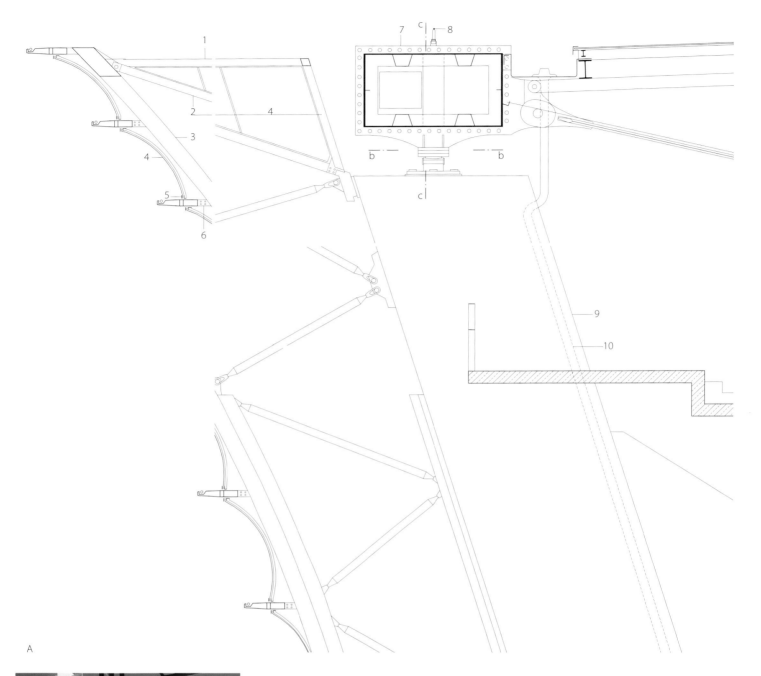

A

Radial section of inner and outer
edge of roof
scale 1:50
Detail sections compression ring
scale 1:20

1 top boom, 120/300 mm
 steel beam
2 bottom boom, 120/300 mm
 steel beam
3 vertical facade beam
 welded steel box section
 255/205 mm
4 facade panels, membrane
 PFTE/glass open mesh coated
5 welt rail, membrane
 extruded aluminium beading
6 support, 90/180 mm steel RHS
7 2200/200 mm
 compression ring
 top and bottom flange

 22 mm steel plate with
 25 mm web plate welded on
8 anchorage of fall protection
9 post, 3000/800 mm
 steel/reinforced concrete
 composite
10 drainpipe inside
11 planar glazing, 2× 8 mm
 laminated safety glass of
 white enameled
 lower surface heat
 strengthened
12 planar glazing, 2× 8 mm lami-
 nated safety glass of
 transparent, lower surface
 heat-strengthened
13 radial girder,
 Ø 139 mm steel tube
14 tangential girder,
 steel I-beam
 deep 200 mm

15 200/220 mm steel beam
16 floodlight
17 200/200 mm steel beam
18 tension boom as
 cable binder
 Ø 98 mm 8× steel cables
19 vertical truss,
 160/160 mm steel beam
20 service runway
21 sound system
22 indirect illumination
 of stands
23 bracket for lower cable
24 membrane PVC
 coated PES open-mesh fabric
25 stiffening, 100/20 mm
 continous steel plate
26 stiffening, 80 mm steel plate
27 bolts M36
28 bolts 12× M24
29 base, 700/600/50 mm steel plate

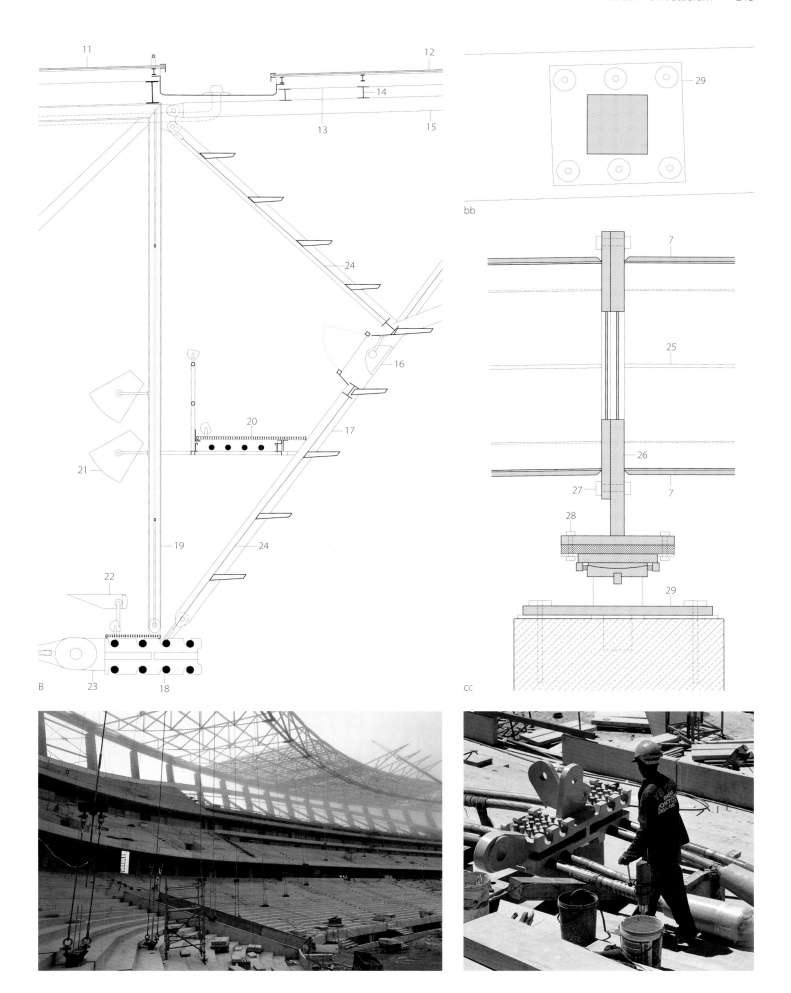

11
12
14
13
15
29
bb
24
7
16
25
20
26
17
27
7
21
28
19
24
29
22
B 23 18
cc

Appendix

Persons and organizations involved in the planning • Contractors and suppliers

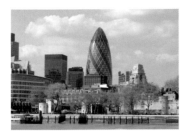

page 138
30 St Mary Axe

30 St Mary Axe
London EC3A 8EP

• Client:
Swiss Re Investments Ltd, Zurich (CH)
• Architects:
Foster + Partners, London (GB)
• Structural engineering:
Ove Arup & Partners, London (GB)
• Steel construction:
Victor Buyck – Hollandia Joint Venture
Ldt, Wraysbury (GB)
www.buyck.be

page 141
Shanghai World Financial Center

No.100, Century Avenue
021-38672008 Shanghai

• Client:
Shanghai World Financial Center
Corporation a subsidiary of Mori
Building Company, Tokyo (J)
• Architects:
Kohn Pedersen Fox Associates PC,
New York (USA)
• Project architect:
Eugene Kohn, William Pedersen,
Paul Katz
• Structural engineering:
Leslie Robertson Associates,
New York (USA)
• Steel construction:
China State Construction Engineering
Corporation, Beijing (RC)
www.cscec.com
Shanghai Construction Group,
Shanghai (RC), www.scg.com.cn
• Steel product:
HISTAR® steel sections

page 144
Naberezhnaya Tower

Presnenskaya Naberezhnaya, 10
Moscow

• Client:
City Center Investment B.V.,
Amsterdam (NL)
• Architects and Structural engineering:
ENKA Structural and Architectural
Design Group, Istanbul (TR)
• Steel construction:
ENKA Construction & Industry Inc.,
Istanbul (TR)
ÇIMTAS, Istanbul (TR)
www.cimtas.com.tr
• Steel product:
HISTAR® steel sections

page 146
New York Times Building

620 Eighth Avenue
New York, NY 10018

• Client:
The New York Times/Forest City
Ratner Companies,
New York (USA)
• Architects:
Renzo Piano Building Workshop,
Paris/Genua (F/I)
in collaboration with FXFowle Archi-
tects, P.C. New York (USA)
• Design Team:
B. Plattner, E. Volz, G. Bianchi, J. Mool-
huijzen, S. Ishida, P. Vincent, A. Eris, J.
Knaak, T. Mikdashi, M. Pimmel, M. Prini,
A. Symietz, J. Carter, S. Drouin, B. Lenz,
B. Nichol, S. Salceda, M. Seibold, J.
Wagner, C. Orsega, J. Stanteford, R.
Stubbs, G. Tran, J. Zambrano, O.
Aubert, C. Colson, Y. Kyrkos
• Consultants:
Ove Arup & Partners (structure and
services)

• Structural engineering:
Thornton Tomasetti, New York (USA)
• Steel construction:
AMEC, New York (USA)
• Steel product:
Jumbo steel sections (HD 400)

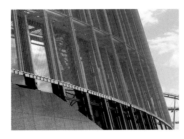

page 150
Aspire Tower

Al Aziziyah,
Doha, Ad Dawhah

• Client:
Midmac-Six Construct JV,
1758, Doha (QA)
• Concept architect:
Hadi Simaan, Orlando (USA)
• Executive architect:
AREP Groupe, Paris (F),
Bruno Sarret (project architect),
Ali Dehbonei (on site architect)
• Team:
Alan Murray, Stephane Mairesse,
Cyrille Hugon, Ana Paula Vaz Correa
• Structural engineering:
Arup, London (GB)
• Steel construction:
MBG/Iemants Staalconstructies,
Arendonk (B)
www.iemants.com
• Steel product:
Cofraplus 60® composite slab

page 152
New Museum of Contemporary Art

235 Bowery
New York 10002

• Client:
New Museum of Contemporary Art,
New York (USA)
• Architects:
SANAA, Tokio (J)
Principals: Kazuyo Seijma,
Ryue Nishizawa

• Design team:
Florian Idenburg, Toshihiro Oki, Jonas
Elding, Koji Yoshida, Hiroaki Katagiri,
Javier Haddad, Erika Hidaka
• Associate architects:
Gensler, New York (USA)
Madeline Burke-Vigeland, William Rice,
Karen Pedrazzi, Kristian Gregerson,
John Chow, Will Rohde, Sohee Moon,
Christopher Duisberg, Edgar Papzian
• Structural engineering:
Guy Nordenson and Associates,
New York (USA)
Guy Nordenson, Brett Schneider
SAPS-Sasaki and Partners, Tokio (J)
Mutsuro Sasaki
Simpson Gumperts & Heger Inc.,
New York (USA)
James C. Parker, Kevin Poulin,
Fillipo Masetti
• Construction management:
Sciame, New York (USA)
• Steel construction:
Metropolitan Steel Industries Inc.,
Frederick, MD (USA)
www.metropolitansteel.com
SteelCo, Roselle NJ (USA)
• Facade meshwork:
Expanded Metal Company,
Hartlepool (UK)
www.expandedmetalcompany.co.uk
• Stainless steel fasteners:
James & Taylor, New Malden (UK)
www.jamesand taylor.com

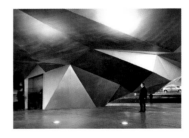

page 154
CaixaForum

Paseo del Prado 36
28014 Madrid

• Client:
Obra Social Fundación "LaCaixa",
Madrid (E)
Caixa d'Estalvis i Pensions de
Barcelona, Barcelona (E)
• Architects:
Herzog & de Meuron, Basel (CH)
Partner: Jacques Herzog, Pierre de
Meuron, Harry Gugger
• Project architects:
Peter Ferretto, Carlos Gerhard,
Stefan Marbach, Benito Blanco
• Associate architect:
Mateu i Bausells Arquitectura,
Madrid (E)
• Structural engineering:
WGG Schnetzer Puskas Ingenieure,
Basel (CH); NB35, Madrid (E)

- Steel construction:
 Emesa-Trefileria, S. A., Arteixo (E)
 www.emesa-trefileria.es
- Steel product:
 Heavy steel sections (HEM 700)

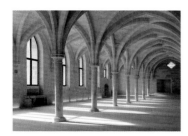

page 158
Collège des Bernardins

20 rue de Poissy
75005 Paris

- Client:
 Association diocésaine de Paris
- Architects:
 Conception: Wilmotte et Associés SA
 d'Architecture, Paris (F)
 Restauration: Hervé Baptiste, Paris (F)
- Project architect:
 Jean-Michel Wilmotte
- Design team:
 Emmanuel Brelot, Xavier Turk
- Structural engineering:
 Bureau Michel Bancon, Paris (F)
- Steel construction:
 ACCMA – Ateliers de Constructions et
 de Chaudronnerie Métalliques Autu-
 nois, Autun Cedex (F)
 www.accma.fr
- Steel product:
 ACB® cellular beams

page 160
Tevfik Seno Arda School

Saraybahce, Orhan Mahallesi,
Saadettin Yalim Caddesi
Izmit/Kocaeli

- Client:
 Governorship of Izmit
- Architects:
 UMO Architecture, Istanbul (TR)
 Yaşar Marulyalı, Levent Aksüt
- Structural engineering:
 Seza Engineering, Istanbul (TR)
 Sezai Güvensoy

- Steel construction:
 Tabosan A.Ş., Izmit (TR)
 Aksan Yapi, Istanbul (TR)
- Steel product:
 Confrastra® composite floor

page 162
House in Montbert

La Noé Vallon
44140 Montbert

- Client:
 Mr. & Mrs. B.
- Architects:
 Berranger & Vincent Architectes,
 Nantes (F)
- Design team:
 Jérôme Berranger, Stéphanie Vincent
- Structural engineering:
 ProfilduFutur – Usinor,
 Horbourg-Wihr (F)
- Steel construction:
 Fouillade, Les Alleuds (F)
- Steel product:
 Styltech® construction system

page 164
Refúgio São Chico

São Francisco de Paula
Brazil

- Client:
 Robson Langhamer
- Architects:
 Studio Paralelo, Porto Alegre (BR)
- Project architect:
 Luciano Andrades
- Structural engineering:
 Formac Chile

- Steel frame engineering:
 Formac Chile
- Concrete Engineering:
 Multiprojetos

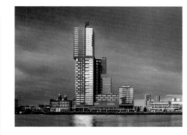

page 166
Montevideo

Otto Reuchlinweg, Wilhelminapier
3072 Rotterdam

- Client:
 ING Real Estate, Den Haag (NL)
- Architects:
 Mecanoo Architects, Delft (NL)
- Project architect:
 Francine Houben
- Structural engineering:
 ABT, Delft (NL)
- Steel construction:
 Iemants Staalconstructies,
 Arendonk (B), www. iemco.be
- Steel product:
 IFB® integrated floor beam

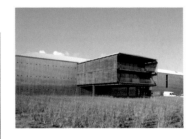

page 170
Rectorate Office Building

Rectorat de la Guyane
97306 Cayenne Cédex

- Client:
 Ministry of National Education
- Architects:
 Christian Hauvette, Paris (F)
- Project architect:
 Christian Félix
- Construction architect:
 Daniel Jos

- Design team:
 Pierre Champenois, Laetitia Delubac,
 Stéphanie de Lajartre, Amélie Len-
 grand, Marie Menant, Elena Ranaletti
- Structural engineering:
 Cera Ingenierie, Nantes (F)
- Steel construction:
 Castel & Fromaget Constructions
 Métalliques, Fleurance cedex (F)

page 172
Head Office PLL LOT

17 Stycznia Street
00-906 Warsaw

- Client:
 LOT Polish Airlines Headquarters,
 Warsaw (PL)
- Architects:
 Autorska Pracownia Architektury
 APA Kuryłowicz & Associates,
 Warsaw (PL)
- Project architect:
 Stefan Kuryłowicz, Marek Szcześniak,
 Katarzyna Flasińska-Rubik
- Structural engineering:
 PRO-INVEST SP z. o. o., Warzaw (PL)
- Steel construction:
 Budimex S. A., Warsaw (PL)
 www.budimex.com.pl

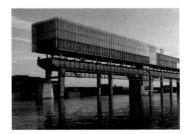

page 174
Kraanspoor

Kraanspoor 12–58
1033 SE Amsterdam

- Client:
 ING Real Estate Development
 Netherlands, Den Haag (NL)
- Architects:
 OTH Ontwerpgroep Trude Hooykaas
 bv, Amsterdam (NL)

- Project team:
 Trude Hooykaas , Julian Wolse,
 Steven Reisinger, Gerald Lindner
- Structural engineering:
 Aronsohn raadgevende ingenieurs,
 Rotterdam (NL)
- Steel construction:
 WVL Staalbouwers, Schagen
 www.wvl.nl
- Steel product:
 Slimline floor system

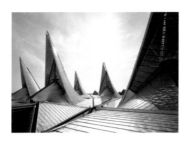

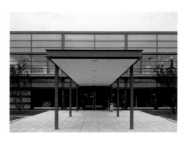

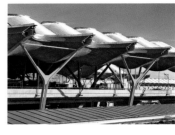

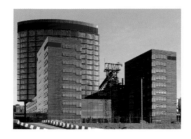

page 178
Dexia B.I.L.

69, Route d'Esch
L–2953 Luxembourg

- Client:
 Dexia Banque Internationale,
 Luxembourg (L)
- Architects:
 Claude Vasconi and Associates Archi-
 tecte, Paris (F); Jean Petit Architecte
 Associé, Luxembourg (L)
- Project architects:
 Jürgen Mayer, Thomas Schinko
- Design team:
 Simona Albracht, Guy Bez, Eric Bourg,
 Karim Boumrifak, Hans Funk, Léonie
 Heinrich, Charlotte Lardinois, Katrin
 Thorhauer
- Structural engineering:
 Simon & Christiansen, Capellen (L)
 Bollinger + Grohmann,
 Frankfurt a. M (D)
- Steel construction:
 Victor Buyck Steel Construction,
 Eeklo (B)
 www.buyck.be
- Steel product
 Enamelled steel panels
 Cofrastra® composite floor

page 180
Antwerp Law Courts

Bolivarplaats, 20
2000-2660 Antwerp

- Client:
 Regie der Gebouwen
- Architects:
 Richard Rogers Partnership
 London (GB)
- Co-Architect:
 VK Studio, Roeselare (B)
- Structural engineering:
 Arup, London (GB)
 VK Engineering, Roeselare (B)
- Steel construction:
 MBG/Iemants Staalconstructies,
 Arendonk (B)
 www.iemants.com
- Steel product:
 Ugibat® austenitic stainless steel

page 184
Sophysa – Office and Production Building

Rue Sophie Germain
25000 Besançon

- Client:
 Sophysa, Orsay cedex (F)
- Architects:
 METRA & Associés, Paris (F)
- Design team:
 Gaelle Lenouenne, Olivier Foucher
- Structural engineering:
 Frachon Soder, Dole (F)
 RFR, Paris (F)
- Steel construction:
 Ravoyard Constructions Métalliques,
 Vaudrey (F)
 www.ravoyard.fr
- Steel product:
 Gascogne® profiled steel cladding
 Aluzinc® metallic coated steel sheet

page 186
Windscreen-Wiper Factory

Poststraessle 10
74321 Bietigheim-Bissingen

- Client:
 Valeo Auto-Electric,
 Bietigheim-Bissingen (D)
- Architects:
 Ackermann und Partner Architekten,
 München (D)
- Project architect:
 Katrin Kratzenberg
- Structural engineering:
 Christoph Ackermann, München (D)
 G. Lachenmann, Vaihingen a. d. Enz (D)

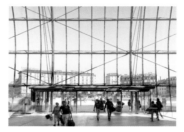

page 190
Gare de Strasbourg

20 Place de la gare
67000 Strasbourg

- Client:
 SNCF/Direction des Gares et de
 l'Escale, Paris (F)
- Architects:
 SNCF/DAAB, Paris (F)
 Jean-Marie Duthilleul & François
 Bonnefille, Paris (F)
- Engineering:
 RFR, Paris
- Glass and steel construction:
 Seele, Gersthofen (D)
- Climate control strategy:
 Transsolar, Stuttgart (D)

page 194
Terminal 4, Barajas Airport

Avenida de la Hispanidad
28042 Madrid

- Client:
 AENA, Campamento de Obra nat
 Barajas, Madrid (E)
- Architects:
 Richard Rogers Partnership
 London (GB)
- Co-architect:
 Estudio Lamela, Madrid (E)
- Structural engineering:
 Anthony Hunt Associates, London (GB);
 TPS, Croydon (GB);
- Steel construction:
 Horta Coslada Construcciones
 Metálicas, Madrid (E)
 www.hortacoslada.com
 Emesa, A Coruña (E)
 www.emesa.net

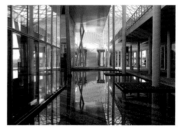

page 198
Fiera Milano

Strada Statale del Sempione, 28
20017 Rho (MI)

- Client:
 Fondazione Fiera Milano (I)
- Architects:
 Massimiliano and Doriana Fuksas,
 Roma (I)
- Structural engineering:
 Schlaich Bergermann & Partner,
 Berlin (D)
- Structural engineering roofing:
 MERO TSK International,
 Würzburg (D)

- Steel supplier:
 Icom Engineering, Padova (I)
 www.gruppomanni.it
 Ask Romein, Rossendaal (NL)
 www.ask-romein.com
 Carpentieri d'italia, Mappa (I)
 www.comeal.it

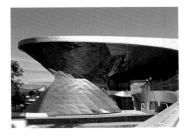

page 202
BMW Welt

Am Olympiapark 1
80809 Munich

- Client:
 BMW AG, Munich (D)
- Architects:
 COOP HIMMELB(L)AU, Vienna (A)
 Wolf D. Prix / W. Dreibholz & Partner
 ZT GmbH
 Principal in charge: Wolf D. Prix
 Project architect: Paul Kath
- Structural engineering:
 Bollinger + Grohmann,
 Frankfurt a. M (D)
- Steel construction:
 Maurer Söhne GmbH & Co KG,
 Munich (D)
 Josef Gartner GmbH, Gundelfingen (D)
- Steel product:
 steel beams (HE 100-HE 300)

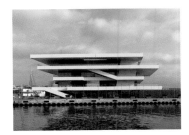

page 206
Veles e Vents

Port America's Cup 1
46000–46099 Valencia

- Client:
 Consorcio Valencia 2007
- Architect:
 David Chipperfield Architects,
 London (GB)
- Design Team:
 David Chipperfield, Marco de Battista,
 Mirja Giebler, Jochen Glemser, Regina
 Gruber, David Gutman, Melissa John-
 ston, Andrew Phillips

- Associate architect:
 b720 Arquitectos, Barcelona (E)
- Structural engineering:
 Brufau, Obiol, Moya & Associats S. L.
 (Boma), Barcelona (E)
- Steel construction:
 Ute Foredeck (Acciona, LIC, Rover
 Alcisa), Valencia (E)

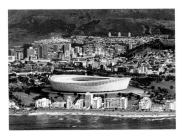

page 210
Green Point Stadium

Green Point
Peninsula/South Afrika

- Client:
 City of Cape Town, spv 2010
- Architects:
 design: gmp – von Gerkan, Marg und
 Partner, Berlin (D)/Cape Town (RSA)
 execution: Louis Karol and Point archi-
 tects and Urban Designers,
 Cape Town (RSA)
- Design team:
 Volkwin Marg, Hubert Nienhoff,
 Robert Hormes
- Project management gmp:
 Michèle Rüegg
- Structural engineers:
 Roof: Schlaich, Bergermann & Partner,
 Stuttgart (D)
 Bowl: BKS (pty) ltd, engineering and
 management, Iliso Consulting, Henry
 Fagan & Partners, KFD Wilkinson
 consulting engineers, Arcus Gibb con-
 sulting engineers, all Cape Town (RSA)
- Steel construction:
 Joint venture between Pfeiffer Seilbau,
 Memmingen (D) and Birdair, New York
 (USA)

Project data are provided as is by the
responsible architectural offices. The
publisher is not responsible for correct-
ness of provided data.

Acknowledgments

Thanks to all persons supporting the realization of
this publication with their contributions, advises,
engagements and any other kind of involvement.

ArcelorMittal
Veronique De Bruyne
Pierre Huriaux
Carine Bouichou
Claudia Liedl
Georges Axmann
Jean-Claude Grass
Marc Poullin
Carlos Espina
Chaubal Pinakin
Jacques Charles
Thierry Braine-Bonnaire
Corinne Le Caignec
René Pepin
Manfred Aufleger
Fabrice Petermann
Sophie Le Guillou
Selcuk Ozdil
Eric Bonnefond
Bernard Cvijanovic
Peter Böhnlein

And the complete ArcelorMittal Distribution Solu-
tions – Innovation & Construction Development
department, especially
Sergio Baragano
Mathias Beuster
Luis Boada
Marie-Claude Broussaud
Françoise Carrara
Lara Capello
Philippe Coigné
Marta Dziarnowska
Pierre Engel
Christine Etzenbach
Jean-Yves L'Hostis
Jie Li
Evelyne Manchon
and the Constructalia team
Philippe Marcon
Henri Marraché
José Angel Maza
Eric Moscato
Sylvia Navas
Pierre Quaquin
Joanna Rayska
Maria José Sanchez
Silvia Scalzo
Bruno Théret
Tommaso Tirelli

Infosteel
Arnold De Vries Robbé

Hilti Corporation
Robert Lipsky
Thomas Engleder

Leighs Paints
Paul Clayton
Anthony Ward
Lisa Hilton

mielke comunication
Andreas Mielke

Index

Internet links

Worldwide
www.worldsteel.org
www.worldstainless.org
www.livingsteel.org

Europe
www.access-steel.com
www.euro-inox.org
www.iposteelnetwork.org
www.steelconstruct.com
www.epaq.eu

Norway
www.stalforbund.com

Sweden
www.sbi.se

Netherland
www.bouwenmetstaal.nl

Belgium
www.infosteel.be

Switzerland
www.szs.ch

France
www.construiracier.fr

Italy
www.promozioneacciaio.it

Germany
www.stahl-info.de
www.bauforumstahl.de
www.stahlhandel.com
www.edelstahl-rostfrei.de
www.stahlbau-verband.de
www.stahlhandel.com

Austria
www.stahlbauverband.at

Turkey
www.tucsa.org

USA
www.aisc.org

South Africa
www.saisc.co.za
www.sasfa.co.za

Brazil
www.cbca-ibs.org.br

Croatia
www..grad.hr

Romania
www.apcmr.ro

Slovenia
www.gzs.si

Picture credits

The authors and editor wish to extend their sincere thanks to all those who helped to realise this book by making illustrations available. All drawings contained in this volume have been specially prepared in-house. Photos without credits are from the architects' own archives or the archives of "DETAIL, Review of Architecture". Despite intense efforts, it was not possible to identify the copyright owners of certain photos and illustrations. Their rights remain unaffected, however, and we request them to contact us.

from photographers, photo archives and image agencies:

- p. 10 fig. 1, p. 11 fig. 4/6/8, p. 12 fig. 10, p. 16 fig. 20/21, p. 125 fig. 35/36, p. 209 (right):
 Christian Schittich, Munich
- p. 10 fig. 2, p. 12 fig. 11:
 Margita Jocham, Munich
- p. 10 fig. 3:
 Pierre Mens/HSB, Malmö
- p. 11 fig. 5, p. 31 fig. 21, p. 69 fig. 2c, p. 73 fig. 8b, p. 80 fig. 19, p. 84 fig. 26, p. 125 fig. 37, p. 130 fig. 47, p. 205 top/middle:
 Frank Kaltenbach, Munich
- p. 11 fig. 7:
 Chuck Choi, New York
- p. 11 fig. 9:
 Roland Tännler, Zurich
- p. 13 fig. 12:
 Hisao Suzuki, Barcelona
- p. 13 fig. 13:
 D. Yvette Wohn, Seoul
- p. 14 fig. 14:
 Robert Mehl, Aachen
- p. 14 fig. 15:
 Claus Bach, Weimar
- p. 14 fig. 16, pp. 153, 166, 167, 168 (bottom), 169, 180, 182 (top), 206:
 Christian Richters, Münster
- p. 15 fig. 17:
 Brigida González, Stuttgart
- p. 15 fig. 18:
 Ben McMillan, Beijing
- p. 16 fig. 19:
 Alexander Gempeler, Bern
- p. 17 fig. 22:
 Janine Mahler/IBA, Chemnitz
- p. 17 fig. 23, p. 105 fig. 21b, pp. 155, 156, 157, 207, 208, 209 (left):
 Duccio Malagamba, Barcelona
- p. 17 fig. 24:
 Earl Carter, St. Kilda/Australia
- p. 17 fig. 25:
 Norbert Miguletz, Frankfurt am Main
- p. 18 fig. 26:
 Nicolas Borel, Paris
- p. 18 fig. 27:
 David Boureau, Paris
- p. 19 fig. 28:
 André Yves, Saint-Aubin
- p. 19 bottom, 70 fig. 3:
 Mario Bellini Architects, Milan
- p. 22 fig. 5:
 ecosistema urbano architects ltd., Madrid
- p. 23 fig. 7:

- MCA/Daniele Domenicali, Imola/Italy
- p. 24 fig. 10:
 Roland D'Soua, Glenpool/USA
- p. 25 fig. 11/12, p. 29 fig. 18, p. 37 fig. 9/10, p. 45 fig. 21:
 Christian Richters/arturimages
- pp. 25 (bottom), 29 (bottom), p. 110 fig. 2, p. 111 fig. 4, p. 112 fig. 7, p. 119 fig. 23, p. 121 fig. 27, p. 127 (bottom), 40 fig. 13/14, p. 44 fig.18/19/20, p. 60 fig. 44, p. 77 (bottom), p. 88 fig. 29, p. 93 fig. 46, p. 122 fig. 32, p. 134 fig. 64/65, p. 135 fig. 67:
 ArcelorMittal, Luxembourg
- p. 27 fig. 16:
 Jürgen Schmidt, Cologne
- p. 28 fig. 17:
 Tim Griffith, San Francisco
- p. 30 fig. 19/20:
 Johannes Marburg, Berlin
- p. 31 (bottom):
 ILEK Institut für Leichtbau, Entwerfen und Konstruieren, Stuttgart
- p. 35 fig. 6:
 Hisao Suzuki, Barcelona
- p. 38 fig. 11, p. 177:
 Rob Hoekstra, Kalmhout/Belgium
- p. 41 (bottom):
 Stainless Design Weidmann & Baumberger OEG, Ansfelden/Austria
- p. 42 fig. 16:
 James Kelly, Ballymore-Eustace/Ireland
- p. 43 (bottom):
 Claude Abron/ArcelorMittal, Luxembourg
- p. 53 fig. 19:
 Tobias Richter, Gröbenzell/Germany
- p. 55 fig. 26, p. 83 fig. 23a:
 seele holding GmbH & Co. KG, Gersthofen; photographer: Rene Müller Photographie
- p. 69 fig. 2a/2b:
 Harry Schiffer, Graz
- p. 74 fig. 9/10:
 Mauro Prini/RPBW, Paris
- p. 74 fig. 11:
 Attila Eris/RPBW, Paris
- p. 75 fig. 12:
 Morten Petersen/RPBW, Paris
- p. 76 fig. 13, pp. 186, 189:
 Dietmar Strauß, Besigheim
- p. 76 fig. 14, pp. 202, 203, 204, 205 (bottom):
 BMW AG München, Munich
- p. 77 fig. 15, p. 109 fig. 26c:
 H.G. Esch, Hennef
- p. 78 fig. 16a/16b:
 Claus Bury, Frankfurt am Main
- p. 82 fig. 22:
 Gerald Zugmann, Vienna
- p. 84 fig. 24:
 Werner Huthmacher, Berlin
- p. 84 fig. 25, pp. 198–200, 201 (top/bottom):
 archivio fuksas, Rome
- p. 87 fig. 28c:
 Pagitz Metalltechnik, Friesach/Austria
- p. 87 fig. 28d, pp. 195, 197:
 Roland Halbe, Stuttgart
- p. 89 fig. 34, p. 95 fig. 50:
 David S. McAdam, Palm Springs CA

- p. 90 fig. 38:
 Japan Iron and Steel Federation, Tokyo
- p. 96 fig. 1:
 Christophe Nouri, Boutigny-sur-Essonne
- p. 97 fig. 3/4, p. 102 fig. 13, p. 108 fig. 24/25:
 Pierre Engel, Paris
- p. 98 fig. 7b/7c, pp. 159, 170, 171:
 Géraldine Bruneel, Paris
- p. 100 fig. 9b
 Christophe Urbain, France
- p. 107 fig. 23a
 Hannes Henz, Zurich
- p. 110 fig. 1:
 Stahlinstitut VDEh, Düsseldorf
- p. 111 fig. 5, p. 116 fig. 16/17, p. 117 fig. 19/20, p. 118 fig. 21/22:
 Jeroen Op de Beeck, ArcelorMittal, Gent
- p. 111 fig. 6:
 SHS Siemag, Düsseldorf
- p. 113 fig. 9:
 Hertha Hurnaus, Vienna
- p. 113 fig. 10:
 Florian Holzherr, Munich
- p. 119 fig. 25:
 Mitsumasa Fujitsuka, Tokyo
- p. 121 fig. 28/29:
 Heike Werner, Munich
- p. 121 fig. 30:
 Jesús Granda, Seville
- p. 122 fig. 31/33, p. 187:
 Jens Weber, Munich
- p. 124 fig. 34:
 Eckhardt Matthäus, Augsburg
- p. 127 fig. 41:
 Siegener Verzinkerei Holding, Groß-Rohrheim
- p. 127 fig. 40:
 www.mineralienatlas.de, Peter Seroka, L'Escala
- p. 129 fig. 43, pp. 184, 185, 201 (middle):
 Phillipe Ruault, Nantes
- p. 129 fig. 44, p. 154:
 Roland Halbe/arturimages
- p. 129 fig. 45:
 Heide Wessely, Munich
- p. 130 fig. 46/49:
 Michael Heinrich, Munich
- p. 130 fig. 48:
 Stefan Müller, Berlin
- p. 130 fig. 50:
 Kjellberg Finsterwalde, Finsterwalde
- p. 130 fig. 51:
 Firma Trumpf GmbH + Co., Ditzingen
- p. 131 fig. 53:
 SLV, Munich
- p. 132 fig. 57:
 Edmund Sumner/arturimages
- p. 134 fig. 63:
 ThyssenKrupp Nirosta GmbH, Krefeld
- p. 135 fig. 68:
 Construir Acier, Puteaux Cedex
- pp. 138, 139 (bottom), 140:
 Nigel Young, London
- pp. 141, 142:
 Mori Building Co. Ldt., Tokyo
- p. 143:
 Leslie E. Robertson Associates, New York

- pp. 146, 147, 148:
 Thomas Madlener, Munich
- p. 149:
 Michel Denancé/RPBW
- pp. 150, 151 (left):
 BESIX, Brussels
- p. 152:
 Iwan Baan, Amsterdam
- p. 161:
 Selçuk Özdil, Istanbul
- pp. 162, 163:
 Stéphane Chalmeau, Nantes
- p. 164:
 Eduardo Aigner, Porto Alegre
- pp. 172, 173:
 Wojciech Kryński, Warsaw
- pp. 174, 175:
 Christian de Bruijne, Koog aan de Zaan/Netherlands
- p. 176 (bottom):
 Fedde de Weert, St. Maartensbrug
- pp. 178, 179:
 Luc Boegly, Paris
- pp. 183, 194:
 Katsuhisa Kida, Tokyo
- p. 190:
 Michel Denancé, Paris
- pp. 191, 193:
 seele holding GmbH & Co. KG, Gersthofen
- p. 192 :
 AREP, Paris
- p. 196:
 Estudio Lamela, Madrid
- pp. 210, 211:
 Design: gmp – von Gerkan, Marg und Partner, Berlin/Visualisation: MACINA, Hannover
- pp. 212, 213 (left):
 Bruce Sutherland, City of Cape Town
- p. 213 (right):
 gmp – von Gerkan, Marg und Partner, Berlin

from books and journals:

- p. 70, fig. 4:
 Durm, Joseph, Prof., Handbuch der Architektur, Stuttgart 1899

References

Steel and Sustainability

[1] Intergovernmental Panel on Climate Change (IPCC) (ed.): Working Group III Report: Mitigation of Climate Change. Geneva 2007

[2] ibid. [1]

[3] United Nations Human Settlements Programme: Istanbul Declaration on Human Settlements. 1996

[4] Oxford University Press (ed): World Commission on Environment and Development (WCED): Our common future. Oxford 1987.

[5] International Council for Research and Innovation in Building and Construction (CIB) (ed): Agenda 21 on Sustainable Construction. Rotterdam 1999

[6] International Labour Organization (ILO) (ed): The construction industry in the twenty-first century: its image, employment prospects and skills requirements. Geneva 2001

[7] Davis Langdon Management Consulting (ed): World construction review – outlook 2004/5. London 2004

[8] United Nations Environment Programme UNEP (ed): Buildings and climate change: Status, Challenges and Opportunities. Paris 2007

[9] World Business Council for Sustainable Development (WBCSD) (ed): Overview. Geneve 2006

[10] International Oranisation for Standardisation (ISO): Technical Specification ISO/TS 21931-1 Sustainability in building construction – Framework for methods of assessment for environmental performance of construction works – Part 1: Buildings, International Organization for Standardization. 2006 Geneva

[11] Fujita Research (ed.): What is Sustainable Construction? http://www.fujitaresearch.com/reports/index.html

[12] Kilbert Charles; Grosskopf, Kevin: Envisioning Next-Generation Green Buildings. Journal of Land Use. Vol. 23 1/2007

[12] International Oranisation for Standardisation (ISO): Technical Specification ISO/TS 21931-1 Sustainability in building construction – Framework for methods of assessment for environmental performance of construction works – Part 1: Buildings, International Organization for Standardization. Geneva 2006

[13] Gorgolewski, Mark: Canadian Sheet Steel Building Institute (CSSBI): LEEDing with STEEL. Toronto (Undated)

[14] National Audit Office (NAO) (ed): Using Modern Methods of Construction to Build Homes More Quickly and Efficiently. London 2004

[15] Lane, Thomas: Building. BRE says steel frame is fastest way to build homes. London 2008

[16] International Oranisation for Standardisation (ISO): ISO 21930:2007 – Sustainability in building construction – Environmental declaration of building products, International Organization for Standardization. Geneva 2007

[17] Steel Construction Institute (SCI) (ed): Sustainability of Steel in Housing and Residential Buildings: A European Perspective. Berkshire 2007

[18] Gervásio, da Silva; Santos, Quaquin, Bourrier: Life cycle comparison of a light-weight steel house vs. a concrete house. Porto 2007

[19] The British Constructed Steelwork Association Limited BCSA (ed): Steel buildings. London 2003

[20] Widman, J: Swedish Institute of Steel Construction: Sustainability of Modular Construction, SBI Report 229-2. Stockholm 2004

[21] Aromaa, Pekka: Research report for the European Commission: Low-energy steel house for cold climates. Luxemburg 2001

[22] Stromberg, J.; Lawson, M.; Kergen, R.; Moutafidou, A.; Mononen, T.; Johansson, B.; Nieminen, J. (for the European Commission): Development of dry composite construction systems based on steel in residential applications. Luxemburg 2002

[23] Edwards, Brian: Rough Guide to Sustainability. London 2005

Steel and Economics

[1] Ware, Isaac: The First Book of Andrea Palladio's Architecture. London 1783

[2] Ive, Graham Building for Research & information: Re-examining the costs and value ratios of owning and occupying buildings. Vol 34 issue 3 05/2006

[3] ec.europa.eu/enterprise/construction/compet/life.../final_report.pdf

[4] ec.europa.eu/environment/urban/pdf/stakeholder.../who.pdf. (2004)

[5] Royal Institution of Chartered Surveyors Quantity Surveying Division Report 1986

[6] Hojjat Adeli, Kamal C. Sarma. In: International Journal for Numerical Methods in Engineering. Vol. 55 12/2002

[7] Tordoff, Derek: Comment. In: New Steel Construction Vol 8 No 5 9–10/2000

[8] Oxford Brookes University Dept. of Architecture with the assistance of Sworn King & Partners: Insite™ on Life Cycle Costs. London 2003

[9] Ferry, Douglas: Cost Planning of Buildings. London 1999

[10] Gardiner & Theobold, Quantity Surveyors: Annual Report 2005

[11] ArcelorMittal (ed.): Study about Car Parks Comparison. http://www.arcelormittal.com/.../tx.../AM-Car_parks_in_steel_-_EN.pdf (2009)

[12] http://www.acierconstruction.com (2009)

Design of Steel structures and Building Physics

• Official Journal of the European Communities: Directive 2002/91/EC of the European Parliament and of the Council of 16 December 2002 on the energy performance of buildings. Brussels 2002

• Döring, Bernd: Einfluss von Deckensystemen auf Raumtemperatur und Energieeffizienz im Stahlgeschossbau. Frankfurt am Main 2008

Conception of Steel Structures

• Reichel, A.; Ackermann, P.; Hentschel, A.; Hochberg, A.: DETAIL Practice. Building with Steel. Munich 2007

• Tessmann, Oliver: Collaborative Design Procedures. Kassel 2008

• Landowski, Marc; Lemoine, Bertrand: Concevoir et construire en acier. Luxembourg 2005

• Schulitz, Helmut C.; Sobek, W.; Habermann, Karl J.: Steel Construction Manual. Basel 2003

• Kilian, Axel: Design Exploration through Bidirectional Modeling of Constraints, Massachusetts 2006

• Gramazio, Fabio; Kohler, Matthias: Digital Materiality in Architecture. Baden 2007

• Bisch, Philippe; Calgaro, Jean Armand: Eurocodes. Codes – Européens de Conception des Construction Techniques de l'ingénieur.

• Szabó, István: Geschichte der mechanischen Prinzipien. Basel 1987

• Bollinger, Klaus: Neue Techniken in der Tragwerksplanung. Tiefbau 11/2008

• Engel, Heino: Structure systems. Ostfildern 2006

• Petersen, Christian: Stahlbau. Wiesbaden 1988

• Lohse, W.; Thiele, A.: Stahlbau 1. Wiesbaden 2002

• Steel Construction. Design and Research, Volume 1 09/2008

• Cachola Schmal, Peter (ed.): Workflow: Struktur – Architektur – Engineering, Klaus Bollinger und Manfred Grohmann. Basel 2005

• American Iron and Steel Institute (ed.): Residential steel framing manual. Washington DC (continuously updated)

• Davies, J. Michael; Bryan, Eric R.: Manual of stressed skin diaphragm design. London 1982

• Davies, J. Michael: Lightweight sandwich construction. Oxford 2001

• Australian Institute of steel Construction (ed): Design of cold-formed steel structures, 3rd Edition. Sydney 1998

Steel and Refurbishment

• De Section, Francaise: Créer Dans Le Crée. Milan-Paris 1986

• Engel, Pierre: Réhabiliter, renforcer, transformer et rénover avec l'acier Art et technique de rénover les bâtiments avec l'acier. Paris 2010

• World Commission on Environment and Development (WCED): Our Common future (Brundtland Report). Suffolk 1987

Authors' CVs

Andrea Bruno

works on various projects all over Europe, including architectural renovations, e.g. museums, historical and public buildings. He is president of the "Raymond Lemaire International Centre for Conservation" at the Catholic University of Leuven. He also works for the UNESCO as adviser on Restoration and Conservation of the World's Cultural Heritage.

Markus Feldmann

studied civil engineering at RWTH Aachen University. He received the Dipl.-Ing. in 1991 and Dr.-Ing. degree in 1994. After a period in research and industry he was appointed a full professor for steel construction at the Technical University of Kaiserslautern in 2001. Since 2004 he has been full professor for steel- and lightweight construction at the RWTH Aachen University. He is partner in the structural design studio "Feldmann + Weynand GmbH", Aachen.

Francis Rambert

is an architecture critic. Since 2004 he has been the director of the "Institut français d'architecture", contemporary department of the "Cité de l'Architecture et du patrimoine" in Paris. As a journalist, he wrote in the culture section of "Le Figaro" daily newspaper, from 1990 till 2004. In addition, he participated in the creation of "d'Architectures" magazine in 1999 and was the chief editor of that monthly review till 2002. Francis Rambert is an author of several books and has curated many exhibitions as well.

Bollinger + Grohmann

is a Frankfurt am Main based engineering consultancy. Founded in 1983, today Bollinger + Grohmann has 100 employees in three European offices and provides a complete range of structural design services for clients and projects worldwide. For years they have been collaborating successfully with numerous internationally recognised architects and strive to always provide the best solution through their creativity and technical excellence. Their scope of work ranges from building structures to classic civil engineering structures such as bridges, roofs and towers.

Federico Mazzolani

is professor of structural engineering at the University of Naples "Federico II". He is an internationally recognised expert in metal structures, seismic design and rehabilitation of constructions.
Chairmanships: STESSA Conference "Behaviour of Steel Structures in Seismic Areas". CEN Committee for Eurocode 9 "Design of Aluminium Structures". COST C26 Action "Urban Habitat Constructions under Catastrophic Events". PROHITECH Conference on "Protection of Historical Buildings".

Alexander Reichel

studied architecture at the Technical University in Darmstadt, graduated in 1992, and worked afterwards together with Prof. Joachim Schürman in Salzburg. Since 1997 he has been the head of an own office named Reichel Architekten BDA located in Kassel. Between 2002 and 2005, he worked as visiting professor for design and building construction at the Technical University in Darmstadt. As a specialist author he writes books about structural theory, such as DETAIL Practice "Building with Steel".

Michael Davies

is emeritus professor of structural engineering at the University of Manchester. He also acts as an international consultant and expert witness in light gauge steel structures and cladding. He has been the lead author in two books and editor and contributor to a third, each of which is state-of-the-art in its field. He has also authored over 200 technical papers and has played a leading role in a number of international committees.

Gerard O'Sullivan

is a cost and construction law consultant/director with well known Irish firm of Mulcahy McDonagh & Partners, with over 30 years experience. He is also active as an arbitrator and conciliator. He has been president since 2005 of the "European Council of Construction Economists" (CEEC) and a former chairman of "The Society of Chartered Surveyors". Gerard O'Sullivan is member of several commitees and works also as an author.

Llwellyn van Wyk

is a qualified and registered architect in South Africa. He ran his own architectural practice in Cape Town for 20 years before joining the CSIR research council in 2002 where he is a senior researcher in advanced construction methods. His research includes sustainable building and construction, a subject he regularly delivers papers, lectures and keynote addresses on around the world.